A STITCH IN TIME

THE NEEDLEWORK OF AGING WOMEN
IN ANTEBELLUM AMERICA

AIMEE E. NEWELL

OHIO UNIVERSITY PRESS

Athens

Ohio University Press, Athens, Ohio 45701

ohioswallow.com

To obtain permission to quote, reprint, or otherwise reproduce or distribute material from
Ohio University Press publications, please contact our rights and permissions department at
(740) 593-1154 or (740) 593-4536 (fax).

Printed in the United States of America

Ohio University Press books are printed on acid-free paper ♾ ™

24 23 22 21 20 19 18 17 16 15 14 5 4 3 2 1

This book was made possible in part by the generous support
of the Quilters Guild of Dallas and The Coby Foundation, Ltd.

THE COBY FOUNDATION, LTD.

Library of Congress Cataloging in-Publication Data

Newell, Aimee E., author.

A stitch in time : the needlework of aging women in antebellum America / Aimee E. Newell.

pages cm

Summary: "Drawing from 167 examples of decorative needlework — primarily samplers and quilts from 114 collections across the United States — made by individual women aged 40 and over between 1820 and 1860, this exquisitely illustrated book explores how women experienced social and cultural change in antebellum America. The book is filled with individual examples, stories, and over eighty fine color photographs that illuminate the role that samplers and needlework played in the culture of the time. For example, in October 1852, Amy Fiske (1785–1859) of Sturbridge, Massachusetts, stitched a sampler. But she was not a schoolgirl making a sampler to learn her letters. Instead, as she explained, "The above is what I have taken from my sampler that I wrought when I was nine years old. It was w[rough]t on fine cloth [and] it tattered to pieces. My age at this time is 66 years." Situated at the intersection of women's history, material culture study, and the history of aging, this book brings together objects, diaries, letters, portraits, and prescriptive literature to consider how middle-class American women experienced the aging process. Chapters explore the physical and mental effects of "old age" on antebellum women and their needlework, technological developments related to needlework during the antebellum period and the tensions that arose from the increased mechanization of textile production, and how gift needlework functioned among friends and family members. Far from being solely decorative ornaments or functional household textiles, these samplers and quilts served their own ends. They offered aging women a means of coping, of sharing and of expressing themselves. These "threads of time" provide a valuable and revealing source for the lives of mature antebellum women"— Provided by publisher.

Includes bibliographical references and index.

ISBN 978-0-8214-2052-2 (pbk.) — ISBN 978-0-8214-4475-7 (electronic)

1. Quilting—United States—History—19th century. 2. Older women—United States—Social conditions—19th century. 3. Middle class women—United States—History—19th century. 4. United States—Social life and customs—19th century. 5. Aging—Psychological aspects. I. Title.

TT835.N473 2014

746.46—dc23

2013041740

For my grandmothers, Faith Hill Newell
and Sybil Hartley Eshbach, who always
inspired me with their many talents.
And for Bill, who wouldn't be satisfied until
he saw my name on a spine.

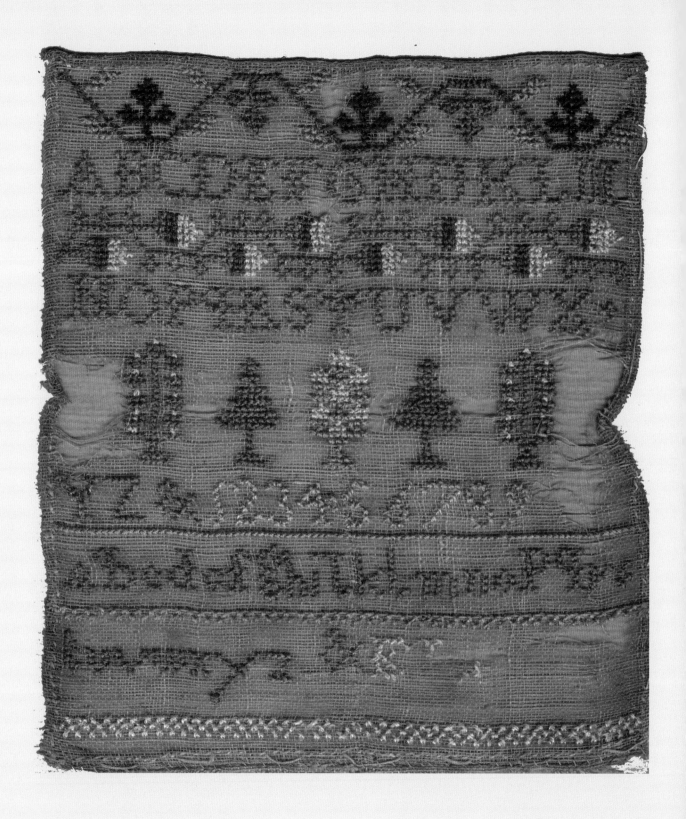

CONTENTS

❧ ❧

❧ ❧

Facing page: Sampler by Esther Johnson (1778–1859), 1787, England.
Courtesy of the Slater Mill Historic Site, Pawtucket, Rhode Island.

ACKNOWLEDGMENTS

❧ ❧

THIS TOPIC first occurred to me more than a decade ago, as I sat in my living room happily stitching away on a counted cross-stitch sampler. I enjoy my stitching so much, I thought, surely there were women of the past who also enjoyed making samplers far past their school years. When I returned to school myself and the time came to choose a dissertation topic, I remembered this idea, which was bolstered by the Amy Fiske sampler that I, as curator of textiles, had recently acquired at Old Sturbridge Village and which opens this book.

I am indebted not only to Amy Fiske but also to many people along the way who encouraged me and inspired me to pursue my doctorate, complete my dissertation, and revise it into this book. Marla R. Miller, Joyce Avrech Berkman, Jay Demerath, and Martha Saxton read and commented on my dissertation, asked insightful questions, provided support and motivation, and cheered me on to find a publisher. Carrie Alyea and Ned Lazaro also read earlier drafts and offered supportive comments. Alden O'Brien, curator of costume and textiles at the Daughters of the American Revolution Museum, was unfailingly helpful with my earlier drafts. She was generous to a fault, sharing her own research, e-mailing me about objects that might fit my criteria, and assisting me with looking at the smallest details during my two research visits to the museum.

The original research behind my ideas was supported by a partial Bauer-Gordon Fellowship from the University of Massachusetts–Amherst History Department, a Lucy Hilty Research Grant from the American Quilt Study Group, and a Beveridge Grant from the American Historical Association. I am deeply grateful to the Quilters Guild of Dallas, which provided funding from the Helena Hibbs Endowment Fund that made this book possible. I am also grateful to The Coby Foundation, Ltd., for its generous support of this book.

To do justice to the needlework discussed here, I required many images. I am especially indebted to the following: Suzanne B. Anderson; Selina Bartlett, Allen Memorial Art Museum, Oberlin College, Ohio; Joan R. Brownstein; Adrienne Donohue, Concord Museum; Deborah Tritt, Gregg-Graniteville Archives, Gregg-Graniteville Library, University of South Carolina–Aiken; Amy Finkel, M. Finkel and Daughter, Philadelphia, Pennsylvania; Nantucket Historical Association; the National Archives; the National Gallery of Art; Doris Bowman, National Museum of American History, Smithsonian Institution, Washington, DC; Northeast Auctions, Portsmouth, New Hampshire; Jeannette Robichaud, Old Sturbridge Village; Whitney Pape, Redwood Library and Athenaeum, Newport, Rhode Island; Merikay Waldvogel; and Susan Newton, Winterthur Museum and Country Estate, Delaware.

At Ohio University Press, I thank the anonymous readers who made numerous helpful suggestions, Gillian Berchowitz, and Nancy Basmajian.

Facing page: Nantucket Agricultural Society quilt, 1856, Nantucket, Massachusetts. *Courtesy of the Nantucket Historical Association, Nantucket, Massachusetts.*

Finally, I thank, from the bottom of my heart, my friends and family who supported me in many different ways throughout the process. Special mention goes to Ned Lazaro, Annann Hong, William Guy, and Hilary Anderson Stelling. And I thank my parents, Norman Newell and Marion Eshbach Newell, who helped in too many ways to count, from teaching me how to cross-stitch when I was six up to providing pep talks during the home stretch. I hope that, like the needlework described within, this book will celebrate, instruct, and inspire.

A STITCH IN TIME

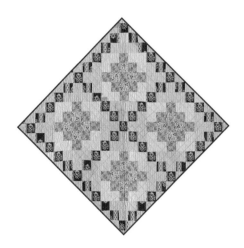

FIGURE I.1. SAMPLER BY AMY FISKE (1785–1859), 1852,
STURBRIDGE, MASSACHUSETTS.

Collections of Old Sturbridge Village, Sturbridge, Massachusetts, 64.1.121, photograph by Thomas Neill.

As she explained on the sampler, Amy Fiske stitched this piece at the age of sixty-six. She based it on the sampler that she made when she was nine years old, which had "tattered to pieces." While most extant samplers were made by girls and young women, Fiske's sampler demonstrates that older women did make samplers during the antebellum decades, contrary to many published histories of American needlework.

INTRODUCTION

IN OCTOBER 1852, Amy Fiske (1785–1859) of Sturbridge, Massachusetts, stitched a sampler (figure I.1). But Amy was not a young schoolgirl making a sampler to learn her letters or to reinforce household sewing skills. Instead, as she explained on her sampler, "The above is what I have taken from my sampler that I wrought when I was nine years old. It was w[rough]t on fine cloth it tattered to Pieces My age at this time is 66 years."[1] Indeed, when she stitched the sampler, Amy Fiske was a great-aunt who had raised four children of her own and was living on the farm her husband owned. Girls and young women traditionally made most extant samplers as educational exercises in a school setting. Why did Amy Fiske restitch her childhood sampler so late in her life?

Like that of most women of her generation, those who reached the age of forty between 1820 and 1860, Amy Fiske's life story is frustratingly vague in the documents

she left behind. There are few details to explain her accomplishments, her tastes, or her outlook on life. But her sampler is almost more telling than a letter would be; both the text on the sampler and the materials used to make it offer insight into her life and the life of her community. Amy Fiske's action, restitching her sampler, is a personal response to the changing roles of aging women during the antebellum era (1820–60).

<center>༖ ༖</center>

The needlework (including samplers, quilts, and other decorative needlework) that aging white, middle- and upper-class women like Amy Fiske left behind offers a way to explore how these women experienced social and cultural changes taking place between 1820 and 1860, as well as their personal reactions to growing older. These stitched objects were generally made of the women's own volition. They chose the materials and the patterns as they pleased, in direct contrast to the needlework made by girls and young women that was stitched in a school setting under the guidance of a teacher. For aging middle-class women in antebellum America, this difference meant that their needlework served as a source of identity allowing them to define themselves, serve as a model for others, and leave a piece of themselves behind.

In a survey of early nineteenth-century letters and diaries written by older women, historian Terri Premo determined that aging women "found much of nineteenth-century life unsettling," as "political and technological change seemed rampant and not necessarily welcome."[2] Yet the aging process was neither all positive nor all negative. Some women experienced a loss of power and other negative effects as they grew older, while others embraced this new stage of their life and enjoyed its benefits. Many experienced a combination of negative and positive effects. The samplers, quilts, and other decorative needlework made by these maturing women demonstrate their complicated response to the changes around them. The objects they created carry cultural meanings and reactions—both positive and negative—to the events taking place in the antebellum era, including industrialization, the abolition movement, and women's rights activities.

Of course, some of the motivations to stitch are ageless—women, old and young alike, used needlework to express love and to be remembered—but these motivations could often become more acute as women aged.[3] The familiar medium of needle and thread employed by women from childhood to old age offered the comfort of continuity during personal, community, and national transitions. As one antebellum needlework guide explained, "We find [the needle] the first instrument of use placed in the hand of budding childhood, and it is found to retain its usefulness and charm, even when trembling in the grasp of fast declining age."[4] Many aging women seem to have been motivated by nostalgia when they picked up their needles, which set them apart from girls and young women. Needlework allowed nostalgic women to produce objects that resembled items they had made and owned in the past and to recapture memories of picking up their needles as girls, prospective brides, and young mothers.

While the action of stitching needlework could provide a sense of continuity for aging women, evidence of generational struggle can also be seen in the needlework products made by women born during the late eighteenth and early nineteenth centuries who matured and became elderly during the antebellum period. These aging stitchers were often inspired by the example set by their mothers and

grandmothers and were taught needlework when educational opportunities for white middle- and upper-class girls flourished during the Federal era. But by the 1820s and 1830s, and increasingly into the 1850s, the skills that these women learned were becoming less and less necessary. Their daughters and granddaughters no longer learned to stitch at school and instead relied more and more on factory-produced and store-bought thread, yarn, and cloth, as well as published patterns.[5] How did these societal and cultural changes alter the appearance and meaning of antebellum needlework for its makers and for their families? And how did needlework help aging women in antebellum America express their beliefs, values, and fears in a changing world?

"I Have Lived the Years Allotted to Man": Defining Old Age

There is no consensus about the nineteenth-century definition of "old age." Most scholars suggest that sixty was widely considered to be "old" by people of the early nineteenth century. Indeed, according to David Hackett Fischer's research, in 1850, only 4.3 percent of the U.S. population was aged sixty and over, and only 1.5 percent was aged seventy and over.[6] However, this determination often differed depending on gender, with women considered to be "old" once they reached menopause. Others make the case for sixty-five or seventy as the definition of "old."[7] Writing in 1856, sixty-five-year-old Lydia H. Sigourney (1791–1865) asserted that "only five in one hundred of our race attain the age of seventy."[8] One of Sigourney's contemporaries explained that few live to "three score and ten," citing the statistic that 970 out of 1,000 died before they reached seventy.[9]

Based on a biblical reference, the age of seventy became a traditional benchmark for the human life span. In the Bible, Psalms 90 reads, "The days of our years are threescore years and ten; and if by reason of strength they be fourscore years, yet is their strength labor and sorrow; for it is soon cut off, and we fly away."[10] On her seventieth birthday, for example, Joanna Graham Bethune (1770–1860) wrote in her diary, "According to Scripture, I have lived the years allotted to man, and must now, if I have not before, daily expect to be called to give an account of my stewardship."[11]

Steps in the biological cycle—motherhood, widowhood, and menopause—defined "old" for most antebellum women. An 1835 to 1845 portrait of Esther Belcher Bird (1792–1840) of Foxborough, Massachusetts, resembles countless others from that era (figure I.2). Bird is seated on one end of a sofa and wears a dark dress with a white embroidered collar and a gray embroidered scarf. As befit a woman of her station at that time—a married woman in her late thirties or early forties and mother to six daughters—Bird wears a white ruffled cap on her head. On the back of the portrait is a paper label with a handwritten inscription, "Put on cap when first baby was born 1814 Old woman then."[12] Bird's caption may have been mostly tongue-in-cheek (since she was only twenty-two when her first child was born), but she was not the only woman to associate the wearing of her cap with the aging process. Traditionally, women began to wear caps over their hair when they married and became mothers. Women who had not married by the age of thirty or so also began to wear a cap each day.[13] Indeed, unmarried fifty-year-old Rebecca Dickinson (1738–1813), a generation older than Bird, wrote in a 1788 diary entry that she "felt the pott on her head," probably referring to the conspicuousness of her

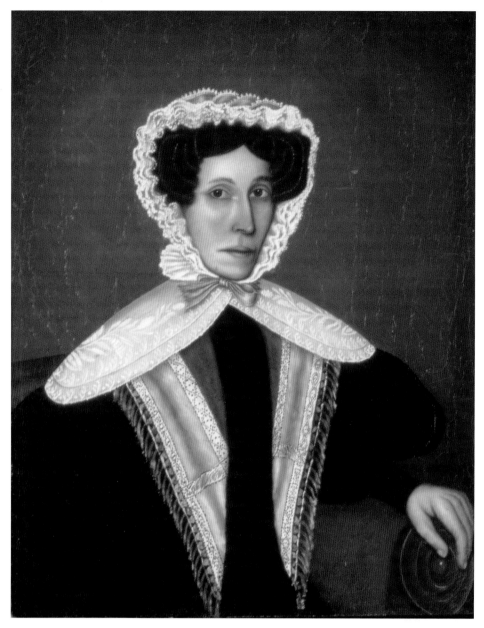

FIGURE I.2. PORTRAIT OF ESTHER BELCHER BIRD (1792–1840) BY AN UNIDENTIFIED
ARTIST, 1835–1845, PROBABLY FOXBOROUGH, MASSACHUSETTS.

Collections of Old Sturbridge Village, Sturbridge, Massachusetts, 64.1.50, photograph by Henry Peach.

Given her youth, Bird's comment about putting on the cap at the birth of her firstborn was presumably poking fun at herself, but most antebellum women did associate the aging process with steps in their biological cycle—including motherhood.

cap, a signal of maturity at odds with her never-married status.[14]

Entering widowhood was another marker by which antebellum aging women defined growing old, although many widows had not yet reached their forties, as women could be widowed at any age. Becoming a widow was often difficult, because women could face uncertain economic status with limited ways to make a living.[15] Through her study of the letters and diaries of aging women in the early republic, Terri Premo found that "widowhood elicited anger, loneliness, and depression; it was often considered the point at which life began to decline."[16]

Mid-nineteenth-century sources found the most agreement in equating old age in women with their late forties and early fifties, not coincidentally a time also associated with menopause. Sixty-five-year-old Connecticut poet and novelist Lydia Sigourney wrote, in a book about aging, "It must be, doubtless, admitted that the meridian of life is fully passed at fifty. It would be an exceedingly liberal construction to extend to sixty, the dividing line between the ante and the post-meridian people."[17] She went on to justify her definition of old age: "Those who have completed a half century, if not literally numbered among the aged, have yet reached a period of great gravity and importance. . . . To a future generation they should pay the debt which they have incurred from the past."[18]

Whether she realized it or not, Sigourney's words found consensus with many of the medical guides of the era, which linked menopause with the definition of old age for women. Antebellum medical guides show consistent agreement that a woman could expect to enter menopause in her forties and imply that at this time she was entering into the latter part of her life, often calling it the "turn

of life." In 1847, Dr. A. M. Mauriceau explained, "The nearer a woman approaches her forty-fifth year . . . will be the risk of some irregularity in the menses."[19] Most medical experts acknowledged that there was no uniform age for menopause to start, instead indicating a range of ages. As Dr. Frederick Hollick noted, "The usual age when this change commences is from *forty* to *forty-five*. It is sometimes, however, protracted to *fifty*, and even *sixty*, and in this country it not unfrequently takes place as early as *thirty-five* or *thirty!*"[20]

In light of the antebellum evidence cited here, this study includes only those examples of needlework that can be documented to have been made by women who were aged forty or older. Generally, by their early forties women had completed their childbearing years. Of the 103 women studied in these pages, accurate information about the age of the maker when she had her last child was unavailable for almost half (47). For 56 makers, this information is available: of them, 16 had no children; 6 had their last child while in their twenties; and 14 women gave birth to their last child while in their thirties. Twenty women were in their forties when they had their last child, but half of them (10) were only forty or forty-one at the time. Despite this small sample size, the evidence does indicate that as their children grew up, many aging women found more time to stitch.

Women's Work

Focusing on women who are aged forty and older also means that they were well past school age—suggesting that they were motivated to make their quilts, samplers, and other decorative needlework for personal reasons and by their own choice, rather

than out of necessity or at the behest of an authority figure. Several of the examples in these pages show that many women were able to turn society's definition of needlework as "women's work" to their advantage. Through display at local agricultural fairs, use in the home, and gifts to family and friends, decorative quilts and samplers ostensibly kept female fingers busy while offering an outlet for creativity, lessons and values, and sometimes political views. As they aged, American women from all geographical regions and social classes continued to stitch, using the materials they had on hand. Their work helps to suggest that even if "women's work" was devalued by certain segments of antebellum American society, it was not universally devalued. Many women maintained their own work and the exchanges of knowledge, support, and sometimes money that accompanied it. In addition, many of the quilts and samplers discussed here served as physical talismans during the aging process. Made by one generation, they were used to educate and remind a younger one of what came before, while allowing the older makers to express their nostalgia for an earlier time.

Decorative needlework and fancywork, previously the purview of a limited group of Americans who achieved a certain economic standing, were quickly adopted by the new provincial middle class as markers of the genteel style of life in the early nineteenth century.[21] In her examination of New England agricultural fairs, Catherine E. Kelly found that by "giving physical form to the abstract values of leisure, cultivation and ornament, antebellum fancywork extended the democratization of refinement that had begun a century earlier. . . . Fancywork was . . . emblematic of bourgeois culture in its individual expressiveness, for the production of explicitly decorative objects allowed for a play of imagination not afforded by the simple sewing that absorbed so much of women's time."[22] Making decorative needlework, like a sampler or a quilt, allowed women a chance to express themselves while also demonstrating an understanding of social codes and a measure of social status. In addition, women "imbued their needlework with special significance," Kelly wrote, noting that sewing "rivaled nursing and child care in its power to evoke women's love for their kin."[23]

Scholarship on the generations that came of age following the Revolution has pointed out that some of those young women despaired of ever living up to the example set by their mothers and grandmothers.[24] But the scholarship on women who believed that they were doing their duty by becoming a "Republican mother" rarely extends into the later years of these women's lives. The pages that follow focus on how mature women experienced the onset of industrialization and the changes to social relations that accompanied the new economy and expressed that experience with their needles.

Almost all studies of samplers have focused on "schoolgirl art"—samplers and needlework pictures made by girls of school age (generally sixteen and younger), which were frequently the product of a specialized private academy or lessons from a local teacher. These books often begin by acknowledging the earliest known extant American sampler, made by Loara Standish (d. 1656) in Plymouth, Massachusetts, around 1640, and then tracing its English roots.[25] The Standish sampler is a band sampler that followed the prevailing English form and aesthetic —long and thin with horizontal rows, or bands, of stitching, showing off particular motifs or stitches. Gradually over the seventeenth and eighteenth centuries, American samplers took a squarer shape and employed naturalistic motifs of flowers and animals.

The use of a verse became more common, and the composition became more pictorial. American samplers reached their peak in terms of both quality and quantity during the first quarter of the nineteenth century.[26]

Contemporary diary accounts and memoirs suggest that many nineteenth-century girls looked forward to their needlework training. When reflecting on her early education, Sarah Anna Emery (1787–1879) of Newburyport, Massachusetts, used language reminiscent of religious worship or conversion to convey her excitement at learning to stitch: "Miss Emerson was a most accomplished needlewoman, inducting her pupils into the mysteries of ornamental marking and embroidery. This fancy work opened a new world of delight. I became perfectly entranced over a sampler that was much admired."[27] Miss Emerson's "accomplished" needlework skills made her a role model for young Sarah. Sarah's use of words such as *mysteries, delight,* and *entranced* shows that she was clearly being drawn into the cult of true womanhood. She was learning skills to set herself apart from a certain class of women in her community and starting along the path to wifehood and motherhood.

But starting in the late 1820s, sampler making began to decline.[28] By the 1840s and 1850s, beginning in New England, educational opportunities widened for girls, with needlework dropping out of curricula across the United States. At Mount Holyoke Female Seminary in the late 1830s, Mary Lyon (1797–1849) established a housekeeping department but "labored to show her friends that she did not design a manual-labor school in any sense, nor a school where young ladies would be taught domestic duties."[29] Catharine Beecher (1800–1878) had even more extreme views about female education. She insisted that "young women should not be

educated to be genteel ornaments. . . . The purpose of a young woman's education was to enable her to translate her knowledge into action."[30] The practical reason for stitching a sampler—to learn how to mark one's household linens—ceased to be quite so important at this time as indelible inks came into common use.[31] Other innovations also simplified needlework. By the time Amy Fiske stitched her sampler in 1852, for instance, her sampler fabric was woven with a colored thread at regular intervals to assist with counting the stitches, suggesting a recognition of the decline in the needlework skill of American girls.

The existing body of curatorial scholarship argues that samplers served two purposes: to educate young women and to offer evidence of their parents' gentility. But despite the significant amount of text written about American samplers, there has been little interest in samplers that do not fit the schoolgirl pattern. A survey of the major books and catalogs (some thirty works) reveals three understandings of samplers made by older women. The majority either state directly that older women did not make samplers or do not address the possibility at all.[32] This is not a new trend. As early as 1921 (in one of the earliest works of contemporary needlework scholarship), Candace Wheeler wrote that "embroidery was work for grown-up people, while samplers were baby-work."[33] Almost seven decades later, Judith Reiter Weissman and Wendy Lavitt echoed her words: "Marking samplers . . . teach little girls the knowledge they would need to initial[;] . . . more elaborate pieces were primarily made in seminaries or academies . . . [by] older girls ages 12 to 18."[34]

A second group of authors acknowledges that some samplers were made by older women but qualifies this observation by suggesting either that

these women were teachers, marking their samplers as models for their students, or that older women made samplers in the sixteenth and seventeenth centuries but not during the eighteenth and nineteenth centuries. In *Girlhood Embroidery,* for example, Betty Ring asserts: "Most likely samplers were always made by young people under the instruction of an experienced needlewoman . . . There is no convincing evidence that samplers were made by mature women other than those engaged in teaching."[35] So entrenched is this conventional wisdom that even in books illustrating a sampler made by an older woman, the authors either neglect to explore what this might mean or go to great lengths to fit the sampler and its maker into the category of teacher.

Finally, there is a small group of authors who do acknowledge that samplers were made by older women and that they were not, by necessity, teaching exercises. Showing how groundbreaking they were, Ethel Stanwood Bolton and Eva Johnston Coe, authors of the 1921 work *American Samplers,* explained that while most of the nineteenth-century samplers they found were made by young children, some samplers *were* made by older women. They cite a sampler made by a sixty-year-old woman named Hannah Crafts. Instead of finding an excuse or fitting her neatly into the category of teacher, Bolton and Coe gave some thought to what this sampler might have meant for its maker. "Her heart probably reverted to the days of her youth," they suggested, "when samplers were even more prevalent, and she doubtless reproduced those she remembered, instead of copying the work of the young people about her."[36]

Unlike stitching samplers, quilt making is not typically understood as the work of women at a particular period in their lives, or at least not strictly

so.[37] Even when the focus of a particular study is on the quilts made by younger women—for example, as they prepared for impending marriage—the activity is often presented in the context of group work, and the group includes mothers, grandmothers, and aunts, as well as the bride-to-be. One study of almost 450 diary entries that referenced quilt making in New England in the early nineteenth century found that in just over half of the entries, women "recorded assistance from outside the quilter's household for the completion of all types of quilting projects."[38] While both older and younger antebellum women quilted, the circumstances under which they did so were different. For example, compared to younger women, older women did not quilt as often at social events. Instead, older women were more likely to quilt alone or with members of their immediate family.[39] Yet while it is acknowledged that older women made quilts, there has not been a study devoted to exploring these quilts.

The majority of existing literature on quilt history focuses on the period from 1850 to 1900, with less attention paid to pre-1850 quilts.[40] The pieced quilt that most think of as the traditional American quilt only started to emerge and become widespread in the 1820s, after the invention of the cylinder-printing machine. This development caused a revolution in the way that fabric was printed and drove down costs sharply while increasing supply. Colorful cotton quilts pieced in blocks became popular throughout the 1820s and 1830s, becoming prevalent in the 1850s and 1860s.

Just like Amy Fiske's sampler, quilts have much to teach us, particularly when we apply the criteria of age, class, geography, and style. A quilt made around 1830 by a Massachusetts widow, for instance, offers analytical potential on several levels. Eliza Macy Howland Barney (1783–1867), for example,

made at least one quilt in her late forties, when she was living in New Bedford, probably after being widowed for the second time (figure I.3). Eliza Macy was born on Nantucket Island in 1783. Around 1808, she married Allen Howland (d. 1809), who was lost at sea in 1809. The couple had one daughter, Hannah Howland (1809–1855). By 1830, Eliza had married Peter Barney (dates unknown); according to the U.S. Census that year, the couple lived in New Bedford with two other females, one aged ten to fifteen and one aged fifteen to twenty (probably Eliza's daughter Hannah). Peter Barney appears to have died prior to the 1840 Census, when Eliza is listed alone, living in New Bedford, with real estate valued at $11,500. In 1860, she resided in Providence, Rhode Island, with forty-one-year-old clergyman Samuel C. Brown (b. 1819) and his family. Her own daughter, Hannah Howland Russell, died in 1855. Eliza died in 1867 in Rhode Island.[41]

Barney used a simple strip-pieced pattern, stitching long pieces of fabric lengthwise to make her bed covering (figure I.4). The quilt employs a mix of fabrics, some dating back thirty years or more. The three red fabrics include two that are block printed, suggesting that they date from the late eighteenth century or the early nineteenth century, prior to the invention of the cylinder-printing machine. Two of the blue-and-white prints are newer, dating to the late 1810s. Cylinder printed in England, one depicts a wild boar hunt.[42] While we cannot be sure, Barney's choice to use the older prints in her quilt may indicate a frugal nature, that she sought a means of remembering happier times, or both.

The evidence presented by the quilt suggests that it was initially intended as a functional bed covering rather than as a treasured keepsake. The strip-pieced style was simple and verged on unfashionable in the 1830s.[43] In addition, a close look at the indi-

vidual strips shows that Barney made some of them by stitching together smaller pieces of fabric, rather than cutting them whole from yardage. There are also several patched areas on the strips, as well as uniform fading on some strips but not others, suggesting that the fabrics used in the quilt may have been recycled from other household textiles, such as window treatments or bed hangings.

The cross-stitched initials "EH" appear on the back of the quilt. Like the front of the quilt, the backing is pieced from many scraps of plain muslin and linen fabrics, again suggesting that these pieces were recycled, this time from old sheets and towels. The initials "EH" date to Barney's first marriage, around 1808, to Allen Howland, who was lost at sea in 1809. The piece of the quilt's backing with these initials was probably recycled from a worn-out sheet or other household textile that Eliza made in preparation for her first marriage. Between 1809 and 1829, Eliza remarried, becoming the wife of Peter Barney, and probably would have used her then-current initials, "EB," if the mark dated from when she made the quilt around 1830.

The quilt employs techniques that were dated in 1830: not only the strip-pieced pattern but also the knife-edge binding, which is often seen on New England wholecloth wool quilts from the late eighteenth century but was superseded by applied bindings as printed cotton fabrics became more affordable in the early nineteenth century.[44] The quilting pattern is simple, adding credence to its intended functional use as a warm bed covering.

As a native Nantucketer, Eliza may have been a Quaker, and this may have affected the type of quilt she chose to make.[45] The Society of Friends was well established on the island by the late eighteenth century. Even if Eliza was not a member herself, both of her husbands were, and she would have

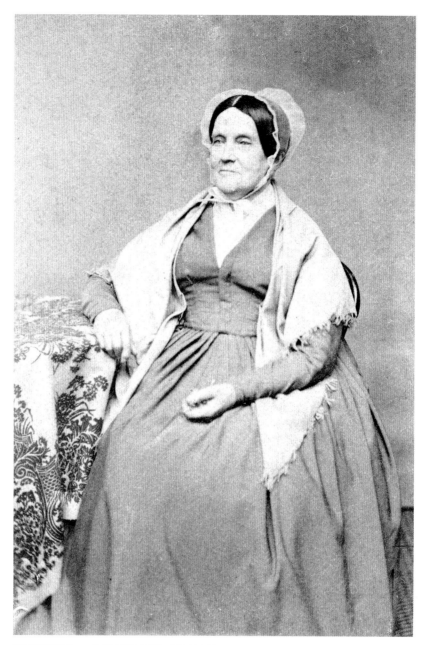

FIGURE I.3. PORTRAIT OF ELIZA MACY HOWLAND BARNEY
(1783–1867) BY BIERSTADT BROTHERS, CIRCA 1860,
NEW BEDFORD, MASSACHUSETTS.

Courtesy of the Nantucket Historical Association, Nantucket, Massachusetts.

By the time she made her quilt around 1830, Eliza Macy Howland Barney had been married and widowed twice. In contrast to the frugal techniques and materials she used to make her quilt, Eliza was listed on the 1840 U.S. Census as a woman of some wealth.

FIGURE I.4. QUILT BY ELIZA MACY HOWLAND BARNEY (1783–1867),
CIRCA 1830, NEW BEDFORD, MASSACHUSETTS.

Courtesy of Historic Deerfield, F.10B, photograph by Penny Leveritt.

This quilt, made by Eliza Macy Howland Barney when she was in her late forties, shows dated fabrics and techniques. The strip-pieced pattern and knife-edge binding are more commonly seen on quilts from the late eighteenth and early nineteenth centuries. Composed of top and backing fabrics that appear to have been recycled from household textiles, Barney's quilt may have served as a record of her past, combining techniques familiar from her childhood and fabrics she used in her home as a young wife.

been familiar with that faith and its principal tenets. Quakerism advocated plainness of speech and dress to avoid worldly concerns that could impede the Quaker pursuit of "inner light," or the spirit of God, that Friends believed dwelt within everyone. Barney's quilt combines frugal construction techniques with a colorful fabric palette, perhaps offering her a way to mediate theological ideals and worldly temptations.[46] Despite its rather utilitarian appearance, the quilt was saved and passed down after her death, perhaps taking on new meaning later in its life as a means of connection to its maker.

Including Barney's quilt, the foundation of this project is a survey of 167 samplers, quilts, and other needlework from fifty museums and sixty-four private owners made (or altered) by women who were aged forty and over between the years 1820 and 1860 (see appendix). Only artifacts for which the identity and age of the maker and the date of construction can be identified are sources for this study. The makers examined here range in age from forty to Mary Laman Kemp (1758–1845), who made a quilt when she was eighty-two, and Betsy Rice Nims (1751–1842), who stitched on her quilt when she was about eighty-nine. Most of the objects were made by women when they were in their forties, fifties, or sixties. While the makers lived throughout the antebellum United States, they generally shared a certain level of economic standing that granted them the time and money it took to make needlework that would be preserved for two hundred years. They were educated beyond basic reading and writing, and they followed popular styles and aesthetics. These are women who read novels and newspapers and were familiar with political and social issues that were being played out in their communities and their nation.

Samplers and quilts make up the largest groups of needlework found for this study, so they offer the bulk of the specific examples discussed in these pages. In addition to the 109 quilts located and the fifty samplers found that fit the criteria, the survey also turned up one rug, three coverlets, one table cover, two mourning pictures, and a group of fabric sculptures, all made between 1820 and 1860 by women who could be determined to be forty or older when these objects were made.[47] The samplers fall into three categories: those made by women aged forty and over; samplers stitched by the woman when she was a young girl and later modified in some way (such as having the age or date or other identifying information picked out of the sampler); and samplers that were modified to trace the life and death of the maker—such as a family record sampler to which the maker's death date was added. The quilts surveyed for this study are also ones conclusively determined to have been made by women aged forty and over. Special attention has been paid to quilts that were entered in agricultural fairs, ones that have some kind of message or biographical information pieced into their tops, those with machine sewing, and those given as gifts to another person. When additional types of needlework (including needlework pictures and other decorative household textiles) made by women aged forty and over between 1820 and 1860 were found, they were considered as well.

All of the needlework examined here falls into the category of "decorative" rather than primarily "functional." This bias stems from the very survival of these artifacts—they were generally not used every day but instead were saved as special objects, stored away carefully and passed down from generation to generation. By definition, these were also

the types of items that had their history preserved. Because they were special, they often retained an association with a particular maker, enabling a determination of that person's age at the time. The age of the maker was the primary criterion for this study. Examples are drawn from all over the antebellum United States, with no particular geographic focus. The survey turned up objects made in twenty-three different states, with an additional twelve objects made in unknown places. Regionally, these objects break down into forty-six with a history of origin in New England; forty-one from the mid-Atlantic states; forty-six from the South; twenty from the Midwest; and two from the western region of the country. However, this points to another bias, a preponderance of examples from the Northeast and mid-Atlantic region.[48] Vast areas of what we know today as the western United States were just beginning to be settled between 1820 and 1860, and those settlers, on the whole, had little access to the time and materials required to make the kind of needlework often saved by subsequent generations.

Tattered to Pieces: Amy Fiske's Sampler

Returning to the story of Amy Fiske illustrates how material and documentary sources can work together to enhance our understanding of aging women during the antebellum era. Amy Fiske Fiske was born on November 9, 1785, in Sturbridge, Massachusetts, the daughter of Henry Fiske Jr. (1745–1815) and Sarah Fiske Fiske (1746–1815). Her father, Henry Jr., was the oldest surviving son of one of the town's founders, Henry Fiske (1707–1790), and his wife, Mary Stone (1705–1805). In 1774, Amy's

father, Henry Jr., married his cousin, Sarah Fiske, the daughter of his father's brother and cofounder of Sturbridge, Daniel Fiske (1748–1836).[49] One of the wealthiest men in Sturbridge in 1798, Amy's father owned land and houses worth almost $7,000, making him one of the top five property owners among Sturbridge's 215 propertied households at that time.[50] When Amy stitched a sampler in 1795 at age nine, she demonstrated, in part, her father's success and financial position. As a daughter of her father's household, Amy followed the steps toward becoming a proper genteel lady by stitching her sampler, probably under the instruction of a local schoolmistress.

In 1812, at the age of twenty-seven, Amy married her second cousin, Daniel Fiske (1786–1859). Daniel, often referred to as "Daniel Jr.," was in fact Daniel III. Born on May 10, 1786, in Sturbridge, he was the son of Daniel Fiske and Elizabeth Morse Fiske (1757–1839). Like Amy, Daniel descended from the Fiske brothers who had settled Sturbridge in 1731.[51] Family history explains that Daniel Jr., Amy's husband, was "a carpenter by trade, but always followed farming."[52] Tax records from 1827 show that he owned a house and barn with Amy's sister, Matilda (1784–1880), along with one-quarter of a sawmill and 131 acres of land, suggesting that the Fiskes led a comfortable life.[53]

Daniel continued to do well over the next two decades. The 1850 census provides a picture of Amy and Daniel's household shortly before she made her sampler. The couple were both sixty-four years of age at that time and lived with their daughter, Sarah (1817–1909); their son Henry (1818–1896) and his wife, Lydia (1815–1887); and a laborer, Hiram H. Ransom (b. ca. 1825).[54] Daniel and Amy had four children, but only Henry married. Lucius Colwell

Fiske was born in 1813 and died in California in 1874. Sarah, the only daughter, was born in 1817 and remained single until her death in 1909 in Southbridge. Henry Morse Fiske was born in 1818, married his cousin Lydia Belknap in 1847, and lived a long life in Sturbridge and neighboring Southbridge, dying in 1896. George Daniel Fiske, Amy and Daniel's youngest son, was born in 1823, when Amy was thirty-eight. George did not marry but moved out west at some point, dying in the Dakota Territory in 1861.[55]

Amy's 1852 sampler is stitched entirely in simple cross-stitch rather than in a mix of decorative stitches. This could be an effect of failing eyesight. Like many other aging women, Amy Fiske may have had to adapt to continue producing needlework. To help us understand how Amy, and women like her, adapted to the physical realities of aging, chapter 1 explores the physical and mental effects of "old age" on antebellum women and their needlework. Chapter 2 examines the societal ideals for aging women by comparing prescriptive literature with the words and needlework of the women themselves.

While Amy Fiske continued to live in Sturbridge after her marriage, not far from her parents' home (where she may have stitched her first sampler), the town did not remain static around her. One of the most striking differences between the Sturbridge of Amy's girlhood and that of her old age was the rise of textile factories. In 1837, six cotton mills in Sturbridge manufactured 829,749 yards of cotton goods and employed 117 women and seventy-one men. In 1855, three cotton mills manufactured over 1.5 million yards of fabric.[56]

Amy's second sampler reflects these developments. The fabric is machine woven with a thread count of thirty-two stitches to the inch and a blue weft thread every tenth thread. The use of this fabric suggests a growing preference for machine-made goods in needlework projects. This development supports the idea that needlework was not being taught the same way as it had been twenty years previously. Girls were in school side by side with boys by the 1850s, following a much more similar program of study than they had earlier in the century. With the rise of industrialization, advances in manufacturing goods for the household meant that women did not have to make as many textiles from scratch; they were able to spend their time pursuing other endeavors.

Chapter 3 focuses on the technological developments related to needlework that took place between the late eighteenth and early nineteenth centuries and the ways in which aging women responded to these changes. By the 1830s, especially in the northeastern United States, industrial manufacturing had removed spinning and weaving from the home, taking it to the factory, where it could be accomplished more cheaply. This profoundly changed women's work, more than any other single factor.[57] Few women had to spend time spinning and weaving cloth to make up clothes and household textiles or to trade at the local store for other types of goods. As a result, they were able to follow new life patterns. With some women starting to work in the factories, still pursuing the traditional women's work of textile production, though in radically altered settings, those who remained in the home needed a new way not only to define their femininity but also to set themselves apart from the women working in the factories. Decorative needlework served as one symbol of this difference.

Rather than being the student, by 1852 Amy Fiske had become the teacher. A sampler by her great-niece, Caroline M. Bracket (b. 1842), dated December 1852, follows the same pattern as Amy's

sampler and employs the same thread, fabric, and stitches (figure I.5).[58] Caroline was the daughter of Amy's niece, Cornelia Taylor Bracket (b. 1807). Cornelia's mother, Mary Fiske Taylor (1780–1827), was Amy's older sister, who died before Caroline's birth. In 1850, when Caroline was eight, the U.S. Census listed her as living next door to Amy, in the household of another great-aunt, her grandmother's and Amy's sister, Matilda Fiske. Matilda never married yet maintained a household of her own, sometimes living with Amy and her husband and, by 1850, living on her own with Caroline.[59] The record is silent on why Caroline was living with her sixty-six-year-old great-aunt in 1850. Perhaps she was there to provide assistance and companionship for Matilda. Whatever the reason, her sampler suggests that she was also learning the proper skills to run her own household someday, under the tutelage of her grandmother's sisters, who were probably playing the role that their deceased sister could not.[60]

By re-creating her sampler, Amy Fiske was making something that would preserve the female tradition of textile arts. Caroline Bracket used Amy's 1852 sampler as a guide, continuing a tradition, showing the skills of womanhood and instilling proper values into the Fiske family female line. However, Caroline's sampler is unfinished, perhaps suggesting the decline of interest in needlework among the rising generation, which was taking place in the 1850s. The quality of Caroline's sampler was several notches below that of samplers made during the early nineteenth century: the fabric had a lower thread count; it was stitched entirely in the basic cross-stitch; and there were blue threads woven in as a guideline for counting.

Chapters 4 and 5 consider how needlework (both finished products and lessons) functioned as a gift between an aging woman and her friends and family members. What were the embedded meanings in these gifts for both the maker/giver and the recipient? A woman's needlework was implicitly considered hers to give away as she saw fit—it was understood to be her property. And as anthropologist Annette Weiner points out, giving is not solely motivated by receiving, nor is it completely altruistic. Instead, there are messages that accompany the gift. The type of gift and how and when it was given reflect cultural understandings. The gift of a sampler or quilt from a grandmother to her granddaughter was a way to pass on some of her identity while also suggesting the kind of woman that she wanted her relative to be. As Weiner explained, "In general, all personal possessions invoke an intimate connection with their owners, symbolizing personal experience that . . . adds value to the person's social identity."[61] When samplers and quilts were passed down from generation to generation, they gained not only personal or familial value but also cultural value, becoming symbols of an earlier period of American history.[62] Long after she died, a woman's needlework could serve as a memorial of her life.[63]

By 1852, the purpose of Amy Fiske's sampler had changed. While it was still meant to be framed and hung on the wall, the location of the wall had changed from Amy's parents' parlor to her own. Rather than an act of obedience, Amy's sampler was an act of assertion, giving her a voice for her nostalgia for her personal past and her community's history. In her study of women growing old during the early nineteenth century, historian Terri L. Premo found that older women set themselves the task "not only to continue serving the needs of family and friends . . . but [also] to act as living reminders of a peculiarly feminine moral order."[64]

Amy Fiske restitched her sampler as a conscious act of expression. Raised in the 1790s and early 1800s,

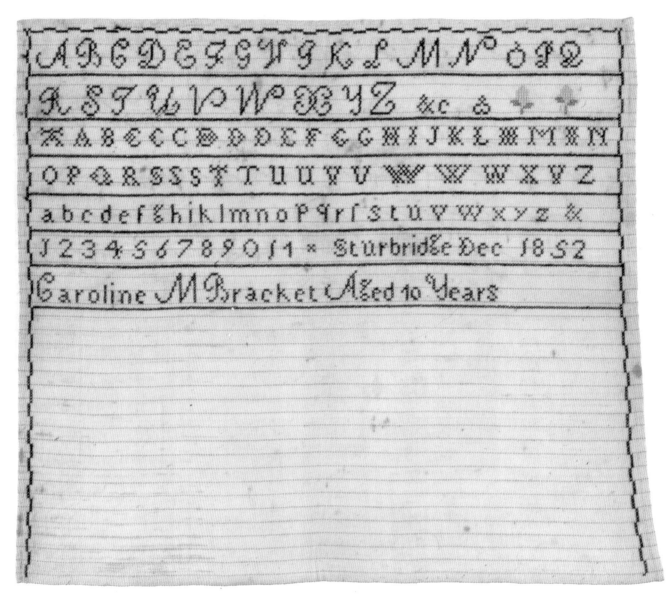

FIGURE I.5. SAMPLER BY CAROLINE M. BRACKET (B. 1842), 1852,
STURBRIDGE, MASSACHUSETTS.

Collections of Old Sturbridge Village, Sturbridge, Massachusetts, 64.1.15, photograph by Henry Peach.

Caroline M. Bracket's sampler is strikingly similar to the sampler made by her great-aunt Amy Fiske. She used the same dark brown thread, the same fabric with horizontal blue guidelines, and the same pattern. Bracket dated her sampler "Dec 1852," just two months after the date of "Oct 1852" on Fiske's sampler. Fiske may have been trying to instill in her grandniece the same needlework lessons she learned as a girl. But Caroline's sampler is unfinished, perhaps reflecting the decreasing need for young girls to mark textiles.

Amy knew her place in the home and in society. She did not leave letters and documents except those few signed by herself under her husband's signature. She left instead a sampler that is with us today because it was valued by her family and passed down.[65] As Laurel Thatcher Ulrich has pointed out, "Needlework that is saved requires two parts—ego enough to sign it in the first place and also descendants who understand it and cherish it enough to save it."[66] Amy Fiske's sampler was a badge of her womanhood, her skill at needlework, and her mastery of the proper values of wife and mother. But at sixty-six years of age, she faced a world that no longer required excellence with the needle or interpreted it as a symbol of gentility.

Chapters 6 and 7 offer an exploration of epistolary needlework, that which relates a message in the form of stitched words. Sometimes samplers and quilts became "biographical objects" for their makers—personally meaningful possessions that took on a "life" of their own.[67] From simple signatures in fabric and thread, documenting the maker and the date, to family information, moral codes, and political commentary, epistolary samplers and quilts provide a layer of context for the lives of their antebellum makers.

When Amy Fiske sat down to stitch her sampler in 1852, she figuratively drew four generations of women around her—her mother, herself, her daughter, and her great-niece. She combined the new products of her old age with the traditions of her youth to cope with the changes taking place and to leave a lasting message for her family. Amy Fiske died in 1859, at the age of seventy-four, leaving a sampler that bridges her lessons as a schoolgirl and her accomplishments as a woman. As these pages show, she was not alone in using her needle to do this.

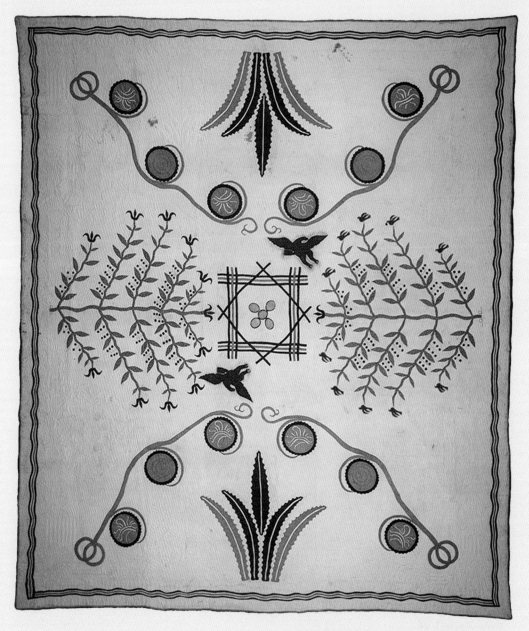

FIGURE 1.1. QUILT BY MARY FRYE VAN VOORHIS (1788–1881),
CIRCA 1850, PENNSYLVANIA.

Courtesy of the Witte Museum, San Antonio, Texas.

According to family history, Mary Frye Van Voorhis made this quilt when she received her "second sight." As happens with many aging people, then and now, her eyesight changed from farsightedness to nearsightedness. As a result, she would have been able to see clearly more closely, enabling her to appliqué and quilt more easily.

1

THE PHYSICAL CHALLENGES OF NEEDLEWORK

CCORDING TO FAMILY history, Mary Frye Van Voorhis (1788–1881) made a quilt around 1850 (figure 1.1).[1] Her quilt, appliquéd in red, green, brown, and blue on a white background, shows an original design called "The Eagle's Nest." The bed covering is elaborately quilted around the appliquéd depiction of eagles guarding their nest. The choice of the pattern reflected events that many aging antebellum women experienced firsthand, having reared their children and had them leave home. According to her family, Van Voorhis made this quilt after receiving her "second sight." Van Voorhis, who was probably farsighted and developed cataracts, would have experienced the focal point of her eyes shifting closer to her body as she aged, resulting in nearsightedness. The nearsightedness allowed Mary to see near targets again after years of only seeing clearly far away, and this was probably what she and her family called "second sight."[2]

A second quilt that employs a strikingly similar style and motifs is inscribed "Made by Mrs. D. Van Voorhis, aged 7[?] 1865."[3] While Van Voorhis's great-granddaughter dated the first quilt to about 1850 and stated that the maker was in her late eighties when she made it, the signature on the second quilt suggests that Van Voorhis was in her seventies in 1865 when she made that one. The family story about the first quilt offers a caution about this type of evidence.

The most important piece of evidence to evaluate is often the object itself, while family stories need to be weighed carefully and corroborated by other sources. According to the 1850 U.S. Census, Daniel Van Voorhis of Carroll Township, Pennsylvania, had a wife named Mary who was sixty-three, which supports the information inscribed on the second quilt. Mary Van Voorhis was born Mary Frye in Pennsylvania in 1788. The two quilts show Pennsylvania German influence. And, indeed, both Daniel and Mary Van Voorhis were raised in Pennsylvania in families of German descent. Because the two quilts employ unusual original patterns, determining a precise date is difficult, but the evidence suggests that the maker is the Mary Van Voorhis who was born in 1788; she thus made the Eagle's Nest quilt when she was in her sixties, not her eighties.[4]

As mature women such as Mary Van Voorhis grew older and experienced menopause, signaling the end of their childbearing years, they were set free from the biological restraints of menstruation and pregnancy, giving some a second lease on life along with a new sense of freedom and purpose.[5] These life changes affected the needlework that aging women produced. But in antebellum America as well as today, growing older also resulted in increasing infirmity and changes in appearance, which often had an effect on a woman's dexterity with a needle. When she turned fifty-seven in 1859,

Catharine Dean Flint (1802–1869) of Boston noted, "I have lost much in health and strength since my last birth day and look very much older—a very distressing and long illness in the Autumn has probably made in roads on my frame, which can never again be effaced."[6] Historian Janet Roebuck has suggested that the antebellum definition of "old" depended more on appearance and ability than on mere chronological age.[7] When Elizabeth Lindsay Lomax (b. 1796) turned fifty-nine in September 1855, she assessed her physical condition and concluded that despite her age, she did not "feel old," for she had "no aches and pains, no gray hairs, no wrinkles."[8]

Few antebellum medical guides and etiquette books addressed the physical effects of aging. Little specific information remains today in published sources to provide a sense of how aging women coped with failing eyesight and hearing, as well as the aches and pains of rheumatism and arthritis, but artifacts for coping—such as canes, spectacles, and ear trumpets—can be found in museum collections. The reason for this, of course, is not that antebellum women did not suffer from these problems but stems from how physicians understood the process of aging. Rather than isolating the effects of old age, antebellum physicians, just like doctors today, looked on aging as a natural process—one that could not be cured. So they treated most adults alike, without considering chronological age.[9] Survival and longevity were more noteworthy than the physical problems of the elderly.[10] However, the words of antebellum women help define the most common complaints.

When it came to needlework, arguably the most difficult effect of aging was changing eyesight. As fifty-eight-year-old Elizabeth Emma Stuart (1792–1866) noted in an 1850 letter to her daughter, Kate (1820–1853), "Today I am fifty-eight years old! Every thing around me admonishes me that wind-

ing up is at hand—I am entirely alone. . . . I read & write, but sew little [for] I cannot see to thread my needle with ease."[11] Many midcentury medical books devoted pages to this problem, identifying causes of eye pain and vision loss as well as offering ways to prevent and mitigate vision trouble.[12] In addition, eyewash products were available from antebellum shops. An 1838 issue of Concord's *New Hampshire Patriot and State Gazette* newspaper advertised Dr. Dana's Eye Wash, which claimed to be "excellent for sore eyes, and peculiar to remove inflammation around the eyes and strengthen the sight, and enable you to see longer without glasses."[13]

The lenses in the eyes grow continuously over time, becoming less flexible. As a result, as the body ages, the muscle that focuses the lens has a harder time focusing on near targets; this is called "presbyopia" and is the reason that people over forty need reading glasses. Midcentury medical guides observed that eyesight started to change around the age of forty. Those who are farsighted usually become presbyopic earlier in their lives than do those who are not. At the same time, ultraviolet light causes cataracts in the lenses. The most common cataracts change the focus of the eyes closer to the body (known as "myopia").[14] "Most persons begin to feel the necessity for some assistance to their eyes in reading and working after the age of forty," noted John Harrison Curtis.[15] The age of forty as a common onset for vision deterioration is supported by antebellum women in their letters and diaries. For example, forty-four-year-old Sarah Jones Hildreth Butler (1816–1876) wrote to her daughter in October 1860, "My eyes still trouble me. I have for a time given up reading and sewing, and walk more than I did when you were at home."[16]

Sewing or reading in low light was often cited as the most common enemy of eye health. One 1844 needlework manual strongly recommended pursuing needlework in "the clear bright light of morning," stating that doing so was important not only for accuracy and "proper choice of color" but also for health reasons: "We should, indeed, strongly advise our fair readers seduously to avoid candlelight, not only with reference to the accuracy of their work, but with a view also to the 'good keeping' of that delicate organ, the eye."[17] An 1852 medical guide concurred, writing that for people "attempting to read, or to finish off the last stitches of their work, by twilight . . . common sense should tell them . . . that such efforts cannot be made without detriment to the eyes."[18]

Several of the quilts examined here, such as the two made by Mary Van Voorhis, show designs with strong contrast between dark and light sections. While these color combinations were popular for quilt makers of all ages during the mid-nineteenth century, the contrast may have been especially helpful for older quilters because contrasting pieces were easier to see and to work with.

Yet author Lydia Maria Child (1802–1880) counseled her readers not to "read or sew . . . by too dazzling a light."[19] William-Edward Coale, perhaps the most detail-oriented author among the ones cited here, provided the following list of the causes of eye damage and problems: "habitual errors in living, the high temperatures of our houses, sitting before the intense glow of anthracite fires, want of out-door exercise, wearing thin shoes, reading badly-printed books[,] . . . too great [an] application to study, constant nervous excitation and . . . a general overestimation of mind and body, without any hygiene correctives."[20] He also believed that eyesight would be affected not by the amount of light but by its position, and he asserted that "light should always come from above[;] . . . an immense deal of the bad eyesight and weariness of the eyes so often complained of by needle-women is caused" by

sewing with misplaced light sources.[21] Still another medical text argued, "Old women, having little else to do, sometimes read too constantly, and frequently with the very same glasses that they used twenty years before. Thus the eyes are kept constantly inflamed."[22] Fifty-one-year-old Elizabeth Dorr of Boston noted in her diary on June 5, 1855, that she "could work but little[,] having had the unaccountable or unaccounted for pain intensely in the left eye last night." Almost three weeks later, her eye pain had abated, as she wrote in her diary, "Rainy day. We enjoyed the opportunity for sewing."[23]

Mature women, such as Dorr, expressed familiarity with this sort of medical advice, although they did not always follow it. For example, seventy-year-old Dolley Payne Todd Madison (1768–1849) wrote to her friend, sixty-year-old Margaret Bayard Smith (1778–1844), in 1838, "I found myself involved in a variety of business—reading, writing, and flying about the house, garden, and grove—straining my eyes to the height of my spirits, until they became inflamed, and frightened into idleness and to quietly sitting in drawing-room with my kind connexions and neighbours . . . being thus obliged to give up one of my most prized enjoyments[,] that of corresponding with enlightened and loved friends like yourself."[24] In July 1853, sixty-four-year-old Catharine Maria Sedgwick (1789–1867) lamented her dependence on her spectacles in a letter to her niece, Katherine Maria Sedgwick Minot (1820–1880):

> There are miseries in human life that Job, or Solomon, or Jeremiah have never described, because probably prophecy never revealed to them the folly of those fools who attempt to write after their eyes lie in a pair of spectacles. For the last *quart d'heure* (of infinite length) I have been looking for my spectacles with the desperate conviction that I have dropped them in my flower-beds,

and shall *never* find them! And I have looked up an old pair with one glass (typically) looking heavenward and the other earthward, and now I proceed [to] what I should have begun my letter with but for this accident—if that can be called accident which is as regular as my pulses.[25]

The documentary evidence linking women's deteriorating vision with aging is further supplemented by visual evidence in the form of portraits showing mature women wearing or holding spectacles. For example, fifty-four-year-old Mary Swain Tucker Paddack (1792–1878) had her portrait painted in 1846 (figure 1.2).[26] A resident of Nantucket, Massachusetts, Paddack exemplifies the Quaker style of dress in her portrait, wearing a dark gown with a light-colored fichu, along with a sheer cap. She faces the artist with her head slightly tilted and wears her spectacles, which give her a wise, benevolent countenance. In addition to suggesting that the sitter needed assistance with her vision, spectacles may have been worn in portraits by women such as Paddack as a symbol of the prosperity to afford them or of the wisdom gained through age. While spectacles are far from universal in portraits of antebellum women over forty, they do appear from time to time. Sometimes the woman held her glasses in one hand (figure 1.3), just as children held the props of youth (flowers and toys) and men were pictured with symbols of their occupation (books, pens, ledgers, and wallets).[27]

Despite the many opinions about the causes of eye trouble and women's own experiences, there was hope. Eye problems late in life could be avoided. According to one expert, there was no reason why the eyes of the elderly should be bloodshot, red, and disfigured. Dr. J. Henry Clark believed that it was a common mistake to regard this as a "necessary infirmity" of old age. Even among those who

FIGURE 1.2. PORTRAIT OF MARY SWAIN
TUCKER PADDACK (1792–1878)
BY WILLIAM SWAIN (1803–1847), 1846,
NANTUCKET, MASSACHUSETTS.

*Courtesy of the Nantucket Historical Association,
Nantucket, Massachusetts.*

While spectacles are far from universal in portraits of
older antebellum women, they do appear from time to
time, suggesting that the sitter needed assistance with
her vision.

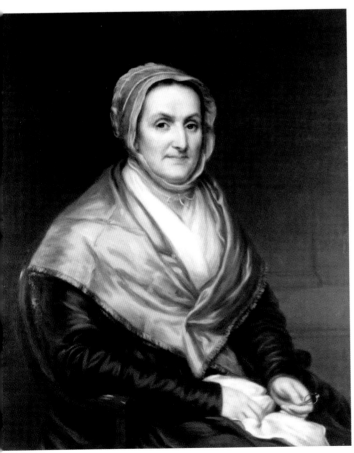

FIGURE 1.3. PORTRAIT OF
UNIDENTIFIED QUAKER WOMAN
BY UNIDENTIFIED ARTIST,
CIRCA 1820, PROBABLY
NANTUCKET, MASSACHUSETTS.

*Courtesy of the Nantucket Historical Association,
Nantucket, Massachusetts.*

While some women chose to be painted while wearing
their spectacles, others preferred to hold them. Just as
children were often painted holding symbolic props
and men were pictured with an item related to their
profession, a woman who held her spectacles was con-
veying a message to the viewer. She may have been
representing her education or her financial well-being,
which allowed her to own this expensive accessory.

d from these symptoms, he believed that [...] could be avoided. In his opinion, the elderly, [...] passed "the active period of life . . . have lit-[...] use for the eyes." Since they did not need to use [...] eyes as much, they could rest them more often and prevent the symptoms of eyestrain altogether.[28] And as John Harrison Curtis noted, "There are many persons upwards of eighty years of age who are able to see to read and write without spectacles. Had they abused their sight, they would not now have been in such perfect enjoyment of it."[29] The natural changes that took place in the eyes as women aged allowed some to recapture the ability to do fine work. Indeed, a quilt made in 1854 includes the inscription "Mrs. Elsey D. Wheeler / Aged 57 years Feb. 8th 1854 / I quilted this without spectacles."[30]

Contemporary prescriptive literature encouraged aging women to remain productive. According to Lydia Maria Child, "The value of occupation is threefold to elderly people, if usefulness is combined with exercise, for in that way the machinery of body, mind and heart may all be kept from rusting."[31] A second author concurred. "The gentler sex have a great resource in age," she wrote, "from their varieties of interesting domestic employment, and especially the uses of the needle."[32] A portrait of forty-one-year-old Allethenia Fisk Holt (1792–1838) of Vermont, painted around 1834, underscores this advice; it depicts her holding a sewing project and wearing a pair of scissors on a chain attached to her waistband (figure 1.4).[33]

Antebellum women who picked up their needles also faced the challenge of contending with achy joints. At the age of fifty-six, Vermont wife and mother Roxana Brown Walbridge Watts (1802–1862) considered herself to be growing old. She found that she had less energy and that her fingers were "old and stiff," making it hard to sew and knit.[34] Watts was certainly not the only antebellum woman

to be troubled by the pain of arthritis as she aged. "I have been trying to do something towards making Edward some shirts," noted forty-year-old Ellen Birdseye Wheaton (1816–1858) in a January 1856 diary entry. She continued, "I am troubled somewhat, with the Rheumatism in my right arm, and I don't think sewing helps it much."[35] Yet observations like Wheaton's and Watts's turned up less frequently in antebellum diaries and letters than did complaints about deteriorating eyesight.

Despite the accounts of these aches and pains, numerous examples of samplers and quilts remain to show that many women continued to stitch and sew as they aged past forty into their fifties, sixties, seventies, and beyond. According to family history, while in her fifties or sixties, Lavinia Prigmore Moore (1811–1861) quilted an elegant appliqué quilt with her teeth because the arthritis in her hands was so painful (figure 1.5).[36] Lavinia Eleanor Prigmore was born in 1811 in Tennessee and married Caleb Moore (1808–1864) in 1833. The couple had ten children, the last in 1853 when Lavinia was forty-two. Caleb was in the mercantile business and also farmed. In 1847, he was elected to the state legislature and became director of the Bank of Tennessee.[37] Quilting with one's teeth seems physically possible but would have taken strong motivation and some practice so as not to break the thread. It seems more likely that Moore might have combined the use of her hands and teeth to quilt. The experience of New Hampshire artist Sally Rogers (circa 1789–1871), who was born without the use of her arms and legs yet toured the country painting watercolors and cutting silhouettes, suggests that women who were motivated to create—whether quilts or paintings—found a way to do so.[38] Unfortunately, material evidence suggests that Lavinia probably did not make this particular quilt either with her hands or with her teeth, because she died in 1861 and the quilt employs a green

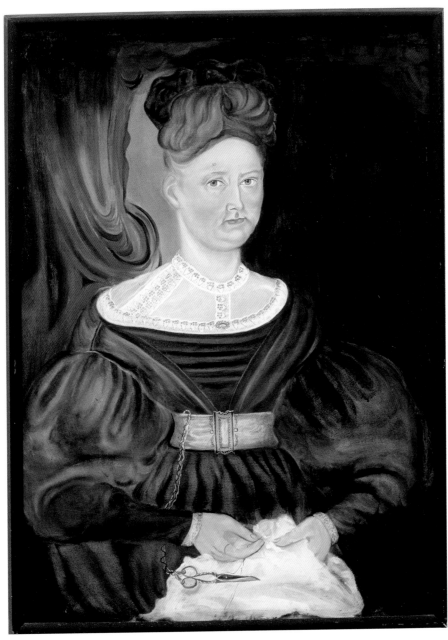

FIGURE 1.4. PORTRAIT OF ALLETHENIA FISK HOLT
(1792–1838) ATTRIBUTED TO ASAHEL POWERS
(1813–1843), 1834–1835, VERMONT.

Courtesy of Historic New England, Boston, Massachusetts.

Just as some aging women chose to be painted in their spectacles, other antebellum women were depicted with their sewing tools. Allethenia Fisk Holt is pictured with her scissors, stitching what looks like a piece of whitework embroidery.

cotton fabric that is usually seen in quilts from the 1870s and 1880s.[39] Despite the uncertainty about whether Lavinia Moore made this particular quilt, the family story does provide evidence that she made quilts during her life and enjoyed the activity enough to find a way to keep quilting despite physical setbacks.

While growing older was marked by decreasing vision and achy joints for many, it also had benefits. Sixty-five-year-old Lydia Sigourney offered a succinct comparison of the positive sides to both youth and old age in an 1856 book. She considered that the A.M.'s (for antemeridians, or the young) were "the beauty and the rigor," while the P.M.'s (postmeridians, or older folks) had "a more rational happiness; for they have winnowed the chaff from the wheat, and tested both what is worth pursuing, and worth possessing."[40] In addition to bringing wisdom and respect, old age—and in particular, for women, the menopause that accompanied it—was seen to offer freedom: "The full conviction that age has stamped them with its irrevocable seal may indeed cast a momentary gloom over the imagination, but in a well-trained mind it must soon be dispelled . . . by the knowledge that this epoch proclaims an immunity from the perils of child-bearing and the tedious annoyances of a monthly restraint. . . . This period of freedom has been em-

Courtesy of Merikay Waldvogel, Quilts of Tennessee.

According to a family story, Lavinia Prigmore Moore quilted this bedcovering with her teeth because the arthritis in her hands was so painful. The family story also suggests that this quilt was made around 1860. Unfortunately, the material evidence in the quilt makes a strong case that Moore did not make this particular quilt, because the green fabric is typical of those colored with a synthetic dye that came into use well after her death. When exposed to light and washing, these dyes took on a brownish cast.

ployed by many eminent women in literary pursuits, or in governing with great discretion that circle of society, limited or extensive, in which they have been placed."[41]

Being set free from the biology of womanhood, that is, knowing that she would not become pregnant again and done with the discomfort of menstruation, the aging woman could focus more time and attention on herself. In August 1852, thirty-four-year-old Sallie Holley (1818–1893) wrote to her friend Caroline F. Putnam (1826–1917) about a visit to an elderly woman who seemed to be enjoying the freedom of age. "The mother made her appearance," wrote Holley, "a lady eighty years old, but, in spirit and conversation and manners more like eighteen than eighty. Indeed she proved to be a most charming old lady. I was quite captivated with her, so fresh, so youthful, so beautiful. She seems to have read almost everything."[42]

While some women found more time to read as they aged, others turned to needlework to fill their time. In 1834, fifty-six-year-old Margaret Bayard Smith (1778–1844) (figure 1.6) of Washington, D.C., described a pleasant domestic scene in a letter to her sister. "How comfortable we looked and how industrious," she wrote, "Virginia and Anna doing their canvas work in frames; Ann and I doing ours on our hands, each with a little table before us, cov-

ered with worsteds of every shade and colour. Mrs. Barret and Julia working muslin, all circled round a blazing fire, while without doors it was cold and lowering."[43] Smith's biographer, Fredrika J. Teute, asserts that Smith "made careful distinctions between different social settings" and preferred discussions with the men who gathered in her home during the evening more than the "endless rounds of morning visits among women."[44] Yet in this 1834 letter, Smith's words express a sense of enjoyment and satisfaction in working together with multiple generations of her family.

Margaret Bayard was born in 1778 and lost her mother, Margaret Hodge Bayard (1740–1780), when she was two years old. Her father, Revolutionary War colonel John Bubenheim Bayard (1738–1807), remarried, but young Margaret's stepmother passed away when she was ten. Without a mother figure in her life, Margaret spent the next three years at a Moravian boarding school where she undoubtedly learned the sewing skills that continued to serve her in 1834. A group of Protestant Reformers who traveled to Philadelphia from Germany in the early eighteenth century, Moravians believed that boys and girls alike ought to receive a universal education. The Moravian Seminary found a permanent home in Bethlehem, Pennsylvania, in 1749 and opened to non-Moravian students in 1785, in time for Margaret

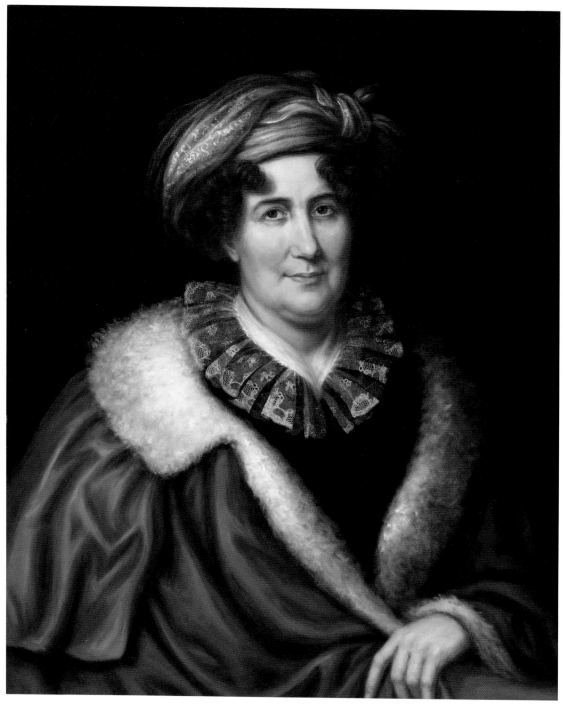

FIGURE 1.6. PORTRAIT OF MARGARET BAYARD SMITH (1778–1844)
BY CHARLES BIRD KING (1785–1862), 1829, WASHINGTON, DC.

From the collection of the Redwood Library and Athenaeum, Newport, Rhode Island.

Bayard to enter in 1788. Instruction in fine needlework was offered for an extra charge, and by the 1790s the school had become known for its elegant silk needlework pictures.[45]

Margaret Bayard married her second cousin, Samuel Harrison Smith (1772–1845), in 1800 when she was twenty-two. Her husband was editor of the *Daily National Intelligencer and Washington Advertiser* in Washington, D.C., and the couple moved in well-connected circles, fostering a friendship with then-president Thomas Jefferson (1743–1826). Between 1801 and 1811, Margaret Bayard Smith gave birth to the couple's four children, two of whom are mentioned in her 1834 letter: Julia Harrison Smith (b. 1801) and Anna Maria Harrison Smith (b. 1811).[46]

In 1809, Samuel Harrison Smith moved into a financial career, becoming president of the Bank of Washington, D.C., and subsequently selling his newspaper. In 1828, he was selected as president of the Washington branch of the Bank of the United States. In the 1820s, as her children grew up, Margaret began a writing career; she published her first novel in 1824, when she was forty-six years old. Her second novel, *What Is Gentility? A Moral Tale,* mocked the prevailing notion that gentility came in one's familial descent. The novel undoubtedly reflected her own education.[47]

Smith's initial description of her sewing party found her houseguest Virginia Southard (circa 1815–1860) and her daughter Anna stitching canvas work in frames.[48] This type of work was a common pastime for women during the first half of the nineteenth century, employing colored wool threads on a woven fabric. Smith and a woman identified only by her first name, Ann, were also doing canvas work, but they used their hands to provide the proper amount of tension for the cloth, rather than the frames preferred by Virginia and Anna. Applying tension to the fabric was necessary to keep the piece smooth, without puckers or creases, and also helped with making uniform stitches. A more experienced stitcher can better monitor the appropriate amount of tension and stitch neatly, while a less experienced stitcher would find the use of a frame helpful. Later in the letter, Smith wrote that "Virginia, Ann and Anna are all working ottomans for Mrs. Clay and I am doing her lamp and shades."[49] Canvas work was ideal for these types of items—ottoman covers could be worked with embroidered designs and then attached to a wooden base. Likewise, when Smith referred to "her lamp and shades," she was probably describing shades for the lamp and perhaps a lamp mat, other household items that were good canvas-work projects.

The other members of the circle, guest "Mrs. Barret" and Smith's daughter Julia, were "working muslin," a form of whitework embroidery, employing white thread on white cotton fabric. Muslin work was often used to decorate women's caps, worn indoors over their hair, or their gowns and petticoats. Figure 1.7 shows a detail of this type of work on the edge of a gown embroidered around 1828, while figure 1.8 shows a paper pattern used to mark a muslin-work design.[50] The types of needlework pursued by this group of Washington's elite women were primarily decorative, but the work was undertaken to serve a function. The ottoman covers and the lamp and shades were to be used on household furnishings for another friend, Mrs. Lucretia (Hart) Clay (1781–1864). And the muslin work stitched by Mrs. Barret and Julia would also be useful—it would adorn caps for themselves or for friends or family members. The practicality at the heart of all of these items mediated their decorative appearance. Smith explained that the group was both "comfortable"

FIGURE 1.7. MUSLIN-WORK DETAIL FROM GOWN BY MARION CHANDLER
(1800–1857), 1828, POMFRET, CONNECTICUT.

Collections of Old Sturbridge Village, Sturbridge, Massachusetts, 26.33.195, photograph by Henry Peach.

Muslin work is a form of whitework—embroidering white fabric with white thread—that was popular during the early nineteenth century. This technique was frequently used to decorate women's clothing, such as gowns, caps, and petticoats.

FIGURE 1.8. EMBROIDERY PATTERN,
1790–1830, PROBABLY PROVIDENCE,
RHODE ISLAND.

Collections of Old Sturbridge Village,
Sturbridge, Massachusetts, 22.12.366.

Paper patterns such as this one were used to transfer a muslin-work pattern to the ground fabric. Although difficult to see in this image, many small holes follow the lines of the design. The pattern could be pinned to the ground fabric, and running a pencil along the lines of the pattern would leave a mark, through the pinprick-sized holes, on the fabric below. The embroiderer would then have guidelines to follow in working her design.

and "industrious." By virtue of her age, as well as her social position, Smith was free to host her friends and family, demonstrating her gentility and fostering it in the next generation.

Several years earlier, in 1827, then-forty-nine-year-old Smith was just starting to explore this new stage in her life when she wrote to her older sister Maria Bayard Boyd, "As Dr. Stevens once said to me, when complaining of nervous affections and restlessness of mind, 'You have almost passed the stormy part of life and are entering on a calm and tranquil state, when all these complaints will vanish.' His prediction is accomplished and I am often astonished at the contentment and serenity I enjoy. Not that I can possibly imagine this arising entirely from physical causes. . . . I wish you would read Cicero's essay on Old Age,—every person advanced in life would I think derive advantage from it."[51] Smith referred to the essay that Cicero wrote in 44 BC when he was sixty-two. Printed by Benjamin Franklin (1706–1790) in 1778 and subsequently reprinted numerous times in the United States, Cicero's essay provided a more positive view of aging than did much of the religious and popular literature available during the mid-nineteenth century.[52] Written in the form of an answer to questions from two younger men, the essay described principles to assist with the aging process. Cicero acknowledged four ways in which old age was difficult: withdrawal from active pursuits, a weakening body, the deprivation of physical pleasures, and the prospect of death drawing near. To counter these issues, Cicero explained that the quality of one's old age depended on the investments made in earlier years—cultivating healthy habits and friendships as well as identifying activities that provided pleasure.[53] For aging women, needlework could be one of these pleasurable activities.

Fifty-two-year-old Mary Berry True (1788–1858) filled some of the time previously devoted to raising her children with stitching a fashionable table cover. Worked in 1840, True's cover was made to fit a round tilt-top table made around the same time by her husband, fifty-five-year-old Joseph True (1785–1873) (figure 1.9).[54] Seeing these two objects in use conjures images of a husband and wife enjoying the freedoms of age by working together to create a symbol of their union that also represents the comfort of growing old as a couple.

Mary True prominently marked her table cover on one side with her initials, "M.T.," and the year, "1840," leaving no doubt as to its maker and owner. This mark shows a relationship to those practiced on schoolgirl samplers and employed on countless other household textiles from the eighteenth and nineteenth centuries (figure 1.10). Mary probably took inspiration from a published pattern to compose the floral design at top center and along the edge.[55] Mary's table cover demonstrates the technique known as canvas work and could be termed "Berlin work," a type of needlework fashionable during the 1830s and 1840s. Floral patterns were particularly popular. Mary's work echoes the advice provided by one period needlework guide, which advocated, "Groups of flowers . . . should always have one or more parts comprised of the hue of the ground[;] . . . on dark grounds, the brightest colours should occupy the centre."[56] The color scheme also helps to verify the date stitched on the cover. Known as "drab," the brown fabric and the greens that she chose were popular at the time, since they blended well with bright colors. A few years later, a needlework guide would explain that "almost all the class of drab and fawn . . . are good with blue . . . [and] the deep rich brown tones of drab are beautiful with yellow."[57]

FIGURE 1.9. TABLE BY JOSEPH TRUE (1785–1873) AND TABLE COVER
BY MARY BERRY TRUE (1788–1858), 1840, SALEM, MASSACHUSETTS.

Photograph courtesy of the Peabody Essex Museum, Salem, Massachusetts, #133540.

Husband and wife Joseph and Mary True worked together to create this elegant piece of furniture. Joseph carved the table, while Mary stitched the cover, marking it with her initials and the date.

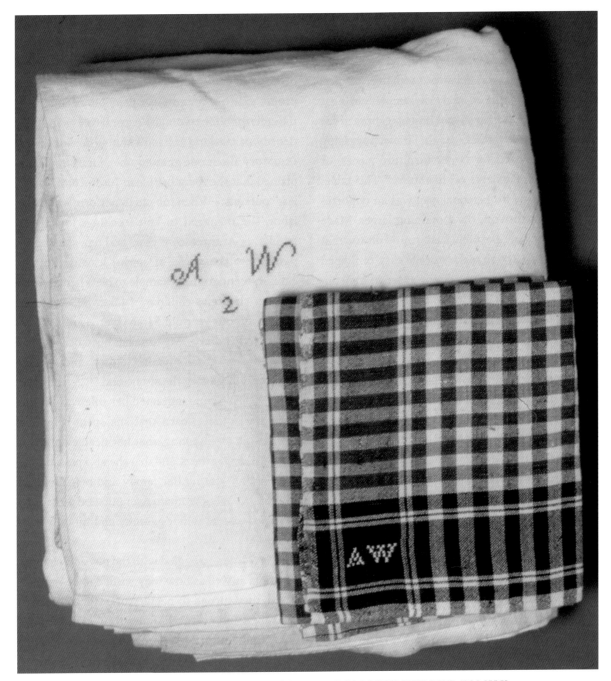

FIGURE 1.10. MARKED TEXTILES FROM THE WILBER FAMILY,
1830–1850, SWANSEA, MASSACHUSETTS.

Collections of Old Sturbridge Village, Sturbridge, Massachusetts, 26.15.300 and 26.21.189.

The initials that Mary Berry True stitched on her table cover resemble the marks that women stitched on innumerable household textiles (including sheets, towels, and table linens). These marks are also what young girls practiced by making a sampler. Marking one's household textiles with initials helped to keep track of them and to rotate them evenly.

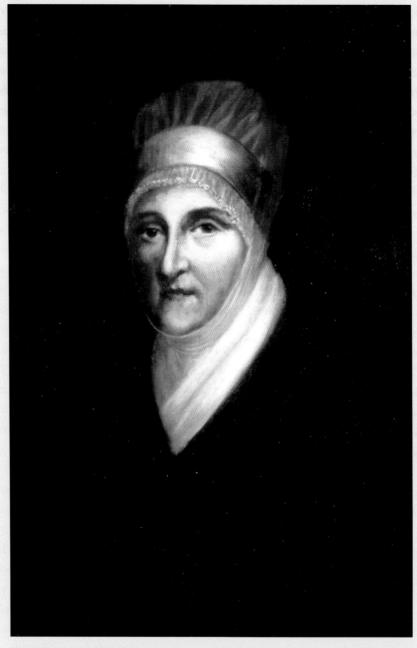

FIGURE 2.1. POST-1934 REPRODUCTION OF PORTRAIT OF DEBORAH NORRIS LOGAN
(1761–1839) BY CHARLES WILLSON PEALE (1741–1827), 1822,
PHILADELPHIA, PENNSYLVANIA.

Courtesy of the National Society of the Colonial Dames of America in the Commonwealth of Pennsylvania at Stenton, Philadelphia.

Deborah Norris Logan did not like this portrait of herself, and one of her descendants destroyed the original in 1934. This copy shows an appropriately dressed older woman wearing modest clothing.

2

GROWING OLD
GRACEFULLY

DEBORAH NORRIS LOGAN (1761–1839) carefully trod the line between her vanity and her concern for posterity when she posed for her portrait in 1822 at the age of sixty-four (figure 2.1).[1] Logan noted that she was not pleased with the final result, writing in her diary that "tho' like me, it is so ugly, that I feel no inclination to let Posterity think me quite so disagreeable, as they unquestionably will from this picture."[2] Fifty-nine-year-old Elizabeth Lindsay Lomax reacted similarly when she was visited by a "young French artist" in 1855. Surprised that he wished to paint her instead of one of her daughters, Lomax declined his offer. "I was once quite pretty," Lomax explained; "And I am too vain to be handed down to posterity pictured in the autumn of my life."[3]

Medical guides, prescriptive literature, fictional stories about grandmothers, and portraits of aging women all presented a social and cultural ideal of what older women in antebellum America should look like and how they were to act. Modest, demure,

quiet, and sweet, antebellum women of a certain age were to resign themselves to their eventual passing, seek a place in heaven, and serve as a role model for the rising generation. One 1852 book painted a picture in words of the model older woman: "Where could we get another grandmamma for the warm corner? Dear old lady, with her well-starched laces, her spotless white satin cap-riband, her shining black silk gown and shawl, her knitting, and her footstove."[4] However, this description, while employing a sense of love and cherished memory, also suggests a darker undertone: the black gown with "well-starched" and "spotless" linens could be interpreted to indicate a woman set in her ways who eschewed the march of progress. She retained her style of dress and mode of work, pursuing the industry and gentility she was taught as a girl without, presumably, adopting or embracing new ideas.

Many portraits from the antebellum era show that most women followed these guidelines, at least while they were being painted for posterity. In 1849, Jane Anthony Davis (1821–1855) painted a double portrait of the widow Phebe Hunt (b. 1781) (figure 2.2).[5] Both images have a handwritten inscription by the artist identifying the sitter and documenting that she was "Aged 68 years" at the time. In both portraits, the widow Hunt wears clothing that her society deemed appropriate for her age: a dark dress with cape collar and a white cap. She is seated with her hands folded in front. One image shows an open book in front of her; her eyeglasses just to the side, suggesting that her eyesight had deteriorated, affecting her reading—and whatever needlework or other close work she might have pursued. Hunt's portrait represents a cultural ideal. She presented all of the hallmarks of aging femininity and at the same time reinforced her society's definition of growing old gracefully, setting an example for younger generations.

While religious texts and social pressure defined the ideal for aging women—to age gracefully, remain productive, and instruct their children and grandchildren in appropriate values—the existence of antebellum prescriptive literature suggests that not all women were doing so. One author wrote quite plainly that she intended to provide instruction on how to "grow old gracefully," because some of "those who have passed through that stage [youth] are not quite willing enough to retire and leave a clear field for others."[6] Often, writers tried to persuade women to look upon aging as something positive. As Lydia Maria Child (1802–1880) explained, "If women could only believe it, there is a wonderful beauty even in growing old."[7] Eliza Leslie (1787–1858) equated age with beauty and acknowledged that around "middle age" a woman would lose either face or figure. But this was not without a trade-off, for "a woman with a good mind, a good heart, and a good temper, can never at any age grow ugly—for an intelligent and pleasant expression is in itself beauty, and the best sort of beauty."[8]

In reality, most aging middle-class women *did* achieve the acceptance preached by etiquette guides and Sunday sermons. In her survey of the letters and diaries of aging American women between 1785 and 1835, Terri L. Premo found that most women were unconcerned with appearing younger than their years.[9] For example, diarist Joanna Graham Bethune (1770–1860) wrote of her resignation and acceptance of growing older in many entries, including one on her seventieth birthday in February 1840: "My birthday, and which completes my threescore and ten years. I can now say with my mother, 'I have turned the last point, and am now waiting a favorable breeze to shoot into port.' I have, on my knees, reviewed my past life from childhood to old age. . . . When I review my past life, I am amazed at the goodness and mercy which has followed me

FIGURE 2.2. TWO PORTRAITS,
BEARING THE INSCRIPTION
"WIDOW PHEBE HUNT
AGED 68 YEARS," BY J. A. DAVIS
(1821–1855), 1849.

Courtesy of Joan R. Brownstein American Folk Paintings.

Antebellum portraits of aging women show a similar mode of dress—dark gown with white cap. Sixty-eight-year-old Phebe Hunt presented what was understood as a respectable appearance for her age in these portraits.

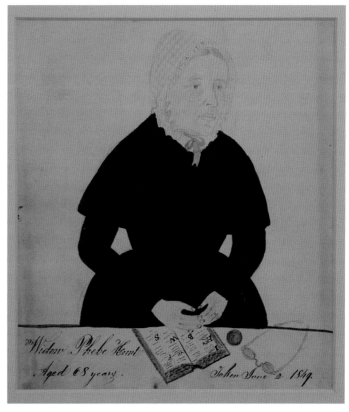

from the cradle, and which I trust shall follow me to the grave."[10] Yet for every Joanna Bethune who worked to "grow old gracefully," there was also a Lucretia Buttrick (1801–1892), presumably so determined to hide her age that she picked out identifying information stitched into her girlhood sampler (figure 2.3).[11] Samplers like this one ceased to be an educational exercise and instead provided the agency for mature women to mediate the divide between their reality and antebellum cultural ideals.

Buttrick was not alone in removing age-identifying information from her girlhood sampler. Twenty-eight such samplers have been identified in this study.[12] These samplers are generally in good condition with just a few numbers missing in key spots; they are not suffering from deterioration throughout, nor do they have tears or rips that have rendered them illegible. The missing numbers are clearly the conscious work of the maker or another person.

The alteration of Buttrick's sampler seems distinctly at odds with antebellum prescriptive literature, which provided specific goals for aging women: "The woman that knows how to grow old gracefully, will adapt her dress to her figure and her age, and wear colours that suit her present complexion. . . . She will allude to her age as a thing, of course; she will speak without hesitation of former times, though the recollection proves her to be really old."[13] Women such as Buttrick did not leave letters or diaries explaining the choice to unstitch part of their samplers, so the nagging question of why it happened remains. Vanity seems a likely explanation for why antebellum women wanted to turn back time: to stem the tide of growing older by recapturing their youth, or to escape the encroaching reality of life's end. Nineteenth-century physician and author Frederick Hollick wrote of

menopause that "the cessation of the menses is as natural to their first appearance, and the constitutional disturbance resulting from it is also as likely to be beneficial as injurious. In fact, many females when they fully get over it, seem to become much younger and more healthy. They . . . actually appear more juvenile at fifty than they did at thirty-five or forty!"[14] This kind of feeling may have motivated women to pick out the dates on their samplers.[15] They did not feel old or look old, so they acted to destroy the evidence that they were aging.

The literature on American samplers shows that the act of altering them was not uncommon. As one scholar explains, "A large number of sampler embroideries underwent similar alterations as their makers grew to adulthood."[16] Overwhelmingly, these same sources explain this act as one of vanity, stating that "many women disliked such conspicuous evidence of their age."[17] But these authors, products of our own time, accept that a woman would want to hide her age and do not problematize the act in a historical context.

Decorative schoolgirl samplers like the ones identified here were made to be framed and hung proudly on the wall of the family parlor. Countless newspaper ads from the early nineteenth century offered frames specifically to display needlework.[18] An English cartoon from 1809 shows the prominent placement of one girl's framed sampler in her parents' parlor (figure 2.4); the same tradition was followed in America.[19] Sarah Anna Smith Emery (1787–1879) of Newbury, Massachusetts, remembered seeing similar displays: "One was considered very poorly educated who could not exhibit a sampler; some of these were large and elaborate specimens of handiwork; framed and glazed, they often formed the chief ornament of the sitting room or best parlor."[20] In 1858, twelve-year-old

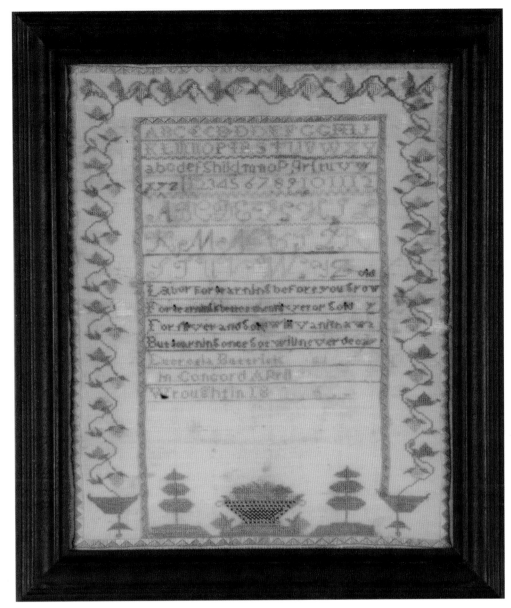

FIGURE 2.3. SAMPLER BY LUCRETIA BUTTRICK (1801–1892),
CONCORD, MASSACHUSETTS.

Courtesy Concord Museum, Concord, Massachusetts.

Stitched verse: *Labor for learning before you grow old, / For learning is better than silver or gold. / For silver and gold will vanish away, / But learning once got will never decay.*

In addition to removing from the sampler the date when she made it and her age at the time, Lucretia Buttrick was not always truthful with the census takers who visited her home as she aged. As she grew older in the late 1800s, Buttrick shaved several years off of her actual age on more than one occasion.

FIGURE 2.4. *FARMER GILES AND HIS WIFE SHOWING OFF THEIR DAUGHTER*
BETTY TO THEIR NEIGHBOURS, ON HER RETURN FROM SCHOOL
BY JAMES GILLRAY (1757–1815), 1809, LONDON, ENGLAND.

Princeton University Library, Princeton, New Jersey, Graphic Arts Collection, Department of Rare Books and Special Collections.

This satirical English print shows the prominence given to young ladies' samplers—one is framed and hung in a central spot on the parlor wall. Given this high visibility, many women seem to have become shy about broadcasting their age in this manner later in life, perhaps explaining why so many samplers show evidence of having dates or ages picked out.

Susan Bradford Eppes (1846–1942) noted in her diary, "This is Father's Birthday and my picture of The Temple of Time was ready for him. He was pleased and surprised. It is prettily framed and is hanging on the Library wall."[21] While continuing to showcase a woman's skill with the needle and her familiarity with the elements of a genteel lifestyle, by the time she entered her forties and beyond, the sampler also continued to proclaim its maker's age to all who entered the parlor.

The interpretation that aging women picked out numbers from their samplers themselves to hide their age is compelling. But this seems to be a direct contrast to prevailing cultural prescriptions to act one's age. The authors of prescriptive literature did not specifically discourage the act of alter-

*Courtesy Concord Museum,
Concord, Massachusetts.*

ing one's sampler, but they did counsel women to act their age and to be proud of their life experiences by "speak[ing] without hesitation of former times."[22] By implication, they offered reasons *not* to alter a schoolgirl sampler, instead encouraging women to cherish an item such as their sampler as a touchstone to the past, even though the sampler would indicate its maker's aging station in life.

Lucretia Buttrick's sampler, originally stitched in the 1810s, was altered later in its life when her age was removed. And Buttrick was not exact about her age on the U.S. Census as she grew older. In 1850, she was listed as forty-nine years old—her correct age—but in 1860, she was listed as fifty-three years old, six years younger than she actually was. In 1870, she gave her age as fifty-eight, eleven years less than her true age.[23] In his study of the history of aging in America, David Hackett Fischer discovered that a certain type of "age heaping," providing an incorrect age to the census taker, increased on late-nineteenth-century census returns. During the eighteenth century, it was quite common for

people to round off their ages to end in a five or a zero because they either did not know how old they were or did not care. However, Fischer found that as literacy increased, this kind of age heaping decreased; instead, people pretended to be younger than they were. He asserts that it was most common for men in their forties and fifties to lie about their age on the census, but the large number of samplers with picked-out ages and years suggests that women were equally conscious of their age in the mid-nineteenth century.[24]

By 1880, Buttrick had slightly lessened the gap between her actual age and the age she gave the census taker; she was listed as seventy-five years old (instead of her actual age of seventy-nine).[25] At some point as a girl she made a sampler that initially included both the year that she made it and her age at that time (see figure 2.5 for detail). Although that information has not been recovered, genealogical records provide information about her birthdate in 1801 and subsequent marriage in 1828. When Buttrick died at the grand old age of ninety, her family

produced an elegant memorial card in her honor. Black with gold-stamped lettering, the card includes an image of a book with lettering on its cover: "In Loving Remembrance / of / Mrs. Lucretia Buttrick / Died January 14, 1892 / Aged 90 Years."[26]

The changes made to Lucretia Buttrick's sampler and her changing age on the census help to show that the aging process was not always embraced in antebellum America. Reactions to growing older varied from woman to woman and from decade to decade. Yet many women shared a common bond—their girlhood sampler—which remained with them throughout their lives, for better or for worse.

Prescriptive literature of the antebellum era minced no words in offering an ideal view of how aging women should look and act. Suitable dress for women over forty required "grave colors" without "flounces or feathers," a cap, and spectacles. Older women were to sit erect and keep busy by sewing or reading.[27] Yet to counter the physical effects of age, some women turned to more youthful forms of dress. One author offered a detailed description of inappropriate dress for aging females:

> I was one day walking the streets of a city, when I perceived just before me an exceedingly juvenile figure enveloped in a cloud of rose-coloured drapery, with towering plumes in her wide spread bonnet . . . when she suddenly turned and disclosed to me, not the bloom and dimples of fifteen as I had anticipated, but a face that I well know had reckoned more than fifty winters. A quantity of artificial curls and rich lace softened the effect of age considerably in her face, but there were distinct traces of the heavy footsteps of time. . . . Had I seen this lady suitably dressed, in grave colours, without flounces and feathers, with a matronly cap surmounted honestly by a pair of spectacles, I should have felt much more respect for her character.[28]

Most prescriptive authors counseled against "deception with regard to age," suggesting that "when elderly people are accused of undue youthfulness of dress or manner, it is usually accompanied with some suggestion of a design upon the other sex," something that was considered altogether inappropriate by mainstream antebellum society.[29]

But even as the aging woman was encouraged to act her age and accept growing older, younger readers were advised not to ask elders about their age. "The slightest jest on the personal defects of those you are conversing with, is an enormity of rudeness and vulgarity," Eliza Leslie warned. "Still worse, to rally any person (especially a woman) on her age, or to ask indirect questions with a view of discovering what her age really is. If we continue to live, we must continue to grow old. We must either advance in age, or we must die. Where then is the shame of surviving our youth?"[30] This directive seems to suggest a mixed message—women should aspire to grow old gracefully, but they could expect to be protected from revealing their age.

Recounting a visit to Montpelier to see sixty-year-old Dolley Payne Todd Madison (1768–1849) in 1828, fifty-year-old Margaret Bayard Smith (1778–1844) embraced the opportunity to reminisce, talking "of scenes long past and of persons far away or dead." Smith was impressed by her friend's appearance. "She looks young and says she feels so. I can believe her, nor do I think she will ever look or feel like an old woman," Smith mused.[31] Smith's words resonate with the advice offered by the published etiquette books of the time. Yet she did pay attention to her friend's looks and described her youthful bearing as something desirable, demonstrating that advice to "grow old gracefully" was a mixed message in reality. Women were to look their age, but they also knew that looking

young was valued. Smith went on to recount a meeting on the same day with "old Mrs. Madison"—her friend's mother-in-law, Eleanor Rose Conway Madison (1731–1829), who, at the time, "lack[ed] but 3 years of being a hundred years old." When Smith asked her how old she was, the lady replied, "I have been a blest woman . . . blest all my life, and blest in this my old age. I have no sickness, no pain; excepting my hearing my senses are but little impaired. I pass my time in reading and knitting." Smith wrote that she "felt much affected by the sight of this venerable woman. Her face is not as much wrinkled as her son's who is only 77 years old."[32] While young people were strongly counseled against asking their elders about their age, Smith's words suggest that mature women were freed from this prohibition.

The experiences recounted by Smith add a layer to the "rules of aging" provided by the etiquette guides. While growing older was met with a great deal of ambivalence by women in their forties, fifties, and even sixties, once these same women reached their seventies, eighties, and beyond, they seem to have adopted a sense of pride in their longevity. Lydia Sigourney drew attention to the value of the needlework made by aging women, implying that the items held added value because of the age of their makers. She described an eighty-four-year-old woman of her acquaintance who "found great pleasure from these unostentatious pursuits." In one year, Sigourney reported, this lady completed forty-eight pairs of stockings and two large bed quilts, one consisting of over three thousand pieces.[33] Production at a great age was both an achievement and an example.[34]

In October 1844, sixty-four-year-old Lucy Hiller Cleveland (1780–1866) (figure 2.6) was awarded a diploma for the best "Specimen of Figures of Rags"

by the Mechanics' Literary Association of Rochester, New York. She had entered vignettes of what she called her "figures of rags" in several antebellum charitable fairs. In 1852, she entered a vignette in the Shirtwoman's Union Fair in New York City, which raised twenty dollars for the financial relief of women garment workers.[35]

Lucy Hiller was born in 1780 in Salem, Massachusetts, the daughter of Joseph Hiller (1748–1814) and Margaret Cleveland Hiller (1748–1804). Her father was a clockmaker, silversmith, and engraver. Her first marriage was in 1806, to Captain William Lambert of Roxbury, Massachusetts; he died in 1807. In 1816, she married her deceased sister's husband, her first cousin, William Cleveland (1777–1842). In 1828 and 1829, she accompanied her sea captain husband on a trading voyage aboard the *Zephyr,* including stops in the East Indies, Timor, and China. Between 1827 and 1842, Cleveland anonymously wrote and published more than a dozen children's books on topics including abolition, temperance, and social benevolence. Lucy Hiller Cleveland died in 1866, aged eighty-six.[36] She grouped some of her doll-like figures into visual stories from her own life, while others expressed her feelings about contemporary reform issues.

From the 1830s through the 1860s, Cleveland made at least eleven vignettes. She created them from a wide variety of materials including silk, cotton, wool, glass, leather, beads, and human hair. Cleveland then embellished them with embroidery, quilting, knitting, and paint.[37] In an 1847 letter to the wife of her stepson, she recounted, "I have been quite at my old trade since here stuffing + dressing, and 'hiking into shape.' . . . It gives great satisfaction."[38] Her granddaughter later remembered that "people would come to her & want her to teach them how to make them. She would tell them it was

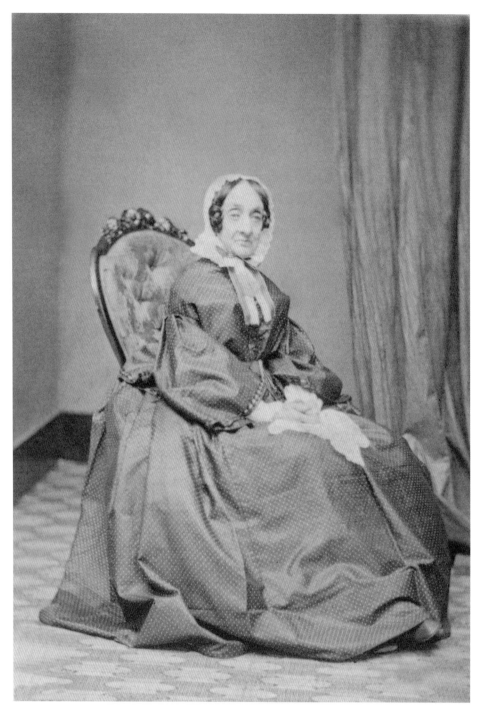

FIGURE 2.6. PHOTOGRAPH OF LUCY HILLER CLEVELAND (1780–1866) BY D. W. BOWDOIN, 1863, SALEM, MASSACHUSETTS.

Photograph courtesy of the Peabody Essex Museum, Salem, Massachusetts, #137861.

knowledge, that she couldn't impart to anyone, it was a gift to her."[39]

One of Cleveland's largest vignettes, "The Sick Chamber," was reportedly made for an unspecified fair in 1831 (figure 2.7).[40] The vignette's composition resembles a well-known lithograph depicting George Washington (1732–1799) on his deathbed.[41] The scene centers on a sickbed, a four-poster draped with white cotton curtains. There is a Bible open on the bed beside the patient. A male figure dressed in knee breeches and a dressing gown—clothing that was old-fashioned in 1831—sits in a wing chair next to the bed. On the far side of the bed, a nurse, holding a medicine bottle, and a female friend or relative seem to be having a disagreement about the patient's treatment. At the end of the bed, a black servant peers through the curtains. Cleveland's furnishings—the bed and a small table at its foot—are meticulously made and suggest a simple room. Her vignette is in keeping with recommendations for the sickroom made by Catharine E. Beecher several decades later: "A sick-room should always be kept very neat and in perfect order. . . . A sick person has nothing to do but look about the room; and when every thing is neat and in order, a feeling of comfort is induced."[42]

This was a scene that Cleveland knew well (figure 2.8). Fifty-one when she made it, Cleveland was undoubtedly confronting her own aging process. Her father had died in 1814, when Cleveland was thirty-four; her sister Mary died the following year. Lucy was the caretaker for both, not surprisingly, since she was the younger single woman in the household.[43] Women were often considered to be natural nurses and were counseled to cultivate "the indispensable qualities in a good nurse[:] . . . common sense, conscientiousness, and sympathetic benevolence."[44] It is tempting to speculate that

Cleveland was thinking of the caretaking role she practiced in the 1810s while she made this vignette, but she did not leave explicit evidence of this.

During the later part of her life, Cleveland kept an album in which she wrote original poems and verses.[45] The book was a gift from her stepson in 1837, when she was fifty-seven, and she wrote regularly in the book until she filled it in 1859. She often noted her birthday, as in December 1845, when she wrote a poem called "Birthday Thoughts." It begins:

> Three score and five! Are in thy pack,
> Which once belonged to me!
> And thou will never give one back,
> or turn thee from thy onward track,
> through vast eternity!

Many entries are poems written for family members and friends to mark special occasions, such as birthdays, weddings, and births. Other entries deal specifically with the passage of time—for example, poems called "Reminiscence" and "The Shadow of Time"—suggesting that her own aging process was on her mind.

Cleveland continued to care for sickly relatives throughout her life. Writing to her stepson in 1842, while in Boston caring for her sister, Cleveland noted, "My sister has been much better since I came, tho' I do not flatter myself with having the remotest agency in the convalescence." After remarking that thoughts of her own home gave her pleasure while away, Cleveland reminded herself, "I did not come for pleasure—alas! The word seems out of place with me, what have I to do with anything but duty."[46] Her words give a hint of intergenerational tension, as she balanced her own wants with the duty and responsibility of caring for her family.

FIGURE 2.7. "THE SICK CHAMBER" BY LUCY HILLER CLEVELAND
(1780–1866), 1831, SALEM, MASSACHUSETTS.

Photograph courtesy of the Peabody Essex Museum, Salem, Massachusetts, #105329.F.

Lucy Hiller Cleveland made at least eleven vignettes. She reproduced many small details—for
example, down to the proper bed furnishings—and formed her figures in such a way as to
give each one some personality. Each vignette tells a story and may have been drawn from
her life experiences.

FIGURE 2.8. "THE SICK NEIGHBOR" FROM *STORIES ABOUT HENRY AND FRANK*
(TROY, NY: MERRIAM AND MOORE, N.D.).

Collections of Old Sturbridge Village, Sturbridge, Massachusetts.

This scene, from an early 1800s book, shows the common elements of the sickroom—patient, caregiver, and bed—which can also be seen in Lucy Hiller Cleveland's vignette.

In the late 1840s or early 1850s, while in her late sixties or early seventies, she made another vignette centered on the aging process. Called "The Foot Bath," it shows an elderly woman and a black servant with an elderly man in eighteenth-century costume (figure 2.9).[47] The woman carries a red flannel bandage and a bottle of bay rum (used for medicinal purposes), while the servant holds a wooden tub. The man shows reluctance for the imminent treatment of his bandaged leg.

An 1841 letter from Cleveland to her stepson describes her experience as she cared for yet another

FIGURE 2.9. "THE FOOT BATH" BY LUCY HILLER CLEVELAND (1780–1866),
1845–55, SALEM, MASSACHUSETTS.

Photograph courtesy of the Peabody Essex Museum, Salem, Massachusetts, #105329.B.

Lucy Hiller Cleveland nursed her father when he was sick. Her personal experience may have informed the details of this vignette.

family invalid. "I found your poor aunt very—very feeble," she reported, "& almost blind with inflammation in the eyes, with blisters on the back of her neck." This experience must have been on her mind when she formed her figures into their scenes. In the 1841 letter, she continued, "The poor invalid sets hour after hour alone, with closed eyes & such weak & lame limbs, as render her exceedingly helpless—and the blessing of a friend to sit in the room even, & give her the sound of the human voice with a kind word occasionally, is most truly acceptable"—words that also describe her fabric sculpture.[48] As one 1830s advice guide observed, "The care of the sick, is a science, to which time and attention should be devoted. It is part of the business of our sex. Appointed as we are, to varieties of indisposition, we are the more readily 'touched with the infirmities' of others."[49] In addition to her letters and her actions, Cleveland's vignettes helped to show her understanding of her caretaking responsibilities, as well as providing an outlet for her own experiences and aging process.

While the physical effects of aging could affect the skill level and appearance of the needlework of middle-aged and older women, the quilts, samplers, and other objects that remain demonstrate that those who wanted to stitch did so. For example, in 1837, thirty-six-year-old Emma P. Forbes (b. 1801) of Milton, Massachusetts, included a rather whimsical comment on her sampler (figure 2.10). "We all have our hobbies . . ." she stitched, referring to the recreational nature of her work.[50] And in April 1860, sixty-seven-year-old Mary Avery Upham (1790–1872) noted in her diary, "I do not know what I should do without my knitting work."[51] Despite commenting almost thirty years apart, these two women suggest that needlework, whether embroidery, quilting, or

knitting, was a valued and necessary means of expression for antebellum women from their thirties to their sixties and beyond. But needlework was no mere hobby; the choice that these women made—to stitch or not to stitch—moved the products of their needle well beyond the functional, as the following example demonstrates.

At first glance, the bedcover in figure 2.11 is a veritable sea of triangles. The unordered use of so many different colors draws the eye around it. Gradually, focus shifts to the center—more triangles and five intricate round blocks with bright yellow, red, and green pinwheels. Each triangle measures just under three inches along its widest edge, and the spread includes more than 3,600 of them. The maker of this bedcover was in her fifties when she stitched it together. While we do not know for sure whether she had good eyesight and limber joints, we can read the object for clues about its maker and consider the choices she made while stitching it. Mary Tayloe Lloyd Key (1784–1859) of Maryland made the bedcover in the late 1830s or early 1840s, when she was in her fifties.[52]

Mary Tayloe Lloyd was the daughter of Edward Lloyd (1744–1796) and Elizabeth Gwynn Tayloe Lloyd (1750–1825). Her grandfather was the royal governor of Maryland, and one of her brothers also served as governor of the state. Mary Lloyd married Francis Scott Key (1779–1843) in 1802. Key was an attorney and the famed author of the poem that would become the American national anthem, "The Star-Spangled Banner." The couple had eleven children, five girls and six boys. She bore her last child in 1827, when she was forty-one, and lived a comfortable life, allowing her the time to stitch this elaborate item.[53] Her bedcover represents hours of careful work.

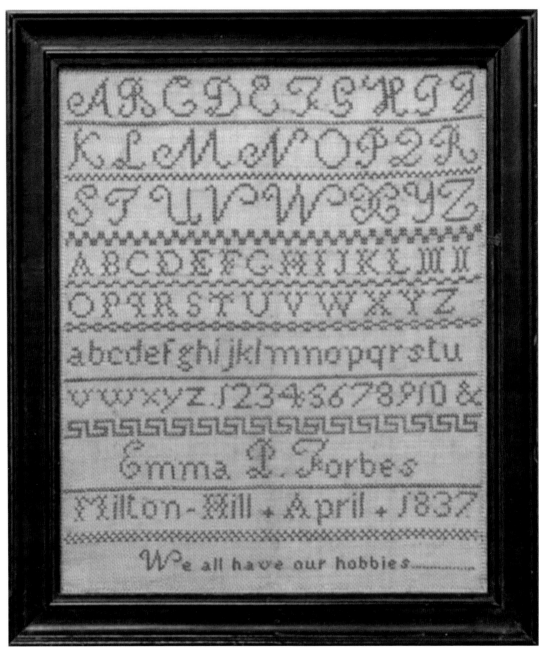

FIGURE 2.10. SAMPLER BY EMMA P. FORBES (B. 1801),
1837, MILTON, MASSACHUSETTS.

Courtesy of M. Finkel and Daughter, Philadelphia, Pennsylvania.

Thirty-six-year-old Emma P. Forbes indicated that she enjoyed stitching her sampler during her leisure time. She included the line "We all have our hobbies."

FIGURE 2.11. COUNTERPANE BY MARY TAYLOE LLOYD KEY (1786–1859),
CIRCA 1840, GEORGETOWN, MARYLAND.

The Daughters of the American Revolution Museum, Washington, DC. Gift of Frank F. Greenawalt.

Mary Lloyd Key created this pieced counterpane using over 3,600 triangles, along with the challenging Mariner's Compass block. The outermost border fabric shows a Greek key motif, which may have been a purposeful choice on the quilt maker's part to symbolize her family.

The bedcover takes on different meanings when we consider whether it was made before her husband's death in 1843 or after. Mary Lloyd Key used a fabric with a Greek key motif for one of her borders, and she carefully cut the fabric into a 2¼-inch band to show that motif.[54] At least one scholar has suggested that this was done quite purposefully as a link to the family's name.[55] If the spread was made prior to her husband's death in 1843, it may suggest pride in the family's accomplishments. Her inclusion of the fabric with the key motif suggests identification with her married name, having left her birth family and become part of a new family. But Mary Key was also described as being somewhat haughty and aware of her social position, having grown up in a wealthy family.[56] Her family owned a mansion near Annapolis known as Wye House, and the family reportedly "spent a fortune on silver knobs, marble stairways and exquisite moldings" for the house.[57] Built between 1781 and 1784, just before Mary's birth, the house embraced the Federal style and may have incorporated the Greek key motif into its design and furnishings.[58] Mary may have employed the fabric with the Greek key design as a memory of her past, using it to bring together her girlhood with her married life.

Alternatively, Mary could have made the piece later in the 1840s, after Francis's death; the fabrics in the bedcover can only limit its origin to the 1835 to 1850 period, not more precisely, and it is undated. If constructed between 1843 and 1850, the bedcover may have taken on another dimension—a memorial to her husband, with whom, by all accounts, she shared a caring and happy marriage.[59] In this case, the inclusion of the key motif fabric could have been a symbolic way of keeping her husband nearby. The bedcover includes a variety of fabrics—reds, greens, browns, pinks, yellows, and blues—many of which

may have been left over from family clothing.[60] By stitching these scraps into her piece, Key could retain memories of those closest to her, even though her children were starting their own families.

Some of the other choices that Mary Key made as she stitched this piece add to an understanding of her life. Perhaps most noticeably, the bedcover, which was intended as a summer spread, is unfinished. As befits a summer bedcovering, it was never intended to be a quilt, but it was never backed and bound around the edges either.[61] Unquilted bedcovers such as this one were not uncommon, particularly in the southern states, where warm weather rendered thick quilts unnecessary for most months of the year. In addition, Key's choice to piece more than 3,600 triangles together would have created more than 1,800 seams on the back and made the quilting more difficult, because there would be more layers of fabric to quilt through.

While sewing triangles together is one of the simplest quilt-making tasks, requiring only a straight seam, which was one of the first lessons taught to a young girl, Key juxtaposed the much more complicated Mariner's Compass block in the center of her piece. In addition to being one of the oldest patchwork patterns, the Mariner's Compass required a quilter to be extremely precise to make the circle of radiating points match up in the center. The maker also needed a basic understanding of geometry to draft the pattern herself; otherwise, she would need to rely on someone with that knowledge to make the pattern for her.[62] And while sewing two triangles together is fairly easy, precisely matching the corners of more than 3,600 is a challenge. Key's work is well done, with most points matching closely.[63]

Taken together, the bits of evidence provided by the bedcover start to suggest a larger interpreta-

tion. Mary Tayloe Lloyd Key, in her fifties, chose to make something that showed off her needlework skill. She used fabrics that were personally meaningful, demonstrating her love of family and perhaps her identification with her married name. Although it was not finished, the spread was tightly associated with its maker, even long after her death. Its good condition is due, in part, to the fact that it was stored out of sight from 1858 until 1925. A note written in 1925 by Key's granddaughter, Mary Tayloe Key McBlair (b. 1855), and given to the Daughters of the American Revolution Museum with the piece reads, "This quilt was made by my grandmother Mary Tayloe Key. . . . [It] was left to her daughter, Mrs. Ellen Key Blunt, who left it to her daughter Miss Alice Key Blunt."[64]

Sewing a sampler or stitching a quilt could offer a sense of purpose to aging women who had completed their childbearing and childraising duties. In a letter to her son in November 1823, fifty-five-year-old Hannah Robbins Gilman (1768–1837) wrote, "When absent from our children, we feel like useless beings."[65] But women of an advanced age could still find usefulness through the needle. Lydia H. Sigourney explained that she "had the honor of be-

ing acquainted with ladies, who after the age of eighty, excelled in the various uses of the needle, executing embroidery by the evening lamp, and sitting so erect, that younger persons, more addicted to languid positions, asserted that 'it made their shoulders ache to look at them.' I am in possession of various articles, both useful and ornamental, wrought by the hands of such venerable friends, and doubly precious for their sakes."[66] While asserting the value of this needlework, Sigourney's words also suggest a disapproval of the young people in the following generations who were not living up to the example set by their elders. The intergenerational tension surrounding needlework is explored in chapters 3 and 5.

Needlework was a constant for antebellum women from girlhood to old age. Their parents passed away, their children grew up and moved out, and their husbands died, but needlework remained, even after its maker died. And as a woman's role changed from daughter to wife to mother to grandmother, so did her needlework, evolving in appearance and in function, serving as a productive contribution to the household but also as a pastime, a means of expression, a gift, and a symbol of love.

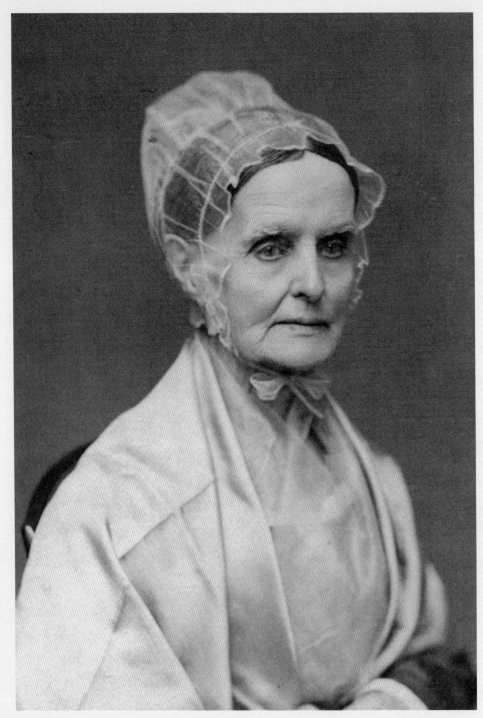

FIGURE 3.1. PORTRAIT OF LUCRETIA COFFIN MOTT (1793–1880)
BY F. GUTEKUNST, 1870–1880, PHILADELPHIA, PENNSYLVANIA.

Courtesy of the Nantucket Historical Association, Nantucket, Massachusetts.

3

THE TECHNOLOGICAL RESHAPING OF ANTEBELLUM NEEDLEWORK

IN 1843, fifty-year-old Lucretia Coffin Mott (1793–1880) (figure 3.1) wrote to her sister, thirty-seven-year-old Martha Coffin Pelham Wright (1806–1875), about her frustration with their seventy-two-year-old mother, Anna Folger Coffin (1771–1844): "It is so like our mother not to want any 'new-fangled' way of doing that which she is in haste to accomplish. Not that she is opposed to improvements and new inventions; not she! when they do not interfere with her desire to make quick work, and finish as she goes. When we were quilting . . . I wanted a border; but not having another pair of hands (as well as a little ingenuity), I was obliged reluctantly to yield to her importunity, 'not to have it forever about;' that 'put-offs never accomplish,' etc."[1] Mott's comments suggest the ambivalence that cut across antebellum generations when they were confronted with "new-fangled" products, techniques, and styles related to their textiles. Mott's words, and those of others like her, show that the process of adopting "improvements" was not clear-cut. For women, ambivalence

and tension about their lives and the changes taking place in their communities often played out in their needlework—a site of the intersection of proper feminine virtues and new materials. A closer look at the quilts and samplers of mature women, as well as at the words written by and about them, suggests that women were not always ambivalent about the changes themselves, but rather about the marginalization of women's work that was marked by these changes. In addition, these sources show a growing generational tension around women and their needlework.

Women's historians have long pointed out that as the production of cloth and (later) garments moved from looms to factories, saving women time on textile production and clothing manufacture, women's tasks and responsibilities changed in other ways. Weaving, spinning, and sewing have long been intimately associated with women. These activities fulfilled societal and cultural roles far beyond their functional nature. Industry and productivity were woven around the threads of the cloth that countless American women produced. As those chores became mechanized and fabric began to be produced on the factory floor—by younger women and by immigrant women—the cultural roles of textiles and needlework shifted. Women who could afford to purchase machine-made textiles made fewer textiles at home. Some women worked outside the home (or inside the home, but for other households) to procure the new goods or to make ends meet and had less time to devote to plain or fancy needlework.[2] As less time was invested in utilitarian tasks, decorative needlework, in particular, became a tool with which women could express opinions, show creativity, and demonstrate their familiarity with genteel standards.

Historian Jonathan Prude asserts that ambivalence surrounded the local textile mills he studied in Dudley and Oxford, Massachusetts, but that anti-mill feelings were "neither continuous nor unanimous."[3] While some feared the change that the mills would bring—citing "moral contagion" brought on by a transient workforce as well as a loss of farmworkers as hands flocked to industrial labor—others welcomed the benefits of cheaper consumer goods and more jobs.[4] Even the factory workers viewed the mills with ambivalence. While some welcomed mechanization—and the new types of work it offered, along with opportunities for advancement—others viewed it as a threat that would lead to fewer jobs, monotonous labor, and oppressive discipline.[5] Most historians of New England's textile mills have approached the subject by focusing on the mills, their owners, and their workers, without considering the perspective of gender or age. Yet the young women who went to work in the Lowell mills, for example, were, in part, choosing to reject rural life by doing so. Some "rural spokesmen" felt that it was an example of these young women "rejecting the values of their parents."[6]

In turn, the mothers of these women also reacted to the rise of industrialized textile production. Over the first half of the nineteenth century, textiles—including cloth, needlework, and fancywork—became a renewed symbol of and the site of cultural tension.[7] Conflicts between home and work, city and country, men and women, hand and machine, and old and young all played out among the woven, stitched, and embroidered threads of antebellum textiles.

The 1832 report of the Committee of Manufactures for the Concord, Massachusetts, Cattle Show acknowledged that there would always be commu-

nity members "to whom all change is unwelcome." In particular, it singled out the older generation of women who were unhappy about water power being applied to the spinning of cotton in the early nineteenth century. The writer stated that "it was supposed by our respected mothers that the spinning business would be endangered by this novel invention of spinning by water, and they viewed it as an evil omen." Those women who feared this change worried that "the nation would be ruined" and that "little else remains for us and our daughters to do." However, the newspaper reminded readers that it turned out that there were "other channels into which their industry might be profitably directed."[8] Indeed, given their interest in the sewing machine and their rapid adoption of cylinder-printed fabrics, aging women seem to have been open to technological innovations for their needlework and sewing.

We can look to the needlework of aging antebellum women to learn more about how new sewing tools and materials were received. The items produced by these women, along with their own words in letters and diaries, add nuances to our understanding of the industrial revolution. This chapter uses the rise of the sewing machine, needlework displayed at agricultural fairs, and signature quilts to explore antebellum mechanization and its effects on mature women.

Antebellum Needlework Innovations

Around 1845, newly widowed forty-one-year-old Emily Vandergrift Snyder (b. 1804) made a quilt top as a family keepsake (figure 3.2).[9] Snyder's quilt employed new materials to stake its place in the pres-

ent, as well as to remember its maker's past. She left no doubt as to her primary purpose in stitching her quilt. Inked around the center medallion is a family record with the names and birth dates of her children, birth and death information about her husband, and several verses (figure 3.3) that acknowledge Emily's grief and piety. One reads:

> How many of us, are another year?
> May sleep beneath the cold & silent sod?
> Then while our lives, are in merc[y] length[en]ed
> here,
> Let us in time prepare to meet our God.

Snyder's husband, Benjamin Snyder (1794–1845), died in October 1845. The couple married in Philadelphia prior to August 1824, when their first child was born. Eight more children followed, the last in 1842, when Emily was thirty-eight. The center medallion of this Pennsylvania quilt shows the influence of the antebellum Pennsylvania-German aesthetic by employing colors and motifs that are seen in frakturs from the early nineteenth century. Surrounding blocks were signed by family members and friends. Snyder used bright new cylinder-printed "rainbow" or "ombre" cottons to piece these blocks.

Scotsman Thomas Bell is recognized as the inventor of the first functional cylinder-printing machine in 1783, and French fabric printers were using it by the late 1790s.[10] The cylinder- or roller-printing machine exponentially increased the supply of these fabrics to meet a demand that had been rising since the early eighteenth century. A single cylinder-printing machine (figure 3.4) could print as much yardage in four minutes as two people with wood blocks could do in six hours.[11] This statistic helps explain the decrease in the cost of printed cotton

FIGURE 3.2. QUILT BY EMILY VANDERGRIFT SNYDER (B. 1804),
CIRCA 1850, PHILADELPHIA, PENNSYLVANIA.

*Collection of Los Angeles County Museum of Art, Los Angeles, California, American Quilt Research Center Acquisition Fund
(M.87.208). Digital image © 2013 Museum Associates/LACMA. Licensed by Art Resource, NY.*

Emily Vandergrift Snyder's colorful quilt serves as a memorial to her family, tracking family information
and meaningful verses.

FIGURE 3.3. DETAIL OF CENTER
MEDALLION FROM QUILT BY
EMILY VANDERGRIFT SNYDER.

Inscribed verses:

*How many of us are another year? / May sleep beneath the
cold & silent sod? / Then while our lives are in merce
length[en]ed here, / Let us in time prepare to meet our God.*

*The fear of The Lord is a fountain of life, to depart
from the snares of death.*

*The fear of The Lord is the beginning of wisdom: which
will lead us to forsake sin.*

*In the fear of The Lord is strong confidence; and his
children shall have a place of refu[g]e.*

Emily Vandergrift Snyder used indelible ink to re-
cord information about her recently deceased husband
and their children.

fabrics during the early nineteenth century, which
made them accessible to far more Americans than
before. In addition, the details that could be en-
graved onto the plates wrapped around the rollers
were much more precise and crisp. Cylinder print-
ers experimented with inking the rollers in dif-
ferent ways. By gradually shading the colors on the
roller, they could get a rainbow effect, or different
shades of one color, for the ground and then have a
pattern overlaid.[12] These colorful printed fabrics
were available at local stores for rural and urban
Americans alike.

Antebellum women quickly embraced the
bright colors, exuberant patterns, and cheaper prices
of cylinder-printed fabric. In 1831, forty-four-year-
old Emma Willard (1787–1870) noted in her travel
diary that she "had long been desirous to see the
process of calico printing."[13] A trip to the British
Isles allowed her the chance to visit a textile print-
ing factory in Glasgow, Scotland, where she was
shown each part of the process from dyeing the

cloth to printing and fixing the colors. Willard noted
that "after the cloths are dried, measured and packed
for market, they are sent to almost every part of
the world—many to our own country."[14] While
few first-person documentary accounts remain to
tell us how antebellum women reacted to these fab-
rics, the large number of extant quilts that employ
them speaks volumes. Made all over the country by
young, middle-aged, and old women, these quilts,
like Snyder's, attest to the popularity of the new fab-
rics, leaving little doubt that this was one technologi-
cal innovation that was roundly embraced, rather
than shunned or feared.

Snyder's quilt also employed an indelible ink to
record the family information she added. New in-
delible inks, which their makers claimed would not
rot fabric, were developed in the mid-1830s, although
India ink, imported from China, had been used
throughout the world for centuries and worked
well for writing on fabric. Despite the availability
of India ink, many women made their own ink at

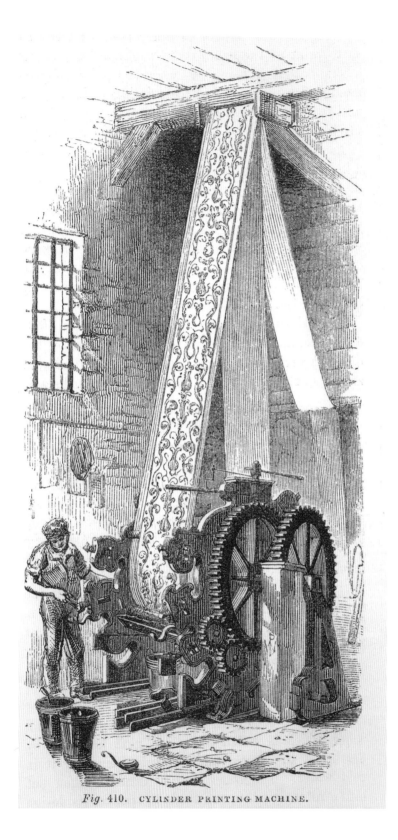

Fig. 410. CYLINDER PRINTING MACHINE.

FIGURE 3.4. "CYLINDER
PRINTING MACHINE"
FROM *CYCLOPAEDIA
OF USEFUL ARTS*,
ED. CHARLES TOMLINSON
(LONDON AND NEW YORK:
GEORGE VIRTUE
AND CO., 1854).

*Collections of Old Sturbridge Village,
Sturbridge, MA.*

home for writing on paper and on fabric.[15] But these inks (both homemade and commercial) were colored with iron or tannin—chemicals that caused cloth to deteriorate. During the 1830s and 1840s, several patents were filed in France and in the United States for "indelible writing ink," which used silver nitrate instead of iron.[16] Payson's Indelible Ink, credited with being the oldest manufactured ink suitable for fabric, came onto the market around 1834.[17] Advertisements for Payson's Ink directly addressed women who wanted to write on cloth. "This Ink is used without a preparation, and with it," the manufacturer claimed, "you can write in Indelible characters upon cotton and linen cloth, in the same manner that you would write with the common ink on paper. It is warranted not to corrode or injure the finest Cambric; and is so perfectly Indelible as not to be effaced either by time or art."[18] Indeed, nineteenth-century literature contains "no reports of damage to paper or cotton fabric from India ink or silver nitrate ink formulations."[19]

Indelible inks allowed antebellum women to save time marking their household textiles, for they could write quickly and directly on sheets, towels, and other textiles rather than cross-stitching countless initials and numbers. Yet inks for writing on fabric also offered a more ornamental and meaningful option, as well. From a memorial viewpoint, a person's handwriting could be preserved, as well as their name, when they signed a quilt block or inscribed a label for their embroidered coverlet.

Quilts were not the only needlework that incorporated new materials. Many antebellum samplers, like Amy Fiske's (described in the introduction) and Esther Banister Richards's (discussed in chapter 6), were worked on a new type of canvas, a machine-produced fabric, usually with a thread count of thirty-two stitches to the inch or less and woven with a blue weft thread every tenth thread. The popularity of this fabric demonstrates the growing preference for new machine-made goods during the 1820s, 1830s, and 1840s. As Miss Lambert explained in her popular 1846 book, The Hand-Book of Needlework, "German cotton canvas . . . is well adapted for some purposes. . . . It is generally woven with every tenth thread of a different colour, which many persons consider to be of great assistance in counting the stitches."[20] Having a fabric with the regular blue thread made counting far easier and faster. For older women, the blue guideline could assist them with compensating for failing eyesight as they stitched. For antebellum girls and young women, the blue-line canvas made stitching a sampler easier in light of less rigorous needlework training.

While cylinder-printed fabric, indelible ink, and blue-line canvas were all eagerly adopted by antebellum women (young and old), the sewing machine was the new technology that would have the most profound effect on American needlework. In July 1860, sixty-four-year-old Elizabeth Lindsay Lomax (b. 1796) noted in her diary, "Virginia Ellicott called in the afternoon. We discussed sewing machines—a very useful invention—I wish that we owned one, I could make shirts in a jiffy for my precious boy."[21] Although it was initially patented by Elias Howe (1819–1867) in 1846, the sewing machine did not achieve widespread use in American homes until after the Civil War.[22] However, antebellum women —of all ages—took notice of this invention during the 1850s, and Lomax was not alone among aging women in her desire to own one. The time-saving nature of the sewing machine was exclaimed over in diaries, letters, and ladies' magazines.

In 1830, Barthelemy Thimmonier (1793–1857), a French tailor, patented the first known machine used in commercial operation. Thimmonier's machine made a chain stitch using a hooked needle moved by a foot treadle. Additional chain-stitch

machines were developed during the 1830s.[23] Shortly after Thimmonier's invention, the lockstitch machine was invented by Walter Hunt (1796–1859) between 1832 and 1834, although he never patented it.[24] During the next decade, in the 1840s, patents were registered on many of the elements that make up the sewing machine as we know it, including support for the cloth, a needle to carry the thread through the fabric, tension controls to provide an even delivery of thread, and a mechanism to ensure the precise performance of each operation in its proper sequence.[25] In 1846, Elias Howe patented a sewing machine that was more sophisticated than ever before. And in the 1850s, Isaac Singer (1811–1875) became active, marketing the sewing machine on a mass scale.[26]

In 1850, forty-two-year-old Frances Swanson Shaw (1808–1876), of Maryland, presented her son, Samuel (b. 1832), with a red and green appliqué quilt on the occasion of his marriage to Elizabeth Schroyer (1837–1922) (figure 3.5).[27] Shaw combined hand sewing with machine sewing to complete her quilt. She appliquéd the central floral motifs by hand, just as her mother and grandmother would have. But she used her sewing machine to seam the backing fabric together, to apply the long vines in the borders, and to add the red binding around the edges. The benefits of the sewing machine were quickly understood by antebellum women, like Shaw, who used her machine to make quick work of sewing long seams and other formerly time-consuming chores.

During the 1840s and 1850s, primarily industrial machines were produced, intended for commercial use, although some women purchased these models for themselves. The early machines cost about $100, a substantial expense for the average farm family with an annual income of $500.[28] As forty-eight-year-old Mary Jones (1808–1869) wrote to her daughter in 1856, "A hundred dollars is a great deal to invest in an uncertainty."[29] Realizing this, Isaac Singer developed the installment plan, putting the sewing machine within reach of a much wider audience. By 1860, 500,000 sewing machines were in use in the United States (commercial and domestic use combined).[30] In August 1860, Washington, D.C., resident Elizabeth Lindsay Lomax seemed to be closer to her goal of getting a sewing machine. "The girls have gone down to the city to look at sewing machines," she wrote in her diary; "Wheeler and Wilson's seems to be the best."[31]

As these women knew only too well, sewing a man's shirt by hand took over fourteen hours, and a woman's dress could take almost seven hours.[32] When a sewing machine was used instead of needle in hand, these common garments took only an hour or two. Proponents of women's rights saw the sewing machine as the savior of thousands of women. Reformer Amelia Bloomer (1818–1894) believed that with the time saved by the sewing machine, female merchants, bookkeepers, shoemakers, cabinetmakers, jewelers, booksellers, typesetters, editors, publishers, farmers, and physicians would become commonplace. As she explained, "Woman has long enough stitched her health and life away, and it is merciful to her that sewing machines have been invented to relieve her of her toilsome, ill-paid labor, and to send her forth into more active and more lucrative pursuits where both body and mind may have the exercise necessary to health and happiness."[33] Forty-three-year-old Harriette Kidder (1816–1915) of Illinois seconded Bloomer's appraisal when she wrote in 1859 that her sewing machine was "a very valuable household article. It renders sewing a pleasure rather than a toil."[34]

An early champion of the sewing machine, Sarah Josepha Hale (1788–1879), editor of *Godey's Lady's Book,* trumpeted its benefits for her readers.

FIGURE 3.5. QUILT BY FRANCES SWANSON SHAW (1808–1876),
CIRCA 1850, HAGERSTOWN, MARYLAND.

Courtesy of the West Virginia State Archives, West Virginia Heritage Quilt Project Collection.

Frances Swanson Shaw combined hand sewing with machine sewing to make this quilt on the occasion of her son's wedding. Antebellum women of all ages quickly embraced the sewing machine as a time-saving device. While especially helpful for making clothes and functional household textiles, the machine was also ideal for quickly seaming quilt backs and applying bindings along quilt edges.

"By this invention," the seventy-two-year-old Hale exclaimed in 1860, "the needlewoman is enabled to perform her labors in comfort; tasks that used to require the midnight watches by the pale light of a single lamp, and drag through, perhaps, twenty hours, she can now complete in two or three hours. She is thus able to rest at night and have time through the day for family occupations and enjoyments. Is not this a great gain for the good?"[35] About a year earlier, forty-eight-year-old Elizabeth Le Breton Stickney Gunn (1811–1906) called on a friend who had a new sewing machine; it was "a Wheeler & Wilson," Gunn wrote, "and it has an attachment which will turn down a hem and sew it at the same time. She told me she had heard of knitting machines at fifteen dollars that would knit drawers as well as stockings. I really do want one."[36]

Many female family members seem to have found consensus in their interest in the sewing machine. While all of the aging women quoted here who wrote about sewing machines expressed their positive enthusiasm for the machine, most of them enlisted the help of younger relatives in learning about the options, purchasing the machine, and using it. As fifty-one-year-old Mary Jones (1808–1869) wrote to her daughter on August 16, 1859, "Laura and Sister Susan both use the sewing machine admirably—*without* basting. . . . Laura says it is the easiest thing in the world. I think it will prove a great comfort."[37]

While the sewing machine was quickly adopted for making clothing and seaming household textiles, its use for quilt making is harder to document. Quilt historians disagree about the number of quilts made in the late nineteenth century and early twentieth century that employed machine stitching.[38] The important distinction to be drawn is in identifying how the machine was used in midcentury

quilts. Machine quilting and machine appliqué were rare initially. However, the power of the sewing machine—with its speed and efficiency in stitching straight seams—was ideal for quickly piecing quilt tops. Recent quilt documentation projects have found many late-nineteenth-century quilts in which the blocks may have been hand pieced but were then joined together in long strips by a machine. And although machine sewing of any kind is rare in quilts made between 1850 and 1860, it does pop up from time to time, as in the quilts discussed in this chapter.[39]

In the 1850s, Mary Deloach Sneed (1807–1905) showed pride not only in her quilt-making skill but also in her ability to keep up with new technology (figure 3.6).[40] Mary Deloach was born in Davidson County, Tennessee, in 1807. In 1824, she married her first cousin, George Washington Sneed (1799–1851), who was a Methodist minister. The couple had seven children. In 1850, Mary Sneed and her husband moved to Navarro, Texas, because of George's declining health. He died in Texas in July 1851. In 1858, Mary moved to Waco, Texas, where she lived until her death in 1905 at age ninety-seven. In her forties at the time she made this quilt, Sneed used her new sewing machine to complete her fruit basket bedcover.[41]

According to a note written by one of her descendants, Sneed "made and stuffed the baskets by hand, and stitched the white part on her new sewing machine—one of the first made after it was invented."[42] Sneed used her machine to appliqué the baskets, to quilt the alternating plain blocks, and to join the blocks together. She cut out a piece of fabric with a printed basket-weave pattern (known as "cheater cloth")[43] and then used rows of machine stitching to give it the appearance of woven strips of fabric rather than the one piece of fabric that it

FIGURE 3.6. QUILT BY MARY DELOACH SNEED (1807–1905), 1850–1860, WACO, TEXAS.

The Daughters of the American Revolution Museum, Washington, DC. Gift of Martha Hunt.

According to family history, Mary Deloach Sneed's quilt, which includes machine stitching, was made using one of the first sewing machines to come to Texas.

actually is.[44] The alternating plain blocks are machine quilted in a crosshatched pattern with lines one-half inch apart. A close look at her quilt shows that Sneed made all of the blocks first—both the appliquéd baskets and the quilted squares—and then sewed them together. As a final step, she added a backing and tied it to the front of the quilt to hold it together—the common purpose behind quilting a quilt.[45] This material evidence of Sneed's construction technique suggests a woman who was excited by the new technology represented by her sewing machine yet was still learning how to incorporate it into her quilt-making process. Combining machine sewing with hand sewing in her quilt was one way for Sneed to adapt to the changes taking place in her culture and to navigate the new ways that were emerging.

The Shaw quilt, the Sneed quilt, and others from the 1850s show that the sewing machine was not feared by women but, instead, was employed by young and old women alike to make a variety of items. Further research is needed to gain a fuller understanding of how many quilts from the sewing machine's first decade show machine stitching. Quilt scholar Anita Loscalzo persuasively suggests that "many more were done, but not kept and valued because of changes in taste."[46] The rise of the Colonial Revival aesthetic during the late nineteenth and early twentieth centuries led to a revival of handwork and a distaste for machine-made items. As quilts—and other decorative needlework—that showed machine work were rediscovered by descendants, museums, and dealers, they do not appear to have been valued or kept by these people to the same degree as entirely handmade examples.

Although the machine made quick work of formerly time-consuming plain sewing, such as the miles of seams sewn to construct sheets and towels, and the constant making and mending of family clothing, the time that was saved was quickly redirected to the production of more elaborate clothing and to fancywork. One 1859 sewing guide championed the machine as "the liberator of our sex" but explained that this meant that women would have more time for hand-wrought fancy work.[47] Likewise, in 1860, *Godey's Lady's Book* suggested, *"The Sewing Machine* should be here named as the completement of the art of needle-work. It, the machine, will do all the drudgeries of sewing, thus leaving time for the perfecting of the beautiful in woman's handiwork."[48] Rather than freeing women from household drudgery, the sewing machine was perceived by some women as merely making one area of their work faster, thus allowing the time saved to be spent on other domestic chores. Decorative needlework continued to be an emotional issue, with two distinct sides—one that lauded the ability of women to focus more time on the beautiful and one that saw it marginalizing women even more, away from skilled jobs and a decent wage. These changing views of women's needlework could often be divided along generational lines.

Agricultural Fairs: A Means of Recognition or Marginalization?

At the end of the 1850s, the *New York Tribune* predicted that "the needle will soon be consigned to oblivion, like the [spinning] wheel, and the loom, and the knitting-needles. . . . The more work can be done, the cheaper it can be done by means of machines."[49] While an urban northeastern newspaper could be matter-of-fact about this development, boiling it down to a clear-cut statement of economic value, changes in textile and needlework produc-

tion between 1820 and 1860 actually provoked numerous types of personal reactions, from fear and reluctance to wholehearted approval. And the conflict between these reactions often played out at agricultural fairs in the northeastern and midwestern United States.

The first American agricultural fair, convened in Pittsfield, Massachusetts, in 1810, was the brainchild of Elkanah Watson (1758–1842). Watson created the Berkshire Agricultural Society to offer a practical means of education for local farmers.[50] While Watson's aims were pragmatic, he also realized that he needed to have a social element to maintain interest. To increase participation, the 1811 fair was bigger and grander with a parade and awards, or premiums, for the best entries. By 1813, the Berkshire Agricultural Fair included an "Agricultural Ball" and invited women to compete for prizes with their textiles.[51]

The agricultural society movement gained strength during the first half of the nineteenth century. By 1860, there were over seven hundred county and local agricultural societies in the North and the West, most modeled on Watson's "Berkshire Plan."[52] Local women quickly took a visible role by assisting with decorating the hall and entering needlework and foodstuffs in the competitions.

New England's agricultural fairs employed the rural agrarian tradition to cope with technological changes, an evolving economy, and shifting gender roles. The annual reports of the exhibits of "domestic manufactures" are often telling, with the descriptions serving as a locus for the intersection of old traditions and new products, as well as for old gender roles and new economic realities. Historian Catherine E. Kelly found that rural men "attempted to reconcile the domestic manufactures of their mothers with the fancy work that occupied the

imaginations of their wives and daughters, simultaneously applauding old-fashioned economy while celebrating the fashionable display that attended middle-class culture even in rural New England. In the process, they elaborated the distinctions between utility and ornament, between farmer's wife and leisured lady, between household economy and middle class domesticity."[53]

Agricultural fairs offered women a socially acceptable means of achieving recognition for their work, allowing them to build self-esteem and make a contribution to their community. As historian Linda Borish observed, "While many farmers criticized and underappreciated farm women's labors at home, when women showed these labors for all to see in public, suddenly, her skills became acclaimed and she held some cultural power."[54] As mechanized industrialization spread across the country during the mid- and late nineteenth century, the displays of "domestic manufactures" at the annual agricultural fair offered a touchstone for residents who were anxious about these changes as well as a means for older women to resist their marginalization.

Not only women noticed the changes taking place in textile and needlework production. Connecticut Congregationalist minister Horace Bushnell (1802–1876) commented in 1851 that "this transition from mother and daughter power to water and steam-power is a great one, greater by far than many have as yet begun to conceive."[55] Yet for every Bushnell who applauded the industrial changes taking place and the impact they had on American women, there was another who was less comfortable with these developments. For example, an 1856 Ohio agricultural society report commented, "We are glad to see from these beautiful specimens, that the spinning wheel and loom are not defunct

institutions in American homes. . . . We were greatly pleased, too, with an embroidered cushion, on an elegant chair, the work of a lady sixty years old . . . Beautiful in itself, it was more still an object of interest from the age of the lady who wrought it."[56]

These comments, found readily in the accounts and records of local agricultural fairs, touch on two sources of anxiety and ambivalence specific to female adoption of mechanized and industrial developments pertaining to needlework. First, they suggest a generational conflict between young women, who could purchase fabric at the local store and sew quick seams on a sewing machine, and their mothers and grandmothers, who were raised to equate industry, gentility, and femininity with their needles. Second, these comments also point to a gender-based conflict between aging women and their menfolk, as women were more and more tightly circumscribed inside the home.[57] In both cases, they suggest how nostalgia for the past could be a motivator for action in the present, influencing the types of needlework aging women made and how they used these products of their needles.

As one (presumably male) reporter wrote in 1829, "We would restore the good old day of housewifery, when . . . women knew the use of the distaff, and instead of waltzes, cantatas, and duets, thrummed out by a boarding school miss, upon a discordant piano, the houses of our farmers rang with the cheerful sound of the wheel . . . and the loom."[58] Disdainful of the shallow achievements of women of his day, this writer bemoaned what he saw as an exchange of productive work spinning thread and weaving cloth for frivolous dances and songs. The farmer's daughter "is better educated than her mother, perhaps, and not half so good a housekeeper," explained another commentator, "and so she naturally takes to fashion and light litera-ture, receives calls and returns them, dusts the parlor for her share of the housework, works worsted cats and dogs for intellectual discipline, and wears a stylish bonnet to church by way of morals and religion."[59] Contemporary literature and prints illustrated the dangers of a society in which young women were taught to value beauty over industry. For example, the satirical print by Gillray in figure 2.4 shows the airs that one daughter returning from boarding school had taken on. Many writers were concerned about the dangers that consumption posed to the financial well-being of American families, as well as to maintaining a sense of class difference, at the expense of industry and thrift.[60]

But for some, mechanization was a good thing —it freed women to pursue nobler aims as they cultivated their knowledge and transferred it to their offspring, not unlike the goals of the Republican Motherhood of their grandmothers. In 1857, the Ohio State Board of Agriculture presented a positive view of these changes for women:

> What a vast amount of female labor has been superceded by the spinning machine, power loom, knitting and sewing machine. So far as the employment of females in the farmers house is concerned, the wives and daughters of the future farmers of Ohio cannot realize the condition of those who lived during the first half century of its existence in this state. We hope the day is not far distant when the farmer's wife shall be relieved from all drudgery, and can devote her time more to the mental and physical education of her offspring, and the cultivation of science, arts and literature.[61]

According to this report, the women of 1857 were better off than their predecessors. They could spend less time working and more time caring for their families and pursuing their own interests, including, presumably, decorative needlework.

Previous studies of needlework at agricultural fairs have relied on the printed records of the societies and the fairs.[62] These studies focused on specific states and used a quantitative methodology to analyze the categories and the premiums awarded. Quilt historian Barbara Brackman's analysis of Kansas agricultural fairs suggests that these displays influenced the spread of quilt patterns and styles. She states that the ribbon winners were held up as worthy of imitation—the women who entered their quilts did so, at least in part, as a point of pride. She concluded that while the prize categories affected aesthetics, the newspaper accounts of the needlework shown created taste.[63] Virginia Gunn's study of Ohio fairs drew similar conclusions, stating that the agricultural fair displays in that state provided inspiration for future needlework and helped shape regional taste and stylistic preferences in quilt making.[64] Winning a prize allowed a woman to gain prestige, feel pride in her work, and acquire some material reward. The premiums rewarded evidence of skill, industry, thrift, and good taste.[65] Certainly, aging women found prize recognition to be a useful tool in fighting their marginalization to the hearth. They were able to display their abilities as well as a pursuit of industry and thrift—and thus their continued value to family, home, and community, despite the many changes taking place around them. Agricultural fairs were not the only venue open to antebellum needlewomen eager to display their best work. In addition, charitable fairs abounded during the mid-nineteenth century, allowing women not only to show off their skill but also to raise funds for political and social causes that they supported.[66]

Previous studies of agricultural fairs have also noted that entries by the very old and the very young were often singled out as particularly noteworthy.[67] Brackman suggests that this may be due to "the inarticulateness of the male reporters assigned to cover the ladies' exhibits."[68] For example, the Domestic Hall at an 1858 Ohio fair was described this way: "There were many quilts there, the handiwork of the fair ladies of Ohio—some were really fine, others pretty, and some gaudy. . . . There were a hundred different articles of use or ornament that doubtless skipped our eye among the rest; for we have only an indistinct recollection of a mixed mass of dry goods. Some one of our lady readers will doubtless supply us with a better description of the remarkables in this hall."[69] Lacking the expertise to comment more specifically on the features of the craftwork displayed, these reporters focused on the "human interest" aspect of the show—youth and age—while implicitly marginalizing women's skill and work, as well as the varied talents and production that they pursued every day in the home and exhibited at the fair.

Agricultural fairs offered mature women an arena in which to express pride in their work and also to call the attention of others to that work—and the skill it represented. A report of the 1843 Lake County Agricultural Society fair in Ohio recounted that part of the parade to the fairgrounds included "about thirty-five ladies engaged in knitting, sewing, spinning, and various other employments, significant of the high and important position which female industry occupies in the great workshop of civilization."[70] Women's work was thus important not only for individual ladies but also for society and civilization. The Ohio reporter went on to explain that the agricultural fairs "produce laudable emulation."[71] Indeed, aging women who entered their needlework in the fairs understood this and used the agricultural fair as a way to show pride in their work and their importance to home, community, and nation.

FIGURE 3.7. NANTUCKET AGRICULTURAL SOCIETY QUILT, 1856,
NANTUCKET, MASSACHUSETTS.

Courtesy of the Nantucket Historical Association, Nantucket, Massachusetts.

This quilt, made for the first Nantucket Agricultural Society fair, seems to have been made under the direction of Lucy Macy Mitchell and Hannah Gardner Fosdick. Each diamond was signed, and the quilt may have been auctioned off to raise money for the society.

In April 1856, a group of Nantucket Island residents gathered to establish the Nantucket Agricultural Society, motivated in large part by a desire to effect significant change on the island, in order to recapture economic viability.[72] In a sense, the group was taking steps to resist the marginalization of their entire community. Nantucket Island is well-known for its history as a whaling port. But by the mid-1840s, the whaling industry was in decline and island residents were forced to consider new ways to make a living. Nantucket's population in 1840 was about ten thousand, but as the whaling industry waned, thousands of islanders left their homes in pursuit of alternative ways of making a living. By 1870, the island's population had declined to four thousand people.[73]

Chartered by the State of Massachusetts, the society was formed "for the encouragement of Agriculture and Mechanic Arts, in the County of Nantucket, by premiums and other means."[74] After its founding, the Nantucket Agricultural Society quickly set to work encouraging residents to farm the land to offset the loss of the whaling industry. From October 28 to October 30, 1856, the society held its first fair. According to newspaper accounts, attendance at the fair was overwhelming. Initially scheduled for only one day, it was so popular that it spilled into a second day, when 1,200 people attended, prompting fair organizers to hold it open for a third consecutive day.[75]

Newspaper accounts reported that the women of the society decorated the hall and arranged the exhibits of fruits, vegetables, and fancy goods. Women were also active in performing evening programs, writing songs, and conducting choirs. And they created a quilt, presumably as a fundraiser for the society (figure 3.7), although details on why the quilt was made are frustratingly vague in the newspaper reports and society records. One island

FIGURE 3.8. DETAIL OF SIGNED BLOCK ON NANTUCKET AGRICULTURAL SOCIETY QUILT.

Inscribed verse:
My humble muse in an ambitious strain, / Paints the forest green and the flowing [plain?]. / Ellen Starbuck.

newspaper reported only that "an Album Quilt was exhibited by the Society, composed of squares marked with the autograph of the maker, each square made by a different person."[76]

Despite this description, physical evidence makes it seem more likely that the quilt was made by a small group of women and then signed by members of the society and their families. At least one handwritten signature runs into the pieced triangle at the corner of the block, suggesting that the quilt top was constructed before the blocks were signed (figure 3.8). And the dates on the signature blocks range from October 15 to October 21, just a week before the fair. The quilt must have been put together long before these dates in order for it to be completed for display on October 28. The society's records suggest that the quilt may have been auctioned off. On the last evening of the fair, a song by

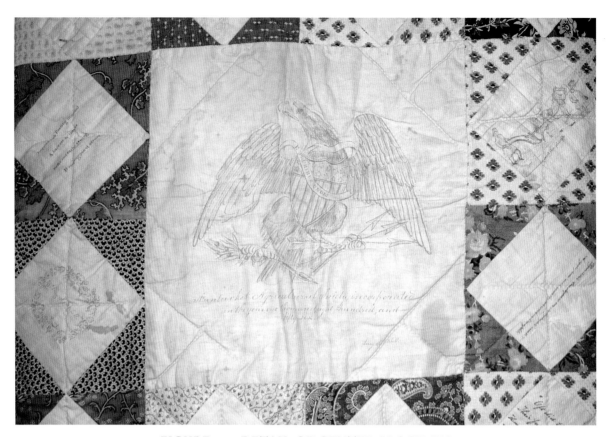

FIGURE 3.9. DETAIL OF CENTER BLOCK ON
NANTUCKET AGRICULTURAL SOCIETY QUILT.

Inscription: *Nantucket Agricultural Society, incorporated / in the year one thousand, eight hundred, and / fifty six. /
Lucy S. Mitchell.*

the glee club was "followed by the auction bell, calling all to the sale of the remaining articles donated to the fair."[77]

The quilt contains about 218 signatures of men, women, and children, although some are now too faint to decipher and others have faded completely. In addition to the names, the quilt includes many verses. Some relate directly to agriculture, such as that on the square signed by Nathaniel Barney (1792–1869), who wrote, "He that ploweth should plow in hope." Other verses reflect more standard sentiments, including "God is love" and "As the twig is bent the tree is inclined." The quilt is pieced in a simple square block, known alternatively as "Friendship Album Quilt," "Broken Sash," and "Dutch Tile."[78] The center square of the quilt is larger than the pieced blocks and has an inked drawing of an eagle with a faint inscription written underneath reading, "Nantucket Agricultural Society, incorporated / in the year one thousand, eight hundred, and / fifty six. / Lucy S. Mitchell" (figure 3.9). These inked inscriptions are a central part of the design plan for the quilt and would not have been possible without the antebellum advances in indelible inks.

Community members were able to personalize their block beyond just signing their name: they could be spontaneous by adding a favorite verse or drawing a personal symbol.

Newspaper accounts of the fair reprinted several of the songs performed during the evening activities, including one called "The Agricultural Fair," written by fifteen-year-old Margaret Getchell (1841–1880), who also signed one of the quilt's blocks. One stanza of the song reads:

> Here's GARDNER with his plenteous horn,
> In Album Quilt displayed,
> With colored squares and stitches fine,
> That ladies fair have made;
> With Mrs. MITCHELL's eagle proud,
> In centre-piece outspread,
> And Mrs. FOSDICK's model plough,
> With not a line mislaid.[79]

The song verse seems to be describing the signature quilt with its central square showing an inked eagle. There is no Mrs. Mitchell or Mrs. Fosdick listed as a premium winner in the quilt category at the fair, but "Mrs. H. Fosdick" received special mention for "handsome specimens of marking with indelible ink" shown at the fair.[80] And "Lucy S. Mitchell" is the name in the central square with the inked eagle, suggesting that she is the Mrs. Mitchell named in the song.

Forty-seven-year-old Hannah M. Gardner Fosdick (1809–1864) and forty-four-year-old Lucy S. Macy Mitchell (1812–1875) signed multiple blocks in the quilt, underscoring that they were instrumental in creating it. The centrality of the inked drawings and signatures attracted attention—from the newspaper and from fairgoers. Hannah M. Gardner was born December 20, 1809, the daughter of

Oliver C. Gardner (1784–1860) and Hannah Macy Gardner (1788–1867). She was the second wife of Obed Fosdick (1801–1852), and they had two children, John B. M. (b. 1848) and Oliver G. (b. 1849). After her husband died in 1852, Hannah Fosdick ran a dry goods store. One island memoirist described her as "a large woman of peculiar and distinctive characteristics. . . . She was indeed a striking character, was a shrewd business woman, and creditably maintained her home from her store sales."[81] According to the 1860 U.S. Census, Hannah Fosdick had a personal estate valued at three thousand dollars. She died on February 21, 1864. Lucy Macy was born on May 19, 1812, the daughter of John W. Macy (1790–1831) and Sally Swain Macy (1790–1824). In 1834, she married Francis Mitchell (1808–1890), and they had one son, John W. (b. 1836). According to the U.S. Census in 1850 and 1860, Francis was a shoemaker and then a dry goods merchant. Francis was also a founding member of the Nantucket Agricultural Society, initially appointed to the society's Finance Committee. Lucy S. Macy Mitchell died on December 27, 1875. Her obituary in the island newspaper remembered her as "a woman of rare Christian virtues, social in her nature, ever welcoming one and all to her quiet home, which, in its beautiful surroundings of nature and art, was truly emblematic of that paradise promised above."[82]

The choice made by these Nantucket women to stitch a signature quilt for the island's first fair was deliberate. Signature quilts initially appeared in the Delaware Valley in the 1840s. From the mid-Atlantic region, the style traveled to New England, Virginia, and Ohio by the mid-1840s and enjoyed enormous popularity until the mid-1850s.[83] Given their rapid rise in popularity, their reliance on a set formula, and their limited duration, signature quilts fit the definition of a fad. But they also served a

serious purpose: they assisted their makers and owners with adapting to major, and often disruptive, life changes when they were given as wedding presents or as going-away gifts to couples or families moving west.[84] Given the significant economic and social changes taking place on Nantucket—the demise of the whaling industry and the resulting departure of many island residents—it is not surprising that the ladies of the Agricultural Society chose a quilt that symbolically gathered their community together. Signature quilts were a tangible reminder of family and friends—and the social support they provided. Made to preserve and remember events and relationships of the past, they can be understood as an attempt to slow down time and cherish the past.

Signature quilts can also serve as symbols of the ambivalence surrounding mid-nineteenth-century mechanization, particularly as it affected textile production. They were a tool by which women could navigate their changing culture. For mature women, making and giving signature quilts could be a reaction to industrialization. As one quilt scholar has explained, these quilts were "a way of countering the disruptive forces that were weakening their networks of social interdependence."[85] They retained the traditional form of the block-set quilt, while also offering women a way to mediate the newness of roller-printed fabrics and seemingly magical indelible ink. These quilts could be personalized in new and different ways, offering a freedom of expression to counsel the recipients with a favorite proverb, or to just sign one's name in his or her own unique way.

In the mid-Atlantic region, sixty-year-old Euphemia Reese Wilson Righter's (1790–1873) signature quilt, finished in 1850, is typical of its era (figure 3.10).[86] She signed the center block: "Mrs. Euphemia Righter / Beaver Meadow / Penna. / Feb-

ruary 8th, 1850" (figure 3.11). The thirty-two smaller blocks making up the quilt top are signed by relatives and neighbors, which allowed Righter to gather her community around her every time she used the quilt.[87] Euphemia grouped the smaller signed blocks by family names.

Euphemia's daughter, Jane Righter McKay (b. 1816), who had married Dr. Isaiah McKay (1812–1858) around 1837, signed the quilt, as did both of Euphemia's daughters-in-law, but not her sons.[88] A younger son, John W. Righter (1819–1856), was a mill owner who married Margaretta Woodnutt Hall (b. 1815).[89] Her older son, William Wilson Righter (known as W.W.) (1817–1854), married Jane Ferguson McNair (1820–1891) in 1841. They moved to Mauch Chunk, Pennsylvania, in 1850, the same year that Righter completed her quilt.[90] W. W. Righter was a doctor, and several of his patients also signed blocks, suggesting that it may have been intended as a gift for the couple.[91]

The quilt is large, measuring 111 inches by 108 inches. It includes thirty-two 13½-inch-square blocks plus the larger and more elaborate center compass block. The earliest dates on the blocks are from 1844, with the latest dates in 1850. This helps pinpoint when Euphemia started her quilt and also tells us that she worked on it for six years. A woman of Righter's experience and skill could certainly have pieced these blocks in a matter of weeks and then spent several days quilting it, either alone or with friends. The six-year spread of dates on the blocks suggests that she did not put the quilt together until after the last block was signed in 1850, since it would be much easier to sign the blocks before they were joined together and quilted. Why did it take six years for her to gather the signatures? Is this a reflection of the changing times? The demands of her occupation? Instead of an aging housewife who found herself with more and more leisure

FIGURE 3.10. QUILT BY EUPHEMIA WILSON RIGHTER (1790–1873),
1850, BEAVER MEADOW, PENNSYLVANIA.

Courtesy State Museum of Pennsylvania, Pennsylvania Historical and Museum Commission.

Euphemia Wilson Righter had her children and neighbors sign the centers of the blocks
on this quilt. She placed herself at the center.

FIGURE 3.11. DETAIL OF CENTRAL
MEDALLION FROM QUILT BY
EUPHEMIA WILSON RIGHTER.

Inscription: *Mrs. Euphemia Righter, / Beaver
Meadow / Penna. / February 8th, 1850.*

time to fill as her children grew up, married, and moved out to their own households, Righter had to support herself. She had less help and less time to sew and quilt. Was this also an effect of her age? As she aged, did failing eyesight and arthritis impede her progress on her quilt? We have no way to know.

Yet Righter's quilt functions as a clear symbol of her family connections and her role as a mother and a neighbor. Her personal history helps support our understanding of the quilt as a cherished touchstone. Born in 1790 in Moreland, Pennsylvania, Euphemia Reese Wilson married John Righter Jr. (c. 1791–1820) in November 1814, when she was twenty-four. Sadly, their marriage was cut short by John's death in 1820.[92] Left a widow with three small children, Euphemia undoubtedly experienced feelings of anxiety and isolation. When she made her quilt thirty years later, she must have taken satisfaction in her achievements, despite her hardships. Indeed, she employed the Mariner's Compass block in her quilt, which was a decided show of skill; it took experience and precision to stitch this block so that all points matched.

Righter does not seem to have married again. According to the 1850 U.S. Census, she was head of a Mauch Chunk, Pennsylvania, household that included fourteen unrelated people, suggesting that she was running a boardinghouse.[93] One study of Pennsylvania widows from 1750 to 1850 found that more than 80 percent of the women who became widows (half of those who married) never married again.[94] For these women, keeping their family together trumped cultural ideas of "proper female behavior." In other words, "When proper femininity stood in the way of providing for herself and her family, cultural prescription was quietly put aside."[95] For Euphemia Righter, this meant opening her home to strangers in order to make a living and provide for her children.

By its appearance, Euphemia's quilt fits neatly into the story of signature quilts—a story told in several previous quilt studies.[96] But when we think about the quilt as a series of choices made by its sixty-year-old maker, consider the six years that she took to complete it, and admire the skill with which the challenging blocks are pieced, we can add a nuanced understanding to the quilt as the needlework of an aging antebellum woman. We should interpret the quilt as a memory object, keeping sight of what it says about its present as well as its maker's past. Like makers of some of the other quilts in this chapter, Righter combined new materials with traditional style. The Mariner's Compass is one of the earliest-named quilt blocks; letters written during the first decade of the nineteenth century call it by this name.[97] The medallion style is also an older component of the quilt, although surrounding it with blocks separated by lattice strips is a newer touch. And the contemporary printed fabrics and indelible ink used for the signatures are also newer components in this quilt.

Recent quilt scholarship suggests that signature quilts are closely tied to the Romantic movement, which reached its peak during the antebellum era.[98] As Protestant churches began to preach that individuals had the power to determine their own religious fate, congregants began to pursue good works and to seek salvation through faith. Looking back to the chivalric knights of the Gothic and Renaissance eras, as well as a rising interest in the individual, offered models for contemporary Americans and contributed to an increase in sentimentality and nostalgia that is evident in antebellum decorative needlework. Signature quilts seem to have been a perfect tool for provoking nostalgia—both when

they were made and, particularly, as they were saved and cherished by subsequent owners.

Navigating Generational Tension with a Needle

In 1831, the *New England Farmer* reported that a "gratuity" was awarded to "a carpet made of shreds of cloths by Mrs. Rachael Holmes (b. 1751) of Sterling, Massachusetts, at the age of eighty—affording evidence that the hand of female industry is busy in New England from life's earliest to its declining period, and that the ingenuity of usefulness which brightens its morning cheers the serene evening of its days of good work."[99] Nine years later, in 1840, ninety-year-old Mrs. Ruth Watson (b. 1750) of Spencer, Massachusetts, entered four woolen work bags in the Worcester Agricultural Society fair. According to the printed account of the fair, these bags "demonstrated to all, that even 90 years have not been sufficient to blot out that skill and dexterity which are required in producing works of ingenuity and taste. May she live a thousand years."[100]

These articles, and countless others that cited the work of aging women, implied that girls and old women alike should be using their needles to remain industrious and to meet societal expectations. In 1834, the *New England Farmer* advocated that girls who won premiums at the annual fair deserved special consideration as potential wives. "A wife could not be dowered better," the paper asserted, "and when an agency for the procurement of marriage contracts shall be established here, the young ladies who have received premiums from this Society, should occasion the largest demands by the broker upon those who may have the good fortune to secure such prizes."[101] While few agricultural

fair reporters went this far—essentially making the women themselves as much a commodity as the goods they were producing—the benefits of the fairs were obvious to the entire community. The show of quilts, textiles, and other items produced by women offered inspiration and a model for improvement. And while fair organizers hoped to involve and inspire community women in direct ways, the evidence also suggests that the women manipulated the fairs to their own ends, using the events to focus attention on their skill, to bring attention to favorite social causes, and to hold their families and communities together.

The work of aging women displayed at agricultural fairs was often singled out, described in terms of the industry it represented and the model it set. The praise encouraged the older generation to remain productive, while reminding the younger generation that their elders represented a valued component of society. In 1843, the *New England Farmer* explained, "No one effect of these annual shows, perhaps, is of more beautiful tendency, than the influence they exert on the *young*. . . . Of more aspiring ambition, with minds less warped by prejudice, and more susceptible of conviction than the old, the young agriculturists see and hear much at these shows that they will *retain*."[102] Indeed, an account of the 1842 Hartford County Agricultural Fair in Connecticut reported that "the specimens of household manufacture, which were numerous and highly creditable, [showed] that industry and thrift are still the distinguishing characteristics of our fair countrywomen."[103] Older women themselves used their needlework to send messages to the younger attendees, reminding them of the older generation's values and achievements.

Antebellum girls seem to have paid attention to their elders' example. In 1842, one reporter offered

FIGURE 3.12. QUILT BY SUBMIT GAY, 1842, CONNECTICUT.

Wadsworth Atheneum Museum of Art, Hartford, Connecticut / Art Resource, NY.

Submit Gay entered her impressive quilt in the local agricultural fair in 1842 and won a prize for the best "bed quilt." Her skilled work and the pleasing visual impact of her quilt may have inspired younger generations of women to follow in her footsteps.

some hope for the rising generation, pointing to the cotton counterpanes submitted by two girls as a counter to fears that "the females of the rising generation" were doomed to "fall behind their granddames."[104] In 1850, the *Hampshire Gazette* encouraged "every bigoted admirer of grandmothers and despiser of granddaughters" to consider "a wondrous picture in worsted" on display at the local fair because of its "elegant chirography" and "meritorious" labor, which would inspire all—young and old alike.[105]

Forty-six-year-old Submit Gay's (1796–1880) striking Star of Bethlehem quilt, which was entered in the Hartford County Agricultural Society's 1842 fair, offered a breathtaking vista to visitors (figure 3.12).[106] In addition to the large central star, the quilt incorporates eight Star of LeMoyne blocks and a pieced sawtooth border. It shows elaborate quilting in a variety of motifs, including flowers, pineapples, and medallions with suns. Gay won a silver medal for her quilt, signifying that the judges considered it the best in the "bed quilt" category.[107] While we cannot know how many younger visitors were inspired by this quilt, Gay's own family did value it. Though she did not have children to whom the quilt descended, the quilt was passed down in her family until it was donated to the Wadsworth Atheneum by her great-niece in 1926.[108]

A silk hexagon mosaic quilt by forty-one-year-old Marina Jones Gregg (1811–1899) (figure 3.13) of Charleston, South Carolina, in 1852 offers a similar example to Gay's quilt, but from the southern United States. Marina was born in 1811, the daughter of Colonel Mathias Jones (1779–1829) and Clara Perry Jones. She married William Gregg (1800–1867) in 1829, and the couple moved to Columbia, South Carolina. They had seven children. William Gregg was a silversmith and jeweler who became quite

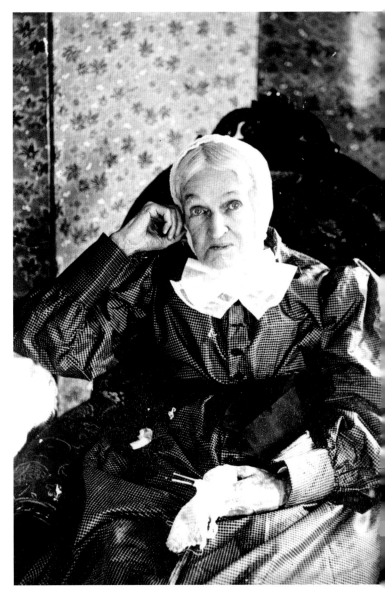

FIGURE 3.13. PHOTOGRAPH OF MARINA JONES GREGG (1811–1899), CIRCA 1890.

Courtesy of the Gregg-Graniteville Archives, Gregg-Graniteville Library, University of South Carolina–Aiken, Aiken, South Carolina.

Marina Jones Gregg appears to be holding a knitting project in her photographic portrait. Just as in antebellum painted portraits, the knitting may have been intended to symbolize her industry, as well as her femininity.

FIGURE 3.14. QUILT BY MARINA JONES GREGG (1811–1899), 1852,
CHARLESTON, SOUTH CAROLINA.

Courtesy of the Charleston Museum, Charleston, South Carolina.

Like Submit Gay, Marina Jones Gregg entered her impressive quilt in a local agricultural fair, where it won a prize.
Local fairs offered quilt makers a venue to show off their skills, while also providing inspiration for other local quilters.

wealthy, eventually becoming a textile manufacturer. In 1838, they moved back to Charleston. According to the 1860 U.S. Census, William owned real estate worth $40,000 and had a personal estate worth $250,000. Marina Jones Gregg died on January 1, 1899, at the age of 87.[109] Like Gay's quilt, Gregg's is impressive because of the number of small pieces that she cut out and stitched together (figure 3.14). In addition, Gregg's quilt shows exemplary quilting at a remarkable fourteen stitches to the inch. Gregg quilted an echo of each hexagon inside the small pieces and a cable design in the navy blue silk border.[110] Her work shows a level of skill that would have been understood by all women viewing the quilt, whether young or old. Whether Gregg was showing off or just taking pride in her work, we will never know. Regardless, like Submit Gay, Gregg was rewarded for her work, winning a silver pitcher inscribed "Southern Central Agricultural Society to Mrs. M. Gregg for Best Quilt."[111]

In 1851, sixty-two-year-old Catharine Maria Sedgwick (1789–1867) wrote to her niece, Katherine Maria Sedgwick Minot (1820–1880):, "It is good, as the burdens of age accumulate, to shake them all off; to change old, tiresome ideas for new ones; to take a world of fresh impressions; to fill the storehouse of imagination with new and beautiful images; to gain assurance to uncertain opinions; to verify old fancies; to throw off some of your old social burdens while you extend the social chain."[112] In the same spirit, aging women often embraced antebellum needlework innovations. They used their needlework to gain agency and to meld old traditions with new technologies. Tensions between the "old way" and the new could be expressed through material objects as they could not be in words. Needlework offered aging antebellum women the opportunity to be a model, to show the younger generation their skill, their achievements, and their idea of beauty. In turn, it offered an outlet for the nostalgia that must have bubbled up in these women as their families and communities grew and changed. Through their needlework, mature women maintained a connection to the past while also manipulating their future.

Above: Detail from Quilt by Euphemia Wilson Righter (1790–1873), 1850, Beaver Meadow, Pennsylvania. *Courtesy State Museum of Pennsylvania, Pennsylvania Historical and Museum Commission.*

The Technological Reshaping of Antebellum Needlework · 83

FIGURE 4.1. SAMPLER BY BETSEY MARIA AYER, 1835,
ST. JOHNSBURY, VERMONT.

Private collection. Courtesy of M. Finkel and Daughter,
Philadelphia, Pennsylvania.

Stitched text: *The Property of Betsey Maria Ayer: wrought by herself in the 12th year of her age:*
in A.D. 1835. St. Johnsbury, Vt.

Betsey Maria Ayer used the word *property* when she signed her sampler. She may have
been learning that her sampler was hers to do with as she saw fit. Girls made samplers to
practice stitching their initials. They would later use these letters to mark their household
textiles, signifying them as domestic property.

I GIVE AND BEQUEATH THIS QUILT

Needlework as Property

IN 1835, Betsey Maria Ayer of St. Johnsbury, Vermont, stitched a sampler that was fairly standard, save for one notable difference: her signature on the piece includes the phrase "Property of Betsey Maria Ayer wrought by herself in the 12th year of her age in A.D. 1835" (figure 4.1).[1] A second sampler, stitched around 1830, shows Quaker-style lettering.[2] Rather than a traditional signature with maker's name, date, and place, the maker simply stitched "Mary R. Dearborn's property" along the bottom (figure 4.2).[3] Considering these samplers from a material culture perspective suggests two interpretations of their unusual signatures. First, both samplers show the traditional style of a "marking sampler," made to teach a young girl how to stitch the letters of the alphabet so she will be able to mark her household textiles and clothing with her initials once she has a home and family of her own to look after (see figure 1.10). From a practical standpoint, marking initials on things signifies the ownership of property and protects that ownership. The marks

FIGURE 4.3. QUILT BY ABIGAIL REYNOLDS GREENE (1794–1889),
CIRCA 1820, RHODE ISLAND.

Photograph courtesy of Rhode Island Quilt Documentation Project, University of Rhode Island.

may have become part of the girl's dowry. Elizabeth Range was born in 1777 in Berkeley, Virginia. In 1798, she married Jacob Miller (1779–1858) in Washington, Tennessee. The couple had nine children. Mary Devault (1825–1889) was the oldest daughter of Elizabeth's oldest daughter, Mary Miller (1799–1859), who had married Daniel Devault (or DeWald) (1800–1886) in 1825. In her will, Elizabeth left her "grand daughter who now lives with [her], Mary Devault," her "Side Board, Desk, One half of [her] kitchen Furniture or kitchen utensils, one feather and one straw bed, bed stead, and well furnished with suitable bed clothing for same, also [her] quilted quilt of the pattern known and called 'Rose of Sharon.'"[14] To outsiders, these items demonstrated the family's full web of kin relationships.[15] For the bride, they allowed her to remember her birth family's history and to preserve her personal identity.

The quilt that forty-seven-year-old Catherine Penniman Bradford (1778–1827) made for her daughter, Catherine Ann (b. 1802), when she married in 1825 fulfilled this role.[16] Catherine Ann Penniman, the quilt maker, was born on November 5, 1778, in Braintree, Massachusetts, the daughter of William Penniman and Rebecca Edmunds Penniman. Her father was a well-known shipbuilder. In 1793, when she was fifteen, Catherine married Charles Bradford, a sea captain. The couple had one child in 1802, Catherine Ann Bradford, the quilt recipient. She married Seraphim Masi in November 1825.[17] Made from hundreds of silk triangles, the quilt has an embroidered central medallion that was brought from England by the bride's father, sea captain Charles Bradford (1767–1823).[18] Because Captain Bradford died two years before his daughter married and her mother died two years after the wedding, the quilt must have been a precious keepsake for young Catherine, allowing her to keep memories of her mother and her father nearby. Transformed into an heirloom almost immediately, the quilt has passed to seven Catherines since 1825.[19] Wedding gifts, such as Catherine Bradford's silk quilt, provided women with a model for giving gifts as they aged, suggesting the meaning that textiles and other moveables could hold, as well as putting the means for creating a gift within their grasp. Once learned, this lesson carried through the woman's life cycle to any bequests she might make.

Most women of the antebellum period recognized that they were not positioned to be able to pass on significant amounts of land or cash. Even a woman as well off as Eleanor Parke (Custis) Lewis (1779–1852), adopted granddaughter of George Washington (1732–1799) (figure 4.4), wrote in 1825, when she was forty-six, that she would give her daughter "half of the only property in my power 600 acres of Kenahwa Land—not of much value at this time, if ever."[20] In addition to this one reference to a gift of land, Lewis frequently wrote about needlework gifts she was making to present to friends and family as tokens of her love.[21] Her gifts took many forms: in March 1821, for example, she sent a watch bag and a pincushion, partially made from "Grandmama's wedding petticoat when she married the Genl," along with four pairs of "cambrick cuffs," to her lifelong friend Elizabeth Bordley Gibson (1777–1863); and in December 1824, she wrote about painting a pair of fire screens to give to the Marquis de Lafayette (1757–1834).[22] During the 1840s and 1850s, she set about completing needlework wall hangings and stool and piano covers so that each of her fourteen grandchildren would have a sample of her needlework after her death.[23] "I am at work on a screen for my darling Conrad Lewis, nine years old," Lewis reported to Bordley in December 1848. "Every winter I work a large piece for one of my Grandchildren, I wish I could show them to you."[24]

Eleanor's older sister, Eliza Parke Custis (1776–1832), seems to have had similar feelings about her own needlework. In 1815, thirty-nine-year-old Eliza added two borders of printed fabric to a quilt her adoptive grandmother, Martha Dandridge Washington (1732–1802), had started shortly before her death (figure 4.5).[25] She later inscribed the quilt: "This Quilt was entirely the work of my grandmother as far as the plain borders. I finished it in 1815 and leave it to my Rosebud [her daughter, Eliza Law (1797–1822)]. E. P. Custis."[26]

Unfortunately, Eliza's words leave little conclusive evidence about her motives. The unfinished quilt top had apparently been laid aside for at least thirteen years (since Martha Washington died in 1802) before Eliza took it up and added the two outer borders. And while Eliza explained in her note that she "finished it in 1815," she also recorded that she *left* it to her daughter, presumably at some future

FIGURE 4.4. PORTRAIT OF ELEANOR PARKE CUSTIS LEWIS (1779–1852)
BY GILBERT STUART (1755–1828), 1804, WASHINGTON, DC.

Courtesy of the National Gallery of Art, Washington, DC.

FIGURE 4.5. QUILT BY MARTHA DANDRIDGE WASHINGTON (1732–1802)
AND ELIZA PARKE CUSTIS (1776–1832),
COMPLETED IN 1815, VIRGINIA.

Courtesy of the National Museum of American History, Smithsonian Institution, Washington, DC.

In 1815, Eliza Parke Custis added borders to this quilt top, which was begun by her grandmother, Martha Washington. Custis then inscribed a note on the quilt stating her intention to leave it to her daughter, Eliza Law.

time, rather than giving it to her in 1815, suggesting that by adding to the quilt, it became hers, rather than solely Martha Washington's. Eliza's daughter was only five when her great-grandmother died and would have had few memories of the woman, despite her historical stature, yet undoubtedly would have treasured the quilt, which represented her mother's work as well.

What motivated the elder Eliza to add to the top? One of the most notable national events of 1815 was the end of the War of 1812. Perhaps the end of the hostilities led her to pick up the quilt once again. After all, the first stitch extended Martha Washington's needlework across four generations —that which was started by the wife of the first president came to rest with a young woman who celebrated a second American victory over the British. As women, both Eleanor and Eliza Parke Custis used tools and materials available to make gifts that would retain family value and remind their descendants about their lives and achievements, as well as those of their grandmothers and great-grandmothers.[27]

English-born Esther Johnson Parkinson Slater (1778–1859) did the same. When she updated her will in 1857, she included numerous bequests to family, servants, and local organizations. While Slater was unusual in that she had a significant estate of almost fourteen thousand dollars, including property and cash, allowing for a two-thousand-dollar bequest to the Domestic and Foreign Missionary Society of the Protestant Episcopal Church for "the support of Foreign Missions," she included heartfelt gifts of her own needlework as well. One of her stepsons received "three pieces of work that hang in the South Parlor."[28] Esther Slater clearly felt a responsibility to care for those around her, financially and emotionally, and used all of the means at her disposal to do so, whether cash, furniture, or needlework.

Several of the quilts identified in this study remain extant because they were specifically bequeathed along a female line, such as the one passed down through eight generations of Catherines. Mary "Betsey" Totten Polhemus Williams (1781–1861) made a spectacular Rising Sun (or Star of Bethlehem) quilt when she was in her mid-forties or early fifties (figure 4.6). Born in Staten Island, New York, Totten was the daughter of Gilbert Totten (1741–1819) and Mary Butler Totten (b. 1739). She married twice, first to Joseph Polhemus (b. 1762) in 1821 when she was forty and then to Matthew Williams (b. 1780) in 1828 when she was forty-seven.[29] The center of the quilt is an eight-point star pieced from 648 diamonds. Appliquéd flowers and birds fill the spaces between the star's points. The printed cottons in the quilt indicate that Totten must have made it during the early 1830s, after her second marriage in 1828. Regardless, she marked the quilt on the front at a bottom corner with red cross-stitched initials, "BT."[30] Although married twice, Betsy Totten Polhemus Williams labeled the quilt with the initials of her birth name, an indication of her identification with her own family.

When she died childless at the age of eighty-one, Totten bequeathed the quilt to her sister's granddaughter, Rachel Drake (b. 1833), who was then twenty-eight. In her will, Totten described her quilt as "my large spread called the Rising Sun." It was the first item she mentioned after payment of her "lawful debts."[31] Not only is the enumeration of a quilt unusual in a will, its placement as the first bequest is also noteworthy. Representing family connections, cultural traditions, and Betsy Totten's personal pride, her quilt provides documentation of the role that quilts played when given as gifts by older women to friends and family.

While it is well documented that antebellum Americans used the transfer of land from father to

FIGURE 4.6. QUILT BY MARY (BETSEY) TOTTEN POLHEMUS WILLIAMS (1781–1861),
CIRCA 1830, STATEN ISLAND, NEW YORK.

Courtesy of the National Museum of American History, Smithsonian Institution, Washington, DC.

Mary Totten Polhemus Williams made at least three quilts using the Rising Sun pattern seen here. She bequeathed this one to a grandniece and gave a second to a niece for her wedding.

FIGURE 4.7. QUILT BY SARAH WADSWORTH MAHAN (1802–1885), 1851, OHIO.

Allen Memorial Art Museum, Oberlin College, Ohio; Special Acquisitions Fund and Gift of Private Donors, 1985. 24.

Sarah Wadsworth Mahan completed this quilt, which was started by her fourteen-year-old stepdaughter, after the girl's premature death.

son in an attempt to "anchor each family member to the community through property arrangements that reinforced patriarchal authority within households," this is just one side of the property equation.[32] Certain types of moveables, including quilts and samplers made and distributed by female family members, provided a comparable structure to maintain family and community ties among women.[33] These two types of property—land and moveables —had an important relationship to one another based, in part, on their gender associations. In short, neither was complete without the other. Just as men felt a responsibility to pass on land to their sons to maintain the family name, women seem to have felt the same responsibility to maintain family traditions and history, with an eye toward helping subsequent generations of female relations. Artist Ruth Henshaw Bascom (1772–1848) made her feelings known in her 1841 will: "If I leave any property at my decease, it may eventually descend to such of my female relatives, to whom it would be most beneficial—for their own personal use & under

their sole control."[34] The textiles women received as their dowry, those they made as gifts, and those named in female-to-female bequests became family heirlooms that were used to bind the generations together.

When forty-nine-year-old Sarah Wadsworth Mahan (1802–1885) completed a quilt in 1851 (figure 4.7), she attached a written inscription (figure 4.8) to the quilt top, making her wishes for its future ownership clear: "This quilt, commenced by our dear Laura & finished by me, principally from fragments of her dresses, I give & bequeath unto her sister Julia M. Woodruff, or in case of her death to her sister Hila M. Hall, if she survives, otherwise to the oldest surviving granddaughter of their father, Artemas Mahan deceased."[35] Far more than a warm bed covering, this quilt was a legacy intended to join a shattered family together and to be a sentimental object for its maker and her family. Initially started by fourteen-year-old Laura Mahan (1834–1848), the quilt was unfinished when she died in 1848. Laura's stepmother, Sarah Wadsworth, married

Laura's father, Artemas Mahan (b. 1790–1800; d. circa 1843), when Laura was a small child. The loss of her stepdaughter, just five years after the death of her husband, must have hit Sarah hard. Laura was the last child living at home with Sarah in Oberlin, Ohio, for her sisters, Hila (b. 1821) and Julia, had married in 1839 and 1847, respectively. Both Laura and Sarah attended classes at the Oberlin Collegiate Institute, then under the presidency of Artemas's brother, Asa Mahan (1799–1889).[36]

As Sarah explained in the inscription, she used scraps from Laura's dresses to finish the quilt. She then asked forty-four friends and relatives to sign quilt blocks in 1850 and 1851. In 1851, around the time she completed the quilt and made her intentions about its future ownership known, Sarah took a teaching job in Minnesota. The quilt represented numerous important connections for her—and was a valuable keepsake linking her to family and friends both living and dead.[37] Despite her specific instructions for the future ownership of the quilt, it actually descended through women in her own family. Mahan's inscription sent the quilt to her stepdaughters (Laura Mahan's older sisters), Julia Mahan Woodruff and then Hila Mahan Hall, and then to the oldest surviving granddaughter of Sarah's husband and Laura's father, Artemas Mahan.[38] Instead, the quilt first went to Sarah Judson Wadsworth (1831–1908), the wife of quilt-maker Sarah's nephew Edward Payson Wadsworth (b. 1830). The couple had no children, so the quilt next went to their niece, Sarah Wadsworth Getchell (1855–1939). Finally, the quilt was transferred to Sarah Wadsworth Getchell's granddaughter, Josephine.[39]

Sarah Wadsworth Mahan's circumstances regarding property ownership were somewhat different from those of many of the other women mentioned here. She was a widow when she made

the quilt and wrote the bequest, which gave her more control over her belongings than most married women had. In addition, Michigan, where Sarah and Artemas Mahan lived before he died, passed a Married Woman's Property Act in 1844, the year after Artemas died. Her husband's estate, predating the property legislation, was in litigation until 1848, giving Sarah a particularly personal understanding of the transfer of property from one person to another.[40] Her experience with her husband's estate may have encouraged her to write out her intentions for the quilt and to state specifically what should happen if one of her intended beneficiaries should die.

Gifts of needlework—whether part of a dowry, as a bequest, or expressing celebratory spirit—are particularly salient examples of women's property ownership patterns during the early nineteenth century because textiles were at the heart of women's inheritances from the seventeenth century on. Textiles, including decorative needlework such as samplers and quilts, provided a well-understood lexicon for women to express themselves, not only in terms of their personal beliefs and opinions but also in terms of their social position, including the material property that they owned.

A group of quilts related to the Scattergood-Savery family of Philadelphia demonstrates how the maternal line used quilts to maintain its own inheritance pattern while also reflecting the social position of their maker. Rebecca Scattergood Savery (1770–1855) was part of two prominent Quaker families in Pennsylvania and New Jersey. Her own family arrived in America during the late 1600s, with many of the Scattergood men subsequently making their living as seafaring merchants. Her husband's father, William Savery (1722–1787), arrived in the colonies around 1740 and became a premier Philadelphia fur-

niture maker. Rebecca Scattergood married Thomas Savery (1751–1819), a carpenter-builder, in 1791 when she was twenty-one years old. The couple raised five children.[41]

In the 1820s and 1830s, after her husband's death, when Rebecca was in her fifties and sixties, she made at least five quilts for her children and grandchildren.[42] Three of the quilts are in the Sunburst pattern, created by stitching thousands of small diamond shapes in rows to make a vibrant quilt top. The earliest of the three dates to 1827, according to family history, and contains a staggering 6,700 pieces (figure 4.9). It was made for Rebecca's daughter Elizabeth (1806–1860) when she became engaged to James Cresson (1806–1872).[43] Unfortunately, when a theological dispute divided the Society of Friends around the same time, the Savery and Cresson families took different sides, and family history suggests that Elizabeth's family subsequently prohibited her marriage. Elizabeth received the quilt, but she never, in fact, married and later passed the quilt on to her namesake niece, Elizabeth L. Savery (1852–1936).[44]

Rebecca made a second Sunburst quilt in the late 1830s, when she was in her late sixties; this quilt was handed down in the family of her granddaughter, and namesake, Rebecca Walter Savery (1836–1902), the only daughter of quilt-maker Rebecca's son William (1798–1858). Like the first Sunburst quilt, this one is made from thousands of pieces —about 2,900.[45] These quilts are made using an English piecing technique, often called Mosaic or Honeycomb. The fabric was basted around paper templates, and then each diamond was whipstitched to the one next to it. After they were joined, the paper patterns were removed. Thought to be the earliest piecing technique used in American quilts, template piecing allows for smooth, uniform pieces

across the entire quilt top.[46] This older technique experienced a resurgence during the 1830s; however, Rebecca Scattergood Savery probably learned the technique as a young girl in the 1780s.

The fabrics in the quilts are good-quality roller-printed cottons, some with a glaze, adding a shine to their finish.[47] Rebecca Scattergood Savery's quilts not only have a stunning arrangement of color and pattern but also are breathtaking by virtue of the sheer amount of work needed to complete each top. As she assembled thousands of small pieces of fabric, Rebecca transmitted messages to her children and grandchildren. She showed that she could afford to use stylish fabrics and demonstrated her fluency with the fashion of the time. As discussed in chapter 3, the explosion in availability of colorful, patterned roller-printed fabrics in the 1820s inspired a vogue for bright, exuberant quilts pieced with multiple fabrics.[48] Savery's Sunburst quilts contain English, and possibly some American, roller prints from the late 1830s, suggesting that she bought the most recently available fabrics expressly to make her quilts.[49] She did not use older fabrics that she already had on hand or recycle scraps from old clothing and household textiles. Her Sunburst quilts are also very large, measuring nine and ten feet square, requiring much time to cut out thousands of diamond-shaped pieces.

Rebecca's third Sunburst quilt was made in 1839, when she was sixty-nine years old, for another granddaughter, Sarah Savery (b. 1839), the daughter of her son Thomas (1802–1860). This quilt, made with over 3,900 pieces, afterwards passed from mother to daughter for five generations. Subsequent owner Hannah Savery Mellor (b. 1872), the daughter of the original recipient, stitched the following note to the back: "This quilt was made for Mother by my great-grandmother, Rebecca Scattergood

FIGURE 4.9. QUILT BY REBECCA SCATTERGOOD SAVERY (1770–1855),
1827, PHILADELPHIA, PENNSYLVANIA.

Courtesy of Winterthur Museum and Country Estate, Delaware.

Rebecca Scattergood Savery made three of these quilts, each one with thousands of small diamonds stitched to-gether. She gave them to family members who subsequently passed them down as family treasures.

Savery, 1839."[50] These three quilts reflect inheritance patterns that were maintained for generations and were valued by Rebecca, her daughters, and her granddaughters. The quilts passed directly from woman to woman; they were a legacy that Rebecca could provide, just as her husband provided land and cash for his sons.

As Laurel Thatcher Ulrich has argued, women used property to "assert identities, build alliances, and reweave family bonds torn by marriage, death or migration."[51] Quilt scholar Laurel Horton believes that "quilts functioned as a kind of currency in an informal, female-centered economy based on kinship, mutual support, and the transformation of ordinary materials into objects of significance and value."[52] Giving a quilt as a gift was an exchange of property, but this was only part of the value that the gift held for giver and recipient. These gifts also held social and cultural value for those involved. Needlework gifts were far more than fabric and thread, and they provided more than just physical and emotional comfort and warmth. These objects created "cultural memory"[53]—allowing their givers to express nostalgia, remember the past, and influence the memories of their descendants.

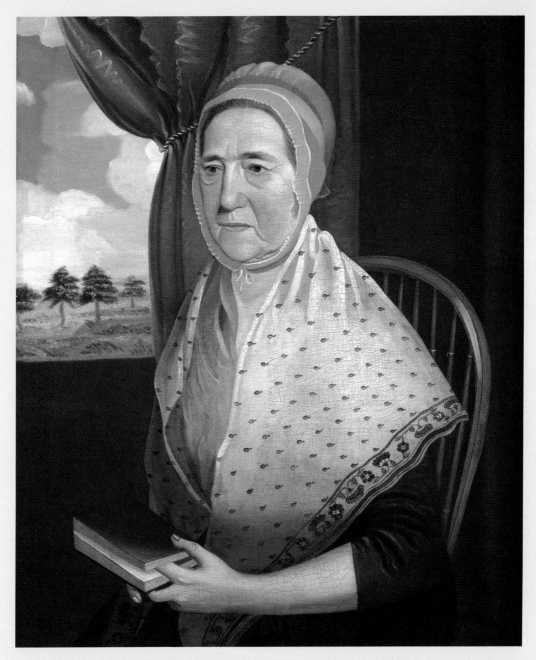

FIGURE 5.1. PORTRAIT OF AMELIA HEISKELL LAUCK (1760–1842)
BY JACOB FRYMIRE (1770–1822), 1801, VIRGINIA.

Courtesy of the Museum of Early Southern Decorative Arts (MESDA), Old Salem Museums and Gardens.

Amelia Heiskell Lauck made three similar quilts, all of which she signed in the quilting and gave to her children. A fourth unsigned quilt has been attributed to Lauck because of its similarities in pattern and construction. It may likewise have been a gift to one of her children.

5
FAMILY CURRENCY

The Gift Needlework of Aging Women

IN 1823, sixty-two-year-old Amelia Heiskell Lauck (1760–1842) (figure 5.1) completed what was at least her second quilt in two years as a gift for one of her six surviving children, Rebecca Lauck Cunningham (1787–1858).[1] Amid the quilted designs is a signature reading "Made by Amelia Lauck in the 62 year of her age April 15th 1823." The center, or medallion, of the quilt has a floral design applied in chintz appliqué (also known today as *broderie perse* or cut-out chintz) (figure 5.2). Lauck thoughtfully cut out colorful floral motifs from a chintz fabric and arranged them to suit her own taste on the white ground fabric. She then pieced three borders in a pattern of red and white printed cotton (now often called Delectable Mountains[2]) and alternated plain white borders where she could quilt fancy motifs. Lauck's quilting skill was masterful. The quilt shows nine stitches to the inch with elaborate motifs including parallel lines, clamshells, feathers, and floral wreaths. She also quilted the initials of the recipients into the design. The quilt includes areas of stuffed work,

a popular antebellum technique in which small sections of the quilting are filled with cotton batting or other stuffing, adding dimension to the work. Lauck completed a second quilt around the same time and a third similar quilt by 1830 when she was about seventy, as well as a fourth at an undetermined time. Three of the quilts have a quilted signature documenting Lauck's work and making clear that these quilts were gifts from Lauck to her children (figure 5.2).

Lauck's quilts remind us of one reason that aging women picked up their needles during the antebellum period. She used her needlework as "family currency"[3]—giving a small piece of herself to her children so she could continue to have a presence in their lives as they married and started their own families and so they could remember the values she espoused, the skills she possessed, and the love and affection she felt for them. A letter written by forty-three-year-old Ann Gillam Storrow (1784–1856) suggests that gifts could function as a stand-in for their maker when she was unable to be physically present. In an 1827 letter to her friend, historian Jared Sparks (1789–1866), Ann wrote, "Mementoes are I know rather useless things to those who can remember their friends without, but I shall feel very much pleased if you will put my 'persevere' pencil case into your pocket and use it while you are absent. I shall then have the gratification of thinking that I can be associated with something that is useful to you."[4]

Anthropologists have studied the act of gift giving and the meaning of the gift for decades, ever since Marcel Mauss's seminal work, *The Gift,* was first published in 1950.[5] Mauss made the point that a gift is more than just an object and that the act of giving is rarely purely altruistic.[6] Subsequent scholars have expanded this analysis, suggesting that gifts have a particular relationship to and meaning for women.[7] Micaela Di Leonardo asserted that "kin work" arose with the "cult of domesticity" during the eighteenth and nineteenth centuries, defining it as the "conception, maintenance and ritual celebration of cross-household kin ties[;] . . . the organization of holiday gatherings; the creation and maintenance of quasi-kin relations; decisions to neglect or to intensify particular ties; the mental work of reflection about all these activities; and the creation and communication of altering images of family and kin."[8] Indeed giving gifts seems to have been a vital part of a woman's life cycle and caretaking duties, only becoming more so as she aged. This is borne out in an 1847 letter, when sixty-eight-year-old Eleanor Parke Custis Lewis (1779–1852) explained that she was "busily engaged in worsted work, a screen . . . for my granddaughter Caroline. It is very tedious but I shall not leave it until completed." Lewis went on to explain that she never left the house "except to church. See the occupations of a *Grandmother*."[9]

Anthropologist Aafke E. Komter stated that giving gifts creates and maintains social ties. She described women as "kin keepers," socially and culturally expected to maintain the family's social relationships and to remember birthdays, weddings, and other important occasions.[10] According to Di Leonardo, these activities, which brought women together in "kin-centered networks," also served as "sources of women's autonomous power and . . . sites of emotional fulfillment, and, at times, as the vehicles for actual survival and/or political resistance."[11] The gifts given by mature women of the antebellum era could be seen as a means of coping with their changing environment. As their society industrialized and urbanized, the family was no longer the basic economic unit, and not all family

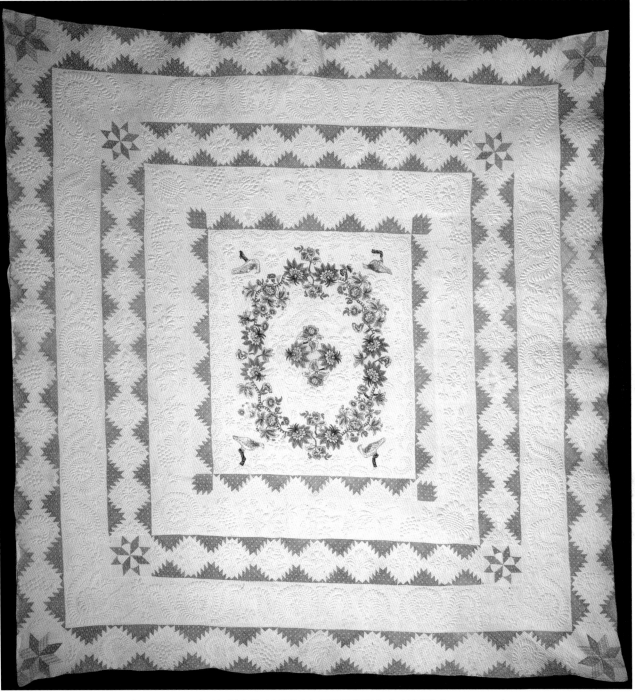

FIGURE 5.2. QUILT BY AMELIA HEISKELL LAUCK (1760–1842),
CIRCA 1822, WINCHESTER, VIRGINIA.

The Daughters of the American Revolution Museum, Washington, DC. Gift of Anne Arundel Chapter, NSDAR.

members remained in the same tight geographical area. They sought to maintain relationships and to stay connected over longer distances. Giving a gift was one way to accomplish this.[12]

Needlework gifts from mature female family members were not unusual during the nineteenth century, and they offer an opportunity to explore the motives behind them as well as the social and cultural roles that quilts, samplers, and other needlework played for women during the antebellum decades. Using needlework as gifts continued a long tradition stretching back to the seventeenth and eighteenth centuries. Museum collections include numerous Irish-stitch pocketbooks, knitted purses, and bead chains that expressed the love and esteem of their makers, complete with histories that identify them as gifts.[13] A socially sanctioned activity, needlework was considered not only appropriate but also proper and uplifting. The gift of needlework set a cultural example for younger generations of women by teaching important skills, reminding them of their history, and attempting to preserve moral order during what was often perceived as an unsettled time. In addition, for aging women who felt nostalgic—or yearned for the past—giving needlework that reflected dated styles and techniques could have been a way for them to prolong a connection to their girlhood.

Although the anthropological literature has advanced our understanding of gift exchange and the gift-giving impulse, historical and material culture analysis of gifts lags behind. Many textile historians make statements about gift needlework as if they were obvious, restating "traditional" ideas without pausing to document their sources. Still other books make broad statements about gift needlework without providing detailed contexts for their sources. These works illustrate the need for a more rigorous examination of gift quilts and their family histories,

which will ultimately enlarge our understanding of American quilt making, as well as of women's lives and their experiences. As quilt scholar Virginia Gunn asserted almost twenty years ago, "If scholars are not careful, and if they do not recognize myths for what they are, the body of 'false beliefs' accepted as valid can color historical analysis and interpretation."[14] Undocumented family stories, often the only source about a quilt's history, are useful but must be considered carefully in conjunction with the quilts themselves. Do the fabrics, pattern, and construction of the quilt correspond with the dates of the people and events of the family story?

Many previous quilt studies give rise to another common misconception: that gift quilts were typically wedding gifts. In an example of this sort of overgeneralization, a study of West Virginia quilts states, "Gift quilts are most often associated with marriage, given in wedding celebration."[15] The romanticism is appealing: this idea intertwines the tradition of quilting with a sense of warmth and maternal instinct. What better gift to give one's child than a soft, warm bedcover—in a sense, allowing the mother's arms to hug her children each night as they slept despite their removal to a home of their own. But is this true? Or is this simply an appealing and tempting explanation, much like the one that swirls around many heirloom family dresses from the eighteenth and nineteenth centuries, which are assumed to be wedding dresses? The West Virginia study would be more accurate if it explained that *in that particular study,* gift quilts were *most often* associated with marriage, if that is the case, and to add information on how many such quilts were located.

Nevertheless, quilts given as gifts—because they tended to be more elaborate than everyday quilts, and because of their sentimental overtones—do seem to survive in disproportionate numbers, at least among museum collections. Among the 167

needlework artifacts located for this study (see appendix), 55 either were inscribed as gifts or have been passed down with specific family stories describing them as gifts. Of the 55 identified gifts, 53 are quilts, and they serve as the primary sources for this chapter.[16] According to the family information preserved with the quilts, all were given by older makers to younger recipients. Almost half of these gift quilts were given by the maker to her daughter (14) or her granddaughter (10); 7 were given to a son; 3 to a grandson; and the remaining 19 were spread among nieces, great-granddaughters, great-nieces, a daughter-in-law, a stepdaughter, and non–blood relations. The 53 quilts were made by thirty-six women. Six of these makers were from New England, four lived in the Midwest, nine makers were from mid-Atlantic states, fifteen makers lived in the southeastern United States, one lived in the West, and for one the state could not be determined.[17] This group of artifacts provides a base for a reconsideration of gift quilts.

Of the 53 gift quilts located for this study, only 15—far fewer than half of them—are identified as wedding gifts. This may reflect the fact that many of the quilts associated with a wedding were made by the bride (either alone or in a group), rather than given to her as a gift. For example, an Ohio quilt documentation project found that half of the wedding quilts documented were made entirely by brides, while the other half were made by relatives.[18] In her study of the pre-1860 diaries of New England quilters, Lynn A. Bonfield noted "the absence of explicit references to wedding or bridal quilts," explaining that while quilting activity often increased around the time of a wedding, "there does not seem to have been a tradition of describing these quilts in such terms."[19]

In this survey, several of the quilts were given to commemorate a birth, while others have no clear-cut occasion associated with the gift. Among this group of gift quilts, only 5 of the 15 quilts with a family history of functioning as a marriage gift have strong evidence to support the family story.[20] The other ten are identified as wedding gifts only through family tradition and/or oral history. This suggests that a quilt given around the time of a wedding was not necessarily a gift *for* the wedding but perhaps served another purpose for its maker, such as maintaining connections and traditions and preserving memories of the bride's relationship to her birth family. Of the remaining 38 gift quilts identified here, 16 were gifts at birth, 3 were bequests, 1 was for a child's eighth birthday, and 18 were given for unspecified or unidentified events.

In view of these numbers, the quilts made by Amelia Heiskell Lauck for her children can perhaps be analyzed and understood in a new way. Amelia Heiskell was born in 1760 in Winchester, Virginia, the daughter of Christopher Heiskell (1721–1808) and Eve Fitzgerald Heiskell (1730–1788). Amelia's father was a property owner in Winchester and a member of the Lutheran church. The family would eventually include six children; Amelia was the second born. In 1779, at the age of nineteen, she married Peter Lauck (1753–1849). Peter Lauck was born in Pennsylvania but moved to Virginia with his family and served in the militia there during the Revolutionary War. After the war, he became proprietor of the Red Lion Inn in Winchester, Virginia, joined the local church, served as county constable in 1781, and was a commissioner for the Farmers Bank of Virginia and a founder of the Friendship Fire Company. He was also a Freemason, serving as Master of Hiram Lodge in 1807.[21] Peter and Amelia Lauck had eleven children; six survived to adulthood. Of the four quilts that Amelia made that are extant today, three are marked with information documenting the recipients and the maker. Her son Morgan

(1796–1828) received his quilt around the time of his marriage to Ann Maria Ott (1804–1872) in 1824; it is marked with the maker's name and age, along with the names of the recipients.[22] Her daughter, Rebecca (1787–1858), and son-in-law, John Cunningham (b. 1764), received theirs in April 1823, more than fifteen years after their marriage; it is marked with the maker's name and age, the date of the gift, and the initials of the recipients.[23] Amelia's son William (1805–1875) and his wife, Eliza Jane Sowers (1812–1872), got their quilt at an unspecified time, perhaps when they married in 1830; their quilt's inscription includes their initials and the words "presented by their mother" (figure 5.3).[24]

Lauck's other three surviving children, sons Samuel (b. 1790), Isaac (1793–1851), and Joseph (b. 1799), also married, and it is likely that the fourth quilt, attributed to Amelia Heiskell Lauck but unsigned and unlabeled, was originally given to one of these men. Samuel married in 1816 and Isaac in 1814, while Joseph married in 1825. Joseph's wedding, which was close in time to two of the other three children's marriages, could be the occasion for the gift of the fourth quilt, which employs the same pattern, techniques, and fabric. However, the fact that this quilt does not have an inscription suggests that it could have been the first of the four made by Lauck. She may not have initially thought to sign her work, but as she began to give her quilts to her children, she may have wanted to commemorate the occasion and started signing them. The fourth quilt was found in Winchester, Virginia; the fact that Samuel Lauck was the only child to remain in that town provides evidence that this quilt was initially given to him, perhaps when he married in 1816.[25] The quilts served a function for the maker and the recipients, those related by marriage as well as by blood. For Lauck, her quilts were a means of

expression of her skill and her love. With the quilts she made a tangible connection to her new son- and daughters-in-law, drawing them into her family, while also introducing herself into their lives. For her children, the quilts prolonged her involvement in their lives, providing a stand-in for herself, her influence, and her love.

While maternal affection was part of what compelled women to make quilts for their children and grandchildren, gift quilts were not purely altruistic. Quilts, and other needlework, were culturally intertwined with women's moral codes and their place in the household during the first half of the nineteenth century. Needlework was a way for a woman to express her identity, her artistic sensibilities, and her opinions about the changes taking place around her. Women whose children and grandchildren were born and got married between 1820 and 1860 had themselves grown up and been educated during and shortly after the American Revolution. They were encouraged to raise their children to be models of Republican virtue and to represent cherished values of industry, morality, and benevolence themselves.[26]

Terri Premo's survey of diaries and letters written by aging women between 1785 and 1835 found that older women saw it as their role to serve as living reminders of the moral code. They believed they needed to carry the achievements of the Revolutionary era forward.[27] Giving gifts was a material extension of this role: older women could pass on an actual physical manifestation of their moral code. They could also pass on important feminine knowledge through sewing and quilting lessons. But in the 1820s, some of their daughters and granddaughters were starting to follow different paths; for example, some found work outside the home—even working in textile factories. Gifts embedded

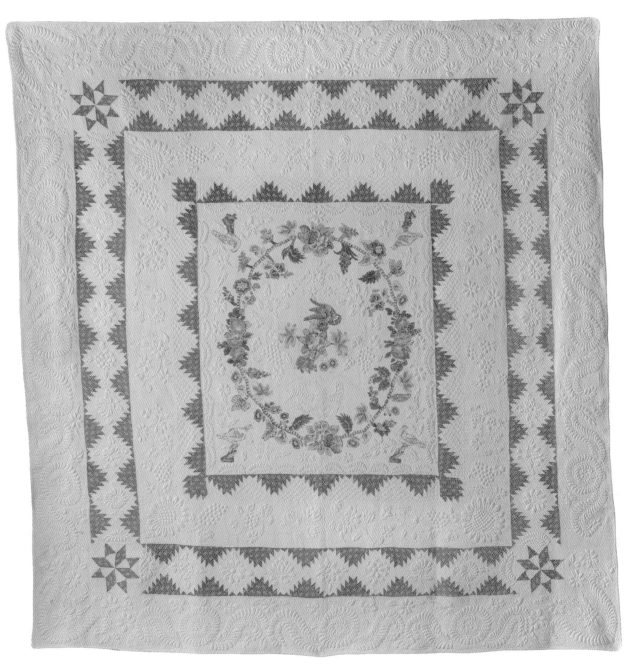

FIGURE 5.3. QUILT BY AMELIA HEISKELL LAUCK (1760–1842),
POSSIBLY CIRCA 1830, WINCHESTER, VIRGINIA.

The Daughters of the American Revolution Museum, Washington, DC. Gift of Sally Ann Lauck Harris.

This quilt was made by Amelia Heiskell Lauck for her son William and his wife, Eliza Jane Sowers. She may have made it around the time of their wedding in 1830.

their recipients in traditions that mitigated the effects of change. Giving a quilt was a way to remind the recipient of woman's proper social role, as well as of the giver's skill with the needle. The quilt could remind the recipient of a certain style or fashion, considered genteel and appropriate by the giver. These gifts also undoubtedly allowed their makers some sense of self-satisfaction—providing an opportunity to express creativity, try out new colors, materials and patterns, and revel in the joy of creating something pretty.

"The Productions of Our Own Industry":[28] The Social Nature of Gifts

While the gifts of needlework discussed here were made by a single person and given to another, they also provided a connection to a larger social matrix of family members and friends and, as such, held meaning and value for that larger community. Society prescribed certain rules around the act of giving gifts, which formed a context for the women who made quilts and then presented them to another person. These needlework gifts provided a means for women to perform one of their most important societal roles—that of maintaining connections between what could be disparate branches of the family tree. For aging women of the antebellum era, this task seems to have increased in importance and urgency as they grew older. Aging women could employ textiles as a badge of their femininity, using them to express their fears, their love and affection, and their opinions.

A group of quilts made by Anna Catharine Hummel Markey Garnhart (1773–1860) while in her forties and fifties bound together generations across long distances (figure 5.4). Known as Catharine,

Garnhart was born on April 27, 1773, in Frederick, Maryland. Her mother, Christiana Catharine Grundler (b. 1747), was German and came to America with her family when she was seven. Christiana married John Hummel (1751–1781), who died in 1781 when Catharine was only eight years old. Christiana later married Johann Fiege (1755–1829), a Hessian soldier who came to the colonies to fight in the Revolutionary War. When the war was over, he stayed in Maryland and purchased a gristmill. Quilt-maker Catharine Hummel married John Markey (1771–1820) in 1796 when she was twenty-three. Together they had three children. After Markey died in 1820, Catharine married again, this time to Henry Garnhart (d. 1825), but the marriage does not seem to have been happy. Catharine and Henry lived together only a short time, and he died in Charlestown, Virginia, in 1825; thirty-five years later, she was buried next to her first husband in Maryland. Catharine amassed a substantial amount of property during her life. She inherited land and moveable goods from her father as his only surviving child and may have inherited from her mother too.[29]

Eleven of her quilts have been located from Florida to Oklahoma, turning up 150 years later in families who had no knowledge that related quilts had descended through other lines.[30] Married twice, with three children, Garnhart had eleven grandchildren, suggesting that she made at least one quilt for each of them. Other quilts may yet reside with families who have lost touch with their extended relations, or the quilts may not have survived to the present. All of her extant quilts are appliquéd, many with flower baskets and five with eagles. Her great-granddaughter remembered that Catharine used quality materials to make her quilts: "The lining of the quilt," she recalled, "was 50 ct. a yard, the top was one dollar a yard and the thread she spun herself."[31]

FIGURE 5.4. PHOTOGRAPH OF ANNA CATHARINE HUMMEL MARKEY GARNHART (1773–1860), CIRCA 1850.

Courtesy of the Plains Indians and Pioneers Museum, Woodward, Oklahoma.

At the time, in the 1820s and 1830s, cheap printed cottons were available for as little as four or five cents a yard, while better-quality fabrics sold for twenty-five to fifty cents per yard.[32] Printed cottons priced at one dollar per yard may have been an exaggeration, a conflation of prices the great-granddaughter remembered, or an expression to signify that Garnhart used expensive cottons. Regardless, the quilts are made from good-quality fabrics and are still in good condition, suggesting that they were not used as bed coverings very often, if at all. Their primary function was not as utilitarian household objects.

Catharine made one of the quilts for her first grandchild, John David Markey (b. circa 1821), around the time of his birth when she was forty-eight.[33] In 1852, as an adult, John David Markey moved west to Iowa, Missouri, Oregon, and finally to Oklahoma, taking his grandmother's quilt with him each time he moved.[34] Catharine's second grandchild, Anna Markey (b. 1824), was the recipient of a bed-size quilt with a striking eagle design in the center (figure 5.5).[35] Although this quilt was given later, around 1824, Markey seems to have made it almost ten years earlier, around 1815, judging by the fabrics she used. In 1846, when the recipient was twenty-two, she reportedly quilted the piece herself.[36] According to family tradition, Garnhart based her central eagle on a similar motif on a Liverpool pitcher that was also passed down in the family.[37] None of Garnhart's quilts can be precisely dated; she did not sign any of them. Her choice to make eleven quilts using the same technique (cut-out chintz appliqué) and design motifs (eagles and flower baskets) implies that she enjoyed it, although she may have had other motivations, as well.

A third quilt shows Garnhart's flower-basket design (figure 5.6).[38] This one was given to her grandson, J. Henshaw Markey (1835–1899). While the two quilts described above seem to have been gifts at birth, this quilt dates to about 1850, when the recipient was fifteen.[39] The remaining eight quilts that are known today include five full-size quilts and three cradle quilts. Five show Garnhart's flower-basket design, and three employ her eagle motif. All of these quilts were passed down through multiple generations.

Perhaps part of what motivated women to give textiles as gifts was their participation in multiple families—one as a daughter, one as a wife, and eventually, several as a mother.[40] Keeping up with their role as "kin keeper" in these many families required antebellum women to maintain connections, as well as their own identity, even though their role changed in each situation. The quilt was a stand-in for the woman, a way to suggest taste and values without being there in person since, presumably, recipients thought of the maker every time they touched, saw, or used the quilt. In turn, the quilt could maintain the "kin-keeping" role of its maker, continuing to fulfill her responsibility to keep family history alive, even after the woman was gone.

These ideas are further illustrated by a group of three quilts associated with the Marion and Palmer families of South Carolina.[41] They visually represent their use by multiple generations, thus telling their own version of family history. Two of the three quilts recycle sections of older quilts. In the reuse of older techniques and fabrics, these quilts offered a way for the makers to transmit the values they cherished to the next generation and to remind following generations of family history.

However, family stories often confuse names and dates across generations. Memories lapse, causing family stories to conflate the path by which a quilt traveled from one generation to another. Gift

FIGURE 5.5. QUILT BY ANNA CATHARINE HUMMEL MARKEY GARNHART (1773–1860),
CIRCA 1815, FREDERICK, MARYLAND.

The Daughters of the American Revolution Museum, Washington, DC. Gift of Mary C. Buynitzky.

Anna Catharine Hummel Markey Garnhart made several quilts employing a similar eagle motif. It is thought to have been inspired by an eagle design on a Liverpool jug, which was also handed down in the family.

FIGURE 5.6. QUILT BY ANNA CATHARINE HUMMEL MARKEY GARNHART (1773–1860),
CIRCA 1850, FREDERICK, MARYLAND.

The Daughters of the American Revolution Museum, Washington, DC. Gift of Mr. and Mrs. Willard Markey.

Eleven quilts made by Anna Catharine Hummel Markey Garnhart are known, and it is thought that she gave one to each of her grandchildren. The central flower-basket design is common to several of the quilts. Garnhart cut out floral motifs from different fabrics and then created her own basket design on the quilt.

quilts must be closely examined, using the fabrics, patterns, and techniques to help date the quilt and to confirm or contest a beloved family story. As in the case of the quilts discussed here, sometimes even this method fails, underscoring the importance of careful consideration of all of the available evidence and of allowing for multiple interpretations.

Around 1830, forty-eight-year-old Harriet Kirk Marion (1782–1856) made a quilt by adding a new chintz border to an earlier piece of patchwork (figure 5.7). The center section is composed of pieced squares in an Irish Chain pattern variation made five to fifteen years earlier and shows signs of having been laundered. The chintz border, in contrast, retains its glaze, suggesting that it was added later and that the quilt was not subsequently washed. A later label on the back of the quilt states that it was made for Harriet's granddaughter and namesake, Harriet Marion Palmer, who was born in November 1830.[42]

The date of 1830 for the quilt is supported by the age of the chintz fabric used in the border, giving credence to the family's statement that the quilt was made to celebrate a birth that year. Genealogical sources confirm that the maker named on the label was alive at the time and could have made the quilt.[43] One quilt historian has suggested that the central section must have held value for its giver, enough that adding a fashionable border renewed the quilt's meaning when presented as a gift to the younger generation.[44] In this way, the quilt was transformed from an everyday bedcover into a family heirloom. The quilt can also be considered symbolically. Just as it brings together an older section and a newer fabric, so too the birth of a new generation carried forward the older generation, ensuring it a small piece of immortality. Harriet Marion Palmer was the third grandchild born to Harriet Kirk Marion, but her first namesake. And her first two grandchildren had died prior to the birth of

the third. The first, a grandson, died shortly before his second birthday in 1828, and the second, a granddaughter, died at nine months, just a few weeks before young Harriet was born in late November 1830.[45] This quilt may have enabled Marion to feel that she was watching over her new grandchild and namesake.

The quilt combines one of the oldest named patchwork patterns—Irish Chain—with crisp, printed chintz fabric.[46] Chintz quilts were particularly popular in the southern United States during the early nineteenth century, especially those made by appliquéing these colorful fabrics to a plain ground. Even when block-style quilts became popular during the mid-nineteenth century, chintz borders remained a frequent quilt component in the region.[47] One quilt scholar has noted that these borders represented a "compromise" for South Carolina quilt makers, "who still associated chintz fabrics with fine quilts . . . and found a way to adapt these fabrics to the changing styles."[48] As part of a well-to-do family, Harriet Kirk Marion used the fashionable chintz she was familiar with to make this quilt for her grandchild.

A second quilt from this same family was made for the same recipient (figure 5.8). In 1847, when she was in her early forties, Catherine Marion Palmer (1807–1895) made the quilt for her daughter, seventeen-year-old Harriet Marion Palmer.[49] This framed-center quilt employs the technique of chintz appliqué. Catherine Palmer cut out motifs from at least five different imported chintz fabrics and rearranged them to her own taste.[50] This technique has been described as "converting yardage into 'Swiss cheese' remnants"; she would have cut entire printed plant or bird motifs out of her fabric, rather than starting at the edge and cutting regular geometrical shapes such as squares or triangles and leaving the motifs to fall where they might.[51]

FIGURE 5.7. QUILT BY HARRIET KIRK MARION (1782–1856),
CIRCA 1830, SOUTH CAROLINA.

Collection of the Museum of Early Southern Decorative Arts, Old Salem Museums and Gardens.

Harriet Kirk Marion recycled the center section of this quilt from an older piece. She freshened up what is one of the oldest named patchwork patterns, Irish Chain, by adding a border of fashionable chintz fabric and gave the quilt to her granddaughter at birth.

FIGURE 5.8. QUILT BY CATHERINE MARION PALMER (1807–1895),
1847, SOUTH CAROLINA.

Collection of the Museum of Early Southern Decorative Arts, Old Salem Museums and Gardens.

Catherine Marion Palmer made this quilt for her daughter when the girl was about seventeen. She used the technique of chintz appliqué—cutting out the motifs from several different fabrics and rearranging them on her ground fabric—to make the central design. This technique was becoming dated by the late 1840s, so Palmer may have been trying to remind her daughter of what was fashionable when Catherine herself was a young woman.

Catherine's quilt has two inscriptions. Handwritten on the quilt is "Harriet M. Palmer from her mother." A later label is sewn to the back: "Quilt made by Catherine Marion Palmer Dwight St. John Berkeley SC 1847."[52] Like the quilt made by Harriet Kirk Marion, this quilt's fabrics support the date on the label, and the people named can be confirmed in genealogical records to have lived at that time. However, the occasion for this gift is unknown. Because this quilt was given by a mother to her oldest daughter as that daughter reached adulthood, Catherine and Harriet Palmer may have understood this quilt as a coming-of-age gift. Harriet Palmer did not marry until 1858, ten years after the quilt was made.[53] The technique used to make the quilt was extravagant in its use of fabric. It could allow the quilt maker to show her friends and family that she was in a financial position to follow this expensive fashion and that her daughter's dowry prospects were quite good.[54] However, by 1840, the popularity of chintz appliqué was starting to wane; Palmer's use of the technique may also be an example of a woman using an older quilt-making fashion to make a personal point.[55]

The third quilt from the extended Marion-Palmer family comprises template-pieced hexagons in a pattern known today as Stars and Honeycombs but known during the early and mid-nineteenth century as Honeycomb or Mosaic (figure 5.9).[56] Interlocking geometric motifs have a long history in architectural decoration. During the late eighteenth century, these mosaic patterns were re-created in patchwork in Europe and America, but they did not become common until the nineteenth century. In the 1830s, the pattern was popular enough to appear in the pages of *Godey's Lady's Book* when the magazine included an illustration of "Hexagon Patch-Work" complete with detailed instructions.[57] Like the other two quilts, this one also has a chintz border. The center section is quilted in a cross-hatched pattern, while the border is marked for the same pattern but is quilted in only one set of parallel lines.[58]

Various family members labeled the quilt at different times, provoking questions about its history. Written in ink on the quilt is "John G Palmer / from his Grandmother / Mother." John Palmer (b. 1807) and Catherine Marion had a son in 1841 and named him after his father.[59] If the quilt was given to John Jr., the grandmother in the inscription would be Harriet Kirk Marion, and the mother, Catherine Marion Palmer. There is a second inscription on a later label sewn to the back that offers similar information, reading, "Quilt made / by Harriet Kirk Marion / of St. Johns Berkeley S.C. / for her grand son / John Gendron Palmer / 1840 / Marked by Kate Palmer Logare / great granddaughter."[60] Although the date on this label does not match genealogical records, two published sources have attributed the quilt to Harriet Kirk Marion based on these inscriptions. The unfinished quilting in the border and the newer wool braid binding on the quilt have been interpreted to mean that Kate Palmer Logare worked on the quilt long after her great-grandmother died.[61]

However, an article published in early 2007 offered a different interpretation of the quilt.[62] Ignoring the later label sewn onto the quilt, the author holds that the quilt was *not* made by Harriet Kirk Marion. In this interpretation, the inked inscription on the quilt refers to John Gendron Palmer (b. 1807), who married Harriet Kirk Marion's daughter Catherine in 1830, and suggests that the makers were John's grandmother, Elizabeth Marion Porcher (1760–1796), and his mother, Elizabeth Catherine Porcher Palmer (1781–1841). In this case, Elizabeth Marion Porcher would have made the central section in the 1790s, and Elizabeth Catherine Porcher

FIGURE 5.9. QUILT BY HARRIET KIRK MARION (1782–1856), CIRCA 1840, OR
BY ELIZABETH MARION PORCHER (1760–1796) AND ELIZABETH CATHERINE PORCHER
PALMER (1781–1841), CIRCA 1790 AND CIRCA 1830, SOUTH CAROLINA.

Collection of the Museum of Early Southern Decorative Arts, Old Salem Museums and Gardens.

This quilt has a recycled center that has been freshened by the addition of a border of chintz. The maker of this
quilt is unknown; there is evidence that it might have been made around 1840 by Harriet Kirk Marion for her grand-
son, or in 1790 and 1830 by Elizabeth Marion Porcher and her daughter, Elizabeth Catherine Porcher Palmer, for the
child who was their grandson and son, respectively.

Palmer would have added the up-to-date chintz border around 1830 when she was in her forties.[63]

The 2007 interpretation is intriguing, as it sends the quilt from a maternal line to a son, but questions remain regarding the attribution of the pattern and the fabrics to this early date.[64] Whether this quilt was made by Harriet Kirk Marion around 1840 or by Elizabeth Porcher and Elizabeth Palmer in the 1790s and around 1830, it demonstrates how carefully gift quilts must be considered. Each of these three quilts represents at least two generations of design and use, documenting the multiple families to which each maker and recipient belonged. In her study of diaries and letters written by women during the early Republic, historian Terri Premo found that, for aging women, biological reproduction and the creation of art or literature reassured them that their lives would continue to influence some small part of the world after they left it.[65] The quilts of the Marion, Porcher, and Palmer families, as well as the others described here, function this way; they were created by women to give to their progeny, which made them talismans of family tradition. As forty-seven-year-old Eleanor Parke Lewis (1779–1852) explained in an 1826 letter to a friend, "My Grandchild is the object of my devoted affection. The Child of My Child, it excites even more interest than I should perhaps feel for my own, at its present age. . . . It is certain that the title of Grandmother is most dear to me & excites the most anxious & affect[ionat]e feelings."[66]

<center>❧ ❧</center>

All of the quilts considered in this chapter to this point have been gifts between members of the same family, whether through birth or by marriage. But two of the gift quilts located for this study were gifts between people who were *not* related by blood or marriage. What motivated those gifts? Did they operate under a different set of circumstances than family gifts? If so, did they represent different things than did family gifts? Recent anthropological studies suggest that the relationship between giver and recipient is what makes the gift, not the actual gift itself. "Even an ordinary object becomes unique when it is given as a gift," explains anthropologist James Carrier, "because it is marked by the tie that links the giver and recipient to each other and by the occasion of the gift."[67] Other anthropologists have found that gifts to friends do differ from gifts for family and that gifts "maintain traditional family structures, but they are creative acts that may be used as well to define new forms of relationships and to support emerging possibilities for social action."[68]

Period etiquette guides offer insight about the rituals of gift giving. Etiquette books prescribed rules of conduct to assist Americans with learning and showing good manners. And manners, like gifts, serve social functions: they constitute a subtle but pervasive system of social regulation or control; they generate feelings that help people assume their social roles; and they tell us about each other and about our place in the social order.[69] Antebellum etiquette manuals provided a guide to basic good manners regarding gifts: let the giver see that you appreciate the gift; thank the giver both verbally and with a short note; do not give the gift away to another person. The books agree on the common occasions when gifts were given: weddings, christenings, and the Christmas and New Year's holidays.[70] One writer also listed the departure of "intimate friends" from the same town, as well as "upon return from a journey," as appropriate gift-giving occasions.[71]

These etiquette books acknowledged the implicit understanding that the recipient of a gift was obligated to return the action, and at a comparable level. However, all of these authors cautioned against giving a gift at a value beyond what the giver could afford; they called into question extravagant gifts to brides and other acquaintances. Indeed, the author of the 1833 *Gentleman and Lady's Book of Politeness* claimed that "the most delicate presents are the productions of our own industry."[72] An 1857 children's story makes the point that "it's the thought that counts" without subtlety. When the girl in the story asked her grandmother what sort of present she might like, the grandmother replied, "I should think a great deal more of the love which induced them to give it to me, than of the present itself."[73] The author of a popular midcentury needlework manual asked her readers, "Does not a gift become trebly valuable when the time and thoughts, as well as the mere money of the giver, are represented in it?"[74] This suggests that although none mention needlework specifically, most prescriptive writers would heartily approve of a gift of this kind.

No less a literary luminary than Ralph Waldo Emerson (1803–1882) concurred with the basic rules and constraints suggested by the etiquette guides. In an 1844 essay on gifts, Emerson reviewed the basic elements of gift-giving etiquette. "The rule for a gift," he wrote, ". . . is that we might convey to some person that which properly belonged to his character, and was easily associated with him in thought."[75] Emerson made the point that "the only gift is a portion of thyself," and thus, the giver should give something that is heartfelt and within his or her budget. As Emerson put it, "This is right and pleasing, for it restores society . . . when a man's biography is conveyed in his gift."[76] Among

his list of suggestions when he comes to "the girl" is the gift of needlework, "a handkerchief of her own sewing."[77] By implication, if "a man's biography is conveyed in his gift," a woman's "biography" is symbolized by her needlework.

Another etiquette book, from 1837, privileged homemade gifts above others: "The least exceptionable presents are those which consist of the work of your own hands." However, the writer points out that these homemade gifts must represent the latest fashion and materials.[78] Yet several of the quilts surveyed here were made using techniques that, by the time of the gift, were outdated. Was the etiquette book author being prescriptive based on her personal experience? Or were the makers and givers of these quilts and samplers flouting, or simply unaware of, these etiquette "rules"?

The gift of a quilt fulfilled all of the written and unwritten etiquette rules of the antebellum period. It was made by hand, often from scraps, thus obviating the need to spend extra money. It also implied the spending of time, presumably during which the maker contemplated her affection for the intended recipient. And it communicated a woman's feelings toward the recipient, showing compassion and tenderness, appropriate whether the gift was for a family member or not.

Quilts were physical objects that could be saved for decades as a source of memories. Quilts given to very young children at their birth or christening seem to fulfill this function.[79] In 1851, seventy-three-year-old Esther Johnson Parkinson Slater (1778–1859), widow of famed textile factory magnate Samuel Slater (1768–1835), made a cradle quilt for Anna Russell Whitney (1851–1940) shortly after her birth on February 8 of that year (figure 5.10).[80] Unlike most of the other gift quilts discussed here, Slater and Whitney do not appear to have been blood relations

or connected through any kind of family relationship. At the time, Slater had been a widow for fifteen years. She did not have any children of her own but reportedly enjoyed a good relationship with her stepchildren from her husband's first marriage.[81]

The recipient of the quilt, Anna Russell Whitney, was the daughter of Dr. James Orne Whitney (1823–1895) and Elizabeth Slack Miller Whitney (1816–1902).[82] The nature of the relationship between Slater and the Whitney family is unknown. Slater may have been a patient of Dr. Whitney, who had an office on High Street in Pawtucket while she lived at 69 East Avenue in the same city.[83] Or she might have known him through church, mutual friends, or Dr. Whitney's work at the local historical society. In some respects, this quilt offers the potential for a more enlightening understanding of gift quilts, since the motive for the gift cannot be ascribed to simple filial duty or maternal love. Baby Anna Whitney was not Esther's responsibility to care for financially or to teach how to stitch. But the quilt—in design and construction—reflects the life experiences of its maker in a striking manner.

Esther Johnson was born on March 15, 1778, in England. As was true of almost every girl in England and America at this time, she learned to stitch at a young age. Accompanying her 1851 quilt in the collection of the Slater Mill Historic Site is a sampler that she made in 1787 at the age of nine (figure 5.11). The sampler is not signed but does have an "E" at the end of one row, helping verify the maker.[84] Stitched in silk thread on fine linen fabric, the sampler shows off a skilled variety of embroidery stitches: seed stitch, cross stitch, feather stitch, closed herringbone stitch, trailing stitch, and hem stitch. Esther included numbers and the alphabet, along with a floral vine border, a row of double carnations, and a central motif of five trees.[85]

Before 1807, Esther married Robert Parkinson (d. 1816) in England, and they made a business trip to the United States during the early years of their marriage. The Parkinsons settled in Philadelphia, where Robert developed a business relationship with Samuel Slater.[86] In 1816, Esther's husband, Robert Parkinson, died of "dropsy of the brain." She returned home to England but returned to Philadelphia in 1817 to settle her late husband's estate. Five years earlier, while Esther and Robert were living in Philadelphia, Samuel Slater's wife, Hannah Wilkinson Slater (1774–1812), gave birth to the couple's youngest child on September 19, 1812. A couple of weeks later, Hannah Slater died of complications from childbirth. When Esther Parkinson returned to Philadelphia in 1817 to deal with her husband's estate, she and Samuel Slater became close; they married in Philadelphia on November 21, 1817.[87]

On April 20, 1835, Samuel Slater died in Webster, Massachusetts. Esther and Samuel had a prenuptial agreement because of his successful mill business and the property each owned as a result of their first marriages. Esther received the interest on $10,000 from Slater's estate annually, which amounted to about $600. After an 1836 trip to England, she returned to Rhode Island and had a house built at 69 East Avenue in Pawtucket, where she lived until her death in 1869. Esther maintained her relationship with her stepchildren and, by all accounts, lived comfortably in her own home with an Irish servant.[88] These were the circumstances of her life when she made this quilt as a gift in 1851.

At thirty-five by twenty-seven inches, the quilt is sized for a small bed or cradle.[89] Pieced in a pattern known as Falling Blocks or Tumbling Blocks, the quilt is made using the technique known as "template piecing" or "paper piecing," like the Catherine Marion Palmer quilt above and the Rebecca

FIGURE 5.10. QUILT BY ESTHER JOHNSON PARKINSON SLATER (1778–1859),
1851, PAWTUCKET, RHODE ISLAND.

Courtesy of the Slater Mill Historic Site, Pawtucket, Rhode Island.

Esther Johnson Parkinson Slater made this crib-size quilt for an unrelated child of her acquaintance.
To make it, she combined a piecing technique that she probably learned as a child in England with
the luxurious American fabrics she could afford as the widow of textile magnate Samuel Slater.

FIGURE 5.11. SAMPLER BY ESTHER JOHNSON (1778–1859), 1787, ENGLAND.

Courtesy of the Slater Mill Historic Site, Pawtucket, Rhode Island.

Esther Johnson Parkinson Slater made this sampler as a child. Stitched on very fine fabric, it shows high technical ability.

Scattergood Savery quilt discussed in chapter 4. Some remnants of the pattern pieces, which appear to have been recycled from a newspaper, are visible through loose seams on the top of the quilt. Several women's magazines, including *Godey's Lady's Book* and *Peterson's Magazine,* included illustrations and descriptions of "box" patterns like this one. This particular pattern is found in an 1851 issue of *Godey's Lady's Book.*[90]

Esther's background suggests that she might have learned this technique as a child in England and was probably making this quilt in the most comfortable way for her. So the quilt incorporates Esther's English heritage (in the technique) as well as her affluent economic position and, perhaps symbolically, her husband's renown as a textile producer (in the fabrics used). The quilt is made from a colorful variety of silk fabrics, both printed and plain. It is backed with a luxurious silk fabric. This type of quilt was primarily decorative—made by women who had the time to stitch it together and who could afford to use silks and velvets, which could not be laundered. For this reason, it is a somewhat odd choice as a baby gift but would have been understood as a cherished keepsake, one that represented Esther's English heritage and her Rhode Island life, while also serving as a fashionable memorial after its maker's death.

🙚 🙖

While providing a general overview of proper gift-giving conduct, most etiquette books from the early and mid-nineteenth century do not specifically address gift giving between close family members, such as parent and child or grandparent and grandchild. Gifts between close family members seem to have been understood to be governed by different

rules. In 1829, etiquette writer Mrs. Parkes explained, "The little interchanges of presents between the members of a family are always pleasing, and afford a tacit assurance of the unchanged affection of each party."[91] There is no mention of the tacit responsibility for the recipient to reciprocate, merely the presumption that gifts between family members signified the love and affection between them. Parkes also stated that marriages and births were "signals for the display of the greatest generosity."[92] In short, the published etiquette guides seem to have been written to navigate the more murky waters between friends, acquaintances, and romantic relations. Family gifts were governed far more by tradition, which was assumed and understood rather than documented and published.

Some of the family gift quilts described here contained a more tangible part of the giver or receiver.[93] A quilt made by fifty-three-year-old Susan Kuhns (circa 1787–circa 1865) of Greensburg, Pennsylvania, for her niece, Anna Mariah Kuhns (1817–1868), was made around 1840 from one of her dresses (figure 5.12).[94] Susan was born about 1787 in Pennsylvania, the daughter of Johan Philip Kuhns (or Kuntz) (1747–1822) and Anna Margaretta Stambach Kuhns (1754–1816). She never married or had children of her own but must have felt a connection to her nieces and nephews. Anna Mariah was the daughter of Susan's brother, John Kuhns (1783–1868), and his wife, Susanna Welty Kuhns (1798–1870). Anna Mariah was her parents' first child, born in 1817. She married Asemus Rumbaugh (1818–1848) in July 1840.[95]

Family tradition suggests that the quilt was made using fabric from the dress Anna Mariah's wore the day after her wedding.[96] But the family story and the quilt do not support the same history: the color and pattern of the fabrics used suggest

FIGURE 5.12. QUILT BY SUSAN KUHNS (CA. 1787–CA. 1865),
CIRCA 1830, GREENBURG, PENNSYLVANIA.

The Daughters of the American Revolution Museum, Washington, DC. Gift of Mrs. Benjamin Catchings.

A family story suggests that this quilt was made by Susan Kuhns for her niece, using the woman's "second day dress," or the dress that she wore to begin housekeeping after her marriage. Family stories must be considered carefully; in this case, the date of the fabric and the date of her niece's wedding do not match up, suggesting that part of the story may have been mixed up by subsequent generations.

that the quilt dates to the 1830s, five to ten years before Anna Mariah married in 1840. Perhaps the quilt was made earlier, in preparation for her marriage. Or it might have been made a few years after her marriage, when her "second day" dress no longer fit or had worn out. This would make the story about the fabric correct—just not the family's date for the origin of the quilt.

As the Kuhns family quilt suggests, gift quilts literally preserved family history. Even Lucy Larcom (1824–1893)—who made no secret of her loathing of sewing in her autobiography—found herself drawn to the family scrap bag because of the sentimental associations she formed with the fabrics within. "I liked assorting those little figured bits of cotton cloth," she wrote, "for they were scraps of gowns I had seen worn, and they reminded me of persons who wore them."[97] Another young woman, writing in 1845 about a patchwork quilt in the *Lowell Offering,* detailed the many connections she felt from one glance at her quilt, "Here is the piece intended for the centre . . . remnants of that bright copper-plate cushion which graced my mother's easy chair," she mused, "here is a piece of that radiant cotton gingham dress which was purchased to wear to the dancing school[,] . . . here is a piece of the first dress I ever saw, cut with what were called 'mutton-leg' sleeves. It was my sister's"[98] The author continued with memories of no less than twelve additional scraps related to several of her family members, as well as some tied to milestones in her own life.[99]

At My Grandmother's Feet: The Cultural Nature of Gifts

Mature women gave gifts on many occasions. Sometimes the giver may have been trying to prolong her influence and to remind others of her existence at the end of her life or even past her death. Needlework was considered an "appropriate" activity for women; as such, older women, in particular, manipulated their society and culture by using needlework to express opinions, engage in relationships socially, and show off pride in their accomplishments. By using specific materials or techniques, sometimes the maker was trying to impose her own values or code of beliefs on the recipient.

In her survey of diaries and letters written by aging women between 1785 and 1835, historian Terri Premo asserts that older women saw it as their role to serve as living reminders of the moral code. It was their role to carry the achievements of the Revolutionary era forward.[100] Susan Stabile contends that the Philadelphia women she studied understood that they were responsible for transmitting the memory of their generation.[101] Giving gifts was a material extension of this role—older women could pass on an actual physical manifestation of their moral code or do the same by passing on knowledge through sewing lessons.

Enhancing the feelings and activities of some of these antebellum grandmothers were larger cultural events. Many of these women were born during or just after the Revolutionary War and felt the responsibilities of that event heavily. In the 1820s, as the Revolutionary generation aged, there was a resurgence of interest in the events of the late eighteenth century. In part, the younger generation wanted to learn what they could from the older generation before it was gone. At the same time, the older people were starting to undertake a "life review," looking back on events and experiences of their lives.[102] In essence, supply and demand for Revolutionary memory came together in the 1820s and 1830s—the younger generation sought an understandable narrative of their history, and the older generation was nostalgically looking back to those formative events

FIGURE 5.14. DOLL QUILT BY ELLA MYGATT WHITTLESEY (B. 1845), 1852.

The Metropolitan Museum of Art, Gift, Mrs. Roger Brunschwig Fund,1988 (1988.213),
Image © The Metropolitan Museum of Art.

Inscription: *Ella Mygatt Whittlesey / Aged seven. Her Stint / taught by her Grandmother Elinor Stuart / 1852.*

Many young girls, such as Ella Mygatt Whittlesey, were taught to sew by their grandmothers. Passing on this knowledge was a different type of gift for aging antebellum women to give.

and clothing were made. Eleanor Parke Custis Lewis took great pride in the needlework skill of her granddaughter, sending an example of the work—a bag—to a friend and explaining, "She is only 10 years old & the work (except the balls & the making up which her Mother did) it is entirely her work, & you will acknowledge that she is a very neat needle woman."[129]

Interacting with one's granddaughter offered a sense of continuity amid change on personal, family, and societal levels. Aging women had to adjust to their changing bodies, as well as to their evolving families and communities. This older generation of women looked to the younger generation with hope for the future and a sense of responsibility to the past. As they used their skills to teach the next generation, these aging women were undoubtedly reminded of their own lessons as girls, forming a bond that was reinforced through the act of stitching.[130] This conclusion is supported by myriad diaries, reminiscences, and autobiographies written during the nineteenth century; almost all recount a sewing lesson with an older female relative.[131] For example, Lucy Larcom remembered threading needles and learning to tie knots at the knee of her elderly aunts.[132] Visual images of the very old and very young side by side were also common in the nineteenth century. These images suggested that the activity was traditional and venerable, as represented by the older person, while the presence of the younger person was "an assurance that the lore and learning of the past will be carried on to future generations" and that some things will remain the same even as time passes.[133]

In turn, grandmothers gifted their quilts to the younger generations. Mary Laman Kemp's (1758–1845) quilt, which is inscribed "This quilt was pieced in the year 1840 by Mrs. Mary Kemp in her eighty-second year for her great grand daughter Mary Jane Elizabeth Doub when she was eight years old," was one such gift (figures 5.15 and 5.16). Mary Laman was born in Maryland in 1758, the daughter of Adam Laman (1732–1823) and Anna Margaretha Steltz Laman (1729–1818). She married Peter Kemp (1749–1811) in 1779, and they had ten children. At her father's death in 1823, Mary was not only the executor of his estate but also its sole beneficiary. Her father willed her the entire estate "for the many favors of services received from her." The recipient of the quilt, Mary Jane Elizabeth Doub, was the granddaughter of Mary Laman Kemp's fourth child, Esther (1785–1866), who married Valentine Doub (1777–1844) in 1804. Mary's grandson, Joshua Doub (dates unknown), was Mary Jane's father and raised her with his wife while he worked as a merchant. Mary Jane would go on to have six children of her own and passed the quilt to the next generation.[134]

Her quilt, pieced in the Feathered Star pattern and composed of many small triangles, demonstrates the importance of sewing straight seams and matching corners and patterns. The quilt would continue to function as a model of womanly skills, even when Kemp could not. Quilts such as this one were not intended as practical household items; instead, they were special, deliberately made to become lasting family heirlooms. In a study of the Revolutionary War in American memory, historian Sarah Purcell explained that "monuments served as powerful physical reminders of what the 'best' American men had sacrificed for their country, and patriots hoped they would serve to further bind the nation together."[135] For women of that same generation, gift needlework could serve as their personal monuments, arranged around the home and within arm's length to provoke frequent memories

FIGURE 5.15. QUILT BY MARY LAMAN KEMP (1758–1845),
1840, ROCKY SPRINGS, MARYLAND.

Mary Laman Kemp made this quilt for her great-granddaughter's eighth birthday. It would have
been a lasting memorial of her love as the girl grew up.

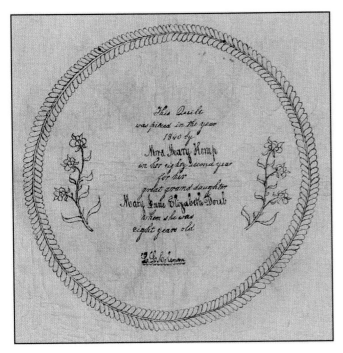

FIGURE 5.16. DETAIL OF
INSCRIPTION ON QUILT BY
MARY LAMAN KEMP.

Inscription: *This quilt / was pieced in the year / 1840 by / Mrs. Mary Kemp / in her eighty-second year / for her / great grand daughter / Mary Jane Elizabeth Doub / when she was / eight years old. / L. L. Coleman.*

and reminders. Hanging a sampler on the wall or placing a quilt on the bed may have been a type of monument to its maker, serving as a personal reminder to her family.

Abigail Reynolds Greene (1794–1889), like many other women of her generation (figure 5.17), could have been inspired to stitch her quilt as part of her role as a "kin keeper"—to maintain connections between family members and to remind her family of its personal history.[136] In 1860, when she was sixty-six years old, Abigail inscribed a quilt "AG 1860 to Abby G. Fry" and gave it to her granddaughter, Abby Fry (1842–1860) (figure 5.18). Born in 1842, Abby Fry was the first granddaughter named for her grandmother (although others would follow—three grandchildren and one niece would ultimately share her name).[137] While naming a child after her grandmother was not uncommon, it does seem significant that so many of Abigail Greene's children offered her namesakes. This suggests respect

for their mother, as well as close-knit family ties, and may be read as a sign of Abigail's success in her role as kin keeper. Sadly, young Abby died of appendicitis on May 14, 1860, at the age of seventeen.[138]

Like many of the other quilts described here, this one offers physical evidence that can be interpreted multiple ways. One scholar—noticing features more consistent with quilts of the 1830s and 1840s than with 1860—has suggested that the quilt was made at an earlier time and only inscribed in 1860. The one-patch block set on point without borders is consistent with Rhode Island quilts made before 1850. The flowers, hearts, and birds resemble those seen on other types of textiles and folk art from the 1830s and 1840s. And fiber analysis suggests that the wool used for the back came from an early breed of sheep.[139] All of these things suggest an earlier date of origin for the quilt. However, the embroidery thread used for the inscription resembles that used to appliqué the various motifs on the

FIGURE 5.17. PHOTOGRAPH OF ABIGAIL REYNOLDS GREENE (1794–1889), 1870–1885, UNIDENTIFIED PHOTOGRAPHER, RHODE ISLAND.

Photograph courtesy of Rhode Island Quilt Documentation Project, University of Rhode Island.

FIGURE 5.18. QUILT BY ABIGAIL REYNOLDS GREENE (1794–1889),
1860, EAST GREENWICH, RHODE ISLAND.

Photograph courtesy of Rhode Island Quilt Documentation Project, University of Rhode Island.

Abigail Reynolds Greene gave this quilt to her namesake, her granddaughter Abigail Fry, shortly
before the girl died in 1860 at the young age of seventeen.

quilt top, which would indicate that the top and the inscription were completed at the same time.[140] The physical evidence presented by the quilt is ambiguous, offering multiple interpretations as to how it was made and used.

One possible way to reconcile this seemingly contradictory evidence is to consider that Abigail Greene may have made the quilt for her granddaughter as a sewing lesson. It is made from older materials and shows an older style. There are also some poor quilting stitches visible in the quilt; perhaps young Abby was working on it with her grandmother when she became ill.

Another way that the quilt's conflicting material evidence can be reconciled is if Abigail Greene took it out when Abby became ill and added the inscription, giving it to her while she was sick to keep her warm and symbolically covered with her grandmother's love and protection. Several of Abigail's close family members died prior to 1860 when the quilt was made and/or given, including six of her children and her husband.[141] This quilt, intended for a granddaughter who died as a young woman, may have been a means for Abigail to cope with her grief or to symbolically ward off the danger of illness from a beloved grandchild.

<center>⚜ ⚜</center>

Needlework gifts from women to friends and family were far more than customary tokens of esteem, particularly for women as they aged. A final example has a particularly poignant associated history. Around 1845 or 1846, Catherine Crast Sloat (1798–1873) gave her daughter, Sarah Sloat Burr (1821–1910), a quilt that she had made. Catherine Crast, sometimes referred to as "Caty," was born in Albany, New York, in 1798 and married John Lounsbury Sloat (1799–1884) in 1818 when she was twenty years old. John and Catherine Sloat had eleven children, all born in New York. According to U.S. Census data, John Sloat was a cooper. In 1850, the census indicates that he owned real estate worth $350, placing the family securely at the middle to lower end of the economic scale.[142] The front of this reversible quilt is pieced in strips, forming a pattern known as Flying Geese. The quilt incorporates many different fabrics, including some that may have been recycled from clothing and household textiles, perhaps representing family stories and memories. The quilt is backed with an older quilt, pieced in the Irish Chain pattern and faded, suggesting that it was previously used and, thus, making it physically representative of the family's history.

In 1843, twenty-two-year-old New York native Sarah Sloat married Charles Clark Burr (1817–1903). Three years later, the couple moved west with his parents and his brother, traveling to California with a group of fellow Mormons. At some point between Sarah's marriage and her departure, her mother, forty-seven-year-old Catherine Crast Sloat, gave her this quilt.[143] According to family history, Sarah took the quilt on this trip. During the long ocean voyage, Sarah Sloat Burr gave birth to one child and lost another to dysentery.[144]

Throughout the long, difficult trip, the quilt may have served Sarah as a stand-in for her mother's love and comfort and as a reminder of her birth family. Sarah was the only child of John and Catherine Sloat to leave New York, so the family must have felt the separation keenly. Catherine Sloat could not read or write, making the quilt an important means of maintaining a connection to her absent daughter.[145]

For the aging women described here, a needlework gift was more than the sum of its parts; it was understood to embody the person who made it. In turn, these women used their needlework to influence their families, society, and culture; to cope with change; and to express their identity and values. Far from being merely a functional bedcover, each quilt discussed here was an extension of its maker's identity. These objects were intended by their givers to be passed down for generations reminding their progeny of their ancestors' existence, talents, and skills, to remind them of where they came from, and to carry forward the same values and traditions.

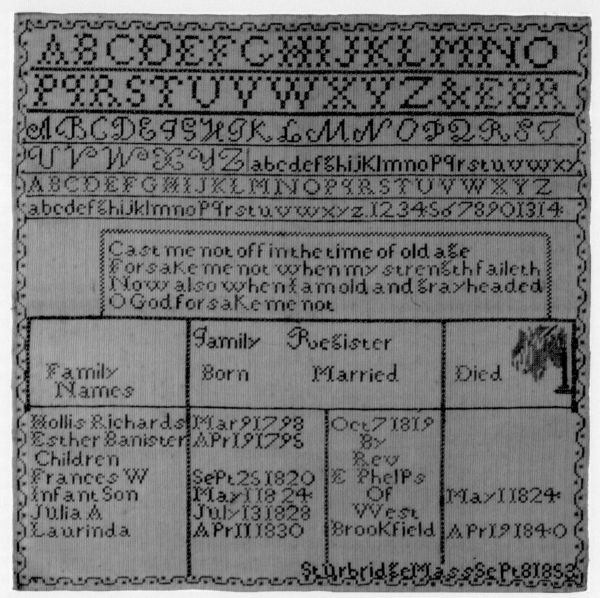

FIGURE 6.1. SAMPLER BY
ESTHER BANISTER RICHARDS (1795–1864), 1853,
STURBRIDGE, MASSACHUSETTS.

Collections of Old Sturbridge Village, Sturbridge, Massachusetts, 64.1.116.
Photograph by Thomas Neill.

Fifty-eight-year-old Esther Banister Richards chose a meaningful verse for her
sampler. From the biblical book of Psalms, the verse reflects some of the wor-
ries of growing older. Her sampler is stitched on what was then a newer type
of canvas, with regular woven blue lines to assist with counting.

BIOGRAPHICAL
NEEDLEWORK

Telling a Life Story

N 1853, fifty-eight-year-old Esther Banister Richards (1795–1864) of Sturbridge, Massachusetts, made a sampler that spells out the facts of her life: her birth, her marriage, and her children (figure 6.1).[1] It includes a biblical verse from what is sometimes called the "Prayer of an Old Man for Deliverance" because it is thought to have been written by the aging King David.[2] The stitched verse reads:

> Cast me not off in the time of my old age,
> Forsake me not when my strength faileth,
> Now also when I am old and gray headed,
> O God forsake me not.[3]

A previous study of family record samplers (needlework samplers stitched with the birth, marriage, and death dates of family members) dismissed the value this type

of needlework had for its maker, stating that "mature women, who were probably instructors, worked a few family records as examples for their students or for their own relatives."[4] While in some cases this may be true—that the sampler was merely a teaching exercise—the sampler made by Esther Banister Richards suggests the personal meaning this needlework had for some makers as a memorial and as a means to demonstrate both personal and familial achievements.

Anthropologists have described items such as the Richards sampler and the other pieces considered here as "biographical objects"—personally meaningful possessions that take on lives of their own.[5] These objects gain value as they are kept by the maker's family, passed from owner to heir. In time, after the family has preserved and revered one of these objects, it can come to define the family, acting as "a vehicle for bringing past time into the present, so that the histories of ancestors . . . become an intimate part of a person's present identity."[6] Anthropologists explain that in many different cultures, "people and the things they valued were so complexly intertwined they could not be disentangled."[7] The memories that these objects evoke become more important than their function or physicality.[8] Terming them "mnemonic objects," Susan Stabile suggests that they were especially important as women aged, merging with the maker's self "to renew a unified identity and a continuous narrative of the past in old age."[9]

Extending the anthropological idea of the biographical object to the samplers and quilts made by aging women offers a new category for needlework that has previously been dichotomized as practical/functional on the one hand or as decorative/ornamental on the other. Defining certain needlework

artifacts as "biographical needlework" allows us to better understand them as objects of their time, building personal, social, and cultural contexts. It also helps us learn more about their makers. As they aged, many women continued to use their needles —not to learn or to provide for their families but to express themselves. These objects function in a much more complex way than as a household tool or an ornament: they document specific events, they present testimony about a woman's life, they represent the life story of their maker's family, and they serve as memorials to their makers. The quilts and samplers explored in this chapter offered their aging makers a voice for lasting words. Each object described here is both biographical (conveying a life story) and epistolary (employing words on the object, whether written, stitched, or applied, to tell that story).

At first glance, Esther Banister Richards's sampler seems to follow the traditional style of any number of family record samplers made by schoolgirls. It has neat columns headed "Born," "Married," and "Died." And like innumerable schoolgirl family register samplers, the columns are not completely filled in. Next to the heading "Died," Richards stitched a weeping willow tree, which provides one of the sampler's small bits of color. A symbol associated with death and the afterlife commonly found on late-eighteenth- and early-nineteenth-century gravestones, willow trees were a common sampler motif, representing death and mourning. Willows were particularly symbolic because of their regenerative power to grow again after being cut.[10] While the names and dates are neatly stitched in a monochromatic shade of brown, the tree has green leaves that hang over its brown trunk. The willow draws the eye sideways, lingering on the death

column, reminding the viewer of the natural cycle of life.

Having spent her life being encouraged to pursue Christian virtues, Richards stitched a verse asking her God for help as she aged; it distinguishes her sampler from the many made by girls and young women. Richards sought God's assistance even when her "strength faileth." She was not the only mature woman to seek solace in this psalm. Almost ten years earlier, in October 1844, seventy-five-year-old Joanna Graham Bethune (1770–1860) repeated the same phrases in her diary, seeking God's help not only in accepting her aging process but also in serving as a model for the younger generation, by showing them the strength of her character and faith: "When I am old and gray-headed, O God, forsake me not, until I have showed Thy strength unto this generation."[11]

Both women may also have been drawing on the sermons this psalm inspired. In 1805, seventy-four-year-old Springfield clergyman Joseph Lathrop (1731–1820) preached "The Infirmities and Comforts of Old Age: A Sermon to Aged People," beginning with Psalm 71:9 and quickly leaping to 71:18, just as Esther Richards did on her sampler.[12] In his sermon, Lathrop urged his listeners to recognize that the effects of age were inevitable, to ask God for grace to deal with the weakening body, and to serve as a positive testimony of faith before others. Through her sampler, Esther Richards fulfilled Lathrop's last suggestion. Richards probably hung her sampler on the wall of her home where it could remind her to ask God for grace as she aged. In this way, it would also demonstrate to her family and friends that she was remaining positive and seeking the virtues that rewarded a Christian life. This verse reflects its aging maker, just as those stitched on schoolgirl samplers offered prescriptive lessons appropriate for girls and young women in their respective life stages.

Richards's stitched words offered a way to communicate her experience with aging as well as her sorrow over the early deaths of two of her children —an unnamed "infant son" in 1824 and a ten-year-old daughter, Laurinda, in 1840. A popular story, "The Patchwork Quilt," originally published in 1845 in *The Lowell Offering,* suggests that the individual objects described here were not the lonely aberrations of a handful of women but a representation of societal and cultural mores. In the story, the author, probably Harriet Farley or Rebecca C. Thompson, both Lowell mill girls, described the quilt as more than the functional sum of its parts. As the story's narrator explained, "to me it is a precious reliquary of past treasures; a storehouse of valuables, almost destitute of intrinsic worth[;] . . . a bound volume of hieroglyphics . . . which is a key to some painful or pleasant remembrance[:] . . . but, oh, I am poetizing and spiritualizing over my 'patchwork quilt.'"[13] The quilt represented bonds and connections between family members. It also marked the passage of time and brought together the different stages of a woman's life. Far from being a simple covering to warm someone's bed, this quilt had a story to tell.

Identifying and studying biographical needlework extends previous scholarship on women's diaries. It enlarges the pool of sources and widens the number of women who can be studied beyond those who had the time, education, and means to keep a diary.[14] While historians often place documentary and material sources at divergent ends of the evidentiary spectrum, paper and fabric actually have an intertwined relationship of their own that was understood during the antebellum period. Not only was paper made from fabric, but antebellum

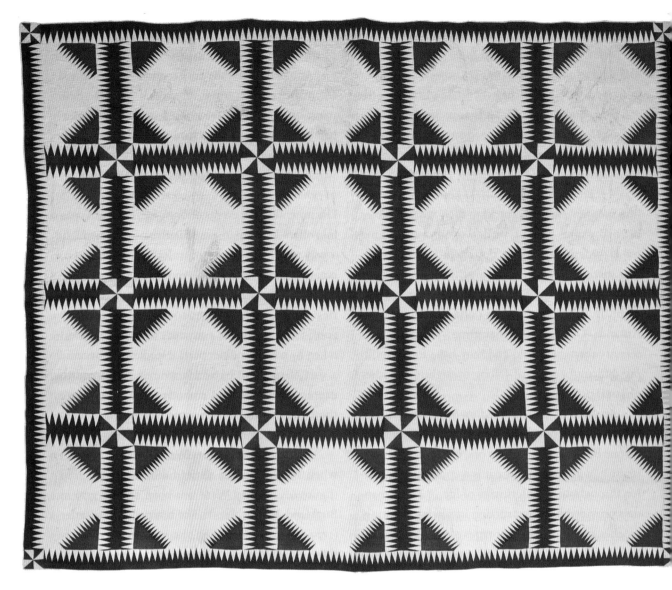

FIGURE 6.2. QUILT BY MARGARET STEELEY KELLEY (1784–1865),
PIECED 1852, QUILTED 1857, PENNSYLVANIA.

Courtesy of the Erie County Historical Society, Erie, Pennsylvania.

Margaret Kelley pieced this quilt in 1852, and five years later it was quilted by Janet
Amanda Coates. The details of its construction are noted on the quilt, which bears the
quilted inscription "Pieced 1852 Quilted 1857" in one corner.

FIGURE 6.3. DETAIL OF SIGNATURE ON KELLEY QUILT.

John Baker, photographer, Erie County Historical Society.

There is little additional ornament. The quilt mourns the beloved granddaughter, serving no other aesthetic purpose. That the maker had a "full heart" that was "overflowing" from sorrow is evident from the quilt's enormous lettering, arranged so as to resemble a tombstone.

The lettering on the quilt resembles what has been termed "plain style" lettering on gravestones —rows of letters spelling out simple inscriptions. While "plain style" gravestones were predominant from 1640 to 1710 in New England, well before this quilt was made, the style never fell completely out of use. Stones from the early nineteenth century in Ithaca, New York, show the "plain style," suggesting that it was still known there when Butler was

stitching her quilt. This gravestone style has been interpreted to represent an attitude of resignation in the face of death.[28] While Butler's quilt seems to suggest that it was created out of anything but resignation, perhaps she sought resignation and peace by making her quilt, deliberately tracing each letter onto her blue cotton fabric and carefully stitching those letters onto the quilt, one by one.

The central lettering is surrounded by an elaborately quilted border with a floral vine motif. Butler may have chosen a vine for her border because of its well-known symbolism of fertility and of the family (the leaves represent family members attached to the larger vine). In addition, the vine was an important religious symbol, representing the

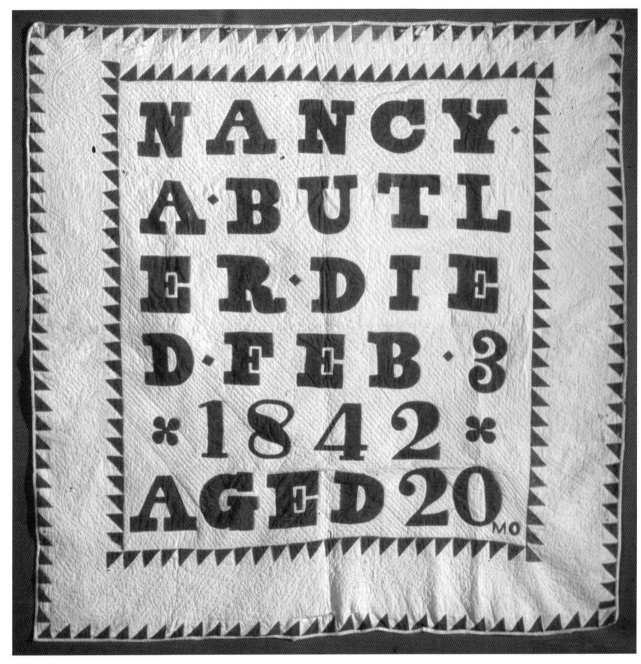

FIGURE 6.4. QUILT BY NANCY WARD BUTLER (1779–1863), 1842, NEW YORK.

Courtesy of the National Museum of American Art, Smithsonian Institution, Washington, DC.

One look at Nancy Ward Butler's quilt conveys the magnitude of the grief she felt at the loss of her granddaughter. Three years later she would make a similar quilt mourning the deaths of one of her sons and another granddaughter, who passed away in 1844 and 1845, respectively.

relationship between God and man. According to the Bible's Gospel of John, Christ told his disciples, "I am the true vine, and my Father is the husbandman; Every branch in me that beareth not fruit he taketh away; and every branch that beareth fruit, he purgeth it, that it may bring forth more fruit . . . I am the vine, ye are the branches. He that abideth in me, and I in him, the same bringeth forth much fruit; for without me ye can do nothing."[29] In addition to being introduced to vine symbolism in the Bible, women were familiar with vines as a common symbol on gravestones.[30] Butler's use of the vine motif on her quilt may have served two purposes: it continued her stylistic analogy to a tombstone and it provided comfort through the idea that her grandchild was resting with God. The quilt is in good condition, suggesting its primary use as a touchstone and memory holder, rather than as a bed covering.

During the early nineteenth century, patterns of mourning were changing. Many Americans took solace in the idea that as long as one's memory was "kept alive by someone else's grief, one was not entirely dead."[31] This project gave Nancy Ward Butler a way to visually express the full extent of her sorrow, far more than writing a letter or dressing in mourning clothes could possibly achieve. By making a quilt, she could make letters large enough to represent the enormity of her grief, leaving no doubt that her grandchild's memory was being kept alive.[32] Indeed, when Butler's son, James (1824–1844), died in May 1844 at age twenty, followed by her granddaughter, Cynthia M. Sage (1822–1845), in 1845 at age twenty-three, she made a second quilt in the same style with the same enormous letters.[33]

While Nancy Ward Butler made a quilt to tell the story of other family members, the quilt that forty-two-year-old Betsey M. Seely Sears (1813–1901) made tells her own story.[34] Betsey Mahala Seely was born August 31, 1813, in Westmoreland, New York, the daughter of Daniel Seely and Betsey E. Doolittle Seely. In 1831, when she was eighteen, Betsey married Silas Sears (1806–1859) of Rome, New York. The couple had five children together, four in New York State and their youngest, George M. Sears (1846–1868), in Wisconsin. By the time of the 1860 U.S. Census, she owned $1,200 worth of real estate and had a personal estate valued at $150. Her sons George and Lowell, along with Lowell's family, lived with her. Lowell was a farmer with real estate of his own worth $600. Betsey Seely Sears lived a long life, passing away in 1901 at the age of eighty-seven.[35]

The flowers on the quilt were carefully chosen and can be identified as wildflowers native to her adopted state of Wisconsin.[36] According to a family story, Betsey would take apart actual plants to be sure she was reproducing them accurately on her quilt.[37] Her colorful appliquéd bedcover has a central cartouche formed by undulating vines, often used, as we have seen on the Butler quilt, to symbolize family and religious relationships, as well as continuity in life and death. In the middle is an embroidered signature, "By Mrs. Betsey M. Sears Aged 42 Years 1855." The prominence of this signature, with her first and last names, as well as her age, suggests that a sense of pride and achievement accompanied her work. Unlike the women discussed elsewhere in these pages who hid their age by altering their childhood samplers, Sears proudly stated her age; in effect, her quilt staked a claim to life. Out of the 167 needlework objects located for this study, only 22 include the maker's age or date of birth on the object, suggesting that those who made

the choice to include this information did so consciously. In contrast, almost twice as many (40) include the maker's name or initials.

While the signature documents the "event" of completing this single quilt, it may also attest to the maker's story of survival in moving west over a decade earlier. At age thirty, Betsey, her husband, Silas, and four small children moved west from New York to Wisconsin in 1843. Their journey was difficult; they ran low on money and then lost two of their children to smallpox. Betsey was also infected but recovered.[38] She kept a diary and recorded her thoughts about the loss of her children. "It had always seemed to me that if I should ever lose a child, I could never let it out of my arms," she mused, "but now two of my loves were dead. . . . But God strengthened my almost exhausted endurance, and I became resigned to my fate."[39]

Betsey was a seamstress, and her skill is evident from her 1855 quilt. Throughout her marriage, she sold her needlework products to help with the family finances. In 1848, when Betsey was thirty-five, her husband built an inn, named "Live and Let Live," in Rome, Wisconsin. For seven years, they lived at the inn, but in 1855, Silas built a house for them on the outskirts of town.[40] At this same time, Betsey made her quilt and signed it. While she did not leave behind an explanation of her work, she may have been celebrating the move to her new home.

Sadly, Silas died in 1859, only four years after the couple moved into the house he built.[41] Betsey continued to make quilts in her widowhood, and she also wrote poetry. According to family tradition, she made fourteen quilts after the age of seventy-five.[42] A quilt from the 1850s is now in the collection of the Fort Atkinson Historical Society in Wisconsin, having been donated by one of Betsey's descendants (figure 6.5).[43] Like the 1855 quilt, it is made in a floral appliqué pattern, but without the central signature.

After examining hundreds of diaries kept by aging women, Terri Premo pointed out that literacy provided them with tools for self-expression, which they relied on "to expand their daily world, to participate in active and meaningful intercourse with others, and to leave a permanent record of themselves, which could be passed down to later generations."[44] Biographical needlework functioned the same way. It offered a means of expression, often in a public, tangible way.

Epistolary Needlework: Telling Stories and Bearing Witness

Epistolary needlework—a subset of biographical needlework made up of quilts, samplers, and other textiles that have words or a story spelled out across their face in fabric, thread, ink, or paint—provided not only a means of recording one's name and achievements but also additional information ranging from family history to religious sentiments or prescriptive advice.[45] In some cases, these objects served as testimony—defined as proof, affirmation, and evidence of a fact—that was, on occasion, legally accepted by the government to document family relationships and past marriages. Partly inspired by the popularity of epistolary novels during the late eighteenth century, epistolary quilts and samplers also drew from their makers' schoolgirl needlework lessons: they incorporated lettering learned by making a sampler.[46] This lettering was directly reproduced on the samplers of aging women, or pieced on quilts. One textile scholar has pointed out that "in a society in which a woman had few

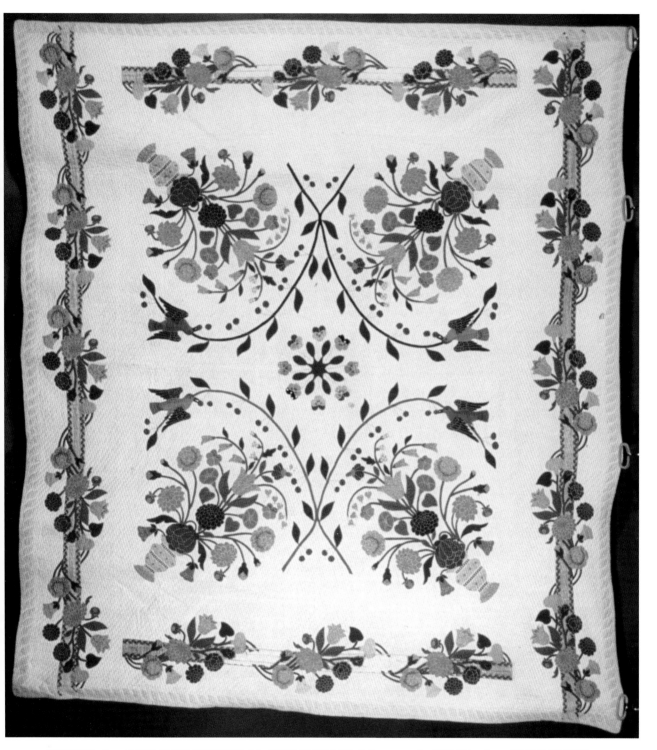

FIGURE 6.5. QUILT BY BETSEY M. SEELY SEARS (1813–1901), CIRCA 1855, WISCONSIN.

Courtesy of the Fort Atkinson Historical Society, Wisconsin.

legal rights, her name was nonetheless often prominently displayed within the household over which she presided."[47] While some have theorized that women made epistolary samplers because they did not know how to write,[48] by the antebellum period it seems more likely that writing with needle and thread was simply another, and in some cases, a more comfortable, way for women to express themselves.

An 1848 quilt by seventy-nine-year-old Maria Cadman Hubbard (b. 1769) makes this point in a striking fashion (figure 6.6).[49] Pieced in red and white in a variation of the Delectable Mountains pattern, the quilt is not only signed with her name, age, and the date, but the white spaces include fifteen pieced inscriptions of her choosing. The white squares and diagonal lines of the quilt top make a strong visual statement, almost forming a checkerboard of advice. Considered together, the quilt offers Hubbard's personal manifesto—her guide to appropriate conduct.

In a sense, Hubbard created a quilt that served a purpose similar to eighteenth- and early-nineteenth-century commonplace books.[50] These books were created by their owners by bringing together favorite verses, ideas, and essays, usually from printed sources. Just as Hubbard did when making her quilt, the writers of commonplace books pursued numerous distinct actions and choices, identifying verses and texts that resonated with them, choosing to re-create them, and accumulating and organizing them in a new format. Susan Stabile suggests that these books became "memory as a lived practice."[51] The pages took ideas and memories and made them real for their keepers, providing instruction and rules to live by. In addition, by collecting ideas and verses from many places and bringing them to one new location, the owner was

taking some control of the material, keeping it close, where it could be easily referenced and shared with others. Hubbard's quilt holds a relationship to these books. Like those works, she chose verses from several sources and brought them together in one place. The quilt, like the books, served as a reminder to its maker and as an inspiration to all who read its words.

In addition to its resonance with commonplace books, the quilt also suggests a relationship to the embroidered perforated paper mottoes that would become popular during the mid- and late nineteenth century. Perforated paper first became available in the 1840s, around the time Hubbard made her quilt. Initially, it was used for small projects—bookmarks and pictures or mottoes that were twelve inches square or smaller. Eventually, larger sheets of the paper were used to stitch mottoes, which were then framed to hang on the wall of the parlor. In addition to needlework versions, mottoes could be found on buildings, on title pages, and at the beginnings of book chapters, carved into furniture, and printed on decorative engravings and lithographs. One study of over 150 embroidered mottoes made between 1860 and 1890 found that 60 percent presented a Christian-themed motto, much like the Hubbard quilt, and that the sentiments were drawn from the Bible, hymns, and sermons.[52]

Hubbard's quilt may also have been inspired by the evangelical religious movements taking place during the early nineteenth century. Indeed, New York State, where Hubbard is thought to have stitched her quilt, was a focal point for the start of the Second Great Awakening, and this may have inspired her to pick up needle and thread.[53] Known in recent years as the "Pieties Quilt," Hubbard's bed covering includes sayings selected from the Bible, as well as poems and at least one hymn.[54]

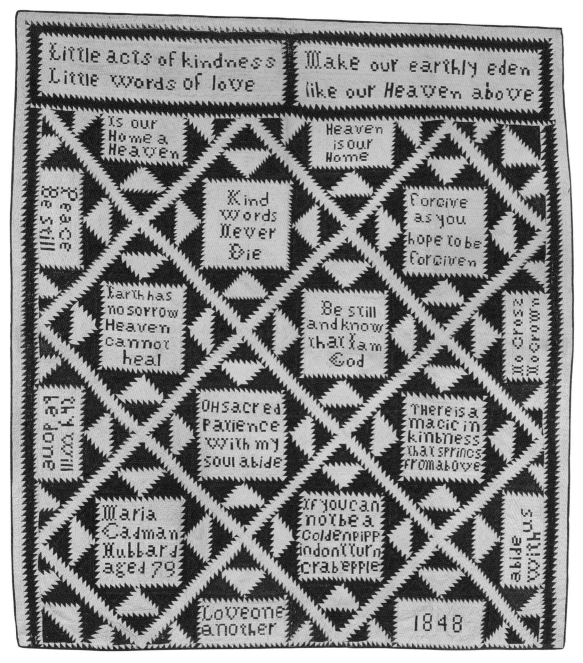

FIGURE 6.6. PIETIES QUILT, BY MARIA CADMAN HUBBARD (B. 1769), DATED 1848,
PROBABLY AUSTERLITZ, NEW YORK, COTTON, 88½ X 81".

Collection of American Folk Art Museum, New York, Gift of Cyril Irwin Nelson in loving memory of his parents,
Cyril Arthur and Elise Macy Nelson, 1984. 27.1, photo by John Parnell, New York.

Maria Cadman Hubbard used her quilt to bring together fifteen verses that held meaning for her. The quilt
draws on magazines, books, the Bible, and hymns to offer a moral guide for all who view it.

The most prominent verse is pieced along the top of the quilt, in two sections, so that when it was put onto the bed, these words would fall along the pillows. This verse reads, "Little acts of kindness / Little words of love // Make our earthly eden / like our Heaven above." The verse is slightly paraphrased from a poem, known as "Little Things," written in 1845 by Julia Fletcher Carney (1823–1908). The poem was published in a Christian periodical that year and apparently struck a chord with American readers: it was subsequently reprinted in many magazines and anthologies, as well as in some children's readers.[55]

Several of the sayings stitched on the quilt are recognizable tenets from the Bible. At the bottom is "Love one another," which is found in John 13:34. Along the right side of the quilt is "Abide with us," which appears in the gospel of Luke (24:29) when the apostles asked Jesus to remain with them after his resurrection. Another verse on the quilt comes from the book of Psalms (46:10): "Be still and know that I am God." The shorter verses on the left side of the quilt are also easily identifiable. "Thy will be done" comes from the Lord's Prayer, second nature to all church members and found in the gospels of Matthew (6:10–14) and Luke (11:2–4). "Peace be still" comes from the New Testament's gospel of Mark, which reads, "Then He arose and rebuked the wind, and said to the sea, 'Peace, be still!' And the wind ceased and there was a great calm."[56] As distilled purely from the biblical story, these words convey the power of God. But did they also carry additional meanings through their use on a woman's quilt? The phrase could encourage rest and sleep each night as the quilt's owners crawled under it.

Two verses on the quilt come from hymns. "Heaven is our home" appears in a hymn written

by the English Congregational minister Thomas Rawson Taylor (1807–1835) shortly before his death in 1835. It was published the following year in his memoirs as part of a selection of hymns.[57] A hymn known as "Come, Ye Disconsolate," written around 1816 by Thomas Moore (1779–1852), is the source for the quilt's verse "Earth has no sorrow heaven cannot heal."[58] This verse was also popular on gravestones throughout the nineteenth century, offering comfort to mourners.

A shorter verse on the right side of the quilt reads, "No Cross, No Crown," a popular motto during the eighteenth and nineteenth centuries. Referring to the crucifixion and subsequent resurrection of Jesus Christ, the verse reminds the faithful that reward and achievement do not come without pain, suffering, and difficulty first. In turn, it also reminded those who sought the rewards of heaven that they must bear the crosses in their lives, remaining true to their faith and following the rules of the church. Popular for mid- and late-nineteenth-century embroidered mottoes, this verse was also the title of an early work by Quaker leader William Penn (1644–1718), written in 1668 while he was held prisoner in England for blasphemy.[59]

Hubbard brought together verses and ideas from a multitude of sources, and sometimes identifying the exact source for a passage she quoted is difficult, because it circulated so widely in the culture. For example, the verse "Forgive as you hope to be forgiven" turns up in many sermons and stories from the mid- and late nineteenth century, such as when it concludes the story "The Broken Vow," published in an issue of *The Lowell Offering and Magazine* from 1843.[60] A few of the verses she selected can be found in post-1848 books and magazines, often unsigned, suggesting that they were

reprinted multiple times. For example, an unsigned poem in *The Soul's Welfare; A Magazine for the People*, published in London in 1851, is titled "Forgive and Forget" and begins with a verse that is included on the quilt, "There's a magic in kindness, / That springs from above."[61] And the phrase "Kind words never die," which appears on the quilt near the top center, would become the chorus for a hymn written in 1855 and made popular by the Hutchinson Family Singers, a traveling family singing group of evangelists.[62] Prior to 1848, a slightly different version of this motto, "Kind words can never die," was published as part of a poem titled "My Philosophy," in *The Rover: Weekly Magazine of Tales, Poetry, and Engravings*.[63]

The sources for three of the verses Hubbard inscribed on her quilt are not known.[64] At the top, one block reads, "Is our Home a Heaven," an apparent reversal of the companion block to its right, which reads, "Heaven is our Home." Another block reads, "Oh sacred Patience with my soul abide," which may come from an unidentified hymn, sermon, or story.[65] The third unidentified verse is one of the most charming: "If you can not be a golden pippin, don't turn crab apple." A pippin was any one of several varieties of sweet apples, contrasting it with the sour crabapple.[66]

Whether reminders or aspirations, the "pieties" on Hubbard's quilt offered validation of her past and inspiration for her family's future. The fifteen verses on the quilt include one question, five imperatives, and nine observations or statements of advice. Reading through all fifteen provides encouragement to be kind to others, to forgive, and to seek the peace of resignation. In addition, several of the verses remind the reader to place their faith in God —"Thy will be done" and "Oh sacred patience with

my soul abide"— to achieve eternal reward. Terri Premo's study of the diaries of aging women between 1785 and 1835 found that "older women began to fear the prospect of a future void of moral and spiritual substance."[67] Stitching a quilt or sampler as a physical manifestation of moral and spiritual values could have been one way to cope with this fear.

※ ※

While Hubbard's quilt, like most of the others discussed here, was primarily intended for family use, some antebellum textiles quite unexpectedly extended their reach, moving beyond the domestic sphere to the most public sphere of all—the courts. The sampler made by ten-year-old Mary Hearn (b. 1782) of Nantucket, Massachusetts, in 1793, traveled from Massachusetts to Rhode Island to upstate New York and ultimately to Washington, D.C., where it served as legal evidence of the marriage of its maker's parents, qualifying Hearn's mother for a military pension (figure 6.7).[68] Mary Hearn was born in Dutchess County, New York, on December 12, 1782, the daughter of Daniel Hearn (d. 1783) and Elizabeth Ray Hearn (1755–1849). Her father served as a wagon conductor during the Revolutionary War but died in July 1783 when Mary was an infant. Elizabeth Hearn took her baby to Nantucket, where she had family.[69] Mary's sampler includes a row of the motif known as the "Nantucket tree" along the bottom. Given its similarities to other known Nantucket samplers, the sampler is likely to have been made on the island under the instruction of a local teacher.[70]

Mary Hearn left Nantucket with her mother, and her sampler, before the War of 1812, settling in Rhode Island, where she taught school. A few years later, Mary and her mother moved to New York

FIGURE 6.7. SAMPLER BY MARY HEARN (B. 1782),
1793, NANTUCKET, MASSACHUSETTS.

*Courtesy of the National Archives, Record Group 15, Records of the Department of Veterans Affairs, Entry A1-2A,
Case Files of Pension and Bounty–Land Warrant Applications Based on Revolutionary War Service.*

Stitched verse: *And I said Oh that I had wings like a dove, / For then would I fly away & be at rest. / Mary Hearn born December 12, 1782, / Markt this sampler in the year 1793.*

Mary Hearn Fralick used her girlhood sampler as evidence to prove the marriage of her parents so her mother could qualify for a government pension as the widow of a Revolutionary War soldier. While Mary and her mother were ultimately successful, there were questions about the date the sampler was made, since digits in the year appeared to have been picked out and later restitched.

Table 6.1. Samplers submitted to the Pension Office

Maker	Birth date	Date of sampler	Age of maker when sampler made	Year submitted to Pension Office	Age of maker when sampler submitted	Pensioner
Harriet Bacon	b. 1794	ca. 1804–1805	10 or 11	1844	50	Her mother
Patsey Bonner	b. 1775	1792	17	1843	68	Herself
Huldah Booth	b. 1789	ca. 1818	29	1848	59	Her siblings
Martha Earl	b. 1781	1787	6	1842	61	Her mother
Laura Goodale	b. 1793	ca. 1809	ca. 17	1840	47	Her mother
Mary Hearn	b. 1782	1793	11	1846	64	Her mother

Sources: All six samplers are currently in the collection of the National Archives and Records Administration, Washington, D.C. All information in the table comes from Heaps, "Remember Me," 185–95.

State, taking up residence in the town of Marathon, where Mary Hearn married Peter Fralick (b. 1783) in 1818.[71] Many years later, Peter Fralick would recall that his wife had the sampler when they wed, as he testified before the court, "the needle work spoken of by my wife was in her possession when I married her."[72]

Beginning in 1818, the same year that Mary Hearn married Peter Fralick, the federal government enacted its first legislation regarding pensions for military service.[73] The files compiled during the early and mid-nineteenth century are full of not only documentary evidence, providing fascinating details about the lives of Revolutionary-era soldiers as well as their widows and children, but also the odd artifact, including six samplers, sent in to prove various family dates (marriage, births, and so forth) to secure a pension (see table 6.1).[74] These samplers are noteworthy not merely because the applicants sent them in but because the federal government *accepted* them as evidence. They were not rejected as ornamental trifles, nor were they discarded by the pension office. Instead, the samplers were closely examined and used to make decisions about whether the family should receive a military pension, then were kept as part of the official file.

Widows received the right to apply for a pension beginning in 1836. To qualify, the woman had to prove that her late husband had served in the conflict and that they were married at the time.[75] In the absence of a marriage license for Elizabeth and Daniel Hearn, Mary's mother and Mary and Peter Fralick offered sworn statements to a local judge in Marathon, New York. The statements track Daniel Hearn's service, as well as the subsequent movements of his widow and daughter.[76] Initially the sampler was used as evidence to prove the connections between the Revolutionary veteran Daniel Hearn, his widow, Elizabeth, and his daughter, Mary. When Mary and her mother compiled their pension application in the spring of 1846, Mary's statement explained that

she has no record of her age Exsept what is contained in a piece of needle work in her possession made by herself as many as 53 years ago which needle work is in the words and figures[,] to wit "And I said O that I had wings like a Dove, for then I would fly away and be at rest—Mary Hearn Born December 12th 1782 marked this sampler in the year 1793" which would make [her] 64 years old Dec next. . . . She made said record in needlework, the recollection she had of her age from her earliest childhood, as her age was told her by her mother.[77]

Accompanying Mary's statement was a supporting statement by Walton Swetland, a local judge, who examined the sampler and "believe[d] the said Marys age to be therein truly stated. . . I have carefully examined the same and believe it to be what it purports to be[:] an ancient memorandum or memento of the age and needle work by Mary Fralick."[78] These statements were important because they established Mary Hearn's date of birth, helping prove the marriage of her parents and qualifying her mother for a pension.

While the value of the sampler as appropriate legal evidence of Daniel and Elizabeth Hearn's marriage was not disputed, the accuracy of this particular sampler came into question during the pension application process. Although Swetland was convinced that it offered the requisite information, the pension office did not initially agree. The sampler was sent to Washington and examined. In the eyes of the pension office, the sampler appeared to be altered. And it still shows evidence of having some of the numbers in the signature picked out. At some point after initially making the sampler in 1793 but before it was sent to the pension office in 1846, Mary Hearn Fralick picked out her age and one of the digits of her birth year. After the pension office questioned this, Mary made another statement explain-

ing that "at the time she mailed said sampler . . . the figures which appear altered appeared somewhat obliterated and Deponent caused said figures to be reworked and that said figures are the same they were originally except the stile of the work and the color of the silk."[79]

Did Mary Fralick pick out these numbers to hide her age at some time before she and her mother started their pension application? Or did she do it because the sampler was difficult to read by the mid-1840s and she wanted the pension office to be able to easily read the information? Or was she trying to change the dates to assist with the pension application? We cannot know for sure. Apparently, Mary Fralick's explanation of the alterations on her sampler was acceptable to the pension office; the office awarded her mother, Elizabeth Hearn, a pension of $276.66 per year, which was paid until her death in December 1847.[80]

Like Mary Hearn Fralick's sampler, four of the other five samplers found in the pension files were used as evidence to secure pensions for women (either the maker or her mother).[81] It is significant that these "female" items, by virtue of being needlework, were used to help secure support for another female family member. The use of these samplers in this manner fits into the established patterns of female inheritance, as discussed in chapter 4. Whereas land and currency were passed down from father to son, women received moveable goods for their dowry, representing their share in their father's estate.[82] Furthermore, these samplers do not simply fill in the historical record for the twenty-first-century scholar, who is used to seeing how public records and manuscript collections omit women. The samplers had to fill a gap at the time, whether for the women who made them or for a female relative in need of financial support.

And these examples show that women understood their textiles and needlework as their property. Anthropologist Annette Weiner has asserted that "all personal possessions invoke an intimate connection with their owners, symbolizing personal experience that . . . adds value to the person's social identity."[83] Likewise, using their needles offered antebellum women a way to both tell and control their story. For the women discussed here, their needles were always accessible, offering not only comfort and warmth for their families but also a means of expression and a source of identity—and not merely symbolically—for themselves.

FIGURE 7.1. SAMPLER BY ELCEY PATTERSON (1803–1862), 1845, UNION VILLAGE, OHIO.

Courtesy of Northeast Auctions, New Hampshire.

Stitched verse: *Christ comforteth his disciples John C.24 V1. Let not your hearts be troubled, Ye believe in God believe also in me. In my fathers house are many mansions.*

Forty-two-year-old Elcey Patterson used her sampler to tell her life story. She included the basic facts of her life and also chose verses that had meaning for her.

7
THREADS
OF LIFE

Needlework as Memorial

IN THE EARLY 1830s, decades after making her schoolgirl sampler, forty-year-old Caroline Gilman (1794–1888) reflected on her family's changing perception of the sampler. "This sampler was a matter of curiosity, and sometimes of ridicule, to my children," she wrote, "but now that they perceive my gray hairs and increasing infirmities, I find the sampler neatly folded and laid aside, and sometimes a conscious look reveals to me that they think I may soon be folded to rest in the grave."[1] For Gilman and her children, the sampler became intertwined with the threads of her life as it progressed. And its meaning changed over those years, evolving from a young girl's school lesson to a quaint outmoded household decoration to a family touchstone, cherished for its association with a beloved mother. Although not specifically using the words, Gilman suggests that "family chauvinism"—a belief in the superiority of one's own family—may have been at work.[2] The sampler took on a connotation of far more than a school lesson; it was proof of the family's

past and a demonstration of their familiarity with genteel standards. Autobiographical needlework suggests that the maker was proud of her skill, making it by definition somewhat narcissistic. Even when Gilman was "folded to rest in the grave," she knew her sampler would remain behind to tell her story.

When forty-two-year-old Elcey Patterson (1803–1862) stitched her sampler in 1845 she left no doubt as to the motivation behind her work (figure 7.1).[3] The bottom section reads, "Elcey Pattersons Sampler August 23 1845/ When this you see remember me my old companions / Look at this and learn of me my Young fiends [sic] / Elcey Patterson is my name you see." While this verse is not original, or individual, instead drawn from autograph albums, gravestones, and other samplers of the nineteenth century, the layout of the sampler reflects choices made by its stitcher and can be read as an autobiography of its maker.

The top section presents the maker's early history. After the traditional alphabets and numbers, which she would have learned as a young girl, the maker stitched, "Elce Patterson was Born in the state of Ohio Butler County Lemon Township April 17 1803." Patterson was three years old when her family became members of the United Society of Believers, a Shaker community in Warren County, Ohio. Patterson's Shaker community grew from the first group of dissident Quakers who came to America in 1774 with leader Mother Ann Lee (1736–1784). At the movement's peak in the 1850s, there were nineteen Shaker communities in the United States, with approximately six thousand members. Patterson's community, Union Village, near Lebanon, Ohio, was initially organized in 1805, a year before Patterson and her parents arrived; it became the largest Shaker community west of the Allegheny Mountains.[4]

Shakers chose to separate themselves from the world, practicing cooperation, harmony, and simplicity, as well as equality between the sexes. Shakers valued function over appearance, which is reflected in Patterson's sampler. Shaker girls and women did not display their samplers the way that many schoolgirls did, nor were the Shaker samplers decorated with the floral borders, small animals, and other spot motifs common on American samplers. These samplers instead followed the style of functional marking samplers, since the Shakers' communal washhouses made marks essential for distinguishing the inhabitants' clothing.[5] Yet even as Patterson's sampler fits the Shaker functional style and was probably used as a teaching exercise, it still carries personal messages by and about its maker.

While the top section tells the story of Patterson's childhood, the middle section reflects the story of her adulthood. There is a band with a series of marks made up of two or three initials each. A closer study of this series of initials, and the knowledge that Patterson was part of a Shaker community, reveal that the initials are those of founding Shaker elders and eldresses.[6] While these names would have been influential on Patterson in her youth, as she aged they would have continued to serve as role models for her. In addition, as a Shaker, who did not believe in procreation, she would not marry and have children, so the usual type of family record needlework, tracking marriage and children, would never be available to her. Perhaps the initials of the eldresses on the sampler filled that role; she considered them to be part of her family and including their initials provided a sense of tradition and continuity. There were no children to pass the sampler to, who would have other motives to remember her, hence the need for the instruction— or plea. Whether the eldresses represented on the sampler were still alive or not, Patterson may have

started to see them as peers by the time she made the sampler as an adult, rather than as the teachers of her youth. The bottom two sections of the sampler, with a verse and Patterson's statement of purpose, quoted above, bring her life story to a close. When she made this sampler, Patterson was one of the community's teachers, instructing the girls in needlework as well as other subjects.[7]

Her sampler was at once a documentation of her life and a lesson for those to come. Patterson selected a religious verse for her sampler, "Christ comforteth his disciples." But while Patterson provided a biblical citation for her verse on the sampler, "John C24. V1," it is not quite correct: the verse actually comes from John 14:1–2.[8] Patterson's sampler ends with the request to "remember me." Undoubtedly, the words of the biblical passage provided comfort to an aging woman who was starting to think about the end of her life—she may have been cheered to remember that "in my father's house are many mansions." Like Caroline Gilman and her sampler, Elcey Patterson left behind an object upon which she made her mark, and one that symbolized her entire life story.

A sampler made by Patty Bartlett Sessions (1795–1892), stitched in two distinct stages thirty-seven years apart, evolved from school project to biographical object (figure 7.2).[9] Patty Bartlett started the sampler in 1811 when she was a young woman of sixteen in Maine but did not finish it until she was fifty-four and living in Utah. Stitched as it was, in girlhood and in maturity, almost forty years apart, the sampler shows text, design, and skill that are different from top to bottom, while telling her life story like Patterson's sampler does.

Patty Bartlett was born in Maine in 1795, to Enoch Bartlett (1742–1825) and his second wife, Martha Ann Hall Bartlett (1742–1828). When she started the sampler, she was attending a local school.

However, she married the next year, when she was seventeen, which probably explains why she did not finish her sampler at the time. She wed David Sessions (1790–1850) against her parents' wishes, and they had their first child in 1814.[10] Over the course of her marriage to David Sessions, the couple had eight children, although four died during childhood. Patty became a midwife as a young woman, eventually delivering almost four thousand babies over the course of her life. She also used her needlework skills to earn money to help with the family's expenses.[11]

A close look at the sampler shows that in 1811 she stitched the top and side borders, along with the top section containing alphabets, her name, the year, and a short verse found on countless New England samplers: "Patty Bartlett is my name and with my needle wrought the same." In 1848, she finished the bottom section with animals, flowers, signature, a verse, and the bottom border. The bottom section also has a verse:

> The mind should be inured to thought
> the hand in skilful labours taught
> Let time be usefully employed
> And art and nature be enjoyed.

Taken separately, the two parts of the sampler represent the two ages of the woman as she stitched. At the top she signed her birth name, "Patty Bartlett," and stitched a rather common, rote schoolgirl verse. The bottom is signed with her married name and makes no mistake about the time and her age, "AD 1848 I commence again here in the 54th year of my age." Below this she completed the sampler with "Patty Sessions Salt Lake Valley North America August 22 1848."[12] The animals included in this section may have been modeled on those on her farm, in contrast to the flowers or

FIGURE 7.2. SAMPLER BY PATTY BARTLETT SESSIONS (1795–1892), 1848, UTAH.

Private collection, courtesy of Suzanne B. Anderson.

Stitched text:

> *Patty Bartlett is my name and with my needle wrought the same.*
>
> *The mind should be inured to thought / the hand in skilful labours taught / Let time be usefully employed / And art and nature be enjoyed.*
>
> *AD 1848 I commence again here in the 54th year of my age. Patty Sessions Salt Lake Valley North America August 22 1848.*

In Utah, at age fifty-four, Patty Bartlett Sessions completed the sampler she had started as a young woman of sixteen in Maine. A convert to Mormonism, Sessions took her unfinished sampler with her across the country from Maine. The top and bottom of the sampler document the two stages of life that she experienced as she stitched.

standard motifs designed by a teacher for use on a young girl's sampler. The verse in this section seems to reflect her older stage of life, cherishing the value of industry and counseling an appreciation of work, art, and nature.

When Patty was thirty-nine, she converted to Mormonism. Missionaries came to her town in Maine in 1833. Patty was the first of her family to believe in their message, but she held off her baptism in the faith for a year, until 1834, to give her family more time to explore the religion. As she entered her forties, Patty and her family started a new life with the Mormons. They moved west to Missouri in 1837, when Patty was forty-two, subsequently moving to Illinois in 1839, when Patty was forty-four.[13]

In 1846, when she was fifty-one, Patty began to keep a diary. Her sampler makes its appearance in entries from the spring and summer of 1848. She had packed the sampler away, unfinished, with her silk threads, and carried it west during the 1830s. Her diary entries about the sampler are frustratingly mundane, such as her first notation about picking up the sampler after almost forty years, "Commenced to finish my sampler that I began when I was a girl and went to school."[14] She noted working on the sampler in March, May, and June 1848. On August 22, 1848, she recorded, "Finished my sampler that I commenced when I was young."[15]

However, reading the other diary entries from these months places her terse comments into context, suggesting a theory about her motivation in picking up the sampler again. First, in late March 1848, about ten days after she recorded working on her sampler, there was a large leak in her house during a torrential rainstorm, and many of her things were damaged. About a month later, Patty noted that she had obtained her first floor since moving

to her current home. "I helped Mr Sessions lay down a floor," she wrote, "the first floor that I could set my foot upon as my own for more than two years I have lived on the ground all that time."[16] Without stating it directly, her words convey a sense of past impatience and dissatisfaction, now at least somewhat allayed. Feeling settled at last, Patty Sessions may have picked up her sampler with an eye toward framing it and hanging it on her wall, demonstrating her gentility and also staking a claim to the house as hers.

Despite her religious faith, and even though she herself was "sealed" to Joseph Smith (1805–1844) in 1842, Patty found it difficult when her husband David took a plural wife in 1845. For Patty, her own plural marriage to Joseph Smith seems to have been a spiritual one, intertwined with her faith in Mormon beliefs.[17] In contrast, David's plural wife lived nearby, and Patty had to assist with caring for that woman and her children, as well as working in her own household. Several of her diary entries from 1848 record difficulties with her husband, who was traveling between the homes of his two wives. Patty felt neglected and had to do much hard work alone at her home during the months that she worked on her sampler. Her own children were grown and out on their own, so she did not have their assistance. On May 12, 1848, during the same season she was working to complete the sampler, she noted, "much to do got very tired" and on July 1, 1848, she wrote, "finished watering the garden Mr Sessions came home just as I got it done."[18]

Given these events and her feelings of unhappiness, as well as uncertainty, Patty's decision to pick up her sampler may suggest that it afforded her a sense of agency and a way to gain some control over her surroundings. It also may have allowed her a means of expression for her womanly skills

in contrast to those of her husband's younger, less-experienced wife. Indeed, reflecting on her diary entries adds resonance to her choice of verse on the bottom half of her sampler, "The mind should be inured to thought / the hand in skilful labours taught / Let time be usefully employed" Perhaps she sought to be inured to jealous thoughts about her husband's second wife and to protect herself from these thoughts. And by stitching her sampler, she was "usefully employed." Indeed, historian Laurel Thatcher Ulrich has suggested that a need for a diversion may have contributed to Patty's actions.[19]

Many of the samplers and quilts described here, such as the one by Patty Sessions, can be considered as "life reviews." Psychiatrists have found that the life review is a naturally occurring universal process in Western societies as aging people remember past experiences and unresolved conflicts, attempting to complete them before they die.[20] This is not just a modern-day phenomenon; historians of aging have been able to identify the same process in the writings of eighteenth- and nineteenth-century men and women. Susan Stabile's study of a group of aging Philadelphia female friends in the late eighteenth and early nineteenth century found that these women each engaged in "gather[ing], sort[ing] and integrat[ing] the moments of their lives." As they did so, they created and preserved objects, such as commonplace books, that embodied memories that "might otherwise remain dormant or forgotten."[21] Likewise, a study of published life narratives from the eighteenth and nineteenth centuries suggests that "writing a life narrative aided in the reframing of the past, expanded the consciousness of self, and prepared the individual for a new future."[22] Stitching an autobiographical or epistolary sampler or quilt, which required similar repetitive motions to writing and offered the chance to reflect on the words as they were stitched, provided the same outlet to aging women.

In contrast to Patty Sessions, who picked up a half-finished sampler, Ruth Pierce Croswell (1765–1862) started a fresh sampler in 1827 when she was sixty-three (figure 7.3).[23] Stitched in two shades of blue thread on a bleached piece of linen fabric, the sampler begins with four traditional sampler alphabets. The bottom half of the sampler provides some rather untraditional commentary, however. "Ruth Croswell Marked this in the 63 year of her age 1827," it begins, as "A Present for Elisabeth L Wey and may she like Elisabeth of old walk in all the commandments and ordinances of the Lord blameless." A second inscription reads:

> While prudence guards the lovely fair
> From mans deceptive flattering snare
> May modesty in outward mien
> Bespeak the virtuous mind within.

The sampler continues with numbers one through ten, and then provides genealogical information: "Ruth Pierce born February 22 1765 was married to Thomas Croswell July 18 1791." The sampler concludes with three rows of stitching that were added well after Croswell stitched the sampler in 1827—indeed, at least one of the rows was stitched after her death in 1862, since it documents that date. These rows read, "Dr C Died Jan 16 1844 aged 76. Elisabeth L. Wey Died Feb 10 1845. Ruth Croswell Died January 7 1862."

Ruth Pierce was born on February 22, 1765, in Litchfield, Connecticut (figure 7.4).[24] During her childhood, Litchfield was a busy town, located at a transportation hub and known for its cultured and educated residents.[25] Ruth's younger sister, Sarah (1767–1852), would grow up to found the Litchfield Female Academy, which provided a well-rounded

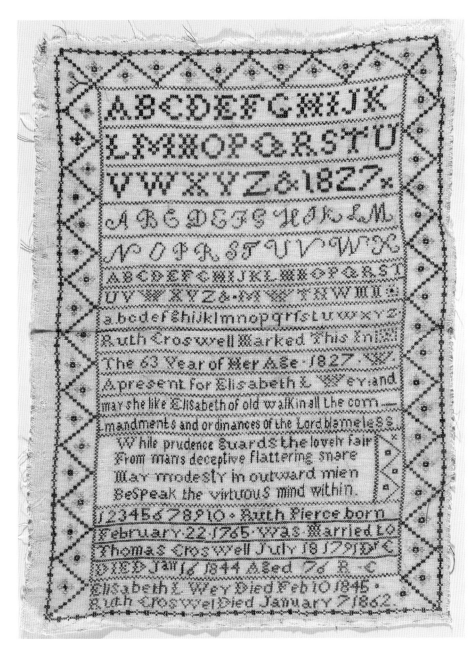

FIGURE 7.3. SAMPLER BY RUTH PIERCE CROSWELL (1765–1862),
1827, CATSKILL, NEW YORK.

Collection of the Litchfield Historical Society, Litchfield, Connecticut.

Stitched verse:

While prudence guards the lovely fair / From mans deceptive flattering snare / May modesty in outward mien / Bespeak the virtuous mind within.

Sixty-three-year-old Ruth Pierce Croswell stitched this sampler as a gift for her young granddaughter. Unfortunately, Ruth's granddaughter, Elisabeth Wey, died in 1845 at age twenty-one. Croswell kept the sampler, and another family member eventually added the date of Ruth's death along the bottom.

FIGURE 7.4. SILHOUETTE OF
RUTH CROSWELL (1765–1862)
BY UNIDENTIFIED MAKER, 1790–1840,
CONNECTICUT OR NEW YORK.

*Collection of the Litchfield Historical Society,
Litchfield, Connecticut.*

some study for she says she wished to ornament their minds when they are with her."[26]

Although Ruth did not become a teacher as Sarah did, she seems to have shared Sarah's belief in combining needlework with intellectual and moral purposes. One obituary attests to Ruth's quilt-making skills, describing a particularly special quilt that she made as "the crown of her industry." According to this source, "she called it 'The Valley of the Mississippi.' The river, with its winding courses, was of white cotton cloth and ran through the middle of the covering. On either side the region which could be called Christian was represented by blocks of bleached muslin; the region just opening to the Gospel by blocks of gray muslin; and the region still in heathen darkness by blocks of black cambric."[27] The religious symbolism that Croswell planned into her quilt suggests that she was accustomed to using her needle to express her opinions and ideals.

She also valued her connection to American history. Ruth's brother, John Pierce (1752–1788), served as the army's paymaster during the American Revolution and developed a friendship with George Washington (1732–1799). In addition, John's wife's father was a physician who treated Washington in New York City, strengthening the social bonds between the families. During a 1789 visit to her brother's in-laws, Ruth was able to attend the inauguration festivities for Washington, and on another visit, she took tea with the Washington family. Reportedly, Ruth "remembered vividly to her last days the majestic form of [Washington] on whom so many and such vast hopes then centered, as he stepped forth upon the balcony of the old federal hall in New York . . . and . . . took the solemn oath to faithfully administer the constitution and the laws of these United States."[28] Family reminiscences suggest that Ruth Croswell held these memories dear throughout her life, retelling them from

education for hundreds of girls and young women during the early decades of the nineteenth century. Sarah Pierce privileged academic accomplishments over the ornamental but realized that she had to provide instruction in needlework and other fancy arts in order to attract students. However, she insisted that needlework be accompanied by reading aloud or serious conversation. One of Pierce's students wrote to her sister in 1802 that Pierce did "not allow anyone to embroider without they attend to

time to time to her friends and family.[29] Her sampler and the story of her attendance at Washington's inauguration help us understand Ruth Pierce Croswell as a woman who was proud of her family and her own achievements and suggest her desire to be remembered as a model by her children and grandchildren.

Ruth and Thomas Croswell adopted a daughter, Caroline Stanley (1796–1881). She was born in Fort Montgomery, New York, in 1796, the daughter of Rufus Stanley (1767–1801) and Lydia Collins Stanley (1772–1801). Lydia Collins was born in 1772 in Litchfield, seven years after Ruth was born in 1765, so Ruth may have known Lydia and her family during her girlhood in Connecticut. Caroline Stanley's parents died within weeks of each other in 1801, and Caroline was adopted by the Croswells. Caroline Stanley married William Wey (d. 1856) in 1815. Wey was a druggist, and after he married Caroline, he took over running the pharmacy that Thomas Croswell had started in the mid-1790s. Among the couple's ten children was a daughter named Ruth Croswell Wey (b. 1820) and a son named Thomas Croswell Wey (b. 1822). In addition, the couple were parents to Elisabeth L. Wey. She was born on October 2, 1824, and was just three years old when the sampler was made.[30]

Ruth Pierce Croswell stitched a message to her three-year-old granddaughter, Elisabeth Wey (1824–1845), in the 1827 sampler, spelling out virtues she hoped Elisabeth would cultivate, as well as a prescription for her actions: "May she like Elisabeth of old walk in all the commandments and ordinances of the Lord blameless." The phrase "Elisabeth of old" refers to the biblical story of the mother of John the Baptist, who, after suffering barrenness for years, found herself with child, because she "walked in all the commandments and ordinances of the Lord blameless."[31] This biblical reference was often included in nineteenth-century obituaries, serving as a high form of praise for those who lived Christian lives and were considered to be virtuous by their neighbors. Women also used the phrase in their diaries and letters to encourage themselves, as well as friends and relatives, to live up to the model provided by the biblical story.[32] The story, and these phrases, offered a goal for women to work toward, but also conveyed accomplishment when they died.

The verse on Croswell's sampler that begins "While prudence guards the lovely fair" is an unattributed verse found on other New England samplers.[33] However, in Croswell's case, the verse's focus on "prudence," "modesty," and "virtuous mind" seems to follow her sister Sarah's ideas about educating girls, encouraging the development of the mind. Croswell may have been providing her granddaughter with additional lessons to learn and goals to reach for as she grew into womanhood.

While many of Ruth Pierce Croswell's generation considered themselves blessed to live to the ripe old age of sixty, she was only beginning her old age when she stitched this sampler at sixty-three in 1827. On January 16, 1844, when she was seventy-eight, her husband died. Sadly, just over a year later, her granddaughter—and the recipient of her sampler—Elisabeth Wey died on February 10, 1845, when she was twenty-one years old. After her husband's death, Ruth moved into her daughter Caroline's household.[34] Ruth Croswell died on January 7, 1862, at the extreme old age of ninety-seven. The esteem in which she was held by her community is evident from her obituaries; they report that during her funeral services all places of business in town were closed and that the bells of all of the local churches tolled as her body traveled to the cemetery.[35]

Croswell's sampler, like Elcey Patterson's and Patty Sessions's (and unlike schoolgirl samplers, planned out by a teacher and rigidly stitched with

alphabets, approved verses, motifs, and a floral border), shows the intent of its maker. She chose to present her story: she decided how to tell it and what to say. Her needle gave her the agency to tell her own story and to represent her life as she saw fit.[36] The sampler also recorded evidence of her life—of her existence—to remind others once she passed that she had lived. Although young Elisabeth did not outlive her grandmother, the sampler continued its own life. Decades after it was initially stitched in 1827, the death dates of its recipient, its maker's husband, and its maker were included along the bottom by an anonymous hand. The sampler was passed down in the extended family until 1949, when it was given to the Litchfield Historical Society.[37]

Memorial Needlework: Keeping the Family Alive

Perhaps the largest subtype of biographical needlework is memorial—objects made to remember a loved one or to venerate their maker. Family record samplers, such as the one by Esther Banister Richards in chapter 6, may be the most common example of this genre of needlework. These samplers are a type of decorative needlework that became popular during the early republic period, roughly from 1785 to 1840. They were inspired by some of the social changes taking place for American families. The size and composition of the family was decreasing, as the nuclear family started to become the standard unit. Families also began to experience increasing levels of privacy as domestic space allowed more room for individuals and as home life became separate from public life. In time, the family, rather than the community, served as the

center of emotional and economic support. These changes led to an increased interest in genealogy and in creating and displaying family records.[38]

Needlework family records were often made by schoolgirls; hundreds have been published in catalogs of schoolgirl needlework. One study found that the majority were made by the oldest or youngest daughter in the family.[39] Many are a snapshot in time—partially filled in with birth, marriage, and death dates at the time the sampler was initially stitched. However, others were filled in more completely over subsequent decades. These examples fit the category of biographical needlework because they acted as "vehicles for bringing past time into the present."[40] They show that families had an interest in maintaining a visible record of their history, enhancing the needlework's function as biographical objects.[41]

Dorothy Knight (1803–1854) of Phillipston, Massachusetts, was fourteen in 1817 when she initially stitched her family record sampler (figure 7.5).[42] It has a classic floral border and includes a house along the bottom along with stylized drapery at the top. Dorothy stitched "Family Record" at the top and divided the body of the sampler into columns headed "Names," "Births," and "Deaths." The lives of her parents and siblings are neatly represented. In 1817 she stitched their names and birth dates. At a later time, the death date for each family member was added, including that of Dorothy, who passed away at the age of fifty on September 8, 1854. Indeed, even after Dorothy's death, additional dates were added to the sampler: her brother Rufus's death in 1855; sister Eunice's death in 1857; brothers Jason's and Levi's death in 1861 and 1880, respectively; and, finally, sister Rebekah's passing in 1887 was recorded, seventy years after the sampler was initially stitched. A close look at the sampler suggests that these later

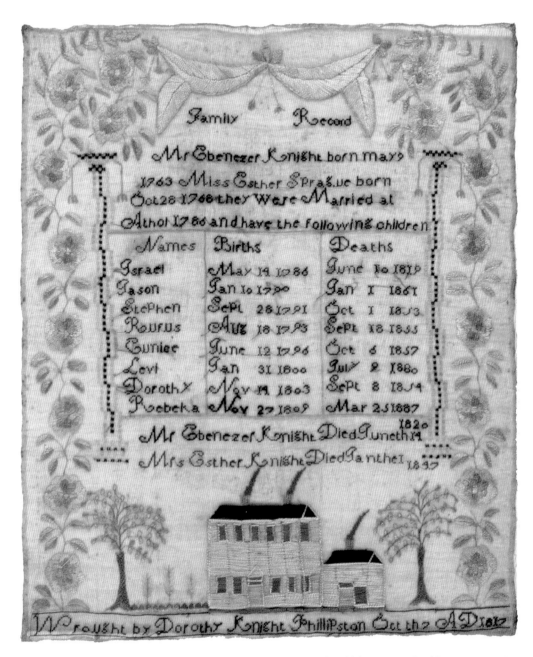

FIGURE 7.5. FAMILY RECORD SAMPLER BY DOROTHY KNIGHT (1803–1854),
1817, PHILLIPSTON, MASSACHUSETTS.

Collections of Old Sturbridge Village, Sturbridge, Massachusetts, 64.1.108. Photograph by Henry Peach.

Dorothy Knight initially stitched her family record sampler in 1817 when she was fourteen. Over the next several decades, Dorothy or another family member added to the sampler, recording the death dates of her siblings and even of Dorothy herself.

dates were added at two points in time, if not more; the color and density of the thread for these entries are visibly different.

Knight's sampler, like the others discussed here, is the result of intergenerational collaboration. She created a document that (by the work's definition) she knew she could not finish. At least one person from a later generation was implicit in the creation of this sampler, if only to add the creator's death date.[43] Chapters 4 and 5 explore gift needlework, which often reminded the recipients of their responsibility to carry forward the memories and achievements of past generations, but the family record samplers discussed here took this responsibility a step further. They do not simply transmit family information, they enlist the next generation in completing them, requiring physical action to bring the memories forward.

Although aging women were counseled by their church and their society to seek resignation about the passage of time, in light of the prospect of eternal happiness after death, they still tried to exert some control over it. In her study of letters and diaries kept by aging American women between 1785 and 1835, historian Terri Premo proposed that women recorded family data as one way of coping with growing older.[44] Keeping family records enabled women to have some agency in the aging process. Tracking family records was considered a woman's task, perhaps as a reflection of her role as a life-giver, so it is not surprising that so many women turned to needlework as one means by which to accomplish that work.[45] Putting these records on paper or cloth provided a sense of permanence for the women by allowing them to mark their own place in time.[46] Deborah Logan (1761–1839) noted her motivation to observe the "anniversaries of Births and Deaths of those [she] love[d]. . . .

They seem like watch words to awaken long trains of ideas and call up tender feelings and affections."[47] Perhaps the most obvious example of how "family chauvinism" could motivate, family records offered a decorative way to show the family's history for all to see, centrally located on the wall of the parlor. These objects provided the added value of demonstrating not only the maker's skill but also the family's very existence.[48]

The urge to keep track of family births and deaths seems to have driven some families to add this information to samplers that were not initially stitched in the family record format. A sampler made by Sarah Holmes (1793–1842) includes the year she completed it—1801 (figure 7.6).[49] Along the bottom, above the original signature, an unidentified person supplemented the sampler after Holmes's death by stitching "Died 1842." Over to the left, along the same row, the same hand stitched Holmes's birth year, "Born 1793," so that we know she originally made it when she was eight (figure 7.7). This sampler retained value for the family. It was passed down and given to the New-York Historical Society in 1968 by the maker's great-granddaughter.[50]

While there are many extant family record samplers to study—both completed and incomplete—only a few "family record quilts" have been found. Making a quilt and giving it to her granddaughter in 1846 offered sixty-one-year-old Mary Rooker Norris (1785–1868) a way to receive recognition for her skill and accomplishments and to embed cherished values in the object (figure 7.8).[51] She was also leaving a piece of herself behind. She created her family in fabric, piecing together her relations in the top of her quilt, which includes a record of her family's births, marriages, and deaths in the center. Then, just as her family tree had grown, branch by branch, Norris attached a series of rectangular border strips

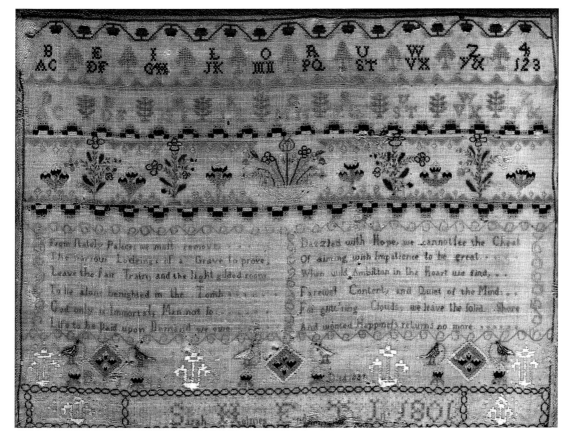

FIGURE 7.6. SAMPLER BY SARAH HOLMES (1793–1842), 1801, NEW JERSEY.

Collection of the New-York Historical Society, 1968.45.

Stitched verses:

From stately Palaces we must remove, / The narrow Lodgings of a Grave to prove, / Leave the fair Train, and the light gilded room / To lie alone benighted in the Tomb. / God only is immortal, Man not so: / Life to be paid upon Demand we owe.

Dazzled with Hope, we cannot see the Cheat / Of aiming with Impatience to be great. / When wild Ambition in the Heart we find, / Farewel Content, and Quiet of the Mind: / For glitt'ring Clouds, we leave the solid Shore / And wonted Happiness returns no more.

Although the alteration is difficult to see, someone added to the sampler made by eight-year-old Sarah Holmes. After Sarah's death in 1842, her birth year and death year were stitched above her signature, one year on the left and one on the right.

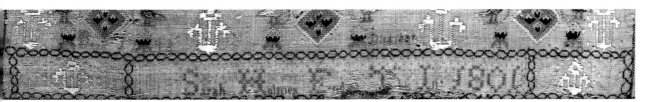

FIGURE 7.7. DETAIL OF DATES ADDED TO SARAH HOLMES'S SAMPLER.

to the sides of her quilt, building it out and making it larger.

Mary Rooker was born in England in 1785, one of twenty-one children of Reverend James Rooker (1756–1828) and Mary Berry Rooker (1762–1814).[52] Being part of such a large family may have influenced her choice to make a family record quilt. She had many family dates to keep track of and had to find her own identity among so many brothers and sisters. The quilt was a gift to the maker's granddaughter, Mary Norris (b. 1845), the daughter of her oldest son, John Saurin Norris (1813–1882). Young Mary was both the first granddaughter and her grandmother's namesake. All three of the elder Mary's children had their first daughters in 1845, and all three were named Mary, presumably in honor of their grandmother.[53]

Mary's quilt provides a wealth of family records. Made in the style known as a medallion quilt, the central medallion section includes Norris's inked family records. Four sections read as follows:

> John Saurin Norris / son of / John and Mary Norris / born / Baltimore City / March 25 1813 / J. S. Norris / and H. T. Tyson / married / in / Philadelphia / June 7 / 1838 / Mary Norris / a memento of / affection / from her Grandmother / Mary Norris Hagerstown, Md. / February 12, 1846 / Isaac T. Norris / born 24 March 1842 / John Olney Norris / born / 11 November 1843 / Mary Norris / born / 4 April 1845 / Henrietta Norris / born / Henrietta T. Norris / daughter of / Isaac and Elizabeth Tyson / born / Baltimore City / Nov. 12 1809.

These records list the quilt recipient's father and mother by name with their birth dates and marriage date, as well as the names of her maternal grandparents. Her two older brothers are also documented with their birth dates. Her younger sister's name, Henrietta, was added at some point, although Henrietta's birth date is left blank. Last, but not least, the maker documented herself, inscribing, "Mary Norris a memento of affection from her Grandmother Mary Norris Hagerstown, Md February 12, 1846."

After her husband died in 1829, Mary taught at a seminary for young ladies run by two of her sisters. In 1830, they advertised that "Mrs. Norris, whose talents as a Teacher will be remembered by many, has returned to the city, and will resume her station in the Institution." Given the skill and artistry of the inscriptions inked on her quilt sixteen years later, it seems likely that this was one of the skills she taught at the ladies' seminary.[54] When she made this quilt, Mary was living in Hagerstown, Maryland, with her daughter Sarah (1822–1878) and son-in-law Thomas Myers (1813–1894), a Methodist itinerant preacher.[55]

The medallion style and chintz appliqué technique seen in Norris's quilt are representative of neoclassical style, first made popular after the American Revolution and lasting into the era of the early republic, but dated by 1846.[56] Classical style does seem to have remained popular in Maryland longer than in some regions.[57] But like the gift quilts made by Catherine Marion Palmer and Rachel Smith that are discussed in chapter 5, this quilt may have employed a dated style to underscore its purpose as a family touchstone. The medallion style with borders, particularly when made with English chintz fabrics, as in this quilt, may reflect Norris's English roots and could have offered her a certain comfort level.[58]

꙳ ꙳

One of the necessary components on all of these examples of family record samplers and quilts was

FIGURE 7.8. QUILT BY MARY ROOKER NORRIS (1785–1868),
1846, HAGERSTOWN, MARYLAND.

The Daughters of the American Revolution Museum, Washington, DC. Friends of Museum Purchase.

While family record samplers were quite common during the early nineteenth century, family record quilts were rare. In this example, Mary Rooker Norris inked the birth and marriage dates of her children in the center block and gave the quilt to her granddaughter as a gift.

the column headed "Died." Previous studies have documented the changes in mourning practices that took place during the late eighteenth and early nineteenth centuries. In reaction to larger social and cultural trends, mourning ceased to be a community activity and became a personal and familial tradition.[59] In addition, the soul of the deceased was celebrated with a rising set of romantic sensibilities and activities. New types of mourning objects such as jewelry, prints, ceramics, and posthumous portraits became common as the bereaved tried to recapture what they had lost.[60] One examination of such objects suggests that "material articles become specially imbued with the emotions of the people who come into contact with them through mere association or through the process of production and exchange."[61]

When she was ten, Mary W. Evans (1814–1888) stitched a family record at Miss Balch's School in Providence, Rhode Island (figure 7.9).[62] Like Dorothy Knight's sampler, the Evans piece employs floral elements and columns. At the top she stitched "A Family Record," and below that, she produced neat columns for the names, births, and deaths. Mary was the only surviving daughter in her family, as well as the youngest at the time, which probably contributed to her role as family record keeper.

As on the Knight sampler, death dates are meticulously included, including Mary's own in 1888, over sixty years after she first stitched those columns. When Mary stitched the sampler in 1824 at the age of ten, she included all of the birth dates for her family, along with death dates for her father, two sisters, and one brother. The sampler may have been a sentimental object for Mary when she made it, because her father had died two years earlier while working as a carpenter on board the ship *Constellation* in Valparaiso, Chile.[63] Over the next sixty-four

years, death dates were added to the sampler for Mary's mother, who died in 1864; for her brothers, Albert and Elisha, who died in 1880 and 1886, respectively; and for Mary herself, who passed away on November 7, 1888, at the age of seventy-four. These additions are discernible because of the thread used to stitch them, which is a different color.[64]

While the line of descent for the Knight family record has been lost, the Evans family record sampler traveled through four generations of the family until it was donated to Winterthur Museum and Country Estate in 1988. Mary W. Evans married Benjamin Cornell (b. circa 1812) around 1833, when she was nineteen. The sampler passed to Mary's youngest daughter, Laura Cornell (b. circa 1851), after Mary's death. Laura Cornell married Henry S. Easton (b. circa 1846), and they had a son, Walter (b. 1878). The sampler eventually passed to Mary's great-granddaughter, Walter's daughter and namesake for his mother, Laura Easton (b. circa 1906). She presented the sampler to the museum, a century after its maker's death.[65]

The Evans and Knight family record samplers are particularly interesting because they were made by young girls who then kept them close for the rest of their lives and updated them, demonstrating that they fulfilled functions of identity and expression for their makers for decades. Other completed family records were filled in decades after the maker passed away, showing the value they held for the maker's family as a memorial. The maker died, but the sampler lived on.

For example, a family record initially made by Frances Fales (1794–1824) when she was thirteen in 1807 was filled in for decades after she died at the age of thirty in 1824 (figure 7.10).[66] When Frances made the sampler in 1807, she filled in birth dates for her parents and all eleven of her older siblings.

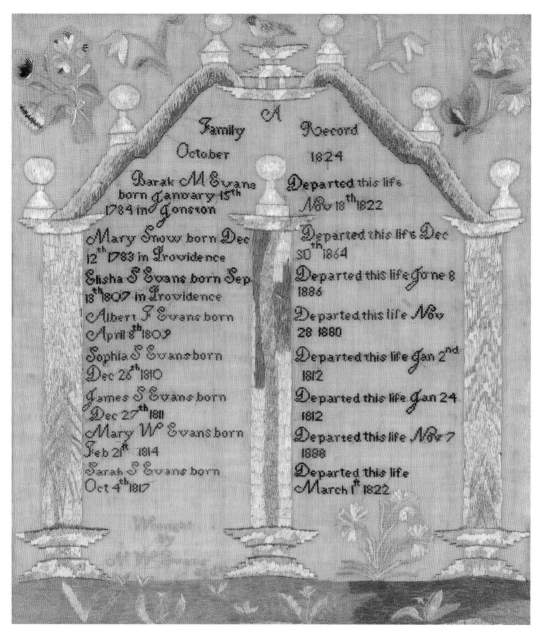

FIGURE 7.9. FAMILY RECORD SAMPLER BY MARY W. EVANS (1814–1888),
1824, PROVIDENCE, RHODE ISLAND.

Collection of Winterthur Museum and Country Estate, Delaware.

Like Dorothy Knight, Mary W. Evans stitched her family record sampler as a young girl. Over the next sixty-five years, Evans or another relative continued to update the sampler, adding the death dates of Mary's siblings and eventually of Mary herself. The sampler was passed down in Mary's family until 1988, when it was donated to Winterthur Museum and Country Estate.

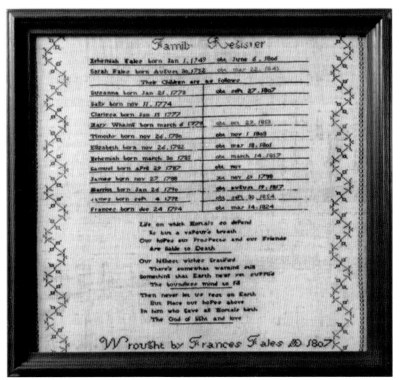

FIGURE 7.10. FAMILY RECORD
SAMPLER BY FRANCES FALES
(1794–1824), 1807.

*Courtesy of M. Finkel and Daughter,
Philadelphia, Pennsylvania.*

Stitched verses:

*Life on which mortals so depend / Is but a
vapour's breath / Our hopes our prospects and
our friends / Are liable to Death*

*Our highest wishes gratified / There's
somewhat wanting still / Something that Earth
ne'er yet suppli'd / The boundless mind to fill*

*Then never let us rest on Earth / But place
our hopes above / In him who gave all mortals
birth / The God of light and love*

Originally stitched by thirteen-year-old
Frances Fales in 1807, this family record sampler
shows death dates that were added over
several subsequent decades, even after Frances's
death at the age of thirty.

She also included her father's death in 1806 and the
death dates for four of her siblings who died prior
to 1807. One date from the period between the sampler's
initial stitching in 1807 and Frances's death in
1824 was added; the death of Frances's older sister,
Harriot, on August 19, 1817. While this date may
have been added after Frances died, the thread does
not match other dates added later, so it is possible
that Frances herself updated the sampler as she
grew. Frances died in 1824, and her death date is
recorded in the proper column, while death dates
for her mother and three additional siblings—in
1845, 1853, 1854, and 1857—were also recorded long
after Frances's death. These four entries are stitched
in thread that is a different color from the earlier
dates but identical to one another, suggesting that
they may have been added together.

Filling in the family record sampler over many
decades offered one way to sustain a prolonged
connection with its maker. This act was also a way
to teach the rising generation about relatives who
had passed on, encouraging them to cultivate an
understanding of family history. It may have offered
tangible support for the extended family, reassuring
its members of their ancestry and reminding them
of their place in history and in their community. In
her study of eighteenth-century American portraiture,
Margaretta Lovell suggests that family portraits
served as "active visual admonishments."
They were not simply a form of wallpaper in the
family home but engaged subsequent generations,
drawing them backward to memories and their
family history, as well as forward to their destiny as
more than just individuals, rather, as part of a long
family line.[67] These needlework family records acted
the same way, perhaps even more so, since they required
actual physical maintenance on top of the
necessary intellectual exercise.

Quilts also lent themselves to this type of association, since they could be stitched simultaneously by multiple people and then put on different beds on different nights, coming into contact with multiple family members and friends. And even if the quilt was made by one person, it could be passed down from generation to generation, with new layers of history and reminiscences added each time.

A well-known quilt by forty-year-old Elizabeth Roseberry Mitchell (1799–1857) serves as an illuminating example of a memorial object; like the samplers above, it was physically altered long after its original maker's death (figure 7.11).[68] Known as the "Graveyard Quilt," Mitchell's quilt is pieced with an eight-point star block repeated around a central square, which is bordered to look like the fence and gate of a cemetery. Inside the central section she quilted several coffin shapes. In addition, Mitchell appliquéd and quilted coffin shapes along the outer edges of the quilt. As beloved family members died, she labeled the coffins with their names and moved them from the border into the central graveyard, allowing her to both memorialize the dead and find an outlet for her grief.

Elizabeth Roseberry married Shadrach Mitchell (1797–1875) in 1817 when she was eighteen. Elizabeth was nineteen when her first child was born and gave birth for the last time when she was forty-one. Two of her sons died before she did: two-year-old John Vannatta Mitchell in 1836 and twenty-year-old Mathias Mitchell in 1843.[69] Her sorrow and grief at these losses seem to have motivated her to begin this quilt in 1843 when she was forty-four.[70] Elizabeth Mitchell recycled fabric from her children's school clothes to piece her quilt.[71] At least a couple of the fabrics used in the quilt are floral dress fabrics of the type that her daughters would have worn, suggesting that she used scraps from the clothing of all of her children, not just the sons who had passed away.

One of the most striking elements of the quilt is the central depiction of a graveyard. While this is unusual, Mitchell was not the only quilt maker to incorporate this motif. A double-sided quilt made by a Cynthia Wells Standish of Wethersfield, Connecticut, and dated 1855 includes a depiction of gravestones at bottom center on one side of the quilt (figure 7.12).[72] The arrangement of the gravestones on the quilt replicates the placement of the stones in the family plot in the Wethersfield cemetery.[73] The Mitchell quilt also purportedly builds on an Appalachian folk tradition of graveyard quilts, which were made to put over the body at the funeral and then hung over the back of a settee or chair in mourning.[74]

Mitchell's quilt served several purposes. It was a picture of the graveyard and plot where her son Matthias was buried, allowing her to maintain a connection to his final resting place.[75] It also preserved a record of the existence of her two sons, as well as that of her entire family and herself. Like the quilt by Nancy Ward Butler described in chapter 6, Mitchell's quilt offered her a way to work out her grief. Her coffins symbolized both the living and the dead, reminding those who looked at the quilt that there was no lasting difference between them.[76] And like all of the quilts and samplers discussed here, it enabled Mitchell to leave a legacy of her life and her love and devotion to her family.

The meaning of this quilt was not lost on her family. When Mitchell died in 1857 at age fifty-eight, the quilt passed to her daughter Sarah (1828–1911), who moved the coffin marked "Mother" from the border into the central graveyard.[77] When Sarah's husband, Pleasant M. Stallcup (1818–1857), died in 1857, shortly after Elizabeth, Sarah added her husband's name to one of the coffins and stitched it to one of the borders. Later that same year, in what must have seemed an overwhelming chore, Sarah

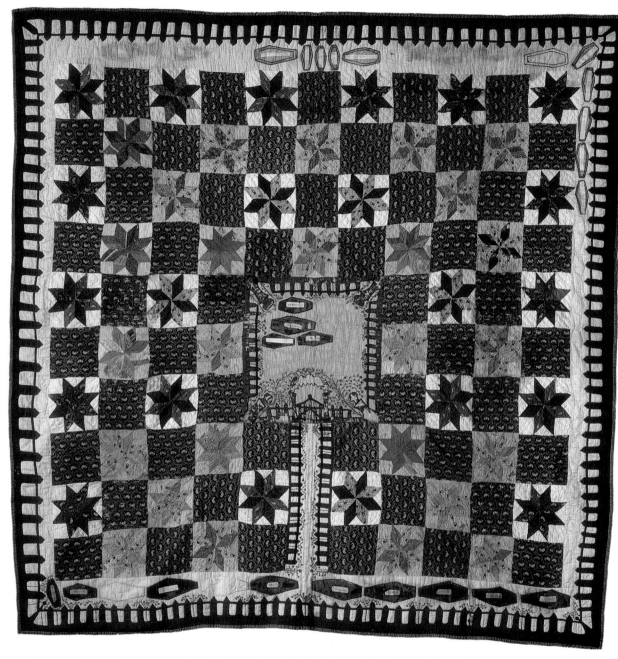

FIGURE 7.11. "GRAVEYARD QUILT" BY ELIZABETH ROSEBERRY MITCHELL (1799–1857),
CIRCA 1839, LEWIS COUNTY, KENTUCKY.

Courtesy of the Kentucky Historical Society, Frankfort, 1959.13.

Motivated by her grief over the death of two of her sons, Elizabeth Roseberry Mitchell designed this so-called graveyard quilt. The coffins along the bottom edge are marked with the names of her children. As family members died, Mitchell—and later her daughter—would move the coffins from the border into the graveyard at the center.

FIGURE 7.12. QUILT BY
CYNTHIA WELLS STANDISH, 1855,
WETHERSFIELD, CONNECTICUT.

*Courtesy of the Wethersfield Historical Society,
Wethersfield, Connecticut.*

The initials "CWS" visible at the right side of this quilt stand for Cynthia Wells Standish, who made this quilt. Unfortunately, both mother and daughter had the same initials, so we cannot tell which of the two women made this double-sided quilt. The design at bottom center represents the family's burial plot at the local cemetery.

added the name of her young son to a coffin and stitched it along the top to mark his untimely death.[78] Over the next thirteen years, nine additional family members were memorialized on the quilt by Sarah: six of her mother's grandchildren; Sarah's sister, Elizabeth (1830–1867); one of her mother's daughters-in-law; and one unidentified relation. Around 1870, when Sarah was forty-seven, she stopped keeping up with the quilt's coffins. When she died in 1911, the quilt passed to her brother, Benjamin Franklin Mitchell (1828–1914), and then to his daughter, Florence (d. 1933). Before Florence passed away in 1933, she gave the quilt to her cousin, another one of Elizabeth Roseberry Mitchell's granddaughters, Nina Mitchell Biggs, who later gave the quilt to the Kentucky Historical Society.[79]

In the maker's mind, her death did not equal the death of the object—quite the contrary, in fact. Mitchell conceived of and produced her quilt so that it would live on after her sons were gone and after she herself had died, as with the family record samplers discussed here. These "biographical objects" not only told the story of their maker's family but also took on a life of their own as memorial objects, a journey that began only after the maker died. The needlework remained, calling the following generations to act by adding to the story that it told and passing it on.

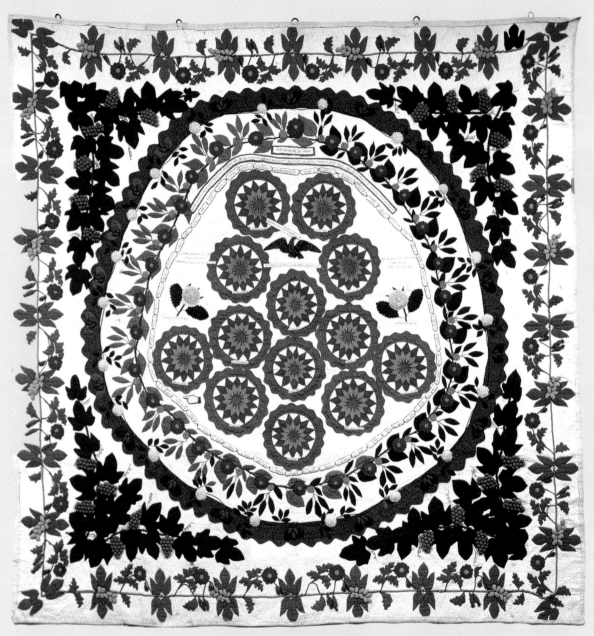

FIGURE C.1. *HEROES OF THE REVOLUTION* QUILT BY RHODA WARNER (B. 1784), 1855, PAINESVILLE, OHIO.

Courtesy of the Buffalo History Museum, Buffalo, New York.

Just like Amy Fiske's sampler, Rhoda Warner's quilt tells a story about her. Born just after the Revolutionary War, Warner experienced the development of the new nation. And as she made her quilt, she witnessed the growing tensions between the North and South. In addition to the political content in her quilt, Warner showed off her needlework skill, employing six different techniques instead of just two or three.

CONCLUSION

ROUND 1855, seventy-one-year-old Rhoda Warner of Painesville, Ohio, stitched an elaborate quilt, which she titled *Heroes of the Revolution* (figure C.1).[1] Born around 1784, just as the Revolutionary War came to an end, Warner later used her needle to make many historical references on her quilt, pulling together her eighteenth-century girlhood with her mid-nineteenth-century old age. The central section includes thirteen circles, each circumscribing a thirteen-point star, symbolizing the original thirteen colonies. At the top of the central section is the American symbol of an eagle. Forming a border around the central group of thirteen stars is a chain of embroidered names. Each signer of the Declaration of Independence is included in this chain. A cloth hand pinned to the quilt points to "J. Witherspoon" and "R. Stockton" in the circle of Declaration signers (figure C.2).[2]

Like Amy Fiske and many of the women discussed in these pages, Warner used her needlework to serve multiple purposes: to comment on the events of her life,

FIGURE C.2. DETAIL FROM *HEROES OF THE REVOLUTION* QUILT BY RHODA WARNER.

to provide a reminder of herself for generations to come, to show pride in her work, to express and reflect nostalgia for the past, to age gracefully, and to adapt to the changes taking place around her by using a medium that was comfortable for her. Exploring this last example of needlework by an aging antebellum American woman reinforces the value that needlework made by mature women holds for scholars.

An 1844 needlework guide offered a lofty view of why its readers should pick up their needles:

> We have a higher end in view than promoting the acquisition of accomplishments, however elegant and pleasing. We wish to direct the minds of those we are thus endeavoring to interest and instruct, to the immortal beauties of moral excellence. These works may be made conducive . . . to the development of family affection, and the promotion . . . of the purposes of genuine charity, benevolence and friendship. But there is yet a higher kind of use to which we would apply them . . . [the lady's] work, and the power and skill to plan and execute it, are emanations of the immortal mind.[3]

The benefits of needlework for women of all ages were constantly being transmitted, socially and cul-

turally, through books, magazines, sermons, and the needlework itself. And as the needlework illustrated here demonstrates, women continued to pursue values of industry, skill, hard work, and motherly affection as they aged, often despite failing eyesight or achy joints. But these same objects were not made in cookie-cutter fashion—or even made as an end in themselves to keep aging fingers occupied. Instead, the needlework shown here offered a way for its makers to express themselves, serving as a means to many different ends.

Indeed, aging women stitched for many of the same reasons that younger women did, such as to show their skill and to express themselves or to be creative. But the context of the work of younger women was inherently different. Aging women had their own experiences that affected their work: changes in their bodies and minds; an increasing nostalgia for the past; and memories to reflect on and remember, which were portrayed in their quilts and samplers. An older woman, in her fifties or sixties, often had more time to devote to her needlework because her child-rearing duties were over and because she had built up more skill over the decades, affecting the kind of work she could do.

Needlework was considered an ideal activity for aging women. It was socially sanctioned, morally uplifting, and enjoyable. As women reached their forties and fifties, coinciding with the arrival of menopause, many found themselves happy to be freed from the cycles of menstruation and child-birth. Antebellum sources suggest that although women were considered "old" as they reached menopause, the women themselves often embraced this part of their lives by pursuing new and old hobbies, while doting on grandchildren and expressing their creativity with their needles.

A close look at Rhoda Warner's quilt helps illustrate the conscious choices that many aging women made as they put needle to cloth. The quilt shows that Warner was capable of incredibly detailed and skilled needlework; it also suggests that she took pride in her work and that she used her needle to express her opinions and earn some money. A handwritten label that was once attached to the quilt tells its story: "This revolutionary Quilt contains 2404 Pieces / 57 names, 80 words, 1063 Letters of needlework / By Mrs. Rhoda Warner Aged 71 Years of Painesville Ohio / Sept. 1. 1855 This Quilt for Sale."[4]

Antebellum women rarely left diaries or collections of letters that tell us about their lives. Instead, their needlework tells their life story. Older women stitched objects that trace the stages of their lives. Biographical and epistolary needlework offers a new category for items previously locked into a binary equation—decorative versus functional. The biographical objects shown here serve both purposes and more. They were meant to be ornamental, but they also served an important function for their makers—and continue to be useful today.

Warner's quilt is biographical, telling her story, as well as the story of her nation. While employing a layout typical of the 1850s, Warner used eighteenth-century content to give her design meaning, thus bringing together her youth with her old age in one quilt. The stars in the center represent the original thirteen colonies; each one has an embroidered label stitched at the bottom with the name of a state.[5] Likewise, as mentioned above, the names of the signers of the Declaration form a border around the center. An American eagle holds a prominent place at top center and has a banner in its beak reading, "O Washington Live Forever." As a fifteen-year-old girl in 1799, Warner would have had lasting memories of the public mourning of the first president's death. This phrase was used in at least one eulogy for Washington, which was delivered by Jeremiah Smith on February 22, 1800, before the New York State Society of the Cincinnati and was later published.[6] Still another verse, "The British King Lost States Thirteen," appeared in a primer that went through 450 editions by 1830.[7] Warner might have known this verse for more than sixty years before incorporating it into her quilt.

Another eighteenth-century element of Warner's quilt is evident from the wide variety of techniques she employed to put it together, all skills that she would have learned as a girl in the 1780s and 1790s, as she prepared to manage a household of her own after marriage. While many quilts show two or three skills at most, for example, piecing and quilting or appliqué and quilting, Warner's quilt includes six: piecing, appliqué, quilting, embroidery, ruching, and stuffed work. The data provided on the quilt's label—the numbers of pieces, words, names, and letters—suggest the pride that Warner took in her work. She was the one who would have kept track of these numbers and decided to include them on the label.

Indeed, the existence of the label indicates that the quilt was on public display around September

1855. Warner undoubtedly enjoyed the attention her work received at the local agricultural fair. The displays of needlework at American fairs offered inspiration to the female community, while also setting the style and defining local fashions. For aging antebellum women, who were watching textile tasks become increasingly industrialized and the work of the home become devalued, agricultural fairs offered recognition of their skill. These venues provided not only an outlet for their pride in their work but also a place where they could offer a model to the younger generations and show that they embraced technological innovations, such as cylinder-printed fabrics, indelible inks, and the sewing machine.

Records of a local agricultural fair demonstrate that Warner was no stranger to submitting her work for public judgment. In 1854, she exhibited a quilt at her local county fair. The newspaper described that quilt as "the most accomplished piece of ladies' work on exhibition."[8] Two years later, in 1856, Warner exhibited her *Heroes of the Revolution* quilt at the county fair, where a reporter recounted, "A 'revolutionary quilt' hung nearby, the name of which awakened inquiry. Its workmanship was not remarkable. But it was made by a lady seventy years old, and embraced the names of nearly all the lovers of Independence, and Revolutionary times. It was made up of 2,404 pieces. The patriotic feelings and patient industry of which it is the result, are worthy of praise."[9] While the presumably male reporter considered the workmanship "not remarkable," the judges saw otherwise, awarding Warner a diploma and a $3 premium for the best "worked quilt."[10] The reporter pointed to "patriotic feelings and patient industry" as being worthy of praise. His comments suggest the cultural backdrop that aging antebellum women stitched against. Their culture encouraged them to show proper virtues of industry and patriotism and to serve as an example for the young. Women such as Warner could do this with their needles, while also manipulating their stitches to their own ends without attracting negative attention.

Although Warner did not leave any written evidence about her motivation to make her quilt, its subject matter does suggest a political viewpoint, which can be understood by reviewing the major national issues of 1855. Throughout the 1840s and 1850s, the abolition movement gained strength, particularly in Warner's home state of Ohio. On May 30, 1854, the Kansas-Nebraska Act was signed into law, repealing the Missouri Compromise of 1820 and reopening the question of slavery in the West. For the next two years, guerilla warfare continued between proslavery and antislavery settlers in Kansas as they fought over whether Kansas would be a slave state.[11]

The southern states saw parallels between their situation in 1855 and that of the original thirteen colonies in the 1760s and 1770s. One of the embroidered mottos included on Warner's quilt reads, "The British King Lost States Thirteen." More than simply a historical statement or a verse drawn from her schoolgirl days, this may be a reference to the threatened loss of the slave states during the 1850s.

For Warner, raised with the model of George Washington ever-present, President Franklin Pierce (1804–1869) may have seemed a weak statesman, unable to resolve the growing national divide over the question of slavery.[12] One of Warner's inscriptions on the quilt can be read as a critique of Pierce and 1855 politics: "May our political horizons glow with truth and the nation learn righteousness."[13] With this verse, Warner seems to be advocating for the abolition of slavery.

By gathering together the names of the heroes of the Revolution, Warner may have been trying, in her own way, to hold on to the union before it

crumbled. "Our fathers fought and bled and died for our liberty," she stitched; "How dear how sweet." The first part of this phrase appeared in the *Congressional Record* in 1837, referring to gains that had been made with the Revolution. And the records of the Continental Congress, which had been published complete with confidential sections in 1821, include the following from September 1774: "It is an indispensable duty which we owe to God, our country, ourselves and posterity, by all lawful ways and means in our power to maintain, defend and preserve those civil rights and religious rights and liberties, for which many of our fathers fought, bled and died, and to hand them down entire to future generations."[14] Unfortunately, the records documenting this quilt—its label and the agricultural fair records—refer only to Warner's married name, and we are unable to trace whether her father fought in the Revolutionary War, which would add yet another layer of resonance to the words she stitched into her quilt as she grew older.

Regardless of her personal attachments to the Revolutionary War and its soldiers, Warner's choice of this verse suggests a desire to remember the heroes and values of the past. She wanted others to remember what the founders fought for, just as she had remembered. Her choice to include the list of the signers of the Declaration of Independence is symbolic. While interest in the Declaration had last peaked in 1826, its fiftieth anniversary, she may also have seen newspaper stories about the death of the last signer in 1832.[15] During the 1820s, commemorative versions of the Declaration were produced and sold to be framed and hung in parlors. While Warner's source for her list of signers is unknown, she would have had access to these prints and to books of American history, which included the names of the signers. By the 1850s, the Declaration was once again attracting notice, as individuals in both the North and the South used it for propaganda to support their political views.[16]

Rhoda Warner's quilt, Amy Fiske's sampler, and the other objects featured here eloquently express the importance of the study of material culture. Scholar Sherry Turkle would call them "evocative objects," objects that serve as "companions to our emotional lives or as provocations to thought."[17] She also believes that "objects have life roles that are multiple and fluid."[18] Indeed, this is why the consideration of age as a category of analysis is important. As the bodies, minds, and lifestyles of aging antebellum women changed, so did their needlework, reflecting their experiences new and old, their wisdom learned, and even the effects of their aching fingers or blurring vision. Rhoda Warner's quilt is a fitting closing example. Her descriptive label, which includes her age, demonstrates that many antebellum women were conscious of their age, whether they embraced it and grew old gracefully or worked to hide it.

Warner's quilt brings together the years of her childhood with those of her maturity. Her quilt commemorates the new country just being formed when she was born and comments on the growing pains of the nation as the question of slavery took center stage. Warner entered her quilt in a local agricultural fair, demonstrating her skill, expressing her pride, and perhaps exhorting the younger generations not to forget those who came before. While she did not make her quilt a gift during her lifetime, she still used it to leave a lasting mark. Warner's quilt is a gift to us today, as are all of the objects examined here—allowing us to admire their workmanship, creativity, and skill; to remember the past; and to learn more about the comparisons and contrasts between then and now.

Just because a woman married, gave birth, or reached menopause, her needlework did not remain

static ever after. The types of items that she stitched, how they looked, and how she intended them to be used continued to change and evolve. The study of women's needlework must also continue to evolve. In 1854, Eliza Leslie offered a hopeful goal to all aging antebellum women. "As long as she lives and retains her faculties," Leslie wrote, the antebellum woman "will endeavour to improve, and to become still a wiser and a better woman; never excusing herself by indolently and obstinately averring that 'she is too old to learn,' or that she cannot give up her old-fashioned habits . . . No one with a mind unimpaired, and a heart still fresh, is too old to learn."[19] The women in these pages followed this advice— and left their needlework behind to continue the cycle. Every time we look at their quilts and samplers, we are learning again, improving our own lives, and carrying the threads of time forward.

Above: Detail from *Heroes of the Revolution* quilt by Rhoda Warner.

APPENDIX

❧ ❧

DECORATIVE NEEDLEWORK MADE BY WOMEN FORTY OR OVER BETWEEN 1820 AND 1860

pages 188–193

Above: Detail from Nantucket Agricultural Society quilt, 1856, Nantucket, Massachusetts.
Courtesy of the Nantucket Historical Association, Nantucket, Massachusetts.

Name (life dates)	Artifact type	Artifact date	Place made	Age when made	Reason for inclusion	Current owner
Susanna Jaquith Abbott (1797–1896)	Quilt	ca. 1846	Bedford, MA	ca. 49	Made by woman 40 or over	Historic New England
Lura Clapp Allen (b. 1791)	Quilt	1851	North Hero, VT	60	Made by woman 40 or over	Private collection
Sarah L. Art (1793–1875)	Sampler	1806	Lewes, DE	13	Picked-out sampler	Winterthur
Martha Jane Avery	Sampler				Picked-out sampler	Historic New England
Elizabeth Benton Boyles Bagley (b. 1815)	Quilt	1860	Fayetteville, TN	45	Made by woman 40 or over	Private collection
Abigail Barnard (1806–1886)	Sampler	1833	Pittsfield, MA	27	Filled-in family record	Cooper-Hewitt Museum
Maria Barnard (1803–1864)	Sampler	ca. 1830	Pittsfield, MA	ca. 27	Filled-in family record	Private collection
Deborah Barnes (b. 1790)	Quilt	1851	Baltimore, MD	61	Made by woman 40 or over	Herbert F. Johnson Museum of Art
Eliza Macy Howland Barney (1783–1867)	Quilt	ca. 1830	New Bedford, MA	ca. 47	Made by woman 40 or over	Historic Deerfield
Mrs. C. Bartlett (b. 1797)	Quilt	1860		63	Made by woman 40 or over	Private collection
Nancy Miller Benson (1809–1879)	Quilt	ca. 1850	Spartanburg, SC	ca. 41	Made by woman 40 or over	Mary Black Foundation
Sarah Berry	Sampler	ca. 1820		13	Picked-out sampler	Private collection
Charlotte Jackson Blackman (b. 1790)	Sampler	1831	Washington County, IN	41	Made by woman 40 or over	DAR Museum
Harriet Woodward Dorsey Blunt (1794–1862)	Quilt	1852	Woodborne, MD	58	Made by woman 40 or over	Montgomery County Historical Society
Ann G. Hitchcock Boker (b. ca. 1803)	Quilt	1860	Lower Chichester, PA	ca. 57	Made by woman 40 or over	Winterthur
Eveline Borden (b. 1816)	Sampler	1832?	Tiverton, MA		Picked-out sampler	Private collection
Catharine Ann Penniman Bradford (1778–1827)	Quilt	1825	Boston, MA	47	Made by woman 40 or over	Private collection
Henrietta Bradford	Sampler	1831	MA		Picked-out sampler	Unknown
Sarah M. Bradford (1813–1848)	Sampler	1832	Cornwall, CT	19	Filled-in family record	Old Sturbridge Village
Susanna Brewer (1764–1855)	Quilt	ca. 1830	MA	ca. 66	Made by woman 40 or over	Private collection
Sarah Stanley Brown	Sampler				Picked-out sampler	Private collection
Nancy Ward Butler (1779–1863)	Quilt	1842	Jamestown, NY	63	Made by woman 40 or over	Smithsonian Institution
Nancy Ward Butler (1779–1863)	Quilt	1845	NY	66	Made by woman 40 or over	McClurg Museum
Lucretia Buttrick (1801–1892)	Sampler		Concord, MA		Picked-out sampler	Concord Museum
Azubah G. Capen (1814–1837)	Sampler	1824–1837	Stoughton, MA	10–23	Filled-in family record	Old Sturbridge Village
Mary McElwain Chenoweth (1815–1897)	Quilt	1860	Webster County, MO	45	Made by woman 40 or over	Private collection
Adeline Eliza Clark (b. 1818)	Sampler	ca. 1830	Schenectady, NY	ca. 12	Picked-out sampler	Private collection
Elizabeth Van Horne Clarkson (1771–1852)	Quilt	ca. 1830	New York, NY	ca. 59	Made by woman 40 or over	Metropolitan Museum
Lucy Hiller Cleveland (1780–1866)	Fabric sculptures	1831–1866	Salem, MA	51–86	Made by woman 40 or over	Peabody Essex Museum
Mary Conger (1808–1888)	Quilt	1858	Casey, IL	50	Made by woman 40 or over	Private collection
Julia Stevens Crosby (1798–1879)	Quilt	ca. 1860	East Hardwick, VT	ca. 62	Made by woman 40 or over	Private collection

Name (life dates)	Artifact type	Artifact date	Place made	Age when made	Reason for inclusion	Current owner
Julia Stevens Crosby (1798–1879)	Quilt	ca. 1860	East Hardwick, VT	ca. 62	Made by woman 40 or over	Private collection
Ruth Pierce Croswell (1765–1862)	Sampler	1827	Catskill, NY	63	Made by woman 40 or over	Litchfield Historical Society
Margaret Boyce Elliott (1800–1867)	Quilt	ca. 1843	MD or DE	ca. 43	Made by woman 40 or over	Maryland Historical Society
Mary W. Evans (1814–1888)	Sampler	1824	Providence, RI	10	Filled-in family record	Winterthur
Sarah Evans (1799–1871)	Quilt	1854	Sugar Creek Township, OH	55	Made by woman 40 or over	Private collection
Tamson C. Evans (poss. b. 1796)	Sampler		Possibly VT	11	Picked-out sampler	Old Sturbridge Village
Rebecca Fairchild (b. 1773)	Mourning picture	1830	New Milford, PA	57	Made by woman 40 or over	Private collection
Frances Fales (1794–1824)	Sampler	1807		13	Filled-in family record	Private collection
Amy Fiske (1785–1859)	Sampler	1852	Sturbridge, MA	66	Made by woman 40 or over	Old Sturbridge Village
Matilda Fiske (1784–1880)	Quilt	1825–1835	Sturbridge, MA	41–51	Made by woman 40 or over	Old Sturbridge Village
Sarah A. Fitch (1800–1869)	Quilt	ca. 1840	Norwalk, CT	ca. 40	Made by woman 40 or over	Old Sturbridge Village
Ann Maria Foltz (b. 1820)	Sampler	ca. 1830	PA	ca. 10	Picked-out sampler	Private collection
Hannah Warner Forwood (1811–1886)	Quilt	1854	Probably Kennett Square, PA	43	Made by woman 40 or over	Chester County Historical Society
Anna Catherine Hummel Markey Garnhart (1773–1860)	Quilt	ca. 1822	Frederick, MD	ca. 49	Made by woman 40 or over	Plains Indians and Pioneer Museum
Anna Catherine Hummel Markey Garnhart (1773–1860)	Quilt	ca. 1850	Frederick, MD	ca. 77	Made by woman 40 or over	DAR Museum
Anna Catherine Hummel Markey Garnhart (1773–1860)	Quilt	ca. 1815	Frederick, MD	ca. 42	Made by woman 40 or over	DAR Museum
Anna Catherine Hummel Markey Garnhart (1773–1860)	Quilt	1830–1845	Frederick, MD	57–72	Made by woman 40 or over	Private collection
Anna Catherine Hummel Markey Garnhart (1773–1860)	Quilt	1835–1855	Frederick, MD	62–82	Made by woman 40 or over	Private collection
Anna Catherine Hummel Markey Garnhart (1773–1860)	Quilt	1835–1845	Frederick, MD	62–72	Made by woman 40 or over	Private collection
Anna Catherine Hummel Markey Garnhart (1773–1860)	Quilt	1820–1835	Frederick, MD	47–62	Made by woman 40 or over	Private collection
Anna Catherine Hummel Markey Garnhart (1773–1860)	Quilt	ca. 1840	Frederick, MD	ca. 67	Made by woman 40 or over	Private collection
Anna Catherine Hummel Markey Garnhart (1773–1860)	Quilt	1820–1840	Frederick, MD	47–67	Made by woman 40 or over	Private collection
Anna Catherine Hummel Markey Garnhart (1773–1860)	Quilt	1820–1840	Frederick, MD	47–67	Made by woman 40 or over	Private collection
Anna Catherine Hummel Markey Garnhart (1773–1860)	Quilt	1825–1840	Frederick, MD	52–67	Made by woman 40 or over	Private collection

Name (life dates)	Artifact type	Artifact date	Place made	Age when made	Reason for inclusion	Current owner
Submit Gay (1796–1880)	Quilt	1842	Simsbury, CT	46	Made by woman 40 or over	Wadsworth Atheneum
Rebecca Gladstone (b. 1795)	Quilt	ca. 1841	Baltimore, MD	ca. 46	Made by woman 40 or over	DAR Museum
Eliza Goddard	Sampler	1813?	Possibly Athol, MA	8	Picked-out sampler	Old Sturbridge Village
Sarah W. Gooch (1797–1856)	Sampler	1822–1849	TN	25–52	Filled-in family record	Private collection
Abigail Reynolds Greene (1794–1889)	Quilt	1860	East Greenwich, RI	66	Made by woman 40 or over	Private collection
Marina Jones Gregg (1811–1899)	Quilt	1852	Charleston, SC	41	Made by woman 40 or over	Charleston Museum
Catherine Babson Griffin (1805–1834)	Sampler	1818	Gloucester, MA	13	Filled-in family record	Private collection
Agnes Grubb	Sampler	1825	Mid-Atlantic		Picked-out sampler	Private collection
Hetty Rosalia Gruet	Sampler	ca. 1820	Probably PA	12	Picked-out sampler	Private collection
Mary Halfline	Sampler	ca. 1780	Probably PA	11	Picked-out sampler	Private collection
Lucretia Street Hall (1773–1851)	Embroidered coverlet	1828	Charlemont, MA	55	Made by woman 40 or over	Historic Deerfield
Mary Hopkins Hayne (1776–1856)	Quilt	ca. 1825	NC or SC	ca. 49	Made by woman 40 or over	Private collection
Mary Hearn (b. 1782)	Sampler	1793	Nantucket, MA	10	Picked-out sampler	National Archives
Mary Dyer Herbert (1781–1852)	Quilt	ca. 1839	Bolair, WV	ca. 58	Made by woman 40 or over	Private collection
Martha Hewitt (b. ca. 1799)	Quilt	1855	MI	56	Made by woman 40 or over	Private collection
Sarah Holmes (1793–1842)	Sampler	1801	NJ	8	Altered sampler	New-York Historical Society
Louvica Creek Houchins (1788–after 1850)	Quilt	ca. 1839	IL	ca. 51	Made by woman 40 or over	DAR Museum
Maria Cadman Hubbard (b. 1769)	Quilt	1848	NY	79	Made by woman 40 or over	American Folk Art Museum
Eleanor Yates Keady (1808–1881)	Quilt	1855	Dunlap, IL	47	Made by woman 40 or over	Private collection
Margaret Steeley Kelley (1784–1865)	Quilt	1852/1857	PA	68/73	Made by woman 40 or over	Erie County Historical Society
Mary Duncan Kelly (1814–1898)	Quilt	1858	St. Clairsville, OH	44	Made by woman 40 or over	Ohio Historical Society
Mary Laman Kemp (1758–1845)	Quilt	1840	Rocky Springs, MD	82	Made by woman 40 or over	Private collection
Mary Tayloe Lloyd Key (1786–1859)	Quilt top	ca. 1840	Georgetown, MD	ca. 54	Made by woman 40 or over	DAR Museum
Mary Tayloe Lloyd Key (1786–1859)	Quilt top	ca. 1840	Georgetown, MD	ca. 54	Made by woman 40 or over	San Jose Museum of Quilts and Textiles
Dorothy Knight (1803–1854)	Sampler	1817	Phillipston, MA	14	Filled-in family record	Old Sturbridge Village
Susan Kuhns (ca. 1787–ca. 1865)	Quilt	ca. 1840	Greenburg, PA	ca. 53	Made by woman 40 or over	DAR Museum
Margaret Larkum	Sampler	1799	Philadelphia, PA		Picked-out sampler	Private collection
Amelia Heiskell Lauck (1760–1842)	Quilt	ca. 1830	Winchester, VA	ca. 70	Made by woman 40 or over	DAR Museum
Amelia Heiskell Lauck (1760–1842)	Quilt	1823	Winchester, VA	62	Made by woman 40 or over	DAR Museum
Amelia Heiskell Lauck (1760–1842)	Quilt	ca. 1824	Winchester, VA	ca. 64	Made by woman 40 or over	Colonial Williamsburg
Amelia Heiskell Lauck (1760–1842)	Quilt	1820–1830	Winchester, VA	59–69	Made by woman 40 or over	Colonial Williamsburg
Mary M. Leggett (b. 1786)	Quilt	1852	Valley Forge, PA	66	Made by woman 40 or over	Private collection

Name (life dates)	Artifact type	Artifact date	Place made	Age when made	Reason for inclusion	Current owner
Sarah Wadsworth Mahan (1802–1885)	Quilt	1851	Oberlin, OH	49	Made by woman 40 or over	Allen Memorial Art Museum
Eleanor Caroline Malone (1828–1894)	Sampler	1836	Boston, MA	8	Picked-out sampler	Private collection
Susan Bishop Marble (1807–1821)	Sampler	1817	New Haven, CT	10	Filled-in family record	DAR Museum
Harriet Kirk Marion (1782–1856)	Quilt	ca. 1830	St. Stephen's Parish, SC	ca. 48	Made by woman 40 or over	MESDA
Harriet Kirk Marion (1782–1856) or Elizabeth Marion Porcher (1760–1796) and Elizabeth Catherine Porcher Palmer (1781–1841)	Quilt	ca. 1841 or ca. 1790/1830	SC	ca. 48 or ca. 30 and 49	Made by woman 40 or over	MESDA
Dorothea "Dolly" Keyes McClanahan (1802–1892)	Quilt	ca. 1860	String Prairie, TX	ca. 58	Made by woman 40 or over	Private collection
Margaret Cabell McClelland (1785–1863)	Quilt	ca. 1850	VA	ca. 65	Made by woman 40 or over	DAR Museum
Elizabeth McClintock (b. 1780)	Quilt	1849	Rockingham County, VA	69	Made by woman 40 or over	Grout Museum
Susan Miller (1793–1861)	Quilt	ca. 1840	Rockingham County, VA	ca. 47	Made by woman 40 or over	Harrisonburg-Rockingham Historical Society
Catharine Mitchell (1775–1847)	Quilt	1830–1840	Dorchester County, MD	55–65	Made by woman 40 or over	Maryland Historical Society
Elizabeth Roseberry Mitchell (1799–1857)	Quilt	ca. 1839	Lewis County, KY	40	Made by woman 40 or over	Kentucky Historical Society
Johanna Penelope Elizabeth Cushing Montell (1784–1857)	Quilt	ca. 1840	Baltimore, MD	ca. 56	Made by woman 40 or over	Maryland Historical Society
Nancy Ely Moore (b. 1807)	Sampler	1859	Warren County, KY	52	Made by woman 40 or over	Western Reserve Historical Society
Lucretia Mulford	Sampler	1785	CT		Picked-out sampler	Private collection
Betsy Rice Nims (1751–1842)	Quilt	ca. 1840	Buckland, MA	ca. 89	Made by woman 40 or over	Pocumtuck Valley Memorial Association
Mary Rooker Norris (1785–1868)	Quilt	1846	Hagerstown, MD	61	Made by woman 40 or over	DAR Museum
Catherine Couturier Marion Palmer (1807–1895)	Quilt	1847–1848	St. John's, SC	40–41	Made by woman 40 or over	MESDA
Elcey Patterson (1803–1862)	Sampler	1845	Union Village, OH	42	Made by woman 40 or over	Private collection
Isabelle Liddon Pennock (b. 1795)	Quilt	1842–1843	Marlborough Township, PA	47–48	Made by woman 40 or over	Chester County Historical Society
Elizabeth Daniel Poindexter (ca. 1807–ca. 1858)	Quilt	ca. 1852	Cooper County, MO	ca. 45	Made by woman 40 or over	DAR Museum
Mary Ann Post (b. 1813)	Sampler	1827	Chatham, CT	14	Filled-in family record	Private collection
Sylvia Punderson (1769–1826)	Mourning picture	1822–1826	Groton, CT	53–57	Made by woman 40 or over	Connecticut Historical Society
Emily C. Rawlings	Sampler	ca. 1820	Probably Baltimore, MD	10	Picked-out sampler	DAR Museum
Katurah Reeve (1775–1852)	Whitework Coverlet	1820	NY	45	Made by woman 40 or over	Winterthur
Jemima Kassel Reger (1815–1902)	Quilt	ca. 1859	Buckhannon, WV	ca. 44	Made by woman 40 or over	Private collection
Elizabeth Abrams Renwick (1782–1863)	Quilt	ca. 1840	Newberry County, SC	ca. 58	Made by woman 40 or over	MESDA
Esther Banister Richards (1795–1864)	Sampler	1853	Sturbridge, MA	58	Made by woman 40 or over	Old Sturbridge Village

Name (life dates)	Artifact type	Artifact date	Place made	Age when made	Reason for inclusion	Current owner
Euphemia Reese Wilson Righter (1790–1873)	Quilt	1850	Beaver Meadow, PA	60	Made by woman 40 or over	State Museum of Pennsylvania
Candace Russell	Sampler			52	Made by woman 40 or over	Western Reserve Historical Society
Jane Richards Russell (1802–1889)	Quilt	ca. 1855	Jerseyville, IL	ca. 53	Made by woman 40 or over	Illinois State Museum
Rachel Engard Saulnier (1776–1866)	Quilt	ca. 1835	Philadelphia, PA	ca. 59	Made by woman 40 or over	Private collection
Rebecca Scattergood Savery (1770–1855)	Quilt	1827	Philadelphia, PA	57	Made by woman 40 or over	Winterthur
Rebecca Scattergood Savery (1770–1855)	Quilt	1835–1840	Philadelphia, PA	65–70	Made by woman 40 or over	American Folk Art Museum
Rebecca Scattergood Savery (1770–1855)	Quilt	1839	Philadelphia, PA	69	Made by woman 40 or over	Philadelphia Museum of Art
Maria Boyd Schulz (b. 1806)	Quilt	mid-1850s	Charleston, SC	ca. 50	Made by woman 40 or over	Charleston Museum
Betsey M. Seely Sears (1813–1901)	Quilt	1855	Jefferson County, WI	42	Made by woman 40 or over	Heritage Park, City of Santa Fe Springs, CA
Betsey M. Seely Sears (1813–1901)	Quilt	1850–1860	Jefferson County, WI	37–47	Made by woman 40 or over	Fort Atkinson Historical Society
Patty Bartlett Sessions (1795–1892)	Sampler	1811/1848	ME and UT	16/53	Made by woman 40 or over	Private collection
Deborah Ellis Shaw (1796–1859)	Quilt	1850–1859	Palmer, MA	54–63	Made by woman 40 or over	Historic Deerfield
Frances Swanson Shaw (1808–1876)	Quilt	ca. 1850	Hagerstown, MD	ca. 42	Made by woman 40 or over	Private collection
Eliza Silbett	Sampler	ca. 1830	Probably Philadelphia, PA	Probably 18	Picked-out sampler	Private collection
Esther Johnson Parkinson Slater (1778–1859)	Quilt	1851	Pawtucket, RI	73	Made by woman 40 or over	Slater Mill Historic Site
Elizabeth Deardorf Slingluff (1775–1852)	Quilt	1825–1830	New Windsor, MD	50–55	Made by woman 40 or over	Private collection
Catherine Crast Sloat (1798–1873)	Quilt	ca. 1845	NY	ca. 47	Made by woman 40 or over	Private collection
Mary C. Slocum (b. ca. 1817)	Quilt	ca. 1858	Rock County, WI	ca. 41	Made by woman 40 or over	State Historical Society of Wisconsin
Mary "Polly" Hutchings Small (1775–1846)	Quilt	ca. 1840	Pleasant Exchange, TN	ca. 65	Made by woman 40 or over	Private collection
Rachel Smith (b. ca. 1795)	Quilt	1859	Derby, CT	ca. 64	Made by woman 40 or over	New-York Historical Society
Rebecca Smith Smith (1807–1875)	Quilt	ca. 1860	Decatur, IL	ca. 53	Made by woman 40 or over	Private collection
Mary Deloach Sneed (1807–1905)	Quilt	1850–1860	Waco, TX	43–53	Made by woman 40 or over	DAR Museum
Emily Vandergrift Snyder (b. 1804)	Quilt top	1845–1850	Philadelphia, PA	41–46	Made by woman 40 or over	Los Angeles County Museum of Art
Eliza Sockman (1807–1887)	Sampler	1821	Wheeling, WV	14	Picked-out sampler	Ohio Historical Society
Hannah Stockton Stiles (1790–1864)	Quilt	ca. 1830	Philadelphia, PA	ca. 40	Made by woman 40 or over	Fenimore Art Museum, NYSHA
Sally Bowen Story (1789–1872)	Sampler	ca. 1800	Marblehead, MA	ca. 11	Picked-out sampler	Peabody Essex Museum
Sarah Summers (ca. 1820–1900)	Quilt	ca. 1860	Jones County, GA	ca. 40	Made by woman 40 or over	Private collection
Eliza Sumner (1802–1856)	Quilt	1848	Spencer, MA	46	Made by woman 40 or over	Private collection
Mary Elizabeth Clayton Miller Taylor (1774–1846)	Quilt	1824	Savannah, GA	50	Made by woman 40 or over	Telfair Museum of Art

Name (life dates)	Artifact type	Artifact date	Place made	Age when made	Reason for inclusion	Current owner
Susanna Bradford Tillson (1807–1835)	Sampler	1817	Plymouth, MA	10	Picked-out sampler	Private collection
Ann Titus (1811–1886)	Sampler	1823	NY	12	Picked-out sampler	Private collection
Chloe Trask	Sampler	ca. 1820	MA		Picked-out sampler	Private collection
Mary Berry True (1788–1858)	Table cover	1840	Salem, MA	52	Made by woman 40 or over	Peabody Essex Museum
Elizabeth Trodge Turley (1792–1881)	Quilt	ca. 1860	Waverly, IL	ca. 68	Made by woman 40 or over	Illinois State Museum
Mary Van Voorhis (1788–1881)	Quilt	ca. 1850	PA	ca. 62	Made by woman 40 or over	Witte Museum
Lucy Walton (1799–1870)	Sampler	1847	Enfield, NH	48	Made by woman 40 or over	Private collection
Catherine Ann Waring (1787–1867)	Quilt	1840–1850	TX or MD	57–67	Made by woman 40 or over	Private collection
Rhoda Warner (b. 1784)	Quilt	1855	Painesville, OH	71	Made by woman 40 or over	Buffalo and Erie County Historical Society
Sara Boyd Waugh (1774–1863)	Quilt	ca. 1830	PA	ca. 56	Made by woman 40 or over	Private collection
Jane Smith Phillips Wells (1794–1874)	Quilt	ca. 1850	Peconic, NY	ca. 56	Made by woman 40 or over	Private collection
C. A. Wetmore	Sampler		NY		Picked-out sampler	Litchfield Historical Society
Margaret Wetmore (1810–1843)	Sampler	1823	OH	13	Picked-out sampler	Western Reserve Historical Society
S. E. Wheeler	Sampler	1840	OH		Picked-out sampler	Private collection
Polly Wheelock (b. 1785)	Quilt	ca. 1850	NY or IL	ca. 65	Made by woman 40 or over	LaSalle County Historical Society
Henrietta Frances Edwards Whitney (1786–1870)	Quilt	1849	New Haven, CT	63	Made by woman 40 or over	New Haven Colony Historical Society
Rebecca Garretson Wickersham (1791–1873)	Quilt	ca. 1854	Newberry Township, PA	ca. 63	Made by woman 40 or over	State Museum of Pennsylvania
Elizabeth Wilder (1811–1873)	Sampler		Sterling, MA		Filled-in family record	Private collection
Eliza Lucas Williams (1773–1844)	Rug	ca. 1825	Deerfield, MA	ca. 52	Made by woman 40 or over	Historic Deerfield
Mary "Betsey" Totten Polhemus Williams (1781–1861)	Quilt	ca. 1830	Staten Island, NY	ca. 49	Made by woman 40 or over	Smithsonian Institution
Mary "Betsey" Totten Polhemus Williams (1781–1861)	Quilt	ca. 1825	Staten Island, NY	ca. 44	Made by woman 40 or over	New York State Historical Association
Mary "Betsey" Totten Polhemus Williams (1781–1861)	Quilt	ca. 1830	Staten Island, NY	ca. 49	Made by woman 40 or over	Staten Island Historical Society
Mary "Betsey" Totten Polhemus Williams (1781–1861)	Quilt	1835	Staten Island, NY	54	Made by woman 40 or over	Staten Island Historical Society
Catharine Woolsey (ca. 1775–1856)	Coverlet	1822	Dutchess County, NY	ca. 47	Made by woman 40 or over	Metropolitan Museum

NOTES

Introduction

1. Amy Fiske's sampler is in the collection of Old Sturbridge Village, Sturbridge, Massachusetts. Alphabets and verses are standard elements of American samplers, while more personal or expository messages like the one on Amy Fiske's sampler are rare but not without English precedent. For a description of seventeenth- and eighteenth-century English epistolary samplers that "relate a message in the form of a prose letter," see Marsha Van Valin, "Epistolary Samplers: When Needles Were Pens," in *Common Thread, Common Ground: A Collection of Essays on Early Samplers and Historic Needlework,* ed. Marsha Van Valin (Sullivan, WI: Scarlet Letter, 2001), 50–55. See also Maureen Daly Goggin, "One English Woman's Story in Silken Ink: Filling In the Missing Strands in Elizabeth Parker's Circa 1830 Sampler," *Sampler and Antique Needlework Quarterly* 8 (Winter 2002): 38–49. American antebellum epistolary needlework is explored in chapters 6 and 7.

2. Terri L. Premo, *Winter Friends: Women Growing Old in the New Republic, 1785–1835* (Urbana: University of Illinois Press, 1990), 137.

3. Premo, *Winter Friends,* 5, 92; Susan M. Stabile, *Memory's Daughters: The Material Culture of Remembrance in Eighteenth-Century America* (Ithaca, NY: Cornell University Press, 2004), 134; Carl N. Degler, *At Odds: Women and the Family in America from the Revolution to the Present* (New York: Oxford University Press, 1980), 191; Marilyn Ferris Motz, *True Sisterhood: Michigan Women and Their Kin, 1820–1920* (Albany: State University of New York Press, 1983), 68.

4. *The Ladies' Work-Table Book* (New York: J. Winchester, 1844), vi.

5. Susan Burrows Swan, *Plain and Fancy: American Women and Their Needlework, 1650–1850* (Austin, TX: Curious Works Press, 1995), 170; Glee Krueger, *New England Samplers to 1840* (Sturbridge, MA: Old Sturbridge Village, 1978), 19.

6. David Hackett Fischer, *Growing Old in America* (New York: Oxford University Press, 1977), 222.

7. Several scholars state that there was no hard-and-fast definition of old age: W. Andrew Achenbaum, *Old Age in the New Land: The American Experience since 1790* (Baltimore: Johns Hopkins University Press, 1978), 2; Carole Haber, *Beyond Sixty-Five: The Dilemma of Old Age in America's Past* (Cambridge: Cambridge University Press, 1983), 8–10; Fischer, *Growing Old in America,* 27, 56; Thomas R. Cole, *The Journey of Life: A Cultural History of Aging in America* (Cambridge: Cambridge University Press, 1992), 49–52, 67; and Howard P. Chudacoff, *How Old Are You? Age Consciousness in American Culture* (Princeton: Princeton University Press, 1989), 13. For those who do define old age, sixty is a popular definition: Premo, *Winter Friends,* 12; Pat Thane, "Social Histories of Old Age and Aging," *Journal of Social History* 37, no. 1 (2003): 97–98; and John Demos, "Old Age in Early New England," in *Turning Points: Historical and Sociological Essays on the Family,* ed. John Demos and Saranne Spence Bocock (Chicago: University of Chicago Press, 1978), 249. Some scholars suggest that for women, old age began with menopause: Janet Roebuck, "Grandma as Revolutionary: Elderly Women and Some Modern Patterns of Social Change," *International Journal of Aging and Human Development* 17 (1983): 253; and Peter N. Stearns, "Old Women: Some Historical Observations," *Journal of Family History* 5 (Spring 1980): 45. At least one scholar suggests that the nineteenth-century sources she studied considered people in their forties and fifties to be old, perhaps in light of the widely held belief that the age of seventy was the upper limit for human old age. See Paula A. Scott, *Growing Old in the Early Republic: Spiritual, Social*

and Economic Issues, 1790–1830 (New York: Garland Publishing, 1997), 10–11.

8. Mrs. L. H. Sigourney, *Past Meridian* (Hartford, CT: F. A. Brown, 1856), 15. Lydia Huntley Sigourney was born in Connecticut in 1791, the daughter of Ezekial Huntley and Zerviah Wentworth Huntley. In 1819, Lydia married Charles Sigourney, a bank president and owner of a hardware business. A teacher before she married, Lydia focused on writing after her marriage. The couple had five children, although only two reached adulthood. Lydia Sigourney continued to publish poetry, fiction, and prose through the 1850s. She died in 1865. Biographical information from the North American Women's Letters and Diaries database, http://solomon.nwld.alexanderstreet.com.silk.library.umass.edu:2048/bios/A2462BIO.html.

9. Rev. John Stanford, *The Aged Christian's Companion* (New York: Stanford and Swords, 1849), 9–10.

10. *The Holy Bible,* King James Version (New York: American Bible Society, 1999). During the antebellum era, reaching the age of seventy was often considered the upper limit, with anything after that considered unusual. Scott, *Growing Old,* 9–10.

11. George Washington Bethune, comp., *Memoirs of Mrs. Joanna Bethune* (New York: Harper and Brothers, 1863), 213. Joanna Graham Bethune was born at Fort Niagara, Canada, in 1770, the daughter of John Graham and Isabella Marshall Graham. Educated in Scotland and the Netherlands, Bethune moved to New York City with her family in 1789; there she taught at her mother's school for young women. In 1795, she married Divie Bethune, and the couple had six children. Throughout her life, Joanna and her husband were involved in many charitable and evangelical causes. After her husband's death in 1824, she focused on charitable activities to benefit children. She died in 1860. Anne M. Boylan, "Bethune, Joanna Graham," in *American National Biography Online* (2000), www.anb.org.silk.library.umass.edu:2048/articles/09/09-00861.html.

12. In 1813, Esther Belcher married Warren Bird in Foxborough, Massachusetts. The couple had six children together. Caroline F. Sloat, ed., *Meet Your Neighbors: New England Portraits, Painters, and Society, 1790–1850* (Sturbridge, MA: Old Sturbridge Village, 1992), 77–78. The portrait is now in the collection of Old Sturbridge Village, Sturbridge, Massachusetts.

13. Eliza Leslie, *The Behaviour Book* (Philadelphia: Willis P. Hazard, 1854), 121–122; Michelle Boardman, "Picturing the Past: Studying Clothing through Portraits," unpub. research paper (Old Sturbridge Village, Sturbridge, MA, 1990), 32–36; Lois W. Banner, *American Beauty* (Chicago: University of Chicago Press, 1983), 220.

14. Rebecca Dickinson, diary entry for September 22, 1788, quoted in Marla R. Miller, "'My Part Alone': The World of Rebecca Dickinson, 1787–1802," *New England Quarterly* 71 (September 1998): 373.

15. Lisa Wilson, *Life after Death: Widows in Pennsylvania, 1750–1850* (Philadelphia: Temple University Press, 1992), 5–6; Premo, *Winter Friends,* 29–38.

16. Premo, *Winter Friends,* 30.

17. Sigourney, *Past Meridian,* 10.

18. Sigourney, *Past Meridian,* 15.

19. Dr. A. M. Mauriceau, *The Married Woman's Private Medical Companion* (New York: [s.n.], 1847), 28. Other sources that identify the early forties as the time to expect the onset of menopause include Samuel Bard, M.D., *A Compendium of the Theory and Practice of Midwifery* (New York: Collins, 1819), 78–79; Frederick Hollick, M.D., *The Diseases of Woman* (New York: T. W. Strong, 1849), 234; Frederick Hollick, *The Marriage Guide; or, Natural History of Generation* (New York: T. W. Strong, ca. 1860), 103; Albert Isaiah Coffin, *A Treatise on Midwifery* (London: W. B. Ford, 1849), 22; Charles Morrill, *The Physiology of Woman* (Boston: Bela Marsh, 1848), 125; A. G. Hall, *The Mother's Own Book and Practical Guide to Health* (Rochester, NY, 1843), 143–144; H. B. Skinner, *The Female Medical Guide and Married Woman's Advisor* (Boston: Skinner's Publication Rooms, 1849), 63–64.

20. Hollick, *Diseases of Woman,* 235.

21. Nancy Dunlap Bercaw, "Solid Objects/Mutable Meanings: Fancywork and the Construction of Bourgeois Culture, 1840–1880," *Winterthur Portfolio* 26 (1991): 231–248; Beverly Gordon, "Victorian Fancywork in the American Home: Fantasy and Accommodation," in *Making the American Home: Middle-Class Women and Domestic Material Culture, 1840–1940,* ed. Marilyn Ferris Motz and Pat Browne, 48–68 (Bowling Green, OH: Bowling Green State University Popular Press, 1988); Amy Boyce Osaki, "A 'Truly Feminine Employment': Sewing and the Early Nineteenth-Century Woman," *Winterthur Portfolio* 23 (Winter 1988): 225–241.

22. Catherine E. Kelly, "'The Consummation of Rural Prosperity and Happiness': New England Agricultural Fairs and the Construction of Class and Gender, 1810–1860," *American Quarterly* 49 (September 1997): 589.

23. Catherine E. Kelly, *In the New England Fashion: Reshaping Women's Lives in the Nineteenth Century* (Ithaca, NY: Cornell University Press, 1999), 50.

24. See Mary Beth Norton, *Liberty's Daughters: The Revolutionary Experience of American Women, 1750–1800* (Boston: Little, Brown, 1980), 193–194; Premo, *Winter Friends,* 58–60; Len Travers, *Celebrating the Fourth: Independence Day and the Rites of Nationalism in the Early Republic* (Amherst: University of Massachusetts Press, 1997), 206, 216–217; Joyce Appleby, *Inheriting the Revolution: The First Generation of Americans* (Cambridge, MA: Belknap Press, 2000), 2–6, 123; Michael Kammen, *A Season of Youth: The American Revolution and the Historical Imagination* (Ithaca, NY: Cornell University Press, 1988), 31, 194–195; and Alfred F. Young, *The Shoemaker and the Tea Party: Memory and the American Revolution* (Boston: Beacon Press, 1999), 133–134.

25. The exact date of Loara Standish's sampler (owned by Pilgrim Hall Museum, Plymouth, Massachusetts) is unknown. See Eileen Bennett, *The Evolution of Samplers—Embroidery and Sampler Time Line—A 400 Year History of Sampler Making* (Jenison, MI: Sampler House, 2001), 14, which dates the Standish sampler to circa 1635–1641. For a date simply before 1656, see Mary Jaene Edmonds, *Samplers and Samplermakers: An American Schoolgirl Art, 1700–1850* (London: Rizzoli, 1991), 16; and Krueger, *New England Samplers,* 12.

26. Krueger, *New England Samplers,* 13; Edmonds, *Samplers and Samplermakers,* 18; Swan, *Plain and Fancy,* 55.

27. Sarah Anna Emery, *Reminiscences of a Nonagenarian* (Newburyport, MA: William H. Huse, 1879), 21.

28. Swan, *Plain and Fancy,* 170. See also Glee Krueger's description of a decline in skill and quality in early-nineteenth-century samplers (*New England Samplers,* 19). She notes the increasing popularity of the simple cross-stitch and a decrease in embellishments, types of materials, and challenging stitches used.

29. Fidelia Fisk, *Recollections of Mary Lyon* (Boston: American Tract Society, 1866), 108.

30. Kathryn Kish Sklar, *Catharine Beecher: A Study in American Domesticity* (New York: W. W. Norton, 1976), 76.

31. Barbara Brackman, *Clues in the Calico: A Guide to Identifying and Dating Antique Quilts* (McLean, VA: EPM Publications, 1989), 118. See chapter 3 for an exploration of the use of indelible ink on antebellum quilts.

32. The books in this group are Mary M. Davidson, *Plimoth Colony Samplers* (Marion, MA: Channings, 1975); Edmonds, *Samplers and Samplermakers,* 12; Olive Blair Graffam, *"Youth Is the Time for Progress": The Importance of American Schoolgirl Art, 1780–1860* (Washington, DC: DAR Museum, 1998); Georgiana Brown Harbeson, *American Needlework* (New York: Bonanza Books, 1938); Jan Hiester and Kathleen Staples, *This Have I Done: Samplers and Embroideries from Charleston and the Lowcountry* (Charleston, SC: Curious Works Press and Charleston Museum, 2001); Stephen Huber and Carol Huber, *Miller's Samplers: How to Compare and Value* (London: Octopus Publishing Group, 2002); Kimberly Smith Ivey, *In the Neatest Manner: The Making of the Virginia Sampler Tradition* (Austin, TX: Curious Works Press and Colonial Williamsburg Foundation, 1997); Glee F. Krueger, *A Gallery of American Samplers: The Theodore H. Kapnek Collection* (New York: Bonanza Books, 1984); John F. LaBranche and Rita F. Conant, *In Female Worth and Elegance: Sampler and Needlework Students and Teachers in Portsmouth, New Hampshire, 1741–1840* (Portsmouth, NH: Portsmouth Marine Society, 1996); Rose Wilder Lane, *Woman's Day Book of American Needlework* (New York: Simon and Schuster, 1963); Pamela Parmal, *Samplers from A to Z* (Boston: MFA Publications, 2000); Gayle A. Rettew, William H. Siener, and Janice Turner Wass, *"Behold the Labour of My Tender Age": Children and Their Samplers, 1780–1850* (Rochester, NY: Rochester Museum and Science Center, 1984); Paula Bradstreet Richter, *Painted with Thread: The Art of American Embroidery* (Salem, MA: Peabody Essex Museum, 2002); Betty Ring, *Let Virtue Be a Guide to Thee: Needlework in the Education of Rhode Island Women, 1730–1830* (Providence: Rhode Island Historical Society, 1983); Margaret B. Schiffer, *Historical Needlework of Pennsylvania* (New York: Charles Scribner's Sons, 1968); *The Story of Samplers* (Philadelphia: Philadelphia Museum of Art, 1971); Swan, *Plain and Fancy,* 129; Van Valin, *Common Thread, Common Ground;* Margaret Vincent, *The Ladies' Work Table: Domestic Needlework in 19th-Century America* (Allentown, PA: Allentown Art Museum, 1988); Judith Reiter Weissman and Wendy Lavitt, *Labors of Love:*

America's Textiles and Needlework, 1650–1930 (New York: Wings Books, 1987); and Candace Wheeler, The Development of Embroidery in America (New York: Harper and Brothers, 1921).

33. Wheeler, Development of Embroidery, 48.

34. Weissman and Lavitt, Labors of Love, 120.

35. Betty Ring, Girlhood Embroidery: American Samplers and Pictorial Needlework, 1650–1850 (New York: Alfred A. Knopf, 1993), 9–10. The other books in this group are Gloria Seaman Allen, Family Record: Genealogical Watercolors and Needlework (Washington, DC: DAR Museum, 1989); Embroidered Samplers in the Collection of the Cooper-Hewitt Museum (Washington, DC: Smithsonian Institution, 1984); Sue Studebaker, Ohio Is My Dwelling Place: Schoolgirl Embroideries, 1800–1850 (Athens: Ohio University Press, 2002); Sue Studebaker, Ohio Samplers: Schoolgirl Embroideries, 1803–1850 (Lebanon, OH: Warren County Historical Society Museum, 1988); and Susan Swan, A Winterthur Guide to American Needlework (New York: Crown Publishers, 1976).

36. Ethel Stanwood Bolton and Eva Johnston Coe, American Samplers (1921; repr., New York: Dover Publications, 1987), 94. More recently, sampler scholar Glee Krueger recognized that "occasionally adults made samplers" (New England Samplers, 18), but she did not expand her study of these samplers, nor did she offer any thoughts on why older women might have stitched a sampler. The third book in this group is Patricia V. Veasey, Virtue Leads and Grace Reveals: Embroideries and Education in Antebellum South Carolina (Greenville, SC: Curious Works Press, 2003), which acknowledges that adults made samplers and suggests that it was a Southern pursuit, but Veasey does not fully explore the idea or provide any comparison to similar samplers in other regions.

37. Lynne Z. Bassett and Jack Larkin, Northern Comfort: New England's Early Quilts, 1780–1850 (Nashville: Rutledge Hill Press, 1998), 91–101. The many books published by state quilt documentation projects provide a wealth of evidence by presenting quilts made by women of all ages. This was not true simply in New England. See, for example, Fawn Valentine, West Virginia Quilts and Quiltmakers: Echoes from the Hills (Athens: Ohio University Press, 2000); Sandi Fox, Quilts: California Bound, California Made, 1840–1940 (Los Angeles: FIDM Museum and Library, 2002); and Ricky Clark, ed., Quilts in Community: Ohio's Traditions (Nashville: Rutledge Hill Press, 1991).

38. Bassett and Larkin, Northern Comfort, 91–92.

39. Marla R. Miller, The Needle's Eye: Women and Work in the Age of Revolution (Amherst: University of Massachusetts Press, 2006), 110–111.

40. A notable exception to this trend is the recent book Lynne Z. Bassett, ed., Massachusetts Quilts: Our Common Wealth (Hanover, NH: University Press of New England, 2009).

41. The quilt is now in the collection of Historic Deerfield, Inc., Deerfield, Massachusetts. I am indebted to Ned Lazaro, collections manager at Historic Deerfield, for facilitating my site visit in February 2009 and for sharing the curatorial file for the quilt with me. Barney Genealogical Record, Nantucket Historical Association, accessed at www.nha.org; U.S. Census information from www.ancestry.com.

42. Lynne Z. Bassett, Telltale Textiles: Quilts from the Historic Deerfield Collection (Deerfield, MA: Historic Deerfield, 2003), 23.

43. Brackman, Clues in the Calico, 124. The strip-pieced technique was more popular in England than in the United States.

44. Knife-edge binding is a technique used to finish and secure the edges of the quilt (the last step in making a quilt) so that it will not unravel or become ragged along the edges. The edges of the quilt's top fabric and its backing fabric are turned inside and then secured using a whipstitch or running stitch to join them together. The term knife-edge comes from the finished appearance of this binding technique; both fabrics are crisply turned in so that the outside edge is as flat as a knife. An applied binding is one in which a third, separate, piece of fabric or twill tape is folded over the top and bottom fabrics of the quilt and stitched (or applied) to the quilt's edges. Bassett and Larkin, Northern Comfort, 21.

45. While the question of Eliza's Quaker membership is unanswered, both of her husbands were Quakers. The presumption is that she was also part of the Society of Friends, since marrying a non-Quaker was grounds

for being "read out," or removed from the church. E-mail correspondence with Elizabeth Oldham, research associate, Nantucket Historical Association Research Library, Nantucket, Massachusetts, August 10, 2009.

46. Patricia J. Keller, "Quaker Quilts from the Delaware River Valley, 1760–1890," *The Magazine Antiques* 156 (August 1999): 185–191. Ties between American Quakers and English Quakers may explain the use of the strip-pieced style by American Quaker quilters. Nantucket, with its high percentage of Friends during the early nineteenth century, may also have turned out a higher than average number of strip-pieced quilts.

47. Antebellum women also made other types of decorative needlework, using techniques such as knitting and tatting. These items were not purposefully excluded from these pages; rather, no examples that conclusively fit the criteria of this study were located. Such items offer additional potential for the study of women in antebellum America.

48. While forty-six items were made in the South (matching the total from New England), this is skewed by eleven objects made by one woman. If this overrepresentation is taken into consideration, then New England has the most objects by different makers represented in this survey. See Heather Ruth Palmer, "Where Is Nineteenth-Century Southern Decorative Needlework?" *Southern Quarterly* 27 (1988): 58–59, which offers several common reasons cited for the lack of extant Southern needlework, compared to the wealth of examples from New England and the mid-Atlantic, such as the deleterious effects of the climate, the variety of insects that flourish in the region, and the effects of the Civil War.

49. Frederick Clifton Pierce, *Fiske and Fisk Family* (Chicago: F. C. Pierce, 1896), 254; *Vital Records of Sturbridge, Massachusetts, to the Year 1850* (Boston: New England Historic Genealogical Society, 1906). For more on Amy Fiske and her sampler, see Aimee E. Newell, "'Tattered to Pieces': Amy Fiske's Sampler and the Changing Roles of Women in Antebellum New England," in *Women and the Material Culture of Needlework and Textiles, 1750–1950,* ed. Maureen Daly Goggin and Beth Fowkes Tobin (Aldershot, UK: Ashgate Publishing, 2009), 51–68; and Aimee E. Newell, "'Tattered to Pieces': Samplers by

Aging Women in Antebellum New England," *Sampler and Antique Needlework Quarterly* 13 (Fall 2007): 28–35.

50. 1798 Federal Direct Tax, research files, Old Sturbridge Village, Sturbridge, Massachusetts.

51. Pierce, *Fiske and Fisk Family,* 259–260; *Vital Records of Sturbridge.*

52. Pierce, *Fiske and Fisk Family,* 384.

53. 1827 town tax records, research files, Old Sturbridge Village, Sturbridge, Massachusetts.

54. 1850 U.S. Census and 1840 town tax records, transcription in research department files, Old Sturbridge Village, Sturbridge, Massachusetts. In 1840, Daniel Fiske Jr. owned one horse, four cows, two swine, four oxen, eight two-year-old cattle, and thirty sheep. By 1850, it seems likely that Daniel and Amy's son Henry and his wife were living at the family farmstead to oversee the operation of the farm. In October 1853, a year after Amy restitched her sampler, Daniel and Amy deeded the home farm to their son Henry, but they retained part of the house for their use "during the term of their natural lives." When they died in 1859, neither Daniel nor Amy owned any real estate—it had been deeded to Henry six years earlier. Worcester County Deeds, Book 516, 476–477, Worcester, Massachusetts.

55. Pierce, *Fiske and Fisk Family,* 384–385.

56. John Warner Barber, *Historical Collections . . . of Every Town in Massachusetts* (Worcester: Dorr, Howland, 1840), 608; Joseph S. Clark, *An Historical Sketch of Sturbridge, Mass., from Its Settlement to the Present Time* (Brookfield, MA: E. and L. Merriam, 1838), 25–26; George Davis, *An Historical Sketch of Sturbridge and Southbridge* (West Brookfield, MA: O. S. Cooke, 1856), 199–201; Levi B. Chase, "Sturbridge" in *History of Worcester County,* ed. D. Hamilton Hurd (Philadelphia: J. W. Lewis, 1889), 118–119; Francis DeWitt, *Statistical Information Relating to Certain Branches of Industry in Massachusetts* (Boston: William White, 1856), 539.

57. Nancy F. Cott, *The Bonds of Womanhood: "Women's Sphere" in New England, 1780–1835* (New Haven, CT: Yale University Press, 1977), 36. In his study of women's work, Thomas Dublin also found that increasing industrialization radically altered the patterns of women's lives in early-nineteenth-century New England. See Thomas

Dublin, *Transforming Woman's Work: New England Lives in the Industrial Revolution* (Ithaca, NY: Cornell University Press, 1994), 7.

58. Caroline Bracket's sampler is in the collection of Old Sturbridge Village, Sturbridge, Massachusetts.

59. *Vital Records of Sturbridge;* 1850 U.S. Census; Pierce, *Fiske and Fisk Family,* 254.

60. Premo, *Winter Friends,* 37, 40.

61. Annette B. Weiner, *Inalienable Possessions: The Paradox of Keeping-While-Giving* (Berkeley: University of California Press, 1992), 36.

62. Laurel Thatcher Ulrich, *The Age of Homespun: Objects and Stories in the Creation of an American Myth* (New York: Alfred A. Knopf, 2001).

63. Swan, *Plain and Fancy,* 57, 60.

64. Premo, *Winter Friends,* 5.

65. The sampler was most likely part of Amy's bequest to her daughter, Sarah, when she died in 1859. Her probate inventory is not itemized, but the last clause of her will reads, "All the remainder and residue of my Estate of every description . . . I give and bequeath to my daughter Sarah Fiske." Will of Amy Fiske, Docket #20823, Worcester County Probate Court, Worcester, Massachusetts. Sarah lived in the Sturbridge area until her death in 1909, when she was living in neighboring Southbridge with family. At some point in the mid-1990s, the sampler was part of a local auction and was purchased by the parents of the woman who sold the sampler to Old Sturbridge Village in 2003, according to Old Sturbridge Village curatorial department files. Amy's daughter, Sarah, also stitched a sampler when she was nine, in 1826. The top of Sarah's sampler is almost identical to Amy's 1852 sampler, suggesting that she used her mother's 1795 sampler as a model, and in turn, perhaps Amy used her daughter's sampler as a model in 1852. Both samplers include several alphabets—in uppercase and lowercase letters, Roman and cursive styles—sometimes with multiple versions of one letter. Sarah's sampler is in the collection of Old Sturbridge Village, Sturbridge, Massachusetts.

66. Ulrich, *Age of Homespun,* 247.

67. Janet Hoskins, *Biographical Objects: How Things Tell the Stories of People's Lives* (New York: Routledge, 1998), 11. Hoskins defines and explores the idea of gendered "biographical objects" through her field study of Kodi natives in Indonesia. While she believes that objects in Western societies do not have the same meaning as they do in Indonesia, she does concede that "anthropologists who have recently turned to analyzing forms of consumption in Western industrial society have noted that some older objects can acquire a certain biographical dimension." Hoskins, *Biographical Objects,* 193. For additional perspectives on the idea of "biographical objects," see Igor Kopytoff, "The Cultural Biography of Things: Commoditization as Process," in *The Social Life of Things: Commodities in Cultural Perspective,* ed. Arjun Appadurai (New York: Cambridge University Press, 1986), 64–91; and Weiner, *Inalienable Possessions.*

Chapter 1: The Physical Challenges of Needlework

1. Information from the catalog file on the quilt, donated to the Witte Museum, San Antonio, Texas, by Mrs. J. F. Dolard. I am grateful to curator Michaele Haynes for generously sharing the file on this quilt. The quilt is pictured in Patsy Orlofsky and Myron Orlofsky, *Quilts in America* (New York: Abbeville Press, 1992), 516, and in Carleton L. Safford and Robert Bishop, *America's Quilts and Coverlets* (New York: Weathervane Books, 1974), 152.

2. I am indebted to Heather Bourdeau, O.D., for explaining "second sight" to me, e-mail correspondence, July 14, 2008.

3. The current location of the second quilt by Van Voorhis is unknown. It is illustrated in Cyril I. Nelson and Carter Houck, *Treasury of American Quilts* (New York: Greenwich House, 1984), 163.

4. U.S. Census and genealogical information from www.ancestry.com; Samuel P. Bates, *A Biographical History of Greene County, Pennsylvania* (Chicago: Nelson, Rishforth, 1888; repr., Baltimore: Genealogical Pub., 1975), 646. The 1850 Census also lists two young men as inhabitants of Daniel Van Voorhis's house: the couple's sons, 23-year-old Jeroam and 21-year-old Harry. Both men were listed as farmers.

5. Carroll Smith-Rosenberg, *Disorderly Conduct: Visions of Gender in Victorian America* (New York: Oxford University Press, 1985), 191.

6. Diary of Catharine Dean Flint, 1859–1861, Flint Family Papers, American Antiquarian Society, Worcester, Massachusetts. Catherine Dean was born in Charlestown, New Hampshire. In 1828, she married Waldo Flint (1794–1879) of Leicester, Massachusetts. Flint was a lawyer, served as a state senator and representative, and later became president of Boston's Eagle Bank. Flint Family Papers, American Antiquarian Society, Worcester, Massachusetts.

7. Janet Roebuck, "Grandma as Revolutionary: Elderly Women and Some Modern Patterns of Social Change," *International Journal of Aging and Human Development* 17 (1983): 253; Janet Roebuck, "When Does 'Old Age' Begin? The Evolution of the English Definition," *Journal of Social History* (2001): 417–418.

8. Lindsay Lomax Wood, *Leaves from an Old Washington Diary* (New York: Books, Inc., 1943), 44. Elizabeth Lindsay was born in Virginia in 1796, the daughter of Colonel William Lindsay (1743–1797) and Martha Fox Lindsay (ca. 1772–ca. 1806). In 1820, she married Mann Page Lomax (1787–1842), an officer in the U.S. Army, and the couple had seven children. After her husband died in 1842 from injuries sustained in the 1835 to 1838 war against the Seminole Indians in Florida, Elizabeth supported her family with the government pension she received and by copying documents for the War Department. Biographical information from the North American Women's Letters and Diaries database, http://solomon.nwld.alexanderstreet.com.silk.library.umass.edu:2048/bios/A315BIO.html.

9. Carole Haber, *Beyond Sixty-Five: The Dilemma of Old Age in America's Past* (Cambridge: Cambridge University Press, 1983), 47.

10. Haber, *Beyond Sixty-Five,* 53.

11. Helen Stuart Mackay-Smith Marlatt, *Stuart Letters of Robert and Elizabeth Sullivan Stuart and Their Children, 1819–1864* (New York: privately printed, 1961), 93.

12. For example, see: William-Edward Coale, *Hints on Health* (Boston: Phillips, Sampson, 1852), 147–151; John Harrison Curtis, *Observations on the Preservation of Sight* (Worcester: C. Harris, 1839), 55–56; J. Henry Clark, M.D., *Sight and Hearing, How Preserved, and How Lost* (New York: C. Scribner, 1856), 175–179, 200.

13. *New Hampshire Patriot and State Gazette,* October 15, 1838. Also see the broadside for "Dr. Isaac Thompson's celebrated eye-water" in the collection of the American Antiquarian Society, Worcester, Massachusetts.

14. I am indebted to Heather Bourdeau, O.D., for explaining this process to me in e-mail correspondence, July 14, 2008.

15. Curtis, *Observations,* 55. Curtis explained, "The average time at which glasses are first needed for reading may be said to be from thirty-five to forty-five. After this latter period of life, the power of adjustment possessed by the eye in youth fails"(*Observations,* 55–56).

16. Blanche Butler Ames, comp., *Chronicles from the Nineteenth Century: Family Letters of Blanche Butler and Adelbert Ames, Married July 21st, 1870,* vol. 1 (Clinton, MA: privately published, 1957), 59. Sarah Jones Hildreth was born in 1816 in Lowell, Massachusetts, to Dr. Israel Hildreth and his wife. She pursued an acting career between 1837 and 1842 but retired when she married Benjamin F. Butler in 1844. Benjamin Butler had a law practice in Lowell, later becoming a Massachusetts state senator and a Union general during the Civil War. The couple had three children. Sarah Jones Hildreth Butler died in Boston, Massachusetts, in 1876. Biographical information from North American Women's Letters and Diaries database, http://solomon.nwld.alexanderstreet.com.silk.library.umass.edu:2048/bios/A353BIO.html.

17. *The Ladies' Hand-Book of Fancy Needlework and Embroidery* (New York: J. S. Redfield, 1844), 56–57.

18. Coale, *Hints on Health,* 148.

19. Lydia Maria Child, *The American Frugal Housewife* (1844; repr., Mineola, NY: Dover Publications, 1999), 88.

20. Coale, *Hints on Health,* 148.

21. Coale, *Hints on Health,* 151.

22. Clark, *Sight and Hearing,* 179.

23. Elizabeth Dorr Diaries, June 5 and June 25, 1855, Massachusetts Historical Society, Boston.

24. Allen C. Clark, *Life and Letters of Dolly Madison* (Washington, DC: Press of W. R. Roberts, 1914), 288. Dolley Madison was the wife of President James Madison (1751–1836).

25. Mary E. Dewey, ed., *Life and Letters of Catharine M. Sedgwick* (New York: Harper and Row, 1871), 351. Catharine Maria Sedgwick was born in 1789 in Stockbridge,

Massachusetts, to Theodore Sedgwick and Pamela Dwight Sedgwick. She began writing for publication in the early 1820s, eventually writing successful novels. She also pursued various social reform initiatives, including prison reform. Sedgwick never married. She died in West Roxbury, Massachusetts, in 1867. Biographical information from the North American Women's Letters and Diaries database, http://solomon.nwld.alexanderstreet.com.silk.library.umass.edu:2048/bios/A198BIO.html.

26. Paddack's portrait is in the collection of the Nantucket Historical Association, Nantucket, Massachusetts. The portrait was painted by William Swain (1803–1847) in 1846. Mary Swain was born December 14, 1792, the daughter of Tristram Swain (1747–1825) and Rachael Bunker Swain (1752–1831). She first married Benjamin Tucker (dates unknown). She later married Laban Paddack (1790–1847), and they had one child. Mary Swain Tucker Paddack died on February 23, 1878. Barney Genealogical Record, Nantucket Historical Association, Nantucket, Massachusetts; Michael A. Jehle, ed., *Picturing Nantucket: An Art History of the Island with Paintings from the Collection of the Nantucket Historical Association* (Nantucket, MA: Nantucket Historical Association, 2000), 172.

27. Other portraits of aging women who hold their spectacles include the portrait of Sarah Barnard, painted by Joseph T. Harris in 1835 and now in the collection of the Nantucket Historical Association, and the portrait of Mrs. David Stevens attributed to Ruth Whittier Shute in the 1830s and now in a private collection (see auction record for this portrait, which was sold by Skinner on June 7, 2009; Skinner, Inc., *American Furniture and Decorative Arts* [Boston: Skinner, 2009], 136–137).

28. Clark, *Sight and Hearing,* 178.

29. Curtis, *Observations,* 55.

30. As described in Ricky Clark, "Mid-Nineteenth Century Album and Friendship Quilts, 1860–1920," in *Pieced by Mother: Symposium Papers,* ed. Jeannette Lasansky (Lewisburg, PA: Oral Traditions Project, 1988), 79. The current location of this quilt is unknown.

31. Lydia Maria Child, *Looking Toward Sunset* (Boston: Ticknor and Fields, 1867), 175.

32. Lydia Sigourney, *Past Meridian* (Hartford, CT: F. A. Brown, 1856), 248.

33. The portrait is in the collection of Historic New England, Boston, Massachusetts. Fisk was the daughter of Reverend Abel Fisk and Anna Spaulding Fisk of Wilton, New Hampshire; she married Asa Holt. The painting is in Mary C. Beaudry, *Findings: The Material Culture of Needlework and Sewing* (New Haven, CT: Yale University Press, 2006), 132. Genealogical information from e-mail correspondence between the author and Adrienne Sage, collection manager at Historic New England, March 30, 2009; Frederick Clifton Pierce, *Fiske and Fisk Family* (Chicago: F. C. Pierce, 1896), 253.

34. Lynn A. Bonfield and Mary C. Morrison, *Roxana's Children: The Biography of a Nineteenth-Century Vermont Family* (Amherst: University of Massachusetts Press, 1995), 18–19.

35. Donald Gordon, *The Diary of Ellen Birdseye Wheaton* (Boston: privately printed, 1923), 304–305. Ellen Douglas Birdseye was born in New York in 1816, the daughter of Victory Birdseye and Electa Beebee Birdseye. She married Charles Augustus Wheaton in 1834, and the couple had twelve children. She died in 1858 at age forty-two. Biographical information from North American Women's Letters and Diaries database, http://solomon.nwld.alexanderstreet.com.silk.library.umass.edu:2048/bios/A219BIO.html.

36. The quilt is currently in a private collection but is pictured as part of the Quilt Index (www.quiltindex.org). For the family story about quilting with her teeth, see www.quiltindex.org/fulldisplay.php?pbd=tennesseetest-a0a0e3-a.

37. Biography of Captain James R. Moore, *History of Meigs County, Tennessee,* www.rootsweb.ancestry.com/~tnmeigs/g_moore.html.

38. See collections database records for two watercolors by Rogers now in the collection of Historic Deerfield, http://museums.fivecolleges.edu. I am indebted to Ned Lazaro, collections manager, Historic Deerfield, for bringing these watercolors and their artist to my attention.

39. On the dating of the green fabric in the quilt, see e-mail correspondence to the author from Merikay Waldvogel, codirector, Quilts of Tennessee Project, April 10, 2009; and Barbara Brackman, *Clues in the Calico: A Guide to Identifying and Dating Antique Quilts* (McLean, VA: EPM Publications, 1989), 59–61.

40. Sigourney, *Past Meridian,* 10–11.

41. E. J. Tilt, *On the Preservation of the Health of Women at the Critical Periods of Life* (New York: John Wiley, 1851), 122.

42. John White Chadwick, ed., *A Life for Liberty: Anti-slavery and Other Letters of Sallie Holley* (New York: G. P. Putnam's Sons, 1899), 87. Sallie Holley was born in 1818 in Canandaigua, New York, to Myron Holley and Sally House Holley. In the early 1840s, she became a teacher, but then she entered Oberlin College in 1847, graduating in 1851. Holley became an abolitionist, but she did not achieve high visibility within the movement. After the war, she taught for a time at a school in Virginia for former slaves but eventually returned north. She died in New York City in 1893. William H. Pease and Jane H. Pease, "Holley, Sallie," in *American National Biography Online* (2000), www.anb.org.silk.library.umass.edu:2048/articles/15/15-00900.html.

43. Letter from Margaret Bayard Smith to her sister, Maria Kirkpatrick, February 10, 1834, as quoted in Gaillard Hunt, *The First Forty Years of Washington Society in the Family Letters of Margaret Bayard Smith* (New York: Frederick Ungar Publishing, 1906), 346.

44. Fredrika J. Teute, "Roman Matron on the Banks of Tiber Creek: Margaret Bayard Smith and the Politicization of Spheres in the Nation's Capital," in *A Republic for the Ages: The United States Capitol and the Political Culture of the Early Republic,* ed. Donald R. Kennon (Charlottesville: University Press of Virginia, 1999), 105.

45. Edward T. James, ed., *Notable American Women, 1607–1950: A Biographical Dictionary* (Cambridge: Belknap Press of Harvard University Press, 1971), 371; Donald B. Cole, "Smith, Margaret Bayard," in *American National Biography Online* (2000), www.anb.org.silk.library.umass.edu:2048/articles/20/20-0961.html; Betty Ring, *Girlhood Embroidery: American Samplers and Pictorial Needlework, 1650–1850* (New York: Alfred A. Knopf, 1993), 434, 436.

46. James, *Notable American Women,* 317–318; Cole, "Smith, Margaret Bayard"; Teute, "Roman Matron," 118–119.

47. For more on Margaret Bayard Smith, see Fredrika J. Teute, "In 'the gloom of evening': Margaret Bayard Smith's View in Black and White of Early Washington Society," *Proceedings of the American Antiquarian Society* 106 (1996): 37–58.

48. Canvas work, which we often call needlepoint today, was stitched on cloth (usually unbleached linen) woven with 18–52 threads per inch. Often the design was drawn onto the cloth before stitching; the cloth could be purchased premarked, or the woman could draw the design herself. In 1804, a print seller in Berlin, Germany, devised a method of illustrating canvas-work designs on gridded paper, which were then hand-colored. This became known as "Berlin work" and was widely popular between 1830 and 1870; over 14,000 designs were published between 1830 and 1840 alone. See Susan Burrows Swan, *A Winterthur Guide to American Needlework* (New York: Crown Publishers, 1976), 26–63; Judith Reiter Weissman and Wendy Lavitt, *Labors of Love: America's Textiles and Needlework, 1650–1930* (New York: Wings Books, 1987), 140; and Miss Lambert, *The Hand-Book of Needlework* (London: John Murray, 1846), 117, 120, 206. Virginia Southard was the daughter of Samuel Lewis Southard (1787–1842), who was governor of New Jersey in 1832 and 1833, until he resigned to serve in the U.S. Senate. *Biographical Directory of the United States Congress,* http://bioguide.congress.gov/scripts/biodisplay.pl?index=S000689.

49. Hunt, *First Forty Years,* 347. "Mrs. Clay" was the wife of statesman Henry Clay (1777–1852), who served as a U.S. senator for Kentucky, was Speaker of the House, and ran unsuccessfully for president of the United States in 1824, 1832, and 1844. Robert V. Remini, "Clay, Henry," in *American National Biography Online* (2000), www.anb.org.silk.library.umass.edu:2048/articles/03/03-00100.html. Unfortunately, the ottomans and lamp shades are now lost; no needlework owned by the family from the 1830s remains at Ashland, the Henry Clay estate (now a museum), in Lexington, Kentucky. I am indebted to Eric Brooks, curator at Ashland, for his assistance with my question about the ottomans and lamp shades in e-mail correspondence, May 14, 2009.

50. This gown is now in the collection of Old Sturbridge Village, Sturbridge, Massachusetts. The gown is attributed to Marion Chandler (1800–1857) of Pomfret, Connecticut, who wore it at her marriage to Dr. Hiram Holt in 1828. Information from the curatorial file at Old

Sturbridge Village, Sturbridge, Massachusetts. The embroidery pattern is also in the collection of Old Sturbridge Village, Sturbridge, Massachusetts. It is part of a large collection of embroidery patterns dating from the 1790 to 1830 period and probably from Providence, Rhode Island.

51. Letter from Margaret Bayard Smith to Maria Boyd, January 12, 1827, quoted in Hunt, *First Forty Years,* 205–206.

52. Paula A. Scott, *Growing Old in the Early Republic: Spiritual, Social and Economic Issues, 1790–1830* (New York: Garland Publishing, 1997), 50.

53. Marcus Tullius Cicero and Andrew P. Peabody, *Cicero De Amicitia, To Which Is Added Scipio's Dream and Cicero De Senectute* (Boston: Little, Brown, 1884), 12, 25–26, 28–29, 31; Herbert Stein, "On Rereading 'De Senectute,'" *Slate Magazine,* November 27, 1998, http://slate.msn.com/id/9139/.

54. Both the table and the table cover are now in the collection of the Peabody Essex Museum, Salem, Massachusetts. I am indebted to Paula Bradstreet Richter, curator of textiles and costumes, for showing the table cover to me and sharing her thoughts about it. Technically, the table is attributed to Joseph True; it does not bear any identifying maker's marks. Joseph True was born in Chichester, New Hampshire, in 1785 and moved to Salem, Massachusetts, by 1809, when he married Mary (Polly) Berry. Margaret Burke Clunie, "Joseph True and the Piecework System in Salem," *The Magazine Antiques* 111 (May 1977): 1007. An 1847 letter described True as a master carver, "Joseph True[,] . . . self taught[,] has real talent, has the best work, is now carving Gothic ornament of a very beautiful kind for the North Church." An 1847 letter from George Phippen to Rev. Joseph B. Felt of Boston, quoted in Clunie, "Joseph True," 1009.

55. Discussion with Paula Bradstreet Richter, curator of textiles and costumes at the Peabody Essex Museum, Salem, Massachusetts, during site visit on May 8, 2006.

56. Lambert, *Hand-Book of Needlework* (1846), 214–215.

57. Lambert, *Hand-Book of Needlework* (1846), 121–122.

58. Clunie, "Joseph True," 1007.

59. Henry Wycoff Belknap, "Joseph True, Wood Carver of Salem, and His Account Book," *Essex Institute Historical Collections* 78 (1942): 121, 128.

60. Belknap, "Joseph True," 121; Paula Richter, *Painted with Thread: The Art of American Embroidery* (Salem, MA: Peabody Essex Museum, 2002), 90.

61. Belknap, "Joseph True," 122.

62. Richter, *Painted with Thread,* 90.

63. Laurel Thatcher Ulrich, *The Age of Homespun: Objects and Stories in the Creation of an American Myth* (New York: Alfred A. Knopf, 2001), 376. An 1812 portrait of Mrs. Ammi Ruhamah Robbins, which predates the period under consideration here, makes Ulrich's point visually, showing its subject with a book in one hand and her knitting on the table next to her. The painting, by artist Reuben Moulthrop, is now in the collection of the Detroit Art Institute. Ulrich, *Age of Homespun,* 376.

64. *The Youth's Sketch Book* (Boston: Benjamin B. Mussey, 1849), 22.

65. Sarah Newman Connell Ayer, *Diary of Sarah Connell Ayer* (Portland, ME: Lefavor-Tower, 1910), 369.

66. Ulrich, *Age of Homespun,* 407.

Chapter 2: Growing Old Gracefully

1. The portrait is now in the collection of the National Society of the Colonial Dames of America in the Commonwealth of Pennsylvania at Stenton, Philadelphia. It is a copy of the original portrait painted by Charles Willson Peale in 1822. The original was burned by a relative in 1934. Susan M. Stabile, *Memory's Daughters: The Material Culture of Remembrance in Eighteenth-Century America* (Ithaca, NY: Cornell University Press, 2004), 130. Deborah Norris was born in 1761 in Philadelphia, Pennsylvania, the daughter of Charles Norris (1712–1766) and Mary Parker Norris (d. 1799). In 1781, she married Quaker doctor George Logan (1753–1821), and they had three sons. Deborah Norris Logan died in 1839. Biographical information from the North American Women's Letters and Diaries database, http://solomon.nwld.alexanderstreet.com.silk.library.umass.edu:2048/bios/A160BIO.html.

2. Logan's diary as quoted in Stabile, *Memory's Daughters,* 129.

3. Lindsay Lomax Wood, *Leaves from an Old Washington Diary* (New York: Books, Inc., 1943), 45–46.

4. Caroline M. Kirkland, *The Evening Book; or, Fireside Talk* (New York: Charles Scribner, 1852), 14. Caroline M. Stansbury was born in 1801 in New York City, the daughter of Samuel Stansbury and Eliza Alexander Stansbury. She became a teacher as a young woman. In 1828, she married William Kirkland, and they founded a girls' school in Geneva, New York. In 1835, the couple and their four children moved to Michigan Territory. Kirkland began writing novels soon after. In 1843, Caroline and her husband moved their family back to New York City and opened another school, while both continued to write. Caroline died in New York City in 1864. Julie A. Thomas, "Kirkland, Caroline Matilda," in *American National Biography Online* (2000), www.anb.org.silk.library.umass.edu:2048/articles/16/16-00924.html.

5. The painting is currently in a private collection. It is pictured in an advertisement for Joan R. Brownstein American Folk Paintings, which appeared in *Antiques and the Arts Weekly,* March 2, 2007.

6. Kirkland, *Evening Book,* 250.

7. Lydia Maria Child, *Looking Toward Sunset* (Boston: Ticknor and Fields, 1867), 325.

8. Eliza Leslie, *The Behaviour Book* (Philadelphia: Willis P. Hazard, 1854), 334. Eliza Leslie (1787–1858) was born in Philadelphia, Pennsylvania, to Robert Leslie (a watchmaker) and Lydia Baker Leslie. The family lived in London from 1793 to 1799. After her father's death in 1803, Leslie and her mother took in boarders, while Leslie also taught drawing. In the early 1820s, she began her writing career by publishing a cookbook; she was then encouraged by her publisher to write juvenile stories. She continued writing throughout her life. She died in Gloucester, New Jersey, in 1858. Jean Pfaelzer, "Leslie, Eliza," in *American National Biography Online* (2000), www.anb.org.silk.library.umass.edu:2048/articles/16/16-00985.html.

9. Terri L. Premo, *Winter Friends: Women Growing Old in the New Republic, 1785–1835* (Urbana: University of Illinois Press, 1990), 113.

10. George Washington Bethune, comp., *Memoirs of Mrs. Joanna Bethune* (New York: Harper and Brothers, 1863), 213–214.

11. The sampler is now in the collection of the Concord Museum, Concord, Massachusetts. I am indebted to curator David Wood and registrar Erin McGough for facilitating my study visit in September 2005. Lucretia Buttrick was born in Concord, Massachusetts, in 1801 and married John Buttrick (1796–1880) of Waltham, Massachusetts, in 1828. John was a carpenter, and the couple lived in Lowell, where they had four children. See William Richard Cutter, *Historic Homes and Places and Genealogical and Personal Memoirs Relating to the Families of Middlesex County, Massachusetts* (New York: Lewis Historical Pub., 1908), 451–452; and George Tolman, *Concord, Massachusetts: Births, Marriages and Deaths, 1635–1850* (Boston: T. Todd, printer, 1895), 279, 391.

12. These samplers were made by American girls and were altered in some manner by having part of the original stitching picked out. They were carefully examined in person or in photographs to determine that the information was intentionally picked out and did not simply deteriorate due to age or materials. If no determination could be made as to whether the missing stitches were removed intentionally, the sampler was not included in the group. A silk needlework picture was also uncovered during this survey. The year of its original stitching, 1819, was reverse-painted on the glass covering the picture when it was framed. At an unknown time, the year was painted over. This piece was appraised on an episode of PBS's *Antiques Roadshow,* first aired on January 5, 2009; the transcript of the appraisal and photographs of the picture were accessed at www.pbs.org/wgbh/roadshow/archive/200001A14.html.

13. Leslie, *Behaviour Book,* 335–336.

14. Frederick Hollick, M.D., *The Diseases of Woman* (New York: T. W. Strong, 1849), 234.

15. The desire to appear younger was not limited to being played out on women's samplers. An image entitled "Old Women Ground Young" appears on at least one piece of eighteenth-century creamware. The scene shows elderly women climbing a ladder to the top of a grain-milling machine and young women coming out

of the bottom. See Jeanne Schinto, "Old Women Ground Young," *Maine Antiques Digest* (May 2009): 29C.

16. Mary Jaene Edmonds, *Samplers and Samplermakers: An American Schoolgirl Art, 1700–1850* (London: Rizzoli, 1991), 60.

17. Betty Ring, *American Needlework Treasures: Samplers and Silk Embroideries from the Collection of Betty Ring* (New York: E. P. Dutton, 1987), 66.

18. See examples cited in Susan Burrows Swan, *Plain and Fancy: American Women and Their Needlework, 1650–1850* (Austin, TX: Curious Works Press, 1995), 57; Glee Krueger, *New England Samplers to 1840* (Sturbridge, MA: Old Sturbridge Village, 1978), 10–11; and Betty Ring, *Girlhood Embroidery: American Samplers and Pictorial Needlework, 1650–1850* (New York: Alfred A. Knopf, 1993), 24.

19. Titled *Farmer Giles and his Wife showing off their daughter Betty to their Neighbours on her return from School,* the print is by James Gillray (1757–1815) of London. The copy of this print in figure 2.4 is in the collection of Princeton University Library, Department of Rare Books and Special Collections, Princeton, New Jersey.

20. Sarah Anna Emery, *Reminiscences of a Nonagenarian* (Newburyport, MA: W. H. Huse, 1879), 222.

21. Susan Bradford Eppes, *Through Some Eventful Years* (Macon, GA: Press of the J. W. Burke Co., 1926), 88–89.

22. Leslie, *Behaviour Book,* 335–336.

23. U.S. Census information from www.ancestry.com. Buttrick is listed incorrectly as "Lucretia Bultrick" in the online 1870 Census records.

24. David Hackett Fischer, *Growing Old in America* (New York: Oxford University Press, 1977), 82–84.

25. 1880 U.S. Census information from www.ancestry.com. The 1890 U.S. Census was destroyed by fire and all records were lost, so we do not know what age Buttrick gave that year when the census taker came around.

26. The memorial card is now part of the Buttrick and Buttrick-related papers and ephemera collection, Concord Library, Concord, Massachusetts. The source of the poem also included on the card is unknown, but an Internet search in July 2008 turned up numerous transcriptions of gravestones that quote all or part of the poem during the last half of the nineteenth century.

The entire poem on the card reads, "A precious one from us has gone, / A voice we loved is stilled; / A place is vacant in our home / Which never can be filled. / God, in His wisdom, has recalled / The boon His love had given. / And though the body slumbers here, / The soul is safe in Heaven."

27. Virginia Cary, *Letters on Female Character, Addressed to a Young Lady on the Death of Her Mother* (Richmond, VA: Ariel Works, 1830), 142.

28. Cary, *Letters on Female Character,* 142.

29. Kirkland, *Evening Book,* 254.

30. Leslie, *Behaviour Book,* 334.

31. Gaillard Hunt, *The First Forty Years of Washington Society in the Family Letters of Margaret Bayard Smith* (New York: Frederick Ungar Publishing, 1906), 234–235.

32. Hunt, *First Forty Years,* 236. The woman referred to as "old Mrs. Madison" in the letter was the mother of President James Madison (1751–1836).

33. Lydia H. Sigourney, *Past Meridian* (Hartford, CT: F. A. Brown, 1856), 248. Sigourney may also have been thinking of the productivity of many New England women as they increased their activism, making small items to sell at antislavery fairs and other events. For more on the rise of antebellum female activism, see Anne M. Boylan, *The Origins of Women's Activism: New York and Boston, 1797–1840* (Chapel Hill: University of North Carolina Press, 2002); and Debra Gold Hansen, *Strained Sisterhood: Gender and Class in the Boston Female Anti-slavery Society* (Amherst: University of Massachusetts Press, 1993), 158, 162–164.

34. Laurel Thatcher Ulrich, *The Age of Homespun: Objects and Stories in the Creation of an American Myth* (New York: Alfred A. Knopf, 2001), 381–382. See chapter 3 for a discussion of aging women's entries in local agricultural fairs, where advanced age was often highlighted in newspaper accounts of the premiums awarded.

35. Paula Bradstreet Richter, "Lucy Cleveland, Folk Artist," *The Magazine Antiques* 158 (August 2000): 204, 206.

36. Paula Bradstreet Richter, "Lucy Cleveland's 'Figures of Rags': Textile Arts and Social Commentary in Early-Nineteenth-Century New England," in *Textiles in Early New England: Design, Production, and Consumption,*

ed. Peter Benes (Boston: Boston University, 1999), 49–50; Richter, "Lucy Cleveland, Folk Artist," 206.

37. In addition to eleven vignettes, the Peabody Essex Museum also owns five additional single figures. A twelfth vignette, now in the collection of the Shelburne Museum, Shelburne, Vermont, has been attributed to Cleveland, but Paula Bradstreet Richter disputes this attribution because of differences in style. E-mail correspondence from Paula Bradstreet Richter, January 6, 2009.

38. Letter from Lucy Cleveland, Boston, to Mrs. W. S. Cleveland, Salem, Massachusetts, May 23, 1847, Lucy Cleveland Papers, Phillips Library, Peabody Essex Museum, Salem, Massachusetts.

39. Manuscript written by Susan Cleveland Bristol, December 9, 1918, quoted in Richter, "Lucy Cleveland, Folk Artist," 211.

40. The vignette is now in the collection of the Peabody Essex Museum, Salem, Massachusetts. When it was donated, it was accompanied by a note about its history. Richter, "Lucy Cleveland, Folk Artist," 207.

41. Richter, "Lucy Cleveland, Folk Artist," 207. The lithograph, *Death of Washington, Dec. 14. A.D. 1799,* was published by Nathaniel Currier in 1841.

42. Catharine E. Beecher and Harriet Beecher Stowe, *The American Woman's Home; or, Principles of Domestic Science* (New York: J. B. Ford, 1869), 339–340.

43. Richter, "Lucy Cleveland's 'Figures,'" 50.

44. Beecher and Stowe, *American Woman's Home,* 342, 343.

45. The album is now in the Lucy Cleveland collection, Phillips Library, Peabody Essex Museum, Salem, Massachusetts.

46. Letter from Lucy Cleveland, Boston, to William S. Cleveland, Salem, October 2, 1842, Lucy Cleveland Papers, Phillips Library, Peabody Essex Museum, Salem, Massachusetts. Cleveland was probably caring for her older sister, Dorcas Cleveland (1773–1850).

47. This vignette is also known as "The Second Wife." This title appears in a January 1922 article in *The Magazine Antiques* and seems to originate from that time. Paula Bradstreet Richter notes that some of the vignettes were named according to family tradition,

while others were assigned names by the museum staff who cataloged them. At least one of the vignettes in the Peabody Essex Museum collection has its name written on the base in pencil, possibly by Cleveland herself. E-mail correspondence from Paula Bradstreet Richter, January 6, 2009.

48. Letter from Lucy Cleveland to William S. Cleveland, May 16, 1841, quoted in Richter, "Lucy Cleveland's 'Figures,'" 58.

49. Lydia Huntley Sigourney, *Letters to Mothers* (Hartford: Hudson and Skinner, 1838), 221–222.

50. This sampler is now in a private collection but is pictured in M. Finkel and Daughter, *Samplings* 6 (1994): 19. Forbes's date of birth is from www.ancestry.com.

51. Diary of Mary Avery Upham, April 23, 1860, Massachusetts Historical Society, Boston.

52. The bedcover is currently in the collection of the Daughters of the American Revolution Museum in Washington, DC. I am indebted to Alden O'Brien, curator of costume and textiles, for allowing me access to it and its records during site visits in June 2006 and June 2009. Family information from www.ancestry.com; entry for Francis Scott Key, Maryland Online Encyclopedia, www.mdoe.org/keyFS.html; Victor Weybright, *Spangled Banner: The Story of Francis Scott Key* (New York: Farrar and Rinehart, 1935), 35–36, 40, 226–227. A second bedcover attributed to Mary Tayloe Lloyd Key is now in the collection of the San Jose Museum of Quilts and Textiles, San Jose, California. This one is paper-pieced in hexagons. It was never finished, and the paper templates are still visible on the back, showing that they are recycled letters. Family history suggests that this bedcover was made for Key's daughter, Mary Alicia Lloyd Nevins Key (1823–1886) (known as Alice), around 1840. Unfortunately, details about why it was made are unknown. Phone conversation with staff at the San Jose Museum of Quilts and Textiles, April 10, 2009.

53. Weybright, *Spangled Banner,* 227, 275.

54. Also known as a fret or a meander, the Greek key motif was a popular running ornament in ancient Greece and Rome and was used frequently on American architecture and decorative arts during the federal era. See Harold Koda, "The Greek Key and Divine

Attributes in Modern Dress," in *Heilbrunn Timeline of Art History* (New York: Metropolitan Museum of Art, 2000–), www.metmuseum.org/toah/hd/god5/hd_god5.htm (October 2003); www.buffaloah.com/a/DCTNRY/f/fret .html. Similar fabric is employed as a border in a quilt made in 1846 by Mary Rooker Norris (1785–1868) of Maryland (also now in the collection of the Daughters of the American Revolution Museum); see chapter 7 for a discussion of that quilt.

55. Gloria Seaman Allen, *Old Line Traditions: Maryland Women and Their Quilts* (Washington, DC: DAR Museum, 1985), 27.

56. Weybright, *Spangled Banner,* 41.

57. Weybright, *Spangled Banner,* 41.

58. Weybright, *Spangled Banner,* 41; National Register Listings in Maryland, www.marylandhistoricaltrust. net; Swepson Earle and Percy G. Skirven, *Maryland's Colonial Eastern Shore: Historical Sketches of Counties and of Some Notable Structures* (Baltimore: Munder-Thomsen Press, 1916), 29–30.

59. Weybright, *Spangled Banner,* 40–41, 275–77.

60. E-mail correspondence between the author and Alden O'Brien, curator of costume and textiles at the Daughters of the American Revolution Museum, July 7, 2008.

61. Allen, *Old Line Traditions,* 27. Currently, the quilt has a twentieth-century replacement backing, which is only basted on and does not cover the entire back of the quilt. E-mail correspondence between the author and Alden O'Brien, curator of costume and textiles at the Daughters of the American Revolution Museum, July 7, 2008; site visit on June 23, 2009.

62. Barbara Brackman, *Clues in the Calico: A Guide to Identifying and Dating Antique Quilts* (McLean, VA: EPM Publications, 1989), 167; Lynne Z. Bassett and Jack Larkin, *Northern Comfort: New England's Early Quilts, 1780–1850* (Nashville: Rutledge Hill Press, 1998), 61, 99; Judy Mathieson, "Some Published Sources of Design Inspiration for the Quilt Pattern Mariner's Compass— 17th to 20th Century," *Uncoverings* 2 (1981): 11–18. Brackman suggests that this quilt block may have been inspired by the depictions of compass roses on sea charts or by representations of the sun. The Key family called the pattern "Five Blazing Stars." Curatorial file

for the bedcover, Daughters of the American Revolution Museum.

63. I am indebted to Alden O'Brien and Virginia Vis of the Daughters of the American Revolution Museum, who examined the quilt with me on June 23, 2009.

64. Curatorial file on the quilt, Daughters of the American Revolution Museum. Mary Tayloe Key McBlair in turn gave the quilt top to her best friend, Maud W. Lipscomb Greenawalt, and it was bequeathed to the Daughters of the American Revolution Museum in 1942 by Maud's husband, Frank F. Greenawalt, in his wife's memory.

65. Letter from Hannah Robbins Gilman to Chandler Robbins Gilman, November 15, 1823, in *A Family History in Letters and Documents* (St. Paul, Minnesota: privately printed, 1919), 596. In a letter to her daughter, Elizabeth Hale Gilman Hoffman, two weeks earlier on October 30, 1823, Gilman wrote, "When parents are growing into years . . . there is a void in their hearts, which nothing but the society of their children can fill. In their absence, they feel like useless beings" (*Family History,* 596).

66. Sigourney, *Past Meridian,* 116.

Chapter 3: The Technological Reshaping of Antebellum Needlework

1. Letter from Lucretia Coffin Mott to Martha Coffin Pelham Wright, September 3, 1843, quoted in Anna Davis Hallowell, *James and Lucretia Mott: Life and Letters* (Boston: Houghton, Mifflin, 1884), 260–261. Lucretia Coffin, who became a well-known abolitionist and women's rights activist, was born on Nantucket Island, Massachusetts, in 1793, the daughter of Thomas Coffin Jr. and Anna Folger Coffin, and was raised in the Quaker faith. She attended the Nine Partners school in Dutchess County, New York. At Nine Partners she met James Mott, whom she married in 1811. Lucretia's parents had moved to Philadelphia in 1809, and Lucretia and James moved there after their marriage, as well. The couple had six children, five of whom survived to adulthood. In 1821, Lucretia was recognized as a Quaker minister. She died in Chelton Hills, Pennsylvania, in 1880.

Nancy C. Unger, "Mott, Lucretia Coffin," in *American National Biography Online* (2000),www.anb.org.silk.library .umass.edu:2048/articles/15/15-00494.html. The Nantucket Historical Association, Nantucket, Massachusetts, has a quilt in its collection (1967.0016.001) attributed to Mott.

2. Laurel Thatcher Ulrich, "Wheels, Looms, and the Gender Division of Labor in Eighteenth-Century New England," *William and Mary Quarterly* 55 (January 1998): 3–38.

3. Jonathan Prude, "Town-Factory Conflicts in Antebellum Rural Massachusetts," in *The Countryside in the Age of Capitalist Transformation: Essays in the Social History of Rural America,* ed. Steven Hahn and Jonathan Prude (Chapel Hill: University of North Carolina Press, 1985), 73.

4. Prude, "Town-Factory Conflicts," 76–80. In his study of the Lowell mills, historian Thomas Dublin found that the proportion of the work force employed outside of agriculture increased from 28 percent to 41 percent between 1820 and 1860. See Thomas Dublin, *Women at Work: The Transformation of Work and Community in Lowell, Massachusetts, 1826–1860* (New York: Columbia University Press, 1993), 5.

5. David A. Zonderman, *Aspirations and Anxieties: New England Workers and the Mechanized Factory System, 1815–1850* (New York: Oxford University Press, 1992), 6.

6. Dublin, *Women at Work,* 55–56.

7. See Laurel Thatcher Ulrich, *The Age of Homespun: Objects and Stories in the Creation of an American Myth* (New York: Alfred A. Knopf, 2001), for an examination of the process by which cloth production became romanticized during the nineteenth century.

8. Report printed in the *New England Farmer,* November 7, 1832.

9. The quilt is now in the collection of the Los Angeles County Museum of Art, Los Angeles, California. The source of the verse in the central medallion is unknown, but the other three verses are from the Bible (Psalm 111:10 and Proverbs 14:26 and 27). Sandi Fox, *For Purpose and Pleasure: Quilting Together in Nineteenth-Century America* (Nashville: Rutledge Hill Press, 1995), 114–117; Gloria Seaman Allen, *Family Record: Genealogical Watercolors and Needlework* (Washington, DC: DAR Museum, 1989), 94–95; curatorial file from the Los Angeles County Museum of Art, Los Angeles, California.

10. Linda Eaton, *Quilts in a Material World: Selections from the Winterthur Collection* (New York: Abrams, 2007), 122; Margaret T. Ordonez, "Technology Reflected: Printed Textiles in Rhode Island Quilts," in *Down by the Old Mill Stream: Quilts in Rhode Island,* ed. Linda Welters and Margaret T. Ordonez (Kent, OH: Kent State University Press, 2000), 122.

11. Lynne Z. Bassett and Jack Larkin, *Northern Comfort: New England's Early Quilts, 1780–1850* (Nashville: Rutledge Hill Press, 1998), 34.

12. Barbara Brackman, *Clues in the Calico: A Guide to Identifying and Dating Antique Quilts* (McLean, VA: EPM Publications, 1989), 86–87. The term *rainbow* to describe this effect was used for wallpaper (which employed a similar printing process) in 1826. "Rainbow" fabrics were also known as *fondu,* French for "melt" or "dissolve," and as *ombre,* French for "shaded" or "tinted."

13. Emma Hart Willard, *Journal and Letters from France and Great Britain* (Troy, NY: N. Tuttle, 1833), 356. Emma Hart was born in 1787 in Berlin, Connecticut, the daughter of Samuel Hart and Lydia Hinsdale Hart. She began teaching in Berlin, Connecticut, in 1804, and took charge of the Middlebury, Vermont, female academy three years later. In 1809, she married John Willard, a physician and politician. They had a son in 1810. Emma Willard established the Troy Female Seminary in New York in 1821, and it became a model for other female institutions. During the 1840s, she continued as an adviser to the seminary but began to focus on writing books. She died in Troy, New York, in 1870. Susan Grigg, "Willard, Emma Hart," in *American National Biography Online* (2000), www.anb.org.silk.library.umass.edu:2048/articles /09/09-00806.html.

14. Willard, *Journal and Letters,* 357.

15. Lynne Z. Bassett, ed., *Massachusetts Quilts: Our Common Wealth* (Hanover, NH: University Press of New England, 2009), 323; Roy Neal, "A Chronological History of Ink," *American Ink Maker* 38 (September 1960): 38–40; David N. Carvalho, *Forty Centuries of Ink* (New York: Burt Franklin, 1971), 2, 134–135.

16. Linda Otto Lipsett, *Remember Me: Women and Their Friendship Quilts* (San Francisco: Quilt Digest Press, 1985), 17–18.

17. Brackman, *Clues in the Calico,* 118.

18. *Connecticut Courant,* November 9, 1835.

19. Margaret T. Ordonez, "Ink Damage on Nineteenth Century Cotton Signature Quilts," *Uncoverings* 13 (1992): 157.

20. Miss Lambert, *The Hand-Book of Needlework* (London: John Murray, 1846), 111. There is no clear data on when the "blue line" canvas was first produced in this country. Some sampler historians link its use to the rise of Berlin work, which filled in the entire ground fabric, in the 1830s and 1840s. See Mary Jaene Edmonds, *Samplers and Samplermakers: An American Schoolgirl Art, 1700–1850* (London: Rizzoli, 1991), 154.

21. Lindsay Lomax Wood, *Leaves from an Old Washington Diary* (New York: Books, Inc., 1943), 127.

22. Suellen Meyer, "Early Influences of the Sewing Machine and Visible Machine Stitching on Nineteenth-Century Quilts," *Uncoverings* 10 (1989): 39–40; Barbara Brackman, *Patterns of Progress: Quilts in the Machine Age* (Los Angeles: Autry Museum of Western Heritage, 1997), 11, 18; Grace Rogers Cooper, *The Invention of the Sewing Machine* (Washington, DC: Smithsonian Institution, 1968), 59; Anita B. Loscalzo, "The History of the Sewing Machine and Its Use in Quilting in the United States," *Uncoverings* 26 (2005): 182.

23. Loscalzo, "History," 177.

24. Brackman, *Clues in the Calico,* 100.

25. Loscalzo, "History," 177. See Cooper, *Invention,* for a detailed technical history of the sewing machine.

26. Brackman, *Clues in the Calico,* 100; Cooper, *Invention,* 32, 143.

27. The quilt descended along a male line and remains in a family collection. It is pictured in Fawn Valentine, *West Virginia Quilts and Quiltmakers: Echoes from the Hills* (Athens: Ohio University Press, 2000), 109. Frances Swanson was born in Maryland; she married Joseph Shaw (1797–1886) around 1825. The couple moved to West Virginia at some point and eventually had seven children together. See Valentine, *West Virginia Quilts,* 107–108.

28. Brackman, *Patterns of Progress,* 11.

29. Robert M. Myers, ed., *The Children of Pride: A True Story of Georgia and the Civil War* (New Haven, CT: Yale University Press, 1972), 287.

30. Loscalzo, "History," 182.

31. Wood, *Leaves,* 127.

32. Loscalzo, "History," 177.

33. D. C. Bloomer, *Life and Writings of Amelia Bloomer* (New York: Schocken Books, 1975), 168. Amelia Jenks was born in 1818 in Homer, New York, the daughter of Ananias Jenks and Lucy Webb Jenks. In 1840, she married Dexter C. Bloomer, a newspaper editor and a lawyer. Amelia began to write articles for her husband's paper, which was located in Seneca Falls, New York, where they lived. In 1849, she founded a monthly journal, the *Lily.* Two years later, in 1851, she adopted the style of dress that became associated with her name—full Turkish-style trousers worn under a short skirt. She was also active throughout the 1840s and 1850s in the temperance movement. In the 1870s, she began to work for woman suffrage. In 1855, the Bloomers had moved to Iowa, where they adopted two children. She died in Council Bluffs, Iowa, in 1894. Kathleen Feeney, "Bloomer, Amelia Jenks," in *American National Biography Online* (2000), www.anb.org.silk.library.umass.edu:2048/articles/15/15-00071.html.

34. Diary entry by Harriette Kidder in 1859, quoted in Pat Ferrero, Elaine Hedges, and Julie Silber, *Hearts and Hands: Women, Quilts, and American Society* (Nashville: Rutledge Hill Press, 1987), 38. Harriette Smith was a teacher and principal at the Worthington Female Seminary in Ohio. She married Rev. Daniel P. Kidder (1815–1891) in 1842 as his second wife. The couple raised their three children and the two from his first marriage. The family moved numerous times between 1844 and the 1890s, with time spent in New York City; Newark, New Jersey; Evanston, Illinois; Madison, New Jersey; Brooklyn, New York; and Ocean Grove, New Jersey. Description of Harriette Smith Kidder Papers, Special Collections, Rutgers University Libraries, www.libraries.rutgers.edu/rul/libs/scua/womens_fa/wfa_h_k.shtml.

35. *Godey's Lady's Book,* July 1860, quoted in Sherbrooke Rogers, *Sarah Josepha Hale: A New England Pioneer, 1788–1879* (Grantham, NH: Tompson and Rutter, 1985), 122. Sarah Josepha Buell was born in 1788 in Newport, New Hampshire, the daughter of Gordon Buell and Martha Whittlesey Buell. She taught school from 1806 until 1813, when she married David Hale, a lawyer. When David died in 1822, leaving her to support their five children, she began to write. In 1828, she began edit-

ing the *Ladies' Magazine,* published by a firm in Boston. From 1837 to 1877, she edited *Godey's Lady's Book.* In 1879, she died in Philadelphia, Pennsylvania. Joyce W. Warren, "Hale, Sarah Josepha Buell," in *American National Biography Online* (2000), www.anb.org.silk.library.umass.edu: 2048/articles/16/16-00686.html.

36. *Records of a California Family: Journals and Letters of Lewis C. Gunn and Elizabeth Le Breton Gunn* (San Diego: privately printed, 1928), 245. Elizabeth Le Breton Stickney married Lewis Carstairs Gunn in 1839, and the couple made their home in Philadelphia. In 1849, Lewis went to California; his wife and four children joined him there in 1851. The family lived in Sonora, California, where Lewis published a local newspaper and owned a drugstore. In 1861, the family moved to San Francisco. Family information from www.familymarriagerecords.com/db .asp?dbid=3772.

37. Myers, *Children of Pride,* 507.

38. Some quilt historians suggest that only 10 percent show machine appliqué or quilting, while others state that 75 percent were at least partially machine stitched if made between 1860 and 1940. Loscalzo, "History," 186; Roderick Kiracofe, *The American Quilt: A History of Cloth and Comfort, 1750–1950* (New York: Clarkson Potter Publishers, 2004), 126.

39. Other extant quilts made between 1850 and 1860 with machine stitching include two Irish Chain machine-pieced quilts from the 1850s (by unknown makers) now in the collection of the International Quilt Study Center, Lincoln, Nebraska; a machine-appliquéd Basket Quilt by Delia Birdsey Crocker in the collection of the New England Quilt Museum, Lowell, Massachusetts; a machine-quilted Whig Rose quilt now in the collection of the Art Institute of Chicago; a machine-quilted whitework quilt of unknown origin from about 1860 now in the collection of the Smithsonian Institution; and a machine-pieced Checkerboard Squares quilt now in the collection of the Illinois State Museum. Loscalzo, "History," 177; Doris M. Bowman, *American Quilts: The Smithsonian Treasury* (Washington, DC: Smithsonian Institution Press, 1991), 64–65, 94; the Quilt Index, www.quiltindex.org /fulldisplay.php?pbd=IllinoisISM-a0a0z8-a.

40. The quilt is now in the collection of the Daughters of the American Revolution Museum, Washington,

DC. It was passed down in the family and was given to the Daughters of the American Revolution Museum by the great-great-great-granddaughter of the maker. Curatorial file, Daughters of the American Revolution Museum; family information from www.ancestry.com.

41. The quilt consists of twelve blocks set on point alternating with plain white squares. It has a white cotton backing and front-to-back binding. The quilt has medium-weight cotton batting and is machine quilted in a grid and outline pattern. The fruit basket appliqué pattern is an original design, although it shows similarities to other floral basket blocks. See Barbara Brackman, *Encyclopedia of Applique: An Illustrated, Numerical Index to Traditional and Modern Patterns* (McLean, VA: EPM Publications, 1993), 149; curatorial file, Daughters of the American Revolution Museum, Washington, DC.

42. Curatorial file, Daughters of the American Revolution Museum, Washington, DC. While it is difficult to document that Sneed's sewing machine was one of the first to make it to Texas, the Austin History Center suggests that the first sewing machine in Travis County, Texas, was purchased by Hugh and Helen Mary Tinnin soon after their arrival in 1850; see www.ci.austin.tx.us /library/ahc/begin/lei_amus.htm.

43. "Cheater cloth," also known as "imitation patchwork" and "printed patchwork," is a cotton fabric printed to look like pieced patchwork. Initially produced by English and American printers in the 1840s and 1850s, simulated patchwork fabrics continued to be popular into the early twentieth century. These fabrics reflected the taste of the time—Log Cabin blocks in the 1850s, Centennial motifs in the 1870s, and Dresden Plate and Grandmother's Flower Garden patterns in the 1930s. Brackman, *Clues in the Calico,* 94–95; Bassett and Larkin, *Northern Comfort,* 78.

44. E-mail correspondence from Alden O'Brien, curator of costume and textiles at the Daughters of the American Revolution Museum, November 10, 2008.

45. I am indebted to Alden O'Brien, curator of costume and textiles, and to Virginia Vis, curatorial volunteer, at the Daughters of the American Revolution Museum for their insights during our examination of the Sneed quilt on June 23, 2009.

46. Loscalzo, "History," 187.

47. Mrs. Pullan, *The Lady's Manual of Fancy-Work* (New York: Dick and Fitzgerald, 1858), xiv–xv.

48. "The Sewing Machine," *Godey's Lady's Book* 60 (November 1860): 463.

49. Quoted in Claudia B. Kidwell and Margaret C. Christman, *Suiting Everyone: The Democratization of Clothing in America* (Washington, DC: Smithsonian Institution Press, 1974), 79.

50. Mark A. Mastromarino, "Elkanah Watson and Early Agricultural Fairs, 1790–1860," *Historical Journal of Massachusetts* 17 (Summer 1989): 106–107.

51. Mastromarino, "Elkanah Watson," 109–110; Catherine Kelly, "The Consummation of Rural Prosperity and Happiness: New England Agricultural Fairs and the Construction of Class and Gender, 1810–1860," *American Quarterly* 49 (September 1997): 581.

52. Kelly, "Consummation of Rural Prosperity," 579.

53. Kelly, "Consummation of Rural Prosperity," 586–587.

54. Linda J. Borish, "'A Fair, Without *the* Fair, is No Fair at All': Women at the New England Agricultural Fair in the Mid-Nineteenth Century," *Journal of Sport History* 24 (1997): 162.

55. Quoted in Ulrich, *Age of Homespun,* 21. Horace Bushnell's "The Age of Homespun," published in an anthology of his work, *Work and Play* (New York: Charles Scribner's Sons, 1881), was originally a speech given on the second day of the Litchfield County Centennial, August 14, 1851, in Litchfield, Connecticut; see Ulrich, *Age of Homespun,* 12–25. As a boy, Bushnell worked in his father's textile mill. For biographical information on Bushnell, see E. Brooks Holifield, "Bushnell, Horace," in *American National Biography Online* (2000), www.anb .org.silk.library.umass.edu:2048/articles/08/08-00219 .html.

56. *11th Annual Report of the Board of Agriculture of the State of Ohio: To the Governor, for the Year 1856* (Columbus, OH: Richard Nevins, 1857), 162.

57. Jeanne Boydston, *Home and Work: Housework, Wages and the Ideology of Labor in the Early Republic* (New York: Oxford University Press, 1990), 156.

58. *New England Farmer,* November 6, 1829.

59. Henry F. French, "Make Your Girls Independent," *New England Farmer,* October 1854.

60. See Catherine E. Kelly, *In the New England Fashion: Reshaping Women's Lives in the Nineteenth Century* (Ithaca, NY: Cornell University Press, 1999), 214–241.

61. *12th Annual Report of the Ohio State Board of Agriculture . . . for the Year 1857* (Columbus: Richard Nevins, 1858), 150.

62. See Barbara Brackman, "Fairs and Expositions: Their Influence on American Quilts," in *Bits and Pieces: Textile Traditions,* ed. Jeannette Lasansky (Lewisburg, PA: Oral Traditions Project, 1991), 91–99; and Virginia Gunn, "Quilts at Nineteenth Century State and County Fairs: An Ohio Study," *Uncoverings* 9 (1988): 105–128.

63. Brackman, "Fairs and Expositions," 92–95.

64. Gunn, "Quilts," 106.

65. Borish, "Fair," 163–166.

66. For a comprehensive history of these fairs, see Beverly Gordon, *Bazaars and Fair Ladies: The History of the American Fundraising Fair* (Knoxville: University of Tennessee Press, 1998).

67. Brackman, "Fairs and Expositions," 94–95; Gunn, "Quilts," 117.

68. Brackman, "Fairs and Expositions," 95.

69. As quoted from a newspaper account in *13th Annual Report of the Ohio State Board of Agriculture . . . for the Year 1858* (Columbus, OH: Richard Nevins, 1859), 142–143.

70. *Weekly Ohio State Journal,* November 1, 1843.

71. *Weekly Ohio State Journal,* November 1, 1843.

72. For more on the early history of the Nantucket Agricultural Society, see Aimee E. Newell, "'No Harvest of Oil': Nantucket's Agricultural Fairs, 1856–1890," in *New England Celebrates: Spectacle, Commemoration, and Festivity,* ed. Peter Benes (Boston: Boston University, 2002), 149–165.

73. Newell, "No Harvest of Oil," 149.

74. *Transactions of the Nantucket Agricultural Society for 1856* (New York: Nantucket Agricultural Society, 1857), 6–10 (hereafter cited as *Transactions*).

75. *Nantucket Inquirer,* October 31, 1856.

76. *Weekly Mirror,* November 1, 1856. The quilt is now in the collection of the Nantucket Historical Association, Nantucket, Massachusetts. For more information on the quilt, see Aimee E. Newell, "Agricultural Fairs and Quilts," in *Massachusetts Quilts: Our Common Wealth,* ed. Lynne Z. Bassett (Hanover, NH: University

Press of New England, 2009), 182–185; and Aimee E. Newell, "Island Pride: The Nantucket Agricultural Society Quilt," *Piecework Magazine* 14 (September/October 2006): 28–31.

77. *Transactions,* 47.

78. Barbara Brackman, *Encyclopedia of Pieced Quilt Patterns* (Paducah, KY: American Quilter's Society, 1993), 300. The quilt blocks have muslin centers with triangles of printed cottons at the corners in pink, brown, blue, and other colors. It is quilted in a grid pattern combined with an "X" through each block. The quilt is backed with a printed pink cotton fabric and bound with brown striped twill tape.

79. *Transactions,* 47–48. The "Gardner" in the song probably refers to Edward Gardner (1804–1863), founding president of the Nantucket Agricultural Society.

80. *Transactions,* 63.

81. Joseph E. C. Farnham, *Brief Historical Data and Memories of My Boyhood Days in Nantucket* (Providence, RI: Snow and Farnham, 1915), 77.

82. *Nantucket Inquirer and Mirror,* December 29, 1875. Genealogical information from the Barney Genealogical Record, Nantucket Historical Association Research Library, Nantucket, Massachusetts; U.S. Census information from www.ancestry.com.

83. Jessica F. Nicoll, *Quilted for Friends: Delaware Valley Signature Quilts, 1840–1855* (Winterthur, DE: Winterthur Museum, 1986), 5, 7; Barbara Brackman, "Signature Quilts: Nineteenth-Century Trends," *Uncoverings* 10 (1989): 28–33.

84. Nicoll, *Quilted for Friends,* 11.

85. Jessica F. Nicoll, "Signature Quilts and the Quaker Community, 1840–1860," *Uncoverings* 7 (1986): 36.

86. The quilt is now in the collection of the State Museum of Pennsylvania, Harrisburg, Pennsylvania. It is pictured in Lucinda Reddington Cawley, Lorraine DeAngelis Ezbiansky, and Denise Rocheleau Nordberg, *Saved for the People of Pennsylvania: Quilts from the State Museum of Pennsylvania* (Harrisburg: Pennsylvania Historical and Museum Commission, 1997), 18–19. The quilt was brought from Pennsylvania to Chicago by members of the Connecticut branch of the Stiles family and then handed down in that family until it was given to the State Museum of Pennsylvania in 1983. The signatures

of Nathan D. Stiles and Richard Stiles appear in two of the quilt's blocks. Curatorial file, State Museum of Pennsylvania, Harrisburg. I am indebted to curator Beatrice Hulsberg for sharing the file with me.

87. The quilt's technique shows that one person, presumably Euphemia Righter, made all of the blocks, but that they were signed individually. Cawley, Ezbiansky, and Nordberg, *Saved for the People,* 18.

88. Cawley, Ezbiansky, and Nordberg, *Saved for the People,* 18; curatorial file, State Museum of Pennsylvania, Harrisburg.

89. *Biographical, Genealogical and Descriptive History of the First Congressional District of New Jersey* (New York: Lewis Publishing, 1900), 1–521.

90. James Birtley McNair, *McNair, McNear, and McNeir Genealogies* (Chicago: privately printed, 1923), 259.

91. Cawley, Ezbiansky, and Nordberg, *Saved for the People,* 18.

92. Cawley, Ezbiansky, and Nordberg, *Saved for the People,* 18.

93. U.S. Census information from www.ancestry.com; Cawley, Ezbiansky, and Nordberg, *Saved for the People,* 18.

94. Lisa Wilson, *Life after Death: Widows in Pennsylvania, 1750–1850* (Philadelphia: Temple University Press, 1992), 1–2.

95. Wilson, *Life after Death,* 5.

96. For examples, see Brackman, "Signature Quilts," 25–37; Nicoll, *Quilted for Friends;* and Lipsett, *Remember Me.*

97. See, for example, the letter from Eliza Southgate, 1798, quoted in Bassett and Larkin, *Northern Comfort,* 61.

98. Bassett, *Massachusetts Quilts,* 269.

99. *New England Farmer,* November 16, 1831.

100. *New England Farmer,* November 4, 1840.

101. *New England Farmer,* November 5, 1834.

102. *New England Farmer,* October 25, 1843.

103. Hartford County Agricultural Society report for 1842 fair, quoted in the curatorial file for quilt by Submit Gay, Wadsworth Atheneum, Hartford, Connecticut.

104. *Hampshire Gazette,* October 18, 1842, quoted in Kelly, "Consummation of Rural Prosperity," 587.

105. *Hampshire Gazette,* October 22, 1850, quoted in Kelly, "Consummation of Rural Prosperity," 591.

106. The quilt is now in the collection of the Wadsworth Atheneum, Hartford, Connecticut.

107. *Connecticut Courant,* October 15, 1842.

108. Submit Gay was born in Simsbury, Connecticut, on March 12, 1796, to Richard Gay and Lucina Granger Gay. She died in Connecticut on March 23, 1880. Genealogical information from www.ancestry.com.

109. The quilt is now in the collection of the Charleston Museum, Charleston, South Carolina. *Mosaic Quilts: Paper Template Piecing in the South Carolina Lowcountry* (Greenville, SC: Curious Works Press, 2002), 45; U.S. Census information from www.ancestry.com.

110. *Mosaic Quilts: Paper Template Piecing in the South Carolina Lowcountry* (Greenville, SC: Curious Works Press, 2002), 45.

111. *Mosaic Quilts,* 45.

112. Letter from Catharine Maria Sedgwick to Katherine Maria Sedgwick Minot in Mary E. Dewey, ed., *Life and Letters of Catharine M. Sedgwick* (New York: Harper and Row, 1871), 332.

Chapter 4: I Give and Bequeath This Quilt

1. Now in a private collection, this sampler is pictured in M. Finkel and Daughter, *Samplings* 24 (2003): 7. Despite having the maker's name and her birth year provided by this sampler, conclusive identification of the maker was not possible.

2. The Quaker alphabet is made up of Roman-style letters, recognizable by its straight letters formed by bold lines of cross-stitch at the left side of the letters.

3. Now in a private collection, this sampler is pictured in M. Finkel and Daughter, *Samplings* 1 (1992): 6. Unfortunately, this sampler does not offer enough information to conclusively identify its maker. The date of its origin is estimated to be about 1830 based on a comparison with other samplers showing a similar style, layout, motifs, and materials.

4. On colonial and antebellum American women and property, see Toby L. Ditz, *Property and Kinship: Inheritance in Early Connecticut, 1750–1820* (Princeton: Princeton University Press, 1986); Marylynn Salmon, *Women and the Law of Property in Early America* (Chapel Hill:

University of North Carolina Press, 1986); Norma Basch, *In the Eyes of the Law: Women, Marriage and Property in Nineteenth-Century New York* (Ithaca, NY: Cornell University Press, 1982); Laurel Thatcher Ulrich, *The Age of Homespun: Objects and Stories in the Creation of an American Myth* (New York: Alfred A. Knopf, 2001); Barbara McLean Ward, "Women's Property and Family Continuity in Eighteenth-Century Connecticut," in *Early American Probate Inventories,* ed. Peter Benes (Boston: Boston University, 1987), 74–85; and Jeannette Lasansky, "Quilts in the Dowry," in *Bits and Pieces: Textile Traditions,* ed. Jeannette Lasansky (Lewisburg, PA: Oral Traditions Project, 1991), 48–55.

5. Basch, *In the Eyes,* 16, 27.

6. Carole Shammas, "Re-assessing the Married Women's Property Acts," *Journal of Women's History* 6 (Spring 1994): 11.

7. Quoted in Basch, *In the Eyes,* 119–120.

8. The quilt is now in a private collection. It is illustrated in Linda Welters and Margaret T. Ordonez, eds., *Down by the Old Mill Stream: Quilts in Rhode Island* (Kent, OH: Kent State University Press, 2000), 67.

9. Ward, "Women's Property," 83–85; Laurel Thatcher Ulrich, "Furniture as Social History: Gender, Property, and Memory in the Decorative Arts," in *American Furniture,* ed. Luke Beckerdite (Milwaukee: Chipstone Foundation, 1995), 55; Laurel Thatcher Ulrich, "Hannah Barnard's Cupboard: Female Property and Identity in 18th-Century New England," in *Through a Glass Darkly: Reflections on Personal Identity in Early America,* ed. Ronald Hoffman, Mechal Sobel, and Fredrika J. Teute (Durham: University of North Carolina Press, 1997), 253–255; Ditz, *Property and Kinship,* 79, 114.

10. Ward, "Women's Property," 76, 85.

11. Ulrich, "Hannah Barnard's Cupboard," 257, 273.

12. Account book kept by Reverend Zenas L. Leonard, 1830–1842, Leonard Family Papers, Old Sturbridge Village Research Library, Sturbridge, Massachusetts. Mary Ann Leonard married Reverend Francis W. Emmons on August 31, 1829; Vernera Leonard married Francis E. Corey on April 25, 1831 (after receiving goods totaling $108.80 in her father's account book); and Sarah Leonard married Thomas Spooner on September 5, 1842 (with a total of only $21.21 worth of goods in her father's

account book). This type of account was not uncommon. Jane Nylander found similar accounts kept a century earlier by Samuel Lane of Stratham, New Hampshire. See Jane C. Nylander, "Provision for Daughters: The Accounts of Samuel Lane," in *House and Home,* ed. Peter Benes (Boston: Boston University, 1990), 11–27.

13. A study of Pennsylvania-German dowry records from the nineteenth century found that after furniture, "textiles were the most highly valued and most abundant items in young peoples' 'outfittings.'" See Jeannette Lasansky, *A Good Start: The Aussteier or Dowry* (Lewisburg, PA: Oral Traditions Project, 1990), 78.

14. Elizabeth Range Miller's will is quoted in Bets Ramsey and Merikay Waldvogel, *The Quilts of Tennessee: Images of Domestic Life prior to 1930* (Nashville: Rutledge Hill Press, 1986), 9. Genealogical information from www.ancestry.com.

15. Barbara McLean Ward and Gerald W. R. Ward, "Sterling Memories: Family and Silver in Early New England," in *The Art of Family: Genealogical Artifacts in New England,* ed. D. Brenton Simons and Peter Benes (Boston: New England Historic Genealogical Society, 2002), 181–182.

16. The quilt is now in a private collection. It is illustrated in Ellen Kort, *Wisconsin Quilts* (Charlottesville, VA: Howell Press, 2001), 3. See Kort, *Wisconsin Quilts,* 2.

17. Kort, *Wisconsin Quilts,* 2.

18. Kort, *Wisconsin Quilts,* 2.

19. Kort, *Wisconsin Quilts,* 3.

20. Letter from Eleanor Parke Custis Lewis to Elizabeth Bordley, April 5, 1825, quoted in Patricia Brady, *George Washington's Beautiful Nelly: The Letters of Eleanor Parke Custis Lewis to Elizabeth Bordley Gibson, 1794–1851* (Columbia: University of South Carolina Press, 1991), 287.

21. See letters written by Eleanor Parke Custis Lewis on March 22, 1821, October 25, 1823, November 24, 1824, December 22, 1824, October 2, 1825, and October 7, 1825 in Brady, *George Washington's Beautiful Nelly,* for additional examples of her handmade needlework gifts. See also the diary kept by Mary Avery Upham (1790–1872) for the years from 1832 to 1860, where she makes numerous references to needlework gifts that she is working on. Upham Diaries, Massachusetts Historical Society, Boston.

22. Brady, *George Washington's Beautiful Nelly,* 104–105, 158.

23. Heather Ruth Palmer, "Where Is Nineteenth-Century Southern Decorative Needlework?" *Southern Quarterly* 27 (1988): 65.

24. Letter from Eleanor Parke Custis Lewis to Elizabeth Bordley, December 17, 1848, quoted in Brady, *George Washington's Beautiful Nelly,* 251.

25. The quilt is currently on loan to the Smithsonian Institution, Washington, DC. The quilt top, which is not quilted or finished, employs both block-printed fabrics and copperplate-printed fabrics. It shows similarities to two other quilts attributed to Martha Washington: "The Penn Treaty Counterpane" made around 1785 and an unfinished bedcover dating to the 1790s. Both, now owned by Mount Vernon, employ colors, fabrics, and patterns similar to those of this quilt. Curatorial file, Smithsonian Institution, Washington, DC. Martha Dandridge was born in 1731, the daughter of John Dandridge and Frances Jones Dandridge. In 1749, she married Daniel Parke Custis. The couple had two children who survived infancy before Daniel died in 1757. In 1759, she married George Washington (1732–1799). Eliza Parke Custis was born in 1776 in Mount Airy, Maryland, the daughter of John Parke Custis (1754–1781) and Eleanor Calvert Custis (1754–1811). In 1796, she married Thomas Law (1756–1834), and the couple had one child, Eliza Law (1797–1822). Eliza later left her husband, divorced him, and returned to using her maiden name. Genealogical information from www.ancestry.com; Edith Tunis Sale, *Old Time Belles and Cavaliers* (Philadelphia: J. B. Lippincott, 1912), 232.

26. The "Rosebud" in the inscription is a reference to her daughter, Eliza Law. Barbara Tricarico, ed., *Quilts of Virginia, 1607–1899: The Birth of America through the Eye of a Needle* (Atglen, PA: Schiffer Publishing, 2006), 46; Doris M. Bowman, *American Quilts: The Smithsonian Treasury* (Washington, DC: Smithsonian Institution Press, 1991), 20.

27. I am indebted to Marla R. Miller for sharing her ideas on the meaning that this quilt top might have held for its makers and owners.

28. Will, probate inventory, and receipts for bequests, Esther Slater (estate) collection, MSS9001S—box 6, Rhode Island Historical Society, Providence.

29. The quilt is now in the collection of the Smithsonian Institution, Washington, DC. See family trees on www.ancestry.com. The Star of Bethlehem pattern was also known as the Lone Star, inspired by the history of Texas. This pattern's appearance in the early 1830s slightly predates the fall of the Alamo in 1836. An adaptation of the central medallion format, the pattern requires precision so that all of the pieces will line up crisply. See Stella Rubin, *Miller's How to Compare and Value American Quilts* (London: Octopus Publishing Group, 2001), 120; Barbara Brackman, *Clues in the Calico: A Guide to Identifying and Dating Antique Quilts* (McLean, VA: EPM Publications, 1989), 171. At least three other quilts are also attributed to Totten. Two employ the same large Rising Sun pattern and are now in the collection of the Staten Island Historical Society, Staten Island, New York. One of these has an embroidered inscription: "Mary Ann Dubois John Dubois October the 6 1835." Mary Ann Johnson (b. 1807) was Totten's niece and married John Dubois on October 6, 1835; family tradition holds that this quilt was a wedding gift for her. Curatorial file, Staten Island Historical Society, Staten Island, New York. A third quilt, in the Sunburst pattern, is now in the collection of the New York State Historical Association, Cooperstown. I thank John Hart Jr., assistant curator of collections, New York State Historical Association, and Maxine Friedman, chief curator, Staten Island Historical Society, for sharing information and images of these quilts with me.

30. Bowman, *American Quilts,* 29; Jacqueline M. Atkins and Phyllis A. Tepper, *New York Beauties: Quilts from the Empire State* (New York: Dutton Studio Books, 1992), 48; Patsy Orlofsky and Myron Orlofsky, *Quilts in America* (New York: Abbeville Press, 1992), 48.

31. Totten's will is quoted in Bowman, *American Quilts,* 28.

32. Ditz, *Property and Kinship,* 80.

33. Carroll Smith-Rosenberg, *Disorderly Conduct: Visions of Gender in Victorian America* (New York: Oxford University Press, 1985), 62–65.

34. A copy of Bascom's will is in the Ruth Henshaw Bascom papers at the American Antiquarian Society, Worcester, Massachusetts. Bascom's will is quoted in Michael R. Payne and Suzanne Rudnick Payne, "A

'woman could paint a likeness?'" *The Magazine Antiques* 175 (January 2009): 182.

35. The quilt is currently in the collection of the Allen Memorial Art Museum, Oberlin, Ohio. The bequest is quoted in Ricky Clark, "Fragile Families: Quilts as Kinship Bonds," *Quilt Digest* 5 (1987): 5.

36. Ricky Clark, ed., *Quilts in Community: Ohio's Traditions* (Nashville: Rutledge Hill Press, 1991), 131; Clark, "Fragile Families," 13–14; Ricky Clark, "Quilt Documentation: A Case Study," in *Making the American Home: Middle-Class Women and Domestic Material Culture, 1840–1940,* ed. Marilyn Ferris Motz and Pat Browne (Bowling Green, OH: Bowling Green State University Popular Press, 1988), 163–166.

37. Clark, *Quilts in Community,* 132; Clark, "Fragile Families," 14; Clark, "Quilt Documentation," 169, 179–186.

38. Precise genealogical information for Artemas and Sarah Mahan and their family is not available, so the reason for the change in descent of the quilt is unknown. A Hila Hall of the correct age does not appear on the 1880 U.S. Census, so she may have passed away by that time. A genealogical record at www.ancestry.com lists a Julia Mahan who was born in 1825, married Francis Woodruff in 1847, and died in 1892. These dates fit the Mahan family timeline, and this may be Laura's sister and Sarah's stepdaughter. She was alive in 1885, but her exact whereabouts in 1885 are not known; it is possible that distance between Julia and Sarah made exchange of the quilt impossible. As for the oldest granddaughter of Artemas Mahan, genealogical records were not available to conclusively identify this person.

39. Clark, "Quilt Documentation," 182.

40. Clark, "Fragile Families," 18.

41. Mimi Sherman, "A Fabric of One Family: A Saga of Discovery," *Clarion* 14 (Spring 1989): 58.

42. Two of the quilts are friendship quilts pieced in the same six-point star block pattern and signed by a network of friends and family. One is currently in a private collection, while the other is owned by the American Folk Art Museum in New York City. Sherman, "Fabric of One Family," 58–59.

43. The quilt is currently in the collection of Winterthur Museum and Country Estate, Delaware. I am

indebted to Linda Eaton for generously sharing curatorial information about this quilt during my site visit on February 7, 2006.

44. Sherman, "Fabric of One Family," 59.

45. This quilt is currently in the collection of the American Folk Art Museum, New York City.

46. Aimee E. Newell, "Paper-Template Piecing in Early-Nineteenth-Century America," *Piecework Magazine* 13 (September/October 2005): 41; Lynne Z. Bassett and Jack Larkin, *Northern Comfort: New England's Early Quilts, 1780–1850* (Nashville: Rutledge Hill Press, 1998), 27–30; *Mosaic Quilts: Paper Template Piecing in the South Carolina Lowcountry* (Greenville, SC: Curious Works Press, 2002), 7–8, 12–14; Aimee E. Newell, "Sarah Clarke Ellis Ide Quilt," in *Massachusetts Quilts: Our Common Wealth,* ed. Lynne Z. Bassett, (Hanover, NH: University Press of New England, 2009), 93–95.

47. Stacy C. Hollander and Brooke Davis Anderson, *American Anthem: Masterworks from the American Folk Art Museum* (New York: Harry N. Abrams, 2001), 325; Linda Eaton, *Quilts in a Material World: Selections from the Winterthur Collection* (New York: Abrams, 2007), 37. Savery's quilts may seem to be at odds with the "plain style" associated with Quakerism. But as many scholars have documented, plain did not mean cheap—members of the Society of Friends often sought out good-quality fabrics to make their clothing. In addition, schisms within the faith led some members to interpret the idea of "the best sort but plain" differently. For more on Quaker aesthetics, see Eaton, *Quilts,* 36–37; Emma Jones Lapsansky and Anne A. Verplanck, eds., *Quaker Aesthetics: Reflections on a Quaker Ethic in American Design and Consumption* (Philadelphia: University of Pennsylvania Press, 2003).

48. Bassett and Larkin, *Northern Comfort,* 8, 34, 74–75. For a thorough exploration of this aesthetic, see Sumpter T. Priddy, *American Fancy: Exuberance in the Arts, 1790–1840* (Milwaukee, WI: Chipstone Foundation, 2004).

49. Her 1839 and circa 1840 Sunburst quilts employ some of the same fabrics. Sherman, "Fabric of One Family," 60–61.

50. Sherman, "Fabric of One Family," 57–59. This quilt is now in the collection of the Philadelphia Museum of Art, Pennsylvania.

51. Ulrich, *Age of Homespun,* 133.

52. Laurel Horton, *Mary Black's Family Quilts: Memory and Meaning in Everyday Life* (Columbia: University of South Carolina Press, 2005), 2.

53. Susan M. Stabile, *Memory's Daughters: The Material Culture of Remembrance in Eighteenth-Century America* (Ithaca, NY: Cornell University Press, 2004), 71–72.

Chapter 5: Family Currency

1. The quilts made for Lauck's daughter, Rebecca, and son William are currently in the collection of the Daughters of the American Revolution Museum, Washington, DC. I am indebted to Alden O'Brien, curator of costume and textiles, for making these quilts and their curatorial files available to me during site visits in June 2006 and June 2009. The quilt made for Lauck's son Morgan and a fourth that is not signed or labeled (but is attributed to Lauck) are in the collection of Colonial Williamsburg, Williamsburg, Virginia. I am indebted to Linda Baumgarten, curator at Colonial Williamsburg, for sharing descriptions of those quilts with me.

2. The "Delectable Mountains" pattern name references John Bunyan's *Pilgrim's Progress* (1678), describing the point from which the travelers were able to view the wonders of the Celestial City. Christie's, *Important American Furniture, Folk Art, Silver and Prints Including Property from the Garbisch Collection from the Sky Club* (New York: Christie's, 2006), 198.

3. I use the phrase *family currency* based on my reading of Marla R. Miller, *The Needle's Eye: Women and Work in the Age of Revolution* (Amherst: University of Massachusetts Press, 2006), 108, and Laurel Horton, *Mary Black's Family Quilts: Memory and Meaning in Everyday Life* (Columbia: University of South Carolina Press, 2005), 2.

4. Frances Bradshaw Blanchard, ed., *Letters of Ann Gillam Storrow to Jared Sparks* (Northampton, MA: Smith College, Department of Government and History, 1921), 228. Ann Gillam Storrow was born in 1784 in Halifax, Nova Scotia, the daughter of Thomas Storrow and Ann Appleton Storrow. The family lived in England and Jamaica before moving to Boston, Massachusetts, where her parents died within a year and a half of each other.

Ann never married, living with her sister, Louisa, and Louisa's husband, Stephen Higginson. After Stephen's death, Ann and Louisa moved to Brattleboro, Vermont, to live with Louisa's son. Ann became a friend of historian Jared Sparks and corresponded with him throughout her life. Ann died in 1856 in Brattleboro, Vermont. Biographical information from the North American Women's Letters and Diaries database, http://solomon .nwld.alexanderstreet.com.silk.library.umass.edu:2048 /bios/A48BIO.html.

5. This study employs the following translation: Marcel Mauss, *The Gift: The Form and Reason for Exchange in Archaic Societies,* trans. W. D. Halls (New York: W. W. Norton, 1990).

6. Mauss, *Gift,* 3–5.

7. For example, see David Cheal, "'Showing Them You Love Them': Gift Giving and the Dialectic of Intimacy," in *The Gift: An Interdisciplinary Perspective,* ed. Aafke E. Komter (Amsterdam: Amsterdam University Press, 1996), 98; Carolyn J. Rosenthal, "Kinkeeping in the Familial Division of Labor," *Journal of Marriage and the Family* 47 (November 1985): 965–966; David Cheal, *The Gift Economy* (London: Routledge, 1988), 183; Mark Osteen, ed., *The Question of the Gift: Essays across Disciplines* (London: Routledge, 2002), 19; and Aafke E. Komter, *Social Solidarity and the Gift* (Cambridge: Cambridge University Press, 2005), 80.

8. Micaela Di Leonardo, "The Female World of Cards and Holidays: Women, Families, and the Work of Kinship," *Signs* 12 (Spring 1987): 442–443, 449.

9. Letter from Eleanor Parke Custis Lewis to Elizabeth Bordley, March 28, 1847, quoted in Patricia Brady, *George Washington's Beautiful Nelly: The Letters of Eleanor Parke Custis Lewis to Elizabeth Bordley Gibson, 1794–1851* (Columbia: University of South Carolina Press, 1991), 248. Eleanor Parke Custis was born in 1779, the daughter of John Parke Custis, who was the son of Martha Washington and her first husband, Daniel Parke Custis. After Eleanor's father died in 1781, she and her brother, George Washington Parke Custis, were adopted by George and Martha Washington. In 1799, she married Lawrence Lewis, George Washington's nephew. The couple had eight children, but only Frances Parke Lewis survived her mother. Eleanor died in 1852. Biographical infor-

mation from the North American Women's Letters and Diaries database, http://solomon.nwld.alexanderstreet .com.silk.library.umass.edu:2048/bios/A200BIO.html.

10. Komter, *Social Solidarity and the Gift,* 2, 87–88.

11. Di Leonardo, "Female World," 441.

12. Cheal, "The Ritualization of Family Ties," *American Behavioral Scientist* 31 (July/August 1988): 632–633.

13. For examples, see Susan Burrows Swan, *Plain and Fancy: American Women and Their Needlework, 1650–1850* (Austin, TX: Curious Works Press, 1995), 55, 57, 104, 106–107; Glee Krueger, "Mary Wright Alsop, 1740–1829, and Her Needlework," *Connecticut Historical Society Bulletin* 52 (Summer/Fall 1987): 125–224; Amy Boyce Osaki, "A 'Truly Feminine Employment': Sewing and the Early Nineteenth-Century Woman," *Winterthur Portfolio* 23 (1988): 225; and Lynne Z. Bassett, "Woven Bead Chains of the 1830s," *The Magazine Antiques* 148 (December 1995): 798–807.

14. Virginia Gunn, "From Myth to Maturity: The Evolution of Quilt Scholarship," *Uncoverings* 13 (1992): 194.

15. Fawn Valentine, *West Virginia Quilts and Quiltmakers: Echoes from the Hills* (Athens: Ohio University Press, 2000), 157.

16. Aside from quilts, this study found two other needlework gifts fitting the criteria for date and age of maker: the sampler made by Ruth Pierce Croswell, which is discussed in chapter 7, and an embroidered coverlet by Lucretia Street Hall. Since the overwhelming majority of needlework gifts found were quilts, this chapter focuses primarily on those objects.

17. The New England makers were from Massachusetts, Vermont, Rhode Island, and Connecticut; the mid-Atlantic makers from New York, Pennsylvania, and Delaware; the midwestern quilters were from Illinois, Ohio, and Missouri; the southeastern makers lived in Maryland, Virginia, South Carolina, Tennessee, Georgia, and West Virginia; and the western maker lived in Texas.

18. Ricky Clark, ed., *Quilts in Community: Ohio's Traditions* (Nashville: Rutledge Hill Press, 1991), 129. A Pennsylvania project found that 264 quilts it documented were identified by their owners as having been made for a specific life event. Of these, 60 percent were "firmly identified" as having been made in preparation for marriage,

adding support to the idea that many "wedding quilts" were made by the bride. See Patricia J. Keller, "To Go to Housekeeping: Quilts Made for Marriage in Lancaster County," in *Bits and Pieces: Textile Traditions,* ed. Jeannette Lasansky (Lewisburg, PA: Oral Traditions Project, 1991), 60.

19. Lynn A. Bonfield, "Diaries of New England Quilters before 1860," *Uncoverings* 9 (1988): 181.

20. That is, five of the quilts were inscribed or labeled with a year by the maker. The other ten quilts have less definite matches between the date of the quilt and the date of the gift-giving occasion, as determined by using the date of the fabric in the quilt to compare to the date of the wedding. Whether the date is inscribed on the quilt or not, quilt dating is never an exact science, but there are methods that can be employed to establish a working date of the object. By analyzing the fabrics in the quilt and comparing them to catalogs of documented fabrics, one can arrive at a date span for the quilt.

21. See Gloria Seaman Allen, *First Flowerings: Early Virginia Quilts* (Washington, DC: DAR Museum, 1987), 23; Christie's, *Important American Furniture, 198;* curatorial files at the Daughters of the American Revolution Museum, Washington, DC.

22. This quilt is now in the collection of Colonial Williamsburg, Williamsburg, Virginia. Stitched into this quilt is the inscription that it was made in Lauck's "62nd year"; she turned sixty-two in 1823. The names of both recipients are also stitched in, but her son Morgan did not marry until 1824. Family information from www .ancestry.com.

23. Rebecca and John Cunningham seem to have received their quilt long after their marriage. Genealogical sources do not provide the date of the couple's marriage, but it was presumably prior to the 1806 birth of their first child, Julia Hannah. See genealogical records for the Lauck and Cunningham families at www.ancestry.com; e-mail correspondence with Alden O'Brien, curator of costume and textiles at the Daughters of the American Revolution Museum, May 29, 2007, and conversation on June 23, 2009.

24. This quilt is in the collection of the Daughters of the American Revolution Museum, Washington, DC. Genealogical information from www.ancestry.com.

25. The fourth, unsigned, quilt is now in the collection of Colonial Williamsburg, Williamsburg, Virginia. I am indebted to Alden O'Brien, curator of costume and textiles at the Daughters of the American Revolution Museum, for sharing her theory that this quilt was originally given to Samuel because he was the only child to stay in Winchester, Virginia.

26. For a thorough explanation of "Republican motherhood" see Linda K. Kerber, *Women of the Republic: Intellect and Ideology in Revolutionary America* (Chapel Hill: University of North Carolina Press, 1987); Mary Beth Norton, *Liberty's Daughters: The Revolutionary Experience of American Women, 1750–1800* (Boston: Little, Brown, 1980); and Ruth H. Bloch, "American Feminine Ideals in Transition: The Rise of the Moral Mother, 1785–1815," *Feminist Studies* 4 (June 1978): 100–126.

27. Terri L. Premo, *Winter Friends: Women Growing Old in the New Republic, 1785–1835* (Urbana: University of Illinois Press, 1990), 5. Also see Barry Schwartz, "The Social Context of Commemoration: A Study in Collective Memory," *Social Forces* 61 (December 1982): 386. Schwartz asserts that history was divided into two stages in the antebellum mind, "an extraordinary period of creation by the Founding Fathers and an ordinary era of preservation and consolidation." The latter was perceived as "an age of ennui," when the subsequent generation did not match the achievements of its parents and grandparents.

28. The subhead for this section is from Mme. Celnart, *The Gentleman and Lady's Book of Politeness* (Boston: Allen and Ticknor, 1833), 152.

29. See Dorothy Cozart, "An Early Nineteenth Century Quiltmaker and Her Quilts," *Uncoverings* 7 (1986): 74–76; Gloria Seaman Allen, *Old Line Traditions: Maryland Women and Their Quilts* (Washington, DC: DAR Museum, 1985), 14–15.

30. Seven of Garnhart's quilts are now at the DAR Museum in Washington, DC (although five of these are on loan to the museum from their owners); an eighth quilt is in the collection of the Plains Indians and Pioneers Museum in Woodward, Oklahoma. Three others remain in private collections: two are pictured in Stella Rubin, *Miller's How to Compare and Value American Quilts* (London: Octopus Publishing Group, 2001), 43; the third is illustrated as number 2054 in Clarence P. Hornung,

Treasury of American Design (New York: Harry N. Abrams, 1972). I am indebted to Alden O'Brien, curator of costume and textiles at the Daughters of the American Revolution Museum, for making the Garnhart quilts at the museum, and their curatorial files, available to me during site visits in June 2006 and June 2009. I also thank Alden O'Brien and Virginia Vis, curatorial volunteer at the DAR Museum, for sharing their thoughts on the dates of the quilts during my site visit in June 2009.

31. Cozart, "Early Nineteenth Century Quiltmaker," 76.

32. Lynne Z. Bassett and Jack Larkin, *Northern Comfort: New England's Early Quilts, 1780–1850* (Nashville: Rutledge Hill Press, 1998), 34, 37.

33. This quilt is now in the collection of the Plains Indians and Pioneers Museum, Woodward, Oklahoma. I am indebted to the museum's former curator, Kristin Mravinec, for sharing the history of the quilt with me in e-mail correspondence, June 5, 2007. This quilt is illustrated in Jane Amstutz Hamden and Pamela Frazee Woolbright, eds., *Oklahoma Heritage Quilts: A Sampling of Quilts Made in or Brought to Oklahoma before 1940* (Paducah, KY: American Quilter's Society, 1990), 125; Louise B. James, "The Federal Eagle Quilt," *Quilting Quarterly* 24 (Spring 1996): 23–24; Allen, *Old Line Traditions,* 15.

34. Cozart, "Early Nineteenth Century Quiltmaker," 80.

35. This quilt was donated to the Daughters of the American Revolution Museum in 1974 by Garnhart's descendant Mrs. Stephen J. Buynitzky. Curatorial files, Daughters of the American Revolution Museum, Washington, DC. The quilt is illustrated in Allen, *Old Line Traditions,* 14.

36. Cozart, "Early Nineteenth Century Quiltmaker," 78.

37. Curatorial files, Daughters of the American Revolution Museum, Washington, DC.

38. This quilt is in the collection of the Daughters of the American Revolution Museum, Washington, DC. It was donated by a descendant of the recipient in 1991. Curatorial file, Daughters of the American Revolution Museum, Washington, DC.

39. Curatorial file, Daughters of the American Revolution Museum, Washington, DC.

40. Carl N. Degler, *At Odds: Women and the Family in America from the Revolution to the Present* (New York: Oxford University Press, 1980), 109.

41. All three quilts are now in the collection of the Museum of Early Southern Decorative Arts (MESDA) in Winston-Salem, North Carolina.

42. Paula W. Locklair, *Quilts, Coverlets and Counterpanes: Bedcoverings from the MESDA and Old Salem Collections* (Winston-Salem, NC: Old Salem, 1997), 43. The quilt has no batting; it has a linen backing and is quilted in a simple pattern of diagonal lines.

43. Benjamin W. Dwight, *The History of the Descendants of John Dwight of Dedham, Mass.* (New York: John F. Trow and Son, 1874), 401–403.

44. Kathleen Staples, "Tangible Displays of Refinements: Southern Needlework at MESDA," *The Magazine Antiques* 171 (January 2007): 201.

45. Dwight, *History of the Descendants,* 402–403.

46. Bassett and Larkin, *Northern Comfort,* 62.

47. Lacy Folmar Bullard and Betty Jo Shiell, *Chintz Quilts: Unfading Glory* (Tallahassee, Florida: Serendipity Publishers, 1983), 10, 30, 36; Laurel Horton, "Quiltmaking Traditions in South Carolina," in *Social Fabric: South Carolina's Traditional Quilts,* ed. Laurel Horton and Lynn Robertson Myers, (Columbia, SC: McKissick Museum, 1986), 12–14; Elizabeth V. Warren and Sharon L. Eisenstat, *Glorious American Quilts: The Quilt Collection of the Museum of American Folk Art* (New York: Penguin Studio, 1996), 14–17; Jeremy Adamson, *Calico and Chintz: Antique Quilts from the Collection of Patricia S. Smith* (Washington, DC: Renwick Gallery, 1997), 34–36.

48. Horton, "Quiltmaking Traditions," 14.

49. Locklair, *Quilts, Coverlets and Counterpanes,* 45.

50. Staples, "Tangible Displays of Refinement," 202.

51. *Mosaic Quilts: Paper Template Piecing in the South Carolina Lowcountry* (Greenville, SC: Curious Works Press, 2002), 16. The quilt has batting and is backed with a cotton fabric. The triple border is constructed from two different chintzes with a plain cotton strip in between. It is quilted throughout.

52. Locklair, *Quilts, Coverlets and Counterpanes,* 45.

53. Dwight, *History of the Descendants,* 402.

54. Staples, "Tangible Displays of Refinement," 202.

55. Bassett and Larkin, *Northern Comfort,* 30, 32; Barbara Brackman, *Clues in the Calico: A Guide to Identifying and Dating Antique Quilts* (McLean, VA: EPM Publications, 1989), 136–137.

56. *Mosaic Quilts,* 36; Bassett and Larkin, *Northern Comfort,* 62. There is no batting; this quilt is backed with a cotton fabric.

57. Aimee E. Newell, "Paper Template Piecing in Early-Nineteenth-Century America," *Piecework Magazine* 13 (September/October 2005), 40–43; Aimee E. Newell, "Sarah Clarke Ellis Ide Quilt," in *Massachusetts Quilts: Our Common Wealth,* ed. Lynne Z. Bassett (Hanover, NH: University Press of New England, 2009), 93–95; Bassett and Larkin, *Northern Comfort,* 27–30; *Mosaic Quilts,* 7–8, 12–14.

58. Locklair, *Quilts, Coverlets and Counterpanes,* 44.

59. Dwight, *History of the Descendants,* 403.

60. Staples, "Tangible Displays of Refinement," 201.

61. Locklair, *Quilts, Coverlets and Counterpancs,* 44; Mosaic Quilts, 36.

62. Staples, "Tangible Displays of Refinement," 201.

63. Staples, "Tangible Displays of Refinement," 201.

64. Staples found that the size of the pattern repeats on the hexagon fabrics is in keeping with those from the 1790s as shown in Barbara Johnson and Natalie Rothstein, *A Lady of Fashion: Barbara Johnson's Album of Styles and Fabrics* (New York: Thames and Hudson, 1987). Some show wear, fading, and signs of previous cleaning. Staples did not check the greens on these fabrics; if they are overprinted (yellow over blue), that would help suggest a 1790s date for this part of the quilt, because a colorfast green dye was not available for the first time until the 1820s. E-mail correspondence from Kathleen A. Staples, March 25, 2009.

65. Premo, *Winter Friends,* 162.

66. Letter from Eleanor Parke Custis Lewis to Elizabeth Bordley, December 24, 1826, quoted in Brady, *George Washington's Beautiful Nelly,* 185.

67. Carrier, "Gifts, Commodities and Social Relations: A Maussian View of Exchange." *Sociological Forum* 6 (1991): 122, 126.

68. Cheal, "Ritualization of Family Ties," 642. See also Aafke E. Komter and Wilma Vollebergh, "Gift Giving and the Emotional Significance of Family and Friends," *Journal of Marriage and the Family* 59 (August 1997): 756.

69. C. Dallett Hemphill, *Bowing to Necessities: A History of Manners in America, 1620–1860* (New York: Oxford University Press, 1999), 3–4; Carroll Smith-Rosenberg, *Disorderly Conduct: Visions of Gender in Victorian America* (New York: Oxford University Press, 1985), 63.

70. Etiquette books consulted for this study include *The Art of Good Behaviour* (New York: C. P. Huestis, 1848); Catharine E. Beecher, *A Treatise on Domestic Economy* (Boston: Marsh, Capen, Lyon and Webb, 1841); Mme. Celnart, *The Gentleman and Lady's Book of Politeness: Etiquette for Ladies* (New York: Burgess, Stringer, 1844); Eliza Farrar, *The Young Lady's Friend* (Boston: American Stationers, 1837); Florence Hartley, *The Ladies' Book of Etiquette and Manual of Politeness* (Philadelphia: G. G. Evans, 1860); *The Ladies' Companion* (Worcester, MA: Spy Office, 1824); Eliza Leslie, *The Behaviour Book* (Philadelphia: Willis P. Hazard, 1854); Mrs. William Parkes, *Domestic Duties; or, Instructions to Young Married Ladies* (New York: J. and J. Harper, 1829); and *True Politeness: A Hand-Book of Etiquette for Ladies* (New York: Leavitt and Allen, 1853).

71. Celnart, *Gentleman and Lady's Book,* 151.

72. Celnart, *Gentleman and Lady's Book,* 152.

73. Mrs. Anne E. Guild, *Grandmother Lee's Portfolio* (Boston: Whittemore, Niles and Hall, 1857), 7.

74. Mrs. Pullan, *The Lady's Manual of Fancy-Work* (New York: Dick and Fitzgerald, 1858), xiii.

75. Ralph Waldo Emerson, *The Complete Works of Ralph Waldo Emerson: Essays,* 2nd series (Boston: Houghton Mifflin, 1903–1904), 3:161.

76. Emerson, *Complete Works,* 3:161.

77. Emerson, *Complete Works,* 3:161.

78. Farrar, *Young Lady's Friend,* 277.

79. In addition to the quilt by Esther Slater, other antebellum quilts made by women aged forty and over for young children that were located as part of this study include a quilt made by Henrietta Whitney (1786–1870) for her granddaughter at birth in 1849, now in the

collection of the New Haven Colony Historical Society, New Haven, Connecticut; a quilt made by Mary Elizabeth Taylor (1774–1846) for her two-year-old grandson in 1824, now in the collection of the Telfair Museum of Art, Savannah, Georgia; a quilt made by Isabelle Pennock (b. 1795) for her three-year-old niece in 1848, now in the collection of the Chester County Historical Society, West Chester, Pennsylvania; a quilt by Margaret Boyce Elliott (1800–1867) for her granddaughter at birth in 1843, now in the collection of the Maryland Historical Society, Baltimore, Maryland; and a quilt by Ann G. Boker (b. ca. 1803) for her three-year-old granddaughter in 1860, now in the collection of Winterthur Museum and Country Estate, Delaware. *Quilts and Quiltmakers: Covering Connecticut* (Atglen, PA: Schiffer Publishing, 2002), 42–43; Anita Zaleski Weinraub, ed., *Georgia Quilts: Piecing Together a History* (Athens: University of Georgia Press, 2006), 49–51; Tandy Hersh, "1842 Primitive Hall Pieced Quilt Top: The Art of Transforming Printed Fabric Designs through Geometry," *Uncoverings* 7 (1986): 47–59; Nancy E. Davis, *The Baltimore Album Quilt Tradition: Maryland Historical Society* (Tokyo: Kokusai, 1999), entry #12; Linda Eaton, *Quilts in a Material World: Selections from the Winterthur Collection* (New York: Abrams, 2007), 56–57.

80. The quilt is now in the collection of the Slater Mill Historic Site, Pawtucket, Rhode Island.

81. Gail Fowler Mohanty, "Esther Slater and Her Falling Blocks Quilt," in *Down by the Old Mill Stream: Quilts in Rhode Island,* ed. Linda Welters and Margaret T. Ordonez (Kent, OH: Kent State University Press, 2000), 226–231.

82. Dr. James Orne Whitney was born in Attleboro, Massachusetts, in 1823 and married Elizabeth Slack Miller in Rhode Island in 1850. Anna was the couple's first child; they had three more children together, but only their three daughters lived to adulthood. The Whitney family's published history states that Dr. Whitney was "regarded by physicians as an exceptionally acute diagnostician, his judgment in this regard being well nigh infallible." In addition, "He was one of the founders and the first physician of the Pawtucket dispensary. . . . He has written a number of articles for medical journals throughout the country and has introduced a number of surgical appli-

ances into the profession." Frederick Clifton Pierce, *Whitney: The Descendants of John Whitney* (Chicago: F. C. Pierce, 1895), 554.

83. Mohanty, "Esther Slater," 230.

84. The sampler is now in the collection of the Slater Mill Historic Site, Pawtucket, Rhode Island. The attribution of the sampler to Esther Johnson Parkinson Slater is based on a label that was affixed to the frame when it was given to the Slater Mill Historic Site in 1964. The sampler may have been originally signed with Esther's name. The letters may subsequently have disintegrated or have been picked out. It is difficult to tell what caused this and what kind of stitching may have originally been there. I am indebted to curator Andrian Paquette for his assistance during my site visit on March 20, 2009.

85. Mohanty, "Esther Slater," 226, 229.

86. For details about her life, see Mohanty, "Esther Slater," 226.

87. Mohanty, "Esther Slater," 228–229.

88. Mohanty, "Esther Slater," 229–230.

89. The quilt is backed with brown silk and has an applied binding. It was given to the Slater Mill Historic Site by a Whitney family descendant, Charles Crawford Carter, in 1952, one hundred years after it was reportedly made. Curatorial file, Slater Mill Historic Site, Pawtucket, Rhode Island. The attribution to Slater probably came from a family story passed along by the donor; the quilt is not signed, nor was any label or letter documenting the story given with the quilt.

90. Mohanty, "Esther Slater," 230; Barbara Brackman, *Encyclopedia of Pieced Quilt Patterns* (Paducah, KY: American Quilter's Society, 1993), 26–27; Virginia Gunn, "Template Quilt Construction and Its Offshoots: From *Godey's Lady's Book* to Mountain Mist," in *Pieced by Mother: Symposium Papers,* ed. Jeannette Lasansky (Lewisburg, PA: Oral Traditions Project, 1988), 72–73.

91. Parkes, *Domestic Duties,* 104.

92. Parkes, *Domestic Duties,* 104.

93. See the quilts by Sarah Wadsworth Mahan in chapter 4 and by Harriet Kirk Marion discussed in this chapter. Also see the quilt made by Ann G. Boker for her granddaughter in 1860, in Eaton, *Quilts in a Material World,* 56–57.

94. The quilt is currently in the collection of the Daughters of the American Revolution Museum in Washington, DC. I am indebted to Alden O'Brien for allowing me access to the quilt and its curatorial file during a site visit in June 2006. The quilt utilizes the Garden Maze pattern, named for its resemblance to the mazes made out of garden vegetation that were popular in America and Europe for centuries.

95. Genealogical information from www.ancestry .com.

96. Curatorial file, Daughters of the American Revolution Museum, Washington, DC.

97. Lucy Larcom, *A New England Girlhood* (Boston: Northeastern University Press, 1986), 122. Lucy Larcom was born in 1824 in Beverly, Massachusetts, the daughter of Benjamin Larcom and Lois Barrett Larcom. When she was seven, her father died, and her mother moved the family to Lowell, Massachusetts, where she managed a boardinghouse and Lucy worked in the textile mills. In 1846, Lucy moved west with her sister and taught in Illinois, but she returned to Massachusetts in 1852. She taught for nine years in Massachusetts and then became a magazine editor. Later, she worked as a freelance writer. Larcom never married; she died in Boston, Massachusetts, in 1893. Shirley Marchalonis, "Larcom, Lucy," in *American National Biography Online* (2000), www .anb.org.silk.library.umass.edu:2048/articles/16 /16-00961.html.

98. Harriet Farley or Rebecca C. Thompson, "The Patchwork Quilt," in *A Patchwork of Pieces: An Anthology of Early Quilt Stories, 1845–1940,* comp. Cuesta Ray Benberry and Carol Pinney Crabb (Paducah, KY: American Quilter's Society, 1993), 20–21.

99. Farley or Thompson, "Patchwork Quilt," 21–22.

100. Premo, *Winter Friends,* 5.

101. Susan M. Stabile, *Memory's Daughters: The Material Culture of Remembrance in Eighteenth-Century America* (Ithaca, NY: Cornell University Press, 2004), 131.

102. Alfred F. Young, *The Shoemaker and the Tea Party: Memory and the American Revolution* (Boston: Beacon Press, 1999), 12; Stabile, *Memory's Daughters,* 133–134; Robert N. Butler, "The Life Review: An Interpretation of Reminiscence in the Aged," *Psychiatry* 26 (February 1963): 65–76.

103. Young, *Shoemaker,* xiii, 89.

104. Len Travers, *Celebrating the Fourth: Independence Day and the Rites of Nationalism in the Early Republic* (Amherst: University of Massachusetts Press, 1997), 216; Schwartz, "Social Context of Commemoration," 386.

105. Diary of Mary Avery Upham, April 13, 1858, Massachusetts Historical Society, Boston. Emphasis added.

106. Florence Hartley, *The Ladies' Hand Book of Fancy and Ornamental Work* (Philadelphia: John E. Potter & Co., 1859), 189.

107. The 1859 quilt is now in the collection of the New-York Historical Society in New York City; the 1870s quilt is in the collection of the Newark Museum in Newark, New Jersey. Genealogical information from www. ancestry.com; curatorial file, Newark Museum, Newark, New Jersey; curatorial file, New-York Historical Society, New York, New York. I am indebted to Ulysses Grant Dietz, curator of decorative arts at the Newark Museum, for sharing information from the quilt's file with me. I also thank David Burnhauser of the New-York Historical Society for facilitating my site visit in August 2005. The 1870s quilt is illustrated in Sandi Fox, *Small Endearments: Nineteenth-Century Quilts for Children and Dolls* (Nashville: Rutledge Hill Press, 1980), 41.

108. Textile historians come to no strict agreement about when whitework passed out of fashion, but most state that it was becoming unfashionable by the 1850s and 1860s. See Jacqueline M. Atkins, "From Lap to Loom: Marseilles Quilts, Marseilles-Style Spreads, and Their White Work Offspring," *Proceedings of the Textile History Forum* (2000): 21; Bassett and Larkin, *Northern Comfort,* 83–86; Brackman, *Clues in the Calico,* 133–134; Kathy Epstein, "Padded, Stuffed and Corded: White-on-White Quilts," *Piecework Magazine* 5 (November/December 1997): 36; Jean Taylor Federico, "White Work Classification System," *Uncoverings* 1 (1980): 68; Yolanda Van De Krol, "Candlewicking," *Piecework Magazine* 5 (November/December 1997): 27; Kimberly Wulfert, "The Journey of a Whitework Wedding Quilt," *Piecework Magazine* 14 (May/June 2006): 32; Merikay Waldvogel, *Childhood Treasures: Doll Quilts by and for Children* (Intercourse, PA: Good Books, 2008), 29; and Lynne Z. Bassett, *Telltale Textiles: Quilts from the Historic Deerfield*

Collection (Deerfield, MA: Historic Deerfield, 2003), 26–29.

109. Another factor that may have had an effect on Rachel's needlework, and who she gave it to, was her status as a single woman. Rachel never married, instead making quilts for the children of her siblings and their children. While motherhood was a constant for many American women during these decades of great social and cultural change, Rachel Smith did not have that role to fall back on. Instead, she may have embraced her needle as evidence of her femininity and proper place.

110. Bassett, *Telltale Textiles*, 26.

111. There is some evidence that whitework quilts were understood to be more valuable than pieced quilts; probate inventory evidence in New England values whitework quilts at four or five times the value of calico quilts. See Bassett and Larkin, *Northern Comfort,* 86.

112. For more on the Victorian aesthetic, see Katherine C. Grier, *Culture and Comfort: People, Parlors, and Upholstery, 1850–1930* (Rochester, NY: Strong Museum, 1988); Kenneth L. Ames, *Death in the Dining Room and Other Tales of Victorian Culture* (Philadelphia: Temple University Press, 1992); William Seale, *The Tasteful Interlude: American Interiors through the Camera's Eye, 1860–1917* (New York: Praeger, 1975); and Harvey Green, *The Light of the Home: An Intimate View of the Lives of Women in Victorian America* (New York: Pantheon Books, 1983), 93–111.

113. Rozsika Parker, *The Subversive Stitch: Embroidery and the Making of the Feminine* (New York: Routledge, 1989), 14.

114. Quoted in Pat Ferrero, Elaine Hedges, and Julie Silber, *Hearts and Hands: Women, Quilts and American Society* (Nashville: Rutledge Hill Press, 1987), 91, 94.

115. Theodore Stanton and Harriot Stanton Blatch, eds., *Elizabeth Cady Stanton, as Revealed in Her Letters, Diary, and Reminiscences,* vol. 1 (New York: Harper and Row, 1922), 336. Elizabeth Cady was born in 1815 in Johnstown, New York, the daughter of Daniel Cady and Margaret Livingston Cady. She attended Emma Willard's Troy Female Seminary. She married abolitionist Henry Stanton in 1840. The couple had seven children. She died in New York City in 1902. Ann D. Gordon, "Stanton, Elizabeth Cady," in *American National Biography Online* (2000), www.anb.org.silk.library.umass.edu:2048/articles/15/15-00640.html.

116. See Jeanne Boydston, *Home and Work: Housework, Wages and the Ideology of Labor in the Early Republic* (New York: Oxford University Press, 1990); Ruth Schwartz Cowan, *More Work for Mother: The Ironies of Household Technology from the Open Hearth to the Microwave* (New York: Basic Books, 1983); Catherine E. Kelly, *In the New England Fashion: Reshaping Women's Lives in the Nineteenth Century* (Ithaca, NY: Cornell University Press, 1999); and Susan Strasser, *Never Done: A History of American Housework* (New York: Henry Holt, 2000).

117. *New England Farmer,* October 16, 1833, quoted in Holly V. Izard, "The Ward Family and Their 'Helps': Domestic Work, Workers, and Relationships on a New England Farm, 1787–1866," *Proceedings of the American Antiquarian Society* 103 (1993): 76.

118. Mrs. E. B. Hall, *My Thimbles* (Boston: Crosby, Nichols, 1852), 3. Emphasis added.

119. Beverly Gordon, "Victorian Fancywork in the American Home: Fantasy and Accommodation," in *Making the American Home: Middle-Class Women and Domestic Material Culture, 1840–1940,* ed. Marilyn Ferris Motz and Pat Browne (Bowling Green, OH: Bowling Green State University Popular Press, 1988), 48–68; Nancy Dunlap Bercaw, "Solid Objects/Mutable Meanings: Fancywork and the Construction of Bourgeois Culture, 1840–1880," *Winterthur Portfolio* 26 (1991): 231–248; Pat Crothers, "Gender Misapprehensions: The 'Separate Spheres' Ideology, Quilters, and Role Adaptation, 1850–1890," *Uncoverings* 14 (1993): 55; Parker, *Subversive Stitch,* 169–170.

120. Parker, *Subversive Stitch,* 14, 153–154.

121. Premo, *Winter Friends,* 84–85.

122. Stabile, *Memory's Daughters,* 12.

123. Lydia Maria Child, *Looking Toward Sunset* (Boston: Ticknor and Fields, 1867), 89–90.

124. The quilt is now in the collection of the Metropolitan Museum of Art, New York, New York. Fox, *Small Endearments,* 159; Deborah E. Kraak and Barbara C. Adams, "Reflections on Little Girls and Their Sewing for Dolls," *Piecework Magazine* 11 (January/February 2003):

60, 63; Amelia Peck, *American Quilts and Coverlets in the Metropolitan Museum of Art* (New York: Metropolitan Museum of Art, 2007), 116, 249.

125. Ferrero, Hedges, and Silber, *Hearts and Hands,* 18.

126. *Village Life in America, 1852–1872, Including the Period of the American Civil War as Told in the Diary of a School-Girl* (New York: Henry Holt, 1913), 39–40. Caroline Cowles Richards was born in 1842 and raised in Canandaigua, New York, by her grandmother. In 1866, she married Edmund Clarke. Caroline died in 1913. Biographical information from the North American Women's Letters and Diaries database, http://solomon.nwld.alexanderstreet.com.silk.library.umass.edu:2048/bios/A300BIO.html.

127. Patricia J. Keller, "Quaker Quilts from Delaware River Valley, 1760–1890," *The Magazine Antiques* 156 (August 1999): 185. Miller wrote her "Early Recollections" in 1889; this manuscript is in a private collection but is quoted in Keller's article.

128. Premo, *Winter Friends,* 84.

129. Letter from Eleanor Parke Custis Lewis to Elizabeth Bordley, December 10, 1844, quoted in Brady, *George Washington's Beautiful Nelly,* 243–244.

130. Parker, *Subversive Stitch,* 130–131. While most of the textiles described here spring from a relationship with the grandmother as giver and the granddaughter as receiver, at least one object shows that grandmothers were also the recipient of the bounty of sewing lessons, whether inside the home or out. A New England sampler made around 1815 by Sarah Salter has a stitched inscription, "Sarah Salter worked this / in the 8th year of her age / A present for Grandmother." M. Finkel and Daughter, *Samplings* 6 (1994): 12.

131. Elaine Hedges, "The Nineteenth-Century Diarist and Her Quilts," *Feminist Studies* 8 (Summer 1982): 295. See the documentary and material examples cited herein: the Whittlesey quilt and Bracket sampler, as well as the Sarah Levis and Caroline Cowles Richards sources.

132. Larcom, *New England Girlhood,* 28–29.

133. Ames, *Death,* 169, 173.

134. This quilt, now in a private collection, is pictured in Gloria Seaman Allen and Nancy Gibson Tuck-horn, *A Maryland Album: Quiltmaking Traditions, 1634–1934* (Nashville: Rutledge Hill Press, 1995), 98–99. The quilt's inscription, signed by an "L .L. Coleman" whose relationship to the family is unknown, suggests that the quilt's function as a family touchstone was well-known enough within, and perhaps outside of, the family that the inscription was made by a third party rather than by the giver or the recipient. Allen and Tuckhorn, *Maryland Album,* 99.

135. Sarah J. Purcell, *Sealed with Blood: War, Sacrifice and Memory in Revolutionary America* (Philadelphia: University of Pennsylvania Press, 2002), 103.

136. The quilt is now in a private collection; it is pictured in Linda Welters and Margaret T. Ordonez, eds., *Down by the Old Mill Stream: Quilts in Rhode Island* (Kent, OH: Kent State University Press, 2000), 237.

137. Genealogical information from www.ancestry.com.

138. Linda Welters, "Homespun Folk Art," in *Down by the Old Mill Stream,* ed. Welters and Ordonez, 236–237.

139. Welters, "Homespun Folk Art," 236. It is plausible that the Greenes, who lived in rural Rhode Island, owned sheep. Unfortunately, extant tax records for East Greenwich, Rhode Island, at the Rhode Island Historical Society and at the East Greenwich Town Hall, do not include a level of detail that would reveal what kind of livestock Abigail and her husband owned. Phone conversations with the Rhode Island Historical Society, Providence, Rhode Island, on September 3, 2009, and with the Town Clerk's Office, East Greenwich Town Hall, Rhode Island, on September 4, 2009.

140. Welters, "Homespun Folk Art," 236.

141. Genealogical information from www.ancestry.com.

142. The quilt is pictured in Sandi Fox, *Quilts: California Bound, California Made, 1840–1940* (Los Angeles: FIDM Museum and Library, 2002), 33–35; U.S. Census information from www.ancestry.com.

143. The story of the quilt is known through family history; see Fox, *Quilts: California Bound,* 34.

144. Fox, *Quilts: California Bound,* 34.

145. Fox, *Quilts: California Bound,* 35.

Chapter 6: Biographical Needlework

1. The sampler is now in the collection of Old Sturbridge Village, Sturbridge, Massachusetts. The sampler documents that Esther Banister was born April 19, 1795, and that she married Hollis Richards (1798–1872) on October 7, 1819; according to the sampler, Reverend Eliakim Phelps (b. 1790) of West Brookfield performed the ceremony. The couple had four children, two of whom died before Esther made her sampler. Esther's husband, Hollis Richards, was a carpenter. The 1840 tax records for Sturbridge place the couple in the bottom two-fifths of the town's residents. Esther died in 1864 at the age of sixty-nine from consumption. 1840 town tax records and 1850 U.S. Census, research files, Old Sturbridge Village, Sturbridge, Massachusetts.

2. See http://bible.cc/psalms/71-9.htm and www.wallbuilders.com/LIBprinterfriendly.asp?id=75.

3. King James Bible, Psalm 71, verses 9 and 18.

4. Gloria Seaman Allen, *Family Record: Genealogical Watercolors and Needlework* (Washington, DC: DAR Museum, 1989), 32.

5. Janet Hoskins, *Biographical Objects: How Things Tell the Stories of People's Lives* (New York: Routledge, 1998), 11; Annette B. Weiner, *Inalienable Possessions: The Paradox of Keeping-While-Giving* (Berkeley: University of California Press, 1992). These sources (along with Nicholas Thomas, *Entangled Objects: Exchange, Material Culture and Colonialism in the Pacific* [Cambridge, MA: Harvard University Press, 1991], 4, 30; and Arjun Appadurai, ed., *The Social Life of Things: Commodities in Cultural Perspective* [New York: Cambridge University Press, 1986]) focus on non-Western societies, but these scholars generally suggest that the idea has relevance for Western societies. In addition, there are Western studies that suggest that certain objects became "biographical" without using the term. For example, in her study of Pennsylvania weaving, Adrienne Hood writes that "spinning wheels were simultaneously a means of support and an emblem of womanly skill and industry," a description that could be interpreted to mean that these objects served as "biographical artifacts" (Adrienne D. Hood, *The Weaver's Craft: Cloth, Commerce and Industry in Early Pennsylvania* [Philadelphia: University of Pennsylvania Press, 2003], 76).

6. Annette B. Weiner, "Inalienable Wealth," *American Ethnologist* 12 (May 1985): 210. Presumably, Esther Richards's sampler was passed down in her family, but that trail is now lost. Old Sturbridge Village acquired the sampler from an antiques dealer who did not have information on the sampler's chain of ownership.

7. Hoskins, *Biographical Objects*, 2.

8. Mihaly Csikszentmihalyi and Eugene Rochberg-Halton, *The Meaning of Things: Domestic Symbols and the Self* (New York: Cambridge University Press, 1981), 97.

9. Susan M. Stabile, *Memory's Daughters: The Material Culture of Remembrance in Eighteenth-Century America* (Ithaca, NY: Cornell University Press, 2004), 135, 189.

10. Anita Schorsch, *Mourning Becomes America: Mourning Art in the New Nation* (Clinton, NJ: Main Street Press, 1976), n.p.

11. George Washington Bethune, comp., *Memoirs of Mrs. Joanna Bethune* (New York: Harper and Brothers, 1863), 227. Bethune reflected on this same psalm in at least one other diary entry—that for February 1, 1845—after lamenting the loss of many of her close friends. Bethune sought strength in the Lord, she explained, because of her age. She needed help to continue the work of her local orphan asylum: "Lord, look on this Institution, which thine own hand planted, and which has been a blessing to many, and forsake us not when we are old and gray-headed" (Bethune, *Memoirs*, 234).

12. Information about Joseph Lathrop, as well as the text of his 1805 sermon, is available at www.wallbuilders.com/LIBprinterfriendly.asp?id=75. This sermon was published; see Joseph Lathrop, *The Infirmities and Comforts of Old Age: A Sermon to Aged People* (Springfield, MA: Henry Brewer, 1805). Lathrop's sermon "Old Age Improved," from 1811, was also published; see Joseph Lathrop, *Old Age Improved* (Springfield, MA: T. Dickman, 1811).

13. Harriet Farley or Rebecca C. Thompson, "The Patchwork Quilt," *Lowell Offering* 5 (1845), reprinted in *A Patchwork of Pieces: An Anthology of Early Quilt Stories, 1845–1940,* comp. Cuesta Ray Benberry and Carol Pinney Crabb (Paducah, KY: American Quilter's Society, 1993), 18–23.

14. See Laurel Thatcher Ulrich, "Of Pens and Needles: Sources in Early American Women's History," *Journal of American History* 77 (June 1990): 200–207, where

she calls for a new methodology to research the lives of everyday women using a combination of traditional and material sources.

15. Stabile, *Memory's Daughters*, 81.

16. On eighteenth-century diaries and the evolution of the diary in the nineteenth century, see Margo Culley, *A Day at a Time: The Diary Literature of American Women from 1764 to the Present* (New York: Feminist Press at CUNY, 1985); Elizabeth Pendergast Carlisle, *Earthbound and Heavenbent: Elizabeth Porter Phelps and Life at Forty Acres, 1747–1817* (New York: Scribner, 2004); Nancy F. Cott, *The Bonds of Womanhood: "Women's Sphere" in New England, 1780–1835* (New Haven, CT: Yale University Press, 1977); Joanna Bowen Gillespie, "'The Clear Leadings of Providence': Pious Memoirs and the Problems of Self-Realization for Women in the Early Nineteenth Century," *Journal of the Early Republic* 5 (Summer 1985): 197–221; Mechal Sobel, *Teach Me Dreams: The Search for Self in the Revolutionary Era* (Princeton: Princeton University Press, 2000); and Laurel Thatcher Ulrich, *A Midwife's Tale: The Life of Martha Ballard, Based on her Diary, 1785–1812* (New York: Alfred A. Knopf, 1990).

17. Martha Saxton, *Being Good: Women's Moral Values in Early America* (New York: Hill and Wang, 2003), 221; Cott, *Bonds of Womanhood*, 16–17. For more on women and their letters, see Marilyn Ferris Motz, *True Sisterhood: Michigan Women and Their Kin, 1820–1920* (Albany: State University of New York Press, 1983).

18. In addition to Margaret Kelley's quilt, see the samplers by Amy Fiske, Elcey Patterson, Patty Sessions, and Ruth Croswell and the quilts by Maria Hubbard, Mary Kemp, Amelia Lauck, and Emily Snyder discussed in these pages. Another example is the appliqué album quilt with a stuffed work inscription, "1860. Done by Mrs. C. Bartlett in the 63 year of her age," which is illustrated in Cyril I. Nelson and Carter Houck, *Treasury of American Quilts* (New York: Greenwich House, 1984), 75.

19. The quilt is now in the collection of the Erie County Historical Society, Erie, Pennsylvania. Margaret Steeley was born in Lewistown, Pennsylvania, in 1784. After she married John Kelley, the couple traveled west to settle in Erie County, Pennsylvania. They had eleven children. See Marianne Berger Woods, ed., *Threads of Tradition: Northwest Pennsylvania Quilts* (Meadville, PA: Crawford County Historical Society, 1997), 32; and *History of Erie County, Pennsylvania* (Chicago: Warner, Beers, 1884), 60.

20. See Ulrich, *Midwife's Tale* for an excellent method on extracting the information that diaries can provide.

21. Woods, *Threads of Tradition*, 32. Unfortunately, evidence documenting the connection between Coates and Kelley remains unlocated, along with any evidence about Coates's life and other quilting activities. The attribution that Coates did the quilting comes from information provided by the donor when the quilt was donated in 1926. Letter to the author from Becky Weiser, curator, Erie County Historical Society, Erie, Pennsylvania, February 2009.

22. Needlework manuals consulted include *The American Ladies' Memorial* (Boston, 1850); Lydia Maria Child, *The Girls' Own Book* (New York: Clark Austin, 1833); Florence Hartley, *The Ladies' Handbook of Fancy and Ornamental Work* (Philadelphia: G. G. Evans, 1859); *The Ladies' Hand-Book of Fancy Needlework, and Embroidery* (New York: J. S. Redfield, 1844); *The Ladies' Handbook of Knitting, Netting and Crochet* (New York: J. Redfield, 1844); *The Ladies' Work-Table Book* (New York: J. Winchester, 1844); *The Lady's Work-Box Companion* (New York: Burgess, Stringer, 1844); Miss Lambert, *The Hand-Book of Needlework* (New York: Wiley and Putnam, 1842); Miss Lambert, *The Hand-Book of Needlework* (London: John Murray, 1846); *The Seamstress* (New York: J. S. Redfield, 1848); Mrs. Ann S. Stephens, *The Ladies' Complete Guide to Crochet, Fancy Knitting and Needlework* (New York: Garrett, 1854); and *The Workwoman's Guide* (London: Simpkin, Marshall, 1838).

23. *Ladies' Work-Table Book*, vi.

24. Quoted in Susan Burrows Swan, *Plain and Fancy: American Women and Their Needlework, 1650–1850* (Austin, TX: Curious Works Press, 1995), 41.

25. Frederick Hollick, M.D., *The Diseases of Woman* (New York: T. W. Strong, 1849), 236–237; Carroll Smith-Rosenberg, *Disorderly Conduct: Visions of Gender in Victorian America* (New York: Oxford University Press, 1985), 185, 193.

26. Stephens, *Ladies' Complete Guide*, 5.

27. The quilt is currently in the collection of the Smithsonian Institution, Washington, DC. See family records at www.ancestry.com; Doris M. Bowman, *American Quilts: The Smithsonian Treasury* (Washington, DC:

Smithsonian Institution Press, 1991), 37; Sandi Fox, *Small Endearments: Nineteenth-Century Quilts for Children and Dolls* (Nashville: Rutledge Hill Press, 1980), 7; and Jacqueline M. Atkins and Phyllis A. Tepper, *New York Beauties: Quilts from the Empire State* (New York: Dutton Studio Books, 1992), 70.

28. James A. Hijiya, "American Gravestones and Attitudes toward Death: A Brief History," *Proceedings of the American Philosophical Society* 127 (October 1983): 341.

29. Douglas Keister, *Stories in Stone: A Field Guide to Cemetery Symbolism and Iconography* (Salt Lake City, UT: Gibbs Smith, 2004), 59. John 15 is quoted on 59–60. Vines were also understood to be connected to grapes and wine; the wine of communion was pressed from the mystical vine. Many New England gravestones depict a vine entwined with effigies of the soul; see Allan I. Ludwig, *Graven Images: New England Stonecarving and Its Symbols, 1650–1815* (Middletown, CT: Wesleyan University Press, 1966), 168, 175, 180.

30. In her comparison of samplers and gravestone art, scholar Laurel K. Gabel points out that "needlework and gravestones, and almost all other forms of decorative art, drew inspiration from a common vocabulary of popular motifs and themes circulating at the time. . . . These patterns were not unique to needlework or gravestones, but were part of a standard vocabulary of motifs in general use at the time" (Laurel K. Gabel, "A Common Thread: Needlework Samplers and American Gravestones," *Markers* 19 [2002]: 19, 42).

31. Hijiya, "American Gravestones," 354.

32. I am indebted to Marla R. Miller for her suggestions on how to interpret the large size of these letters. Genealogical records for Nancy Ward Butler are not complete at www.ancestry.com or in the books that have previously illustrated this quilt, so it is difficult to know whether this was the first death of a child or grandchild that she experienced. However, young Nancy Adelaide Butler was the oldest daughter of Nancy Ward Butler's son, Calvin Butler, and may have been her first namesake. Family records from www.ancestry.com.

33. This second quilt attributed to Nancy Ward Butler is now in the collection of the Chautauqua County Historical Society, New York. "The Unfinished Story of the Twin Quilts," *County History Newsletter* (February 1992): 1–2.

34. The quilt is now in the collection of Heritage City Park, Santa Fe Springs, California. Ellen Kort, *Wisconsin Quilts* (Charlottesville, VA: Howell Press, 2001), 21.

35. Curatorial file, Heritage City Park, Santa Fe Springs, California; U.S. Census information and family tree information from www.ancestry.com.

36. Kort, *Wisconsin Quilts,* 23.

37. Kort, *Wisconsin Quilts,* 22.

38. Kort, *Wisconsin Quilts,* 21.

39. Quoted from diary kept by Betsey Seely Sears (now in a private collection) in Kort, *Wisconsin Quilts,* 21.

40. Kort, *Wisconsin Quilts,* 21.

41. Kort, *Wisconsin Quilts,* 22; curatorial files, Heritage City Park, Santa Fe Springs, California.

42. Curatorial file, Heritage City Park, Santa Fe Springs, California. In later years, Betsey learned to set type to support herself as a job printer in Rome. Kort, *Wisconsin Quilts,* 22.

43. Kort, *Wisconsin Quilts,* 23.

44. Terri L. Premo, *Winter Friends: Women Growing Old in the New Republic, 1785–1835* (Urbana: University of Illinois Press, 1990), 116.

45. For more on epistolary textiles, see Winifred Reddall, "Pieced Lettering on Seven Quilts Dating from 1833 to 1891," *Uncoverings* 1 (1980): 56–63; Stacy C. Hollander, "Talking Quilts," *Folk Art* 29 (Spring/Summer 2004): 32–41; Marsha Van Valin, "Epistolary Samplers: When Needles Were Pens," in *Common Thread, Common Ground: A Collection of Essays on Early Samplers and Historic Needlework,* ed. Marsha Van Valin (Sullivan, WI: Scarlet Letter, 2001), 50–55.

46. Van Valin, "Epistolary Samplers," 50.

47. Hollander, "Talking Quilts," 38.

48. Van Valin, "Epistolary Samplers," 50–52.

49. The quilt is now in the collection of the American Folk Art Museum, New York, New York. Little is known about quilt-maker Maria Cadman Hubbard's life, and the attribution of the quilt to New York is not definite. See Stacy C. Hollander and Brooke Davis Anderson, *American Anthem: Masterworks from the American Folk Art Museum* (New York: Harry N. Abrams, 2001), 337; Atkins and Tepper, *New York Beauties,* 91; Robert

Bishop, *New Discoveries in American Quilts* (New York: E. P. Dutton, 1975), 32; Elizabeth V. Warren and Sharon L. Eisenstat, *Glorious American Quilts: The Quilt Collection of the Museum of American Folk Art* (New York: Penguin Studio, 1996), 53–55; and C. Kurt Dewhurst, Betty Macdowell, and Marsha Macdowell, *Religious Folk Art in America: Reflections of Faith* (New York: E. P. Dutton, 1983), 60.

50. On commonplace books see Stabile, *Memory's Daughters,* 9–16, 133; Catherine La Courreye Blecki and Karin A. Wulf, eds., *Milcah Martha Moore's Book: A Commonplace Book from Revolutionary America* (University Park: Pennsylvania State University Press, 1997); Susan Miller, *Assuming the Positions: Cultural Pedagogy and the Politics of Commonplace Writing* (Pittsburgh: University of Pittsburgh Press, 1998); and Lucia Dacome, "Noting the Mind: Commonplace Books and the Pursuit of the Self in Eighteenth-Century Britain," *Journal of the History of Ideas* 65 (October 2004): 603–625. In addition, the following articles on nineteenth-century scrapbooks, gift books, and photo albums offer additional perspectives on Hubbard's choice to collect verses on her quilt: Patricia P. Buckler and C. Kay Leeper, "An Antebellum Woman's Scrapbook as Autobiographical Composition," *Journal of American Culture* 14 (1991): 1–8; Cindy Dickinson, "Creating a World of Books, Friends, and Flowers: Gift Books and Inscriptions, 1825–60," *Winterthur Portfolio* 31 (1996): 53–66; Marilyn F. Motz, "Visual Autobiography: Photograph Albums of Turn-of-the-Century Midwestern Women," *American Quarterly* 41 (March 1989): 63–92.

51. Stabile, *Memory's Daughters,* 16.

52. Kenneth L. Ames, *Death in the Dining Room and Other Tales of Victorian Culture* (Philadelphia: Temple University Press, 1992), 117.

53. For an overview of the revivals that swept New York's "burned over district," see Whitney R. Cross, *The Burned-Over District: The Social and Intellectual History of Enthusiastic Religion in Western New York, 1800–1850* (Ithaca, NY: Cornell University Press, 1950); Paul E. Johnson, *A Shopkeeper's Millennium: Society and Revivals in Rochester, New York, 1815–1837* (New York: Hill and Wang, 1978); Nancy A. Hewitt, *Women's Activism and Social Change: Rochester, New York, 1822–1872* (Ithaca, NY: Cornell University Press, 1984); and Nathan O. Hatch, *The Democratization of American Christianity* (New Haven, CT: Yale

University Press, 1989). Unfortunately, Hubbard's specific religious beliefs are unknown.

54. Hollander, "Talking Quilts," 38. The title, "The Pieties Quilt," seems to have been applied in the 1980s, shortly before it was given to the American Folk Art Museum in 1984. Correspondence between the author and Stacy C. Hollander, senior curator, American Folk Art Museum, New York, February 19, 2009.

55. Charles S. Nutter and Wilbur F. Tillett, *The Hymns and Hymn Writers of the Church* (New York: Eaton and Mains, 1911), 363; Martin Gardner, *Famous Poems from Bygone Days* (New York: Dover Publications, 1995), 35.

56. This phrase was also the subject of a sermon delivered by Quaker preacher Elias Hicks and subsequently published in *The Quaker* 1 (1827): 105–143.

57. Charles Seymour Robinson, *Annotations upon Popular Hymns* (New York: Hunt and Eaton, 1893), 293–294. The phrase also appears in the novel *The Black Tulip,* by Alexandre Dumas, first published in 1850.

58. www.cyberhymnal.org/htm/c/y/cydiscon.htm.

59. For more on William Penn's *No Cross, No Crown,* see www.bartleby.com/218/0406.html. This phrase is used on many embroidered mottoes during the late nineteenth century; see Ames, *Death,* 144. A poem titled "No Cross, No Crown" by Rev. T.F.R. Mercein appeared in *The Christian Parlor Magazine* 6 (1849): 306. For a nineteenth-century explanation of this verse, see Rev. William Holmes, *Religious Emblems and Allegories* (London: William Tegg, 1868), 151–155.

60. Ione, "Stories from the Linn-Side. No. VIII. The Broken Vow," *The Lowell Offering and Magazine,* series 3, no. 11 (1843): 253.

61. *The Soul's Welfare: A Magazine for the People* 2 (1851): 70. I have been unable to locate a source of this verse published prior to 1848.

62. Frances E. Willard and Mary A. Livermore, eds., *American Women: Fifteen Hundred Biographies* (New York: Mast, Crowell and Kirkpatrick, 1897), 2:561; Andy Logan, Brendan Gill, and Gordon Cotler, "The Talk of the Town: Never Die," *New Yorker,* May 12, 1951, 24.

63. Seba Smith, ed., *The Rover: Weekly Magazine of Tales, Poetry, and Engravings* (New York: S. B. Dean, 1844), 32. Signed only with the initials "C.H.H.," this poem (according to *The Rover*) had been found in the pages of

London's *Illuminated Magazine*. It was reprinted again in 1846 in *Voices of the True-Hearted* (Philadelphia: Merrihew and Thompson, 1846), 4.

64. Sampler historian Toni Flores Fratto has suggested that "the changes that appear [in sampler verses], the misspellings, the freedom with which phrases or lines are pulled apart and recombined, the length of time over which some verses persistently appear, suggest that some sampler inscriptions . . . were not copied from books and were indeed passed along via the sampler medium itself" (Toni Flores Fratto, "'Remember Me': The Sources of American Sampler Verses," *New York Folklore* 2 [Winter 1976]: 212). Hubbard's quilt may be an example of this phenomenon, or she may have taken some of her verses from needlework samplers that she knew.

65. I have been unable to find a pre-1848 source for this saying. However, I am indebted to Marla R. Miller for pointing out a similar phrase in a story called "The Refiner" by "Clement" in *The Local Preachers' Magazine and Christian Family Record* (London: Aylott, 1857), 240–241.

66. Hubbard may have been familiar with the grafting experiments that were performed with golden pippin apples and crabapples during the early nineteenth century. These experiments were discussed in many agricultural manuals and reports from the 1830s through the 1850s. For example, see Peter Mark Roget, M.D., *Animal and Vegetable Physiology Considered with Reference to Natural Theology* (London: William Pickering, 1834), 594–595. And *The Golden Pippin* was the title of a play written by English playwright Kane O'Hara in 1772, although there is no available evidence about whether Hubbard was familiar with this work. A version of this saying appears in Mrs. Herbert A. Barker and Miss Helen S. Whitney, eds., *Boylston Congregational Church Home Department Cook Book* (Jamaica Plain, MA: J. Allen Crosby, 1906), 45.

67. Premo, *Winter Friends*, 5.

68. The sampler is now in the collection of the National Archives and Records Administration, Washington, DC.

69. Pension file of Daniel Hearn, Massachusetts, W17064, National Archives and Records Administration, Washington, DC (hereafter cited as Hearn pension file);

Jennifer Davis Heaps, "Remember Me: Six Samplers in the National Archives," *Prologue* 34 (Fall 2002): 189–190.

70. The samplers by Polly Coffin and Anna Gardner, which are now in the collection of the Nantucket Historical Association, Nantucket, Massachusetts, show several similarities to the Mary Hearn sampler and were made in the late 1790s. All three share a similar layout, style, and motifs. Susan R. Boardman and Aimee E. Newell, "Nantucket Needlework: Samplers from Quaker Schools," *Fine Lines* 7 (Fall 2002): 8.

71. Heaps, "Remember Me," 189. Nantucket genealogical records suggest that Mary Hearn married Joseph Elkins and that the couple had a daughter, Phebe, in 1803. Elkins was killed at sea in 1820. Because Mary Hearn married Peter Fralick in New York in 1818, however, these records seem to be in error or to reference a different Mary Hearn. See the Eliza Barney Genealogical Records at the Nantucket Historical Association; these records are cited in Heaps, "Remember Me," 189.

72. Deposition by Peter Fralick, April 4, 1846, Hearn pension file.

73. Heaps, "Remember Me," 186.

74. Heaps, "Remember Me," 186–187.

75. Heaps, "Remember Me," 186.

76. Hearn pension file.

77. Deposition of Mary Fralick, April 4, 1846, Hearn pension file.

78. Deposition of Walton Swetland, April 4, 1846, Hearn pension file.

79. Deposition by Mary Fralick, April 5, 1847, Hearn pension file.

80. Heaps, "Remember Me," 190; Hearn pension file.

81. The sixth sampler, made by Huldah Booth (b. 1789) around 1818, was submitted by the maker and her siblings to try to collect a pension for their father's service. While their mother did receive a pension between 1836 and 1838, the request by the children in 1848 was denied. See Heaps, "Remember Me," 192.

82. Barbara McLean Ward, "Women's Property and Family Continuity in Eighteenth-Century Connecticut," in *Early American Probate Inventories,* ed. Peter Benes (Boston: Boston University, 1987), 83–85; Laurel Thatcher Ulrich, "Furniture as Social History: Gender, Property,

and Memory in the Decorative Arts," in *American Furniture,* ed. Luke Beckerdite (Milwaukee, WI: Chipstone Foundation, 1995), 39–68; Laurel Thatcher Ulrich, "Hannah Barnard's Cupboard: Female Property and Identity in 18th-Century New England," in *Through a Glass Darkly: Reflections on Personal Identity in Early America,* ed. Ronald Hoffman, Mechal Sobel, and Fredrika J. Teute (Durham: University of North Carolina Press, 1997), 238–273.

83. Weiner, *Inalienable Possessions,* 36.

Chapter 7: Threads of Life

1. Mrs. Caroline Gilman, *Recollections of a Housekeeper* (New York: Harper and Brothers, 1834), 10–11. Caroline Howard was born in Boston, Massachusetts, in 1794, the daughter of Samuel Howard and Anna Lillie Howard. After the early deaths of her parents, Caroline lived with relatives. In 1819, she married Reverend Samuel Gilman, a Unitarian minister. The couple moved to Charleston, South Carolina, where they had seven children, although three died in infancy. In the 1830s, she began to publish a children's weekly, *Rose-Bud,* and later wrote several novels. She died in 1888 in Washington, DC. Diane Prenatt, "Gilman, Caroline Howard," in *American National Biography Online* (2000), www.anb.org.silk .library.umass.edu:2048/articles/16/16-00624.html.

2. Although the following do not use the words "family chauvinism," each author does suggest that objects were, in part, understood to show family pride and even superiority: Margaretta L. Lovell, *Art in a Season of Revolution: Painters, Artisans, and Patrons in Early America,* (Philadelphia: University of Pennsylvania Press, 2005); D. Brenton Simons and Peter Benes, eds., *The Art of Family: Genealogical Artifacts in New England* (Boston: New England Historic Genealogical Society, 2002); Laurel Thatcher Ulrich, *The Age of Homespun: Objects and Stories in the Creation of an American Myth* (New York: Alfred A. Knopf, 2001); and Laurel Horton, *Mary Black's Family Quilts: Memory and Meaning in Everyday Life* (Columbia: University of South Carolina Press, 2005).

3. The sampler is now in a private collection. It is illustrated in Sue Studebaker, *Ohio Is My Dwelling Place:*

Schoolgirl Embroideries, 1800–1850 (Athens: Ohio University Press, 2002), 36.

4. Studebaker, *Ohio,* 35.

5. Mary Jaene Edmonds, *Samplers and Samplermakers: An American Schoolgirl Art, 1700–1850* (London: Rizzoli, 1991), 155; Studebaker, *Ohio,* 35.

6. Studebaker, *Ohio,* 37.

7. Studebaker, *Ohio,* 37.

8. I thank Marla R. Miller for bringing this discrepancy to my attention.

9. The sampler is in a private collection. It has been analyzed in Ulrich, *Age of Homespun,* 404–407; it is also illustrated in Donna Toland Smart, ed., *Mormon Midwife: The 1846–1888 Diaries of Patty Bartlett Sessions* (Logan: Utah State University Press, 1997), 4.

10. Smart, *Mormon Midwife,* 6, 12. For additional biographical information on Patty Bartlett Sessions, see Susan Sessions Rugh, "Patty B. Sessions," in Vicky Burgess-Olson, *Sister Saints* (Provo, UT: Brigham Young University Press, 1978), 305–322; and Kenneth L. Holmes, ed., *Covered Wagon Women: Diaries and Letters from the Western Trails, 1840–1890* (Glendale, CA: Arthur H. Clark, 1983), 157–187.

11. Smart, *Mormon Midwife,* 8, 10.

12. The reference on her sampler to "Salt Lake Valley North America" rather than "United States" reflects the fact that Utah was not a state at the time but a territory. Although the Mormons petitioned for statehood in 1849–1850 (asking to admit a large area from the Colorado Rockies to the Sierra Nevada as the state Deseret), Utah did not become a state until 1896. Edward Leo Lyman, "Statehood for Utah," www.uen.org/utah_history _encyclopedia/s/STATEHOOD.html.

13. Smart, *Mormon Midwife,* 14, 16–19; Ulrich, *Age of Homespun,* 405.

14. Smart, *Mormon Midwife,* 110.

15. Smart, *Mormon Midwife,* 110, 113, 115, 117.

16. Smart, *Mormon Midwife,* 111–112.

17. Smart, *Mormon Midwife,* 19–20, 24, 34.

18. Smart, *Mormon Midwife,* 25. When Patty was fifty-five, in 1850, David Sessions died. A year later, at age fifty-six, Patty married John Parry (1789–1868). Smart, *Mormon Midwife,* 25.

19. Ulrich, *Age of Homespun,* 405.

20. Robert N. Butler, "The Life Review: An Interpretation of Reminiscence in the Aged," *Psychiatry* 26 (February 1963): 65–66. Butler found allusions to the life review process all the way back to Aristotle. See also Thomas R. Cole, *The Journey of Life: A Cultural History of Aging in America* (Cambridge: Cambridge University Press, 1992), 38; and Alfred F. Young, *The Shoemaker and the Tea Party: Memory and the American Revolution* (Boston: Beacon Press, 1999), 12.

21. Susan M. Stabile, *Memory's Daughters: The Material Culture of Remembrance in Eighteenth-Century America* (Ithaca, NY: Cornell University Press, 2004), 133–134.

22. Mechal Sobel, *Teach Me Dreams: The Search for Self in the Revolutionary Era* (Princeton: Princeton University Press, 2000), 4.

23. The sampler is now in the collection of the Litchfield Historical Society, Litchfield, Connecticut. I would like to thank the Litchfield Historical Society's former curator of collections, Jeannie A. Ingram, for assisting me with access to the sampler and its curatorial file in July 2005.

24. Catherine Keene Fields and Lisa C. Kightlinger, eds., *To Ornament Their Minds: Sarah Pierce's Litchfield Female Academy, 1792–1833* (Litchfield, CT: Litchfield Historical Society, 1993), 21. Ruth was the daughter of John Pierce (d. 1783) and Mary Paterson Pierce (d. 1770). John Pierce was a farmer and a potter. In 1770, when Ruth was five, her mother died. Two years later, in 1772, her father married a second time, to Mary Goodman. Fields and Kightlinger, *To Ornament Their Minds,* 21.

25. Fields and Kightlinger, *To Ornament Their Minds,* 20. In addition, the town was home to Tapping Reeve's Litchfield Law School, the first formal school of law in the United States, established in 1784. In 1776 and 1777, when Ruth was twelve, she attended a school held by Ashbel Baldwin, a graduate of Yale and later an Episcopal minister in Litchfield. While New England girls often had the opportunity to attend school, as suggested by the high literacy rates in the region for men and women alike, few had the kind of education offered in this setting. Ruth was able to attend school with boys from the community and take classes in the sciences, beyond basic reading and writing, as well as the ornamental subjects offered at most female schools and academies

at this time. Fields and Kightlinger, *To Ornament Their Minds,* 22.

26. Letter from Nancy Hale to Hannah Hale, September 1802, quoted in Fields and Kightlinger, *To Ornament Their Minds,* 52.

27. Frazer F. Hilder, "The Croswells of Catskill," unpublished typescript, 22, Vedder Research Library, Greene County Historical Society, Coxsackie, New York. Unfortunately, the current location of this quilt is unknown.

28. Emily Noyes Vanderpoel, *Chronicles of a Pioneer School from, 1792–1833* (Cambridge, MA: University Press, 1903), 327; Hilder, "Croswells of Catskill," 21. In 1783, when Ruth was eighteen, her father died. Her older brother, John, who was thirty-one years old at the time, took responsibility for his siblings. John Pierce entered the continental army in 1775 and rose through the ranks, achieving the rank of colonel along with the job of paymaster general in January 1781. On July 18, 1791, Ruth Pierce married Thomas O'Hara Croswell (1767–1844) in Litchfield, Connecticut. Thomas was born on November 6, 1767, to Caleb Croswell (1733–1806) and Hannah Kellogg Croswell (d. 1829), probably in West Hartford, Connecticut. Thomas was a physician, and after their first year of marriage, the couple moved to Catskill, New York, where Thomas eventually became known as the community's beloved "Uncle Doctor." James D. Pinckney, *Reminiscences of Catskill* (Catskill, NY: J. B. Hall, 1868), 19; Vanderpoel, *Chronicles,* 328; Hilder, "Croswells of Catskill," 14, 16.

29. Vanderpoel, *Chronicles,* 326; Hilder, "Croswells of Catskill," 20.

30. J. V. V. Vedder, *Historic Catskill* (Catskill, NY: [s.n.], 1922), 66–67; Hilder, "Croswells of Catskill," 16; genealogical information from www.ancestry.com.

31. Luke 1:6 (King James Bible).

32. See, for example, the letter from Elizabeth Emma Sullivan Stuart (1792–1866) to her daughter, Mary Elizabeth Baker, on December 28, 1858, "to all give a kiss with my hearts fondest love and wishes, and sincere hope that you will all be as happy as 'walking in all the commandments of the Lord *blameless*' can make you," in Helen Stuart Mackay-Smith Marlatt, *Stuart Letters of Robert and Elizabeth Sullivan Stuart and Their Children, 1819–1864* (New York: privately printed, 1961), 894. See

also the diary of Hannah Hobbie for April 13, 1828, where she wrote, "I am often led to cry to God in the language of David, 'Cleanse thou me from secret faults.' O for grace and strength to *crucify sin!* O that I might walk in all the statutes and ordinances of the Lord blameless," in Robert G. Armstrong, *Memoir of Hannah Hobbie; or, Christian Activity, and Triumph in Suffering* (New York: American Tract Society, 1837), 72.

33. Part of this verse is listed in Ethel Stanwood Bolton and Eva Johnston Coe, *American Samplers* (New York: Dover Publications, 1973), 354.

34. U.S. Census information for Catskill, New York, 1850, from www.ancestry.com.

35. Vedder, *Historic Catskill*, 66.

36. Maureen Daly Goggin, "One English Woman's Story in Silken Ink: Filling In the Missing Strands in Elizabeth Parker's Circa 1830 Sampler," *Sampler and Antique Needlework Quarterly* 8 (Winter 2002): 47.

37. Curatorial file, Litchfield Historical Society, Litchfield, Connecticut.

38. Gloria Seamen Allen, *Family Record: Genealogical Watercolors and Needlework* (Washington, DC: DAR Museum, 1989), 1–3. See also Peter Benes, "Decorated New England Family Registers," in *The Art of Family: Genealogical Artifacts in New England,* ed. D. Brenton Simons and Peter Benes (Boston: New England Historic Genealogical Society, 2002), 13–59; and Georgia Brady Barnhill, "'Keep Sacred the Memory of Your Ancestors': Family Registers and Memorial Prints," in Simons and Benes, *The Art of Family,* 60–74.

39. Allen, *Family Record,* 4.

40. Annette B. Weiner, "Inalienable Wealth," *American Ethnologist* 12 (May 1985): 210.

41. Allen, *Family Record,* 7.

42. The sampler is now in the collection of Old Sturbridge Village, Sturbridge, Massachusetts.

43. I am indebted to Marla R. Miller for sharing her thoughts about this action—and its meaning—with me.

44. Terri L. Premo, *Winter Friends: Women Growing Old in the New Republic, 1785–1835* (Urbana: University of Illinois Press, 1990), 138.

45. Aafke E. Komter, *Social Solidarity and the Gift* (Cambridge: Cambridge University Press, 2005), 87–88; Lovell, *Art,* 134; Allen, *Family Record,* 32; Laurel Thatcher

Ulrich, "Creating Lineages," in Simons and Benes, *Art of Family,* 9–11; Nicholas Thomas, *Entangled Objects: Exchange, Material Culture and Colonialism in the Pacific* (Cambridge, MA: Harvard University Press, 1991), 30.

46. Ulrich, *Age of Homespun,* 117.

47. Logan's diary, vol. 12, p. 109, quoted in Stabile, *Memory's Daughters,* 133.

48. In addition to family record samplers, embroidered family coats-of-arms, popular during the late eighteenth century and early nineteenth century, were also ideal for the expression of "family chauvinism." Coats-of-arms originated in England to signify those families that were part of the aristocracy. They were embraced in the colonies and often used whether the family was entitled to them or not. For more on coats-of-arms, see Betty Ring, *Girlhood Embroidery: American Samplers and Pictorial Needlework, 1650–1850* (New York: Alfred A. Knopf, 1993), 60–61; Susan Burrows Swan, *Plain and Fancy: American Women and Their Needlework, 1650–1850* (Austin, TX: Curious Works Press, 1995), 184; and Betty Ring, "New England Heraldic Needlework of the Neoclassical Period," *The Magazine Antiques* 144 (October 1993): 484–493.

49. The sampler is now in the collection of the New-York Historical Society, New York, NY. I am indebted to collections manager David Burnhauser for facilitating my visit in August 2005 to see the sampler and for sharing the file on the sampler. Sarah Holmes was born in New Jersey and married Ralph Mead (1789–1866) in October 1813. The couple had six children: four daughters and two sons. Curatorial file, New-York Historical Society, New York, New York; additional genealogical information from www.ancestry.com.

50. Curatorial file, New-York Historical Society, New York, New York.

51. The quilt is now in the collection of the Daughters of the American Revolution Museum, Washington, DC. I am indebted to Alden O'Brien, curator of costume and textiles, for sharing the curatorial file on this quilt during site visits in June 2006 and June 2009. The quilt is made with block- and roller-printed fabrics. It is bound with green and white woven tape.

52. Mary Rooker came to Baltimore in 1807, when she was twenty-two. Four years later, in 1811, when she was twenty-six, she married Baltimore native John Norris

(1774–1829), a miller. They had five children between 1813 and 1822; three would survive to adulthood. In 1860, when Mary was seventy-five, she was living with her daughter and son-in-law, Sarah and Thomas Myers, in Baltimore. She had a personal estate valued at $10,000, while Thomas owned real estate valued at $5,800. Allen, *Family Record,* 93; Gloria Seaman Allen and Nancy Gibson Tuckhorn, *A Maryland Album: Quiltmaking Traditions, 1634–1934* (Nashville: Rutledge Hill Press, 1995), 108; Thomas M. Myers, *The Norris Family of Maryland* (New York: W. M. Clemens, 1916), 33; U.S. Census information from www.ancestry.com.

53. Allen, *Family Record,* 93. Family information from www.ancestry.com.

54. *Baltimore American and Commercial Daily Advertiser,* January 2, 1830, quoted in Allen and Tuckhorn, *Maryland Album,* 108.

55. Allen and Tuckhorn, *Maryland Album,* 108.

56. Barbara Brackman, *Clues in the Calico: A Guide to Identifying and Dating Antique Quilts* (McLean, VA: EPM Publications, 1989), 123, 136; Allen and Tuckhorn, *Maryland Album,* 15.

57. Allen and Tuckhorn, *Maryland Album,* 41. The quilt made by Mary Lloyd Key, also in the collection of the Daughters of the American Revolution Museum and discussed in chapter 2, employs a very similar border fabric with a Greek key motif, but it dates from an unknown point in the late 1830s or early 1840s.

58. Allen and Tuckhorn, *Maryland Album,* 13.

59. Ann Douglas, "Heaven Our Home: Consolation Literature in the Northern United States, 1830–1880," in *Death in America,* ed. David E. Stannard (Philadelphia: University of Pennsylvania Press, 1975), 54–55; Ann Douglas, *The Feminization of American Culture* (New York: Alfred A. Knopf, 1979), 203, 209–210; Kenneth L. Ames, "Ideologies in Stone: Meanings in Victorian Gravestones," *Journal of Popular Culture* 14 (1981): 641–656; James J. Farrell, *Inventing the American Way of Death, 1830–1920* (Philadelphia: Temple University Press, 1980), 4–7.

60. Martha V. Pike and Janice Gray Armstrong, *A Time to Mourn: Expressions of Grief in Nineteenth Century America* (Stony Brook, NY: Museums of Stony Brook, 1980), 26, 40, 43, 71, 81; David E. Stannard, *Death in America* (Philadelphia: University of Pennsylvania Press, 1975);

Martha Pike, "In Memory Of: Artifacts Relating to Mourning in Nineteenth Century America," in *Rituals and Ceremonies in Popular Culture,* ed. Ray B. Browne (Bowling Green, OH: Bowling Green University Popular Press, 1980), 296–306; Blanche Linden Ward, "Strange but Genteel Pleasure Grounds: Tourist and Leisure Uses of Nineteenth-Century Rural Cemeteries," in *Cemeteries and Gravemarkers: Voices of American Culture,* ed. Richard E. Meyer (Ann Arbor, MI: UMI Research Press, 1989), 295, 298.

61. Mary Louise Kete, *Sentimental Collaborations: Mourning and Middle-Class Identity in Nineteenth-Century America* (Durham, NC: Duke University Press, 2000), 53.

62. The sampler is now in the collection of Winterthur Museum and Country Estate, Delaware. I am indebted to Linda Eaton, curator of textiles at Winterthur, for showing me this sampler and for sharing its curatorial file. The Balch School is one of the best-known New England needlework schools from the late eighteenth and early nineteenth centuries. Mary Balch (1762–1831) founded her school in Providence in the early 1780s and taught generations of young women until her death in 1831. The best-known samplers from the Balch school depict identifiable public buildings in Providence and have elaborate floral borders. See Glee Krueger, *New England Samplers to 1840* (Sturbridge, MA: Old Sturbridge Village, 1978), 21; Ring, *Girlhood Embroidery,* 179.

63. Vital Record of Rhode Island, 1636–1850, at www.americanancestors.org (New England Historic Genealogical Society, 2002); originally published as James N. Arnold, *Vital Record of Rhode Island, 1636–1850, First Series: Births, Marriages and Deaths: A Family Register for the People,* 21 vols. (Providence, RI: Narragansett Historical Publishing, 1891).

64. Although it is difficult to tell for sure, the death date for Mary's mother appears to have been added in 1864, possibly by Mary, and then the death dates for Mary and her two brothers, all in the 1880s, were added together after her death in 1888 by a different family member. The 1864 date is stitched with a slightly different color thread than the dates from the 1880s, which are stitched in the same color.

65. Like Mary's father, her husband, Benjamin Cornell, worked as a ship carpenter; he later became a

roofer. The couple had six children. Information on the sampler's family descent comes from the curatorial file, Registrar's Office, Winterthur Museum and Country Estate, Delaware; the family information is compiled from U.S. Census Records at www.ancestry.com.

66. The sampler is in a private collection. See M. Finkel and Daughter, *Samplings* 2 (1992): 10 for an illustration.

67. Lovell, *Art*, 132. See also Robert B. St. George, *Conversing by Signs: Poetics of Implication in Colonial New England* (Chapel Hill: University of North Carolina Press, 1998), 298–377.

68. The quilt is currently in the collection of the Kentucky Historical Society, Frankfort, Kentucky.

69. Elizabeth Roseberry was born on June 24, 1799, in Pennsylvania, the daughter of Mathias Roseberry (1772–1851) and Sarah Hughes Roseberry (1779–1858). After she married, Elizabeth moved west with her husband, Shadrach Mitchell, first to Ohio and then to Kentucky, as their family grew. Shadrach was an innkeeper, eventually expanding his holdings as he purchased more land and built a sawmill, a gristmill, and a general store. They had eleven children between 1818 and 1841. Linda Otto Lipsett, *Elizabeth Roseberry Mitchell's Graveyard Quilt: An American Pioneer Saga* (Dayton, OH: Halstead and Meadows Publishing, 1995), 14, 75–96.

70. Images of the quilt have been published numerous times since it was donated to the Kentucky Historical Society in 1959. See Ricky Clark, "Fragile Families: Quilts as Kinship Bonds," *Quilt Digest* 5 (1987): 11–12; Dennis Duke and Deborah Harding, eds., *America's Glorious Quilts* (New York: Hugh Lauter Levin Associates, 1987), 74; Kentucky Quilt Project, *Kentucky Quilts, 1800–1900* (Louisville, KY: Time Capsules, 1982), plate 42; Roderick Kiracofe, *The American Quilt: A History of Cloth and Comfort, 1750–1950* (New York: Clarkson Potter Publishers, 1993), 170; and Carleton L. Safford and Robert Bishop, *America's Quilts and Coverlets* (New York: Weathervane Books, 1974), 100. Some of these sources date the quilt to 1839. This may be based on information that the donor gave to the society when she donated the quilt. At that time, she explained that the quilt was begun as a memorial for Elizabeth's two sons shortly after the donor's father's birth in 1838. However, the second son did not die until January 1843, suggesting that the quilt was started later that year. Adding to the confusion is a second quilt top made by the same maker, which was begun after the first son's death in 1836. According to family tradition, Elizabeth became dissatisfied with this first piece, which had design flaws and did not include the entire family. It became known as a "practice piece" and "pattern" for the second quilt and was never quilted or finished. See Lipsett, *Mitchell's Graveyard Quilt*, 14–15. The second quilt is now in the collection of the Kentucky Highlands Museum, Ashland, Kentucky.

71. Lipsett, *Mitchell's Graveyard Quilt*, 96.

72. The quilt is now in the collection of the Wethersfield Historical Society, Wethersfield, Connecticut. It is illustrated in *Quilts and Quiltmakers: Covering Connecticut* (Atglen, PA: Schiffer Publishing, 2002), 58–59. Unfortunately, the precise maker of this quilt is unknown. It is signed with the initials "CWS," for Cynthia Wells Standish, but this may have been mother Cynthia (1799–1885), who was fifty-six in 1855, or her daughter, Cynthia (1829–1888), who never married and was twenty-six in 1855.

73. *Quilts and Quiltmakers*, 58.

74. Lipsett, *Mitchell's Graveyard Quilt*, 18. Lipsett cites an 1810 diary entry by Mrs. John Test near Brookville, Indiana, that describes a hotel that "contained four large feather beds, made up with nice quilts, but something in the form of graves." Lipsett suggests that Mitchell was aware of this Appalachian tradition, but Lipsett does not provide any direct evidence aside from this diary entry and an oblique reference to the memories of "old-timers" in the area where Mitchell made the quilt. Lipsett, *Mitchell's Graveyard Quilt*, 18.

75. The gate resembles that of the Pioneer Cemetery in Woodsfield, Ohio, where Matthias was buried in 1843. Elizabeth's son John, who died in 1836, may also have been buried in this cemetery. Lipsett, *Mitchell's Graveyard Quilt*, 108.

76. Clark, "Fragile Families," 12.

77. Lipsett, *Mitchell's Graveyard Quilt*, 143.

78. Lipsett, *Mitchell's Graveyard Quilt*, 146.

79. Lipsett, *Mitchell's Graveyard Quilt*, 13, 144, 146, 178, 194–195, 202, 207–208, 214.

Conclusion: A Stitch in Time

1. The quilt is now in the collection of the Buffalo History Museum, Buffalo, New York.

2. Lynn T. Hoffman, *Patterns in Time: Quilts of Western New York* (Buffalo, NY: Buffalo and Erie County Historical Society, 1990), 23. Quilt historian Ricky Clark points out that newspapers of the time used similar hands to draw readers' attention to items of particular interest. Pinholes in the hand fabric suggest that it has been moved and may have had an educational purpose with the flexibility to point to sayings or signers as appropriate. Ricky Clark, ed., *Quilts in Community: Ohio's Traditions* (Nashville: Rutledge Hill Press, 1991), 142.

3. *The Ladies' Hand-Book of Knitting, Netting, and Crochet* (New York: J. Redfield, 1844), 56.

4. Clark, *Quilts in Community,* 142.

5. Clark, *Quilts in Community,* 142.

6. Eulogy delivered February 22, 1800, by Hon. Jeremiah Smith for the New York State Society of the Cincinnati. See *Eulogies and Orations on the Life and Death of General George Washington, First President of the United States of America* (Boston: printed by Manning and Loring, 1800), 168.

7. Samuel J. Smith, "New England Primer," http://digitalcommons.liberty.edu/educ_fac_pubs/100.

8. Quoted in Clark, *Quilts in Community,* 143. Details about this quilt, such as the style and pattern, are unknown.

9. Newspaper account quoted in *11th Annual Report of the Board of Agriculture of the State of Ohio: To the Governor, for the Year 1856* (Columbus, OH: Richard Nevins, 1857), 163. The quilt was sold in 1856 to Dr. Charles Lewis Stockton (1816–1874), a descendant of Richard Stockton (1730–1781), who signed the Declaration of Independence and whose name appears on the quilt. Dr. Stockton's grandson and granddaughter-in-law donated the quilt to the Buffalo and Erie County Historical Society in 1924. Hoffman, *Patterns In Time,* 22–23.

10. *11th Annual Report,* 121. Warner's quilt seems to have offered inspiration to other local quilt makers. A quilt known as the *Garden of Eden* quilt and attributed to Olive Batchelor Wells (1822–1873) of Painesville, Ohio, shows strong similarities to Warner's quilt. Wells's quilt was also exhibited at the 1856 Lake County Fair. Like Warner's quilt, it shows the techniques of stuffing and ruching; it employs the same type of embroidered labels; it has the same typeface for the embroidery; and it has the same type of hand pointing to text on the quilt. In addition to the fact that both women showed their work at the local agricultural fair, they seem to have had a personal relationship. According to the 1860 U.S. Census, Rhoda Warner lived with a relative of Olive Wells's husband. See Clark, *Quilts in Community,* 143. The Wells quilt is now in the collection of the Spencer Museum of Art at the University of Kansas, Lawrence.

11. "Key Events in the Presidency of Franklin Pierce," http://millercenter.org/academic/americanpresident/keyevents/pierce.

12. "Franklin Pierce," http://millercenter.org/academic/americanpresident/pierce/essays/biography.

13. I have been unable to track down any pre-1855 sources for this verse.

14. *Journals of the Continental Congress,* vol. 1, September 1774, http://memory.loc.gov. See also "The Gallery of a Misanthrope," *American Monthly Magazine* 5 (1835): 338, which includes the sentence, "'Twas for Liberty our fathers fought, and bled, and died."

15. Michael Kammen, *A Season of Youth: The American Revolution and the Historical Imagination* (Ithaca, NY: Cornell University Press, 1988), 46, 49. Charles Carroll (1737–1832) of Maryland was the last surviving signer of the Declaration of Independence. He died in Baltimore on November 14, 1832. See http://bioguide.congress.gov/scripts/biodisplay.pl?index=C000185. The news of Carroll's death appeared in the Columbus, Ohio, newspaper, the *Ohio State Journal,* on December 1, 1832. Presumably, it also appeared in other Ohio newspapers around the same time.

16. Kammen, *Season of Youth,* 55–58; Pauline Maier, *American Scripture: Making the Declaration of Independence* (New York: Alfred A. Knopf, 1997), 175–180, 189–201.

17. Sherry Turkle, ed., *Evocative Objects: Things We Think With* (Cambridge, MA: MIT Press, 2007), 5.

18. Turkle, *Evocative Objects,* 6.

19. Eliza Leslie, *The Behaviour Book: A Manual for Ladies* (Philadelphia: Willis P. Hazard, 1854), 336.

BIBLIOGRAPHY

꙰ ꙰

Unpublished Primary Sources

Anonymous Woman, Montague, Massachusetts. Diary. Old Sturbridge Village Research Library, Sturbridge, MA.

Clapp Family Letters. American Antiquarian Society, Worcester, MA.

Cleveland, Lucy. Papers. Phillips Library, Peabody Essex Museum, Salem, MA.

Dorr, Elizabeth. Diaries. Massachusetts Historical Society, Boston.

Flint, Catherine Dean. Diary. Flint Family Papers. American Antiquarian Society, Worcester, MA.

Leonard Family Papers. Old Sturbridge Village Research Library, Sturbridge, MA.

Salisbury, Elizabeth Tuckerman. Diary. Salisbury Family Papers. American Antiquarian Society, Worcester, MA.

Slater, Esther. S Miscellaneous Manuscripts (Mss 9001). Rhode Island Historical Society, Providence.

Upham, Mary Avery. Diaries. Massachusetts Historical Society, Boston.

Published Primary Sources

Alcott, William. *The Young Woman's Book of Health*. Boston: Tappan, Whittemore and Mason, 1850.

Alden, Joseph. *The Aged Pilgrim*. Boston: Massachusetts Sabbath School Society, 1846.

Allen, Elizabeth Waterhouse, ed. *Memorial of Joseph and Lucy Clark Allen*. Boston: G. H. Ellis, 1891.

The American Ladies' Memorial. Boston, 1850.

Ames, Blanche Butler, comp. *Chronicles from the Nineteenth Century: Family Letters of Blanche Butler and Adelbert Ames, Married July 21st, 1870*. Vol. 1. Clinton, MA: privately printed, 1957.

Armstrong, Robert G. *Memoir of Hannah Hobbie; or, Christian Activity, and Triumph in Suffering*. New York: American Tract Society, 1837.

The Art of Good Behaviour. New York: C. P. Huestis, 1848.

Ayer, Sarah Connell. *Diary of Sarah Connell Ayer*. Portland, ME: Lefavor-Tower, 1910.

Barber, John Warner. *Historical Collections . . . of Every Town in Massachusetts*. Worcester, MA: Dorr, Howland, 1840.

Bard, Samuel. *A Compendium of the Theory and Practice of Midwifery*. New York: Collins, 1819.

Barker, Mrs. Herbert A., and Miss Helen S. Whitney, eds. *Boylston Congregational Church Home Department Cook Book*. Jamaica Plain, MA: J. Allen Crosby, 1906.

Bates, Samuel P. *A Biographical History of Greene County, Pennsylvania*. Chicago: Nelson, Rishforth, 1888. Reprint, Baltimore: Genealogical Pub., 1975.

Bedford, Gunning. *Lecture Introductory to a Course on Obstetrics and Diseases of Women and Children*. New York: Jennings, 1847.

Beecher, Catharine E. *A Treatise on Domestic Economy*. Boston: Marsh, Capen, Lyon and Webb, 1841.

Beecher, Catharine E., and Harriet Beecher Stowe. *The American Woman's Home; or, Principles of Domestic Science*. New York: J. B. Ford, 1869.

Benberry, Cuesta Ray, and Carol Pinney Crabb, comps. *A Patchwork of Pieces: An Anthology of Early Quilt Stories, 1845–1940*. Paducah, KY: American Quilter's Society, 1993.

Bethune, George Washington, comp. *Memoirs of Mrs. Joanna Bethune*. New York: Harper and Brothers, 1863.

Blanchard, Frances Bradshaw, ed. *Letters of Ann Gillam Storrow to Jared Sparks*. Northampton, MA: Smith

College, Department of Government and History, 1921.

Bloomer, D. C. *Life and Writings of Amelia Bloomer.* New York: Schocken Books, 1975.

Botta, Vincenzo, ed. *Memoirs of Anne C. L. Botta Written by Her Friends: With Selections from Her Correspondence and from Her Writings in Prose and Poetry.* New York: J. Selwin Tait and Sons, 1893.

Brady, Patricia. *George Washington's Beautiful Nelly: The Letters of Eleanor Parke Custis Lewis to Elizabeth Bordley Gibson, 1794–1851.* Columbia: University of South Carolina Press, 1991.

Brevitt, Joseph. *The Female Medical Repository.* Baltimore: Hunter and Robinson, 1810.

Buchan, William. *Domestic Medicine Adapted to the Climate and Diseases of America.* Philadelphia: R. Folwell, 1801.

Bushnell, Horace. *Work and Play.* New York: Charles Scribner's Sons, 1881.

Butler, Charles. *The American Lady.* Philadelphia: Hogan and Thompson, 1839.

Carpenter, William. *Principles of Human Physiology.* Philadelphia: Lea and Blanchard, 1850.

Cary, Virginia. *Letters on Female Character, Addressed to a Young Lady on the Death of Her Mother.* Richmond, VA: Ariel Works, 1830.

Celnart, Mme. *The Gentleman and Lady's Book of Politeness.* Boston: Allen and Ticknor, 1833.

Chadwick, John White, ed. *A Life for Liberty: Anti-slavery and Other Letters of Sallie Holley.* New York: G. P. Putnam's Sons, 1899.

Child, Lydia Maria. *The American Frugal Housewife.* 1844. Reprint, Mineola, NY: Dover Publications, 1999.

———. *The Family Nurse.* Boston: Charles J. Hendee, 1837.

———. *The Girls' Own Book.* New York: Clark Austin, 1833.

———. *Looking Toward Sunset.* Boston: Ticknor and Fields, 1867.

The Child's Picture Gallery. Boston: Otis, Broaders, 1842.

Cicero, Marcus Tullius, and Andrew P. Peabody. *Cicero De Amicitia, To Which Is Added Scipio's Dream and Cicero De Senectute.* Boston: Little, Brown, 1884.

Clark, Allen C. *Life and Letters of Dolly Madison.* Washington, DC: Press of W. R. Roberts, 1914.

Clark, J. Henry. *Sight and Hearing, How Preserved, and How Lost.* New York: C. Scribner, 1856.

Clark, Joseph S. *An Historical Sketch of Sturbridge, Mass., from Its Settlement to the Present Time.* Brookfield, MA: E. and L. Merriam, 1838.

Coale, William-Edward. *Hints on Health.* Boston: Phillips, Sampson, 1852.

Coffin, Albert Isaiah. *A Treatise on Midwifery.* London: W. B. Ford, 1849.

Cooper, Susan Fenimore. *Journal of a Naturalist in the United States.* London: Richard Bentley and Son, 1855.

Crane, Elaine Forman, ed. *The Diary of Elizabeth Drinker: The Life Cycle of an Eighteenth-Century Woman.* Boston: Northeastern University Press, 1994.

Curtis, John Harrison. *Observations on the Preservation of Sight.* Worcester, MA: C. Harris, 1839.

Cutter, Calvin. *The Female Guide.* West Brookfield, MA: Charles A. Mirick, 1844.

Davis, George. *A Historical Sketch of Sturbridge and Southbridge.* West Brookfield, MA: Power Press of O. S. Cooke, 1856.

Dewees, William P. *A Treatise on the Diseases of Females.* Philadelphia: H. C. Carey and J. Lea, 1826.

Dewey, Mary E., ed. *Life and Letters of Catharine M. Sedgwick.* New York: Harper and Row, 1871.

DeWitt, Francis. *Statistical Information Relating to Certain Branches of Industry in Massachusetts.* Boston: William White, 1856.

Dixon, Edward H. *Woman and Her Diseases.* New York: Charles H. Ring, 1846.

Dow, George Francis. *The Holyoke Diaries, 1709–1865.* Salem, MA: Essex Institute, 1911.

Drury, Clifford M. *Elkanah and Mary Walker: Pioneers among the Spokanes.* Caldwell, ID: Caxton Printers, 1940.

11th Annual Report of the Board of Agriculture of the State of Ohio: To the Governor, for the Year 1856. Columbus, OH: Richard Nevins, 1857.

Emerson, Ralph Waldo. *The Complete Works of Ralph Waldo Emerson: Essays.* 2nd series. Boston: Houghton Mifflin, 1903–4.

Emerson, Sarah Hopper, ed. *Life of Abby Hooper Gibbons: Told Chiefly through Her Correspondence.* Vol. 1. New York: G. P. Putnam's Sons, 1897.

Emery, Sarah Anna. *My Generation*. Newburyport, MA: M. H. Sargent, 1893.

———. *Reminiscences of a Nonagenarian*. Newburyport, MA: W. H. Huse, 1879.

Eppes, Susan Bradford. *Through Some Eventful Years*. Macon, GA: Press of the J. W. Burke Co., 1926.

Etiquette for Ladies. Philadelphia: Carey, Lea and Blanchard, 1838.

Etiquette for Ladies. New York: Burgess, Stringer, 1844.

Eulogies and Orations on the Life and Death of General George Washington, First President of the United States of America. Boston: printed by Manning and Loring, 1800.

Extracts from the Memorandums of Jane Bettle, with a Short Memoir Respecting Her. 2nd ed. Philadelphia: J. and W. Kite, 1843.

A Family History in Letters and Documents. St. Paul, MN: privately printed, 1919.

Farnham, Eliza W. *Woman and Her Era*. New York: A. J. Davis, 1864.

Farrar, Eliza. *The Young Lady's Friend*. Boston: American Stationers, 1837.

Fisher, George. *The Instructor; or, American Young Man's Best Companion*. Walpole, NH: Isaiah Thomas and David Carlisle, 1744.

Fisk, Fidelia. *Recollections of Mary Lyon*. Boston: American Tract Society, 1866.

"The Gallery of a Misanthrope." *American Monthly Magazine* 5 (1835): 338.

Gilman, Mrs. Caroline. *Recollections of a Housekeeper*. New York: Harper and Brothers, 1834.

Gordon, Donald. *The Diary of Ellen Birdseye Wheaton*. Boston: privately printed, 1923.

Gove, Mary S. *Lectures to Women on Anatomy and Physiology*. New York: Harper Brothers, 1846.

Guild, Mrs. Anne E. *Grandmother Lee's Portfolio*. Boston: Whittemore, Niles and Hall, 1857.

Hall, A. G. *The Mother's Own Book and Practical Guide to Health*. Rochester, NY: [s.n.], 1843.

Hall, Mrs. E. B. *My Thimbles*. Boston: Crosby, Nichols, 1852.

Hallowell, Anna Davis. *James and Lucretia Mott: Life and Letters*. Boston: Houghton, Mifflin, 1884.

Hamilton, Alexander. *A Treatise on the Management of Female Complaints*. New York: Samuel Campbell, 1792.

Hand, William M. *The House Surgeon*. New Haven, CT: Silas Andrus, 1820.

Hard, M. K. *Woman's Medical Guide*. Mt. Vernon, OH: W. H. Cochran, 1848.

Hartley, Florence. *The Ladies' Book of Etiquette and Manual of Politeness*. Philadelphia: G. G. Evans, 1860.

———. *The Ladies' Hand Book of Fancy and Ornamental Work*. Philadelphia: John E. Potter & Co., 1859.

Hollick, Frederick. *The Diseases of Woman*. New York: T. W. Strong, 1849.

———. *The Marriage Guide; or, Natural History of Generation*. New York: T. W. Strong, circa 1860.

Hopkins, Samuel, ed. *Memoirs of the Life of Mrs. Sarah Osborn (1714–1796)*. Worcester, MA: Leonard Worcester, 1799.

Howe, M. A. DeWolfe, ed. *The Articulate Sisters*. Cambridge, MA: Harvard University Press, 1946.

Hunt, Gaillard. *The First Forty Years of Washington Society in the Family Letters of Margaret Bayard Smith*. New York: Frederick Ungar Publishing, 1906.

Hurd, D. Hamilton, comp. *History of Worcester County, Massachusetts*. Philadelphia: J. W. Lewis, 1889.

The Improved American Family Physician. New York: [s.n.], 1833.

Jones, Alice Johnson. *In Dover on the Charles*. Newport, RI: Milne Printery, 1906.

King, Caroline Howard. *When I Lived in Salem, 1822–1866*. Brattleboro, VT: Stephen Daye Press, 1937.

Kirkland, Caroline M. *The Evening Book; or, Fireside Talk*. New York: Charles Scribner, 1852.

The Ladies' Companion. Worcester, MA: Spy Office, 1824.

The Ladies' Guide in Needlework. Philadelphia: J. and J. L. Gihon, 1850.

The Ladies' Hand-Book of Fancy Needlework and Embroidery. New York: J. S. Redfield, 1844.

The Ladies' Handbook of Knitting, Netting and Crochet. New York: J. Redfield, 1844.

Ladies' Indispensable Assistant. New York: Published at 128 Nassau Street, 1851.

The Ladies' Work-Table Book. New York: J. Winchester, 1844.

The Lady's Work-Box Companion. New York: Burgess, Stringer, 1844.

Lambert, Miss. *The Hand-Book of Needlework*. New York: Wiley and Putnam, 1842.

————. *The Hand-Book of Needlework.* London: John Murray, 1846.

Larcom, Lucy. *A New England Girlhood.* Boston: Northeastern University Press, 1986.

Lathrop, Joseph. *The Infirmities and Comforts of Old Age: A Sermon to Aged People.* Springfield, MA: Henry Brewer, 1805.

————. *Old Age Improved.* Springfield, MA: T. Dickman, 1811.

Leslie, Eliza. *The Behaviour Book.* Philadelphia: Willis P. Hazard, 1854.

Letters of Lydia Maria Child. Boston: Houghton, Mifflin, 1883.

Life and Letters of Miss Mary C. Greenleaf, Missionary to the Chickasaw Indians. Boston: Massachusetts Sabbath School Society, 1858.

Lyman, Arthur T. *Arthur Theodore Lyman and Ella Lyman: Letters and Journals.* Vol. 1. Menasha, WI: George Banta Publishing, 1932.

MacDonald, Edgar E. *The Education of the Heart: The Correspondence of Rachel Mordecai Lazarus and Maria Edgeworth.* Chapel Hill: University of North Carolina Press, 1977.

Marcus, Jacob R., comp. *The American Jewish Woman: A Documentary History.* New York: Ktav Publishing House, 1981.

Mariotti, Eva. *The Diary of Mary Poor of Indian Hill Farm.* Boston: Warren F. Kellogg, 1895.

Marlatt, Helen Stuart Mackay-Smith. *Stuart Letters of Robert and Elizabeth Sullivan Stuart and Their Children, 1819–1864.* New York: privately printed, 1961.

Marvin, Abijah P. *History of Worcester County, Massachusetts.* Boston: C. F. Jewett, 1879.

Mauriceau, A. M. *The Married Woman's Private Medical Companion.* New York: [s.n.], 1847.

Memorial of Sarah Pugh: A Tribute of Respect from Her Cousins. Philadelphia: J. B. Lippincott, 1888.

Morrill, Charles. *The Physiology of Woman.* Boston: Bela Marsh, 1848.

Morse, Frances Rollins, ed. *Henry and Mary Lee: Letters and Journals . . . 1802–1860.* Boston: Thomas Todd, 1926.

Myers, Robert M., ed. *The Children of Pride: A True Story of Georgia and the Civil War.* New Haven, CT: Yale University Press, 1972.

Paine, Harriet E. *Old People.* Boston: Houghton Mifflin, 1910.

Pancoast, Samuel. *The Ladies' Medical Guide.* Philadelphia: John E. Potter, ca. 1859.

Parkes, Mrs. William. *Domestic Duties; or, Instructions to Young Married Ladies.* New York: J and J Harper, 1829.

Philipson, David. *Letters of Rebecca Gratz.* Philadelphia: Jewish Publication Society of America, 1929.

Pinckney, James D. *Reminiscences of Catskill.* Catskill, NY: J. B. Hall, 1868.

Porter, Dr. *Book of Men, Women and Babies.* New York: DeWitt and Davenport, 1855.

Pullan, Mrs. *The Lady's Manual of Fancy-Work.* New York: Dick and Fitzgerald, 1858.

Ralph, Joseph. *A Domestic Guide to Medicine.* New York, 1835.

Records of a California Family: Journals and Letters of Lewis C. Gunn and Elizabeth Le Breton Gunn. San Diego: privately printed, 1928.

Roget, Peter Mark, M.D. *Animal and Vegetable Physiology Considered with Reference to Natural Theology.* London: William Pickering, 1834.

Rollins, Mrs. Ellen Chapman. *New England Bygones.* Philadelphia: J. B. Lippincott, 1883.

Root, Grace Cogswell, ed. *Father and Daughter: A Collection of Cogswell Family Letters and Diaries.* West Hartford, CT: American School for the Deaf, 1924.

Rowe, George Robert. *On Some of the Most Important Disorders of Women.* London: John Churchill, 1844.

The Seamstress. New York: J. S. Redfield, 1848.

See, John. *A Guide to Mother and Nurses.* New York: Printed for the author, 1833.

Sherwood, Mrs. *The Red Book and Mary Anne.* New York: Peter Hill, 1833.

————. *The Rose Buds.* New York: T. Mason and G. Lane, 1837.

————. *What Could I Do without Grandmother.* Providence, RI: Weeden and Peek, [1848–1850].

Sigourney, Lydia H. *Letters to Mothers.* Hartford: Hudson and Skinner, 1838.

————. *Past Meridian.* Hartford, CT: F. A. Brown, 1856.

Skinner, H. B. *The Female Medical Guide and Married Woman's Advisor.* Boston: Skinner's Publication Rooms, 1849.

Smart, Donna Toland, ed. *Mormon Midwife: The 1846–1888 Diaries of Patty Bartlett Sessions.* Logan: Utah State University Press, 1997.

Smith, Ethan, ed. *Memoirs of Mrs. Abigail Bailey (1746–1815).* New York: Arno Press, 1980.

Smith, Seba, ed. *The Rover: Weekly Magazine of Tales, Poetry, and Engravings.* New York: S. B. Dean, 1844.

The Soul's Welfare: A Magazine for the People. London: Houlston and Stoneman, 1851.

Stanford, John. *The Aged Christian's Companion.* New York: Stanford and Swords, 1849.

Stanton, Theodore, and Harriot Stanton Blatch, eds. *Elizabeth Cady Stanton, as Revealed in Her Letters, Diary, and Remembrances.* Vol. 1. New York: Harper and Row, 1922.

Stephens, Mrs. Ann S. *The Ladies' Complete Guide to Crochet, Fancy Knitting and Needlework.* New York: Garrett, 1854.

Sturtevant, Sarah Maria. *Winter Scenes in the Denham Family.* Bangor, ME: D. Bugbee, 1847.

13th Annual Report of the Ohio State Board of Agriculture . . . for the Year 1858. Columbus, OH: Richard Nevins, 1859.

Through Some Eventful Years. Macon, GA: Press of the J. W. Burke Co., 1926.

Ticknor, Caleb. *Philosophy of Living.* New York: Harper and Brothers, 1836.

Tilt, E. J. *On the Preservation of the Health of Women at the Critical Periods of Life.* New York: John Wiley, 1851.

Tolman, George. *Concord, Massachusetts: Births, Marriages and Deaths, 1635–1850.* Boston: T. Todd, printer, 1895.

Transactions of the Nantucket Agricultural Society for 1856. New York: Nantucket Agricultural Society, 1857.

True Politeness: A Hand-Book of Etiquette for Ladies. New York: Leavitt and Allen, 1853.

Tupper, Frederick, and Helen Tyler Brown, eds. *Grandmother Tyler's Book: The Recollections of Mary Palmer Tyler.* New York: G. P. Putnam's Sons, 1925.

12th Annual Report of the Ohio State Board of Agriculture . . . for the Year 1857. Columbus, OH: Richard Nevins, 1858.

Village Life in America, 1852–1872, Including the Period of the American Civil War as Told in the Diary of a School-Girl. New York: Henry Holt, 1913.

Vital Records of Sturbridge, Massachusetts, to the Year 1850. Boston: New England Historic Genealogical Society, 1906.

Voices of the True-Hearted. Philadelphia: Merrihew and Thompson, 1846.

Willard, Emma Hart. *Journal and Letters from France and Great Britain.* Troy, NY: N. Tuttle, 1833.

Wilson, W. Emerson. *Phoebe George Bradford Diaries.* Wilmington: Historical Society of Delaware, 1975.

Wisner, Benjamin Blydenburg. *Memoirs of the Late Mrs. Susan Huntington.* Boston: Crocker and Brewster, 1826.

Wood, Lindsay Lomax. *Leaves from an Old Washington Diary.* New York: Books, Inc., 1943.

The Workwoman's Guide. London: Simpkin, Marshall, 1838.

The Young Lady's Friend. Boston: American Stationers', 1837.

The Young Lady's Own Book. Philadelphia: Thomas, Cowperthwait, 1838.

The Youth's Sketch Book. Boston: Benjamin B. Mussey, 1849.

Secondary Sources

Achenbaum, W. Andrew. "Further Perspectives on Modernization and Aging: A (P)review of the Historical Literature." *Social Science History* 6 (Summer 1982): 347–368.

———. *Old Age in the New Land: The American Experience since 1790.* Baltimore: Johns Hopkins University Press, 1978.

Adamson, Jeremy. *Calico and Chintz: Antique Quilts from the Collection of Patricia S. Smith.* Washington, DC: Renwick Gallery, 1997.

Allen, Gloria Seaman. *Family Record: Genealogical Watercolors and Needlework.* Washington, DC: DAR Museum, 1989.

———. *First Flowerings: Early Virginia Quilts.* Washington, DC: DAR Museum, 1987.

———. *A Maryland Sampling: Girlhood Embroidery, 1738–1860.* Baltimore: Maryland Historical Society, 2008.

———. *Old Line Traditions: Maryland Women and Their Quilts.* Washington, DC: DAR Museum, 1985.

Allen, Gloria Seaman, and Nancy Gibson Tuckhorn. *A Maryland Album: Quiltmaking Traditions, 1634–1934.* Nashville: Rutledge Hill Press, 1995.

Ames, Kenneth L. *Death in the Dining Room and Other Tales of Victorian Culture.* Philadelphia: Temple University Press, 1992.

———. "Ideologies in Stone: Meanings in Victorian Gravestones." *Journal of Popular Culture* 14 (1981): 641–56.

Appadurai, Arjun, ed. *The Social Life of Things: Commodities in Cultural Perspective.* New York: Cambridge University Press, 1986.

Appleby, Joyce. *Inheriting the Revolution: The First Generation of Americans.* Cambridge, MA: Belknap Press, 2000.

Arch, Stephen Carl. *After Franklin: The Emergence of Autobiography in Post-Revolutionary America, 1780–1830.* Hanover: University of New Hampshire, 2001.

Atkins, Jacqueline M. "From Lap to Loom: Marseilles Quilts, Marseilles-Style Spreads, and Their White Work Offspring." *Proceedings of the Textile History Forum* (2000): 13–26.

———. *Shared Threads: Quilting Together Past and Present.* New York: Viking Studio Books, 1994.

Atkins, Jacqueline M., and Phyllis A. Tepper. *New York Beauties: Quilts from the Empire State.* New York: Dutton Studio Books, 1992.

Ayers, Edward L., Patricia Nelson Limerick, Stephen Nissenbaum, and Peter S. Onuf. *All Over the Map: Rethinking American Regions.* Baltimore: Johns Hopkins University Press, 1996.

Banner, Lois W. *American Beauty.* Chicago: University of Chicago Press, 1983.

———. *In Full Flower: Aging Women, Power and Sexuality.* New York: Vintage Books, 1993.

Barnhill, Georgia Brady. "'Keep Sacred the Memory of Your Ancestors': Family Registers and Memorial Prints." In *The Art of Family: Genealogical Artifacts in New England,* edited by D. Brenton Simons and Peter Benes, 60–74. Boston: New England Historic Genealogical Society, 2002.

Basch, Norma. *In the Eyes of the Law: Women, Marriage and Property in Nineteenth-Century New York.* Ithaca, NY: Cornell University Press, 1982.

Bassett, Lynne Z., ed. *Massachusetts Quilts: Our Common Wealth.* Hanover, NH: University Press of New England, 2009.

———. *Telltale Textiles: Quilts from the Historic Deerfield Collection.* Deerfield, MA: Historic Deerfield, 2005.

———. "Virtuous Habits of Perseverance: Quilting and the Education of Girls in Nineteenth-Century America." *Piecework Magazine* 7 (March/April 1999): 46–49.

———, ed. *What's New England about New England Quilts?* Sturbridge, MA: Old Sturbridge Village, 1999.

———. "Woven Bead Chains of the 1830s." *The Magazine Antiques* 148 (December 1995): 798–807.

Bassett, Lynne Z., and Jack Larkin. *Northern Comfort: New England's Early Quilts, 1780–1850.* Nashville: Rutledge Hill Press, 1998.

Baym, Nina. *Woman's Fiction: A Guide to Novels by and about Women in America, 1820–70.* Urbana: University of Illinois Press, 1993.

———. "Women and the Republic: Emma Willard's Rhetoric of History." *American Quarterly* 43 (March 1991): 1–23.

Beaudry, Mary C. *Findings: The Material Culture of Needlework and Sewing.* New Haven, CT: Yale University Press, 2006.

Belknap, Henry Wycoff. "Joseph True, Wood Carver of Salem, and His Account Book." *Essex Institute Historical Collections* 78 (1942): 116–157.

Benes, Peter. "Decorated New England Family Registers." In *The Art of Family: Genealogical Artifacts in New England,* edited by D. Brenton Simons and Peter Benes, 13–59. Boston: New England Historic Genealogical Society, 2002.

———, ed. *Textiles in Early New England: Design, Production, and Consumption.* Boston: Boston University, 1999.

———, ed. *Textiles in New England II: Four Centuries of Material Life.* Boston: Boston University, 2001.

Bennett, Eileen. *The Evolution of Samplers—Embroidery and Sampler Time Line—A 400 Year History of Sampler Making.* Jenison, MI: Sampler House, 2001.

Bercaw, Nancy Dunlap. "Solid Objects/Mutable Meanings: Fancywork and the Construction of Bourgeois Culture, 1840–1880." *Winterthur Portfolio* 26 (1991): 231–248.

Berkin, Carol. *First Generations: Women in Colonial America.* New York: Hill and Wang, 1996.

———. *Revolutionary Mothers: Women in the Struggle for America's Independence.* New York: Alfred A. Knopf, 2005.

Berlo, Janet Catherine, and Patricia Cox Crews. *Wild by Design: Two Hundred Years of Innovation and Artistry in American Quilts.* Lincoln, NE: International Quilt Study Center, 2003.

Biographical, Genealogical and Descriptive History of the First Congressional District of New Jersey. New York: Lewis Publishing, 1900.

Bishop, Robert. *New Discoveries in American Quilts.* New York: E. P. Dutton, 1975.

Blecki, Catherine La Courreye, and Karin A. Wulf, eds. *Milcah Martha Moore's Book: A Commonplace Book from Revolutionary America.* University Park: Pennsylvania State University Press, 1997.

Bloch, Ruth H. "American Feminine Ideals in Transition: The Rise of the Moral Mother, 1785–1815." *Feminist Studies* 4 (June 1978): 100–126.

———. "Inside and Outside the Public Sphere." *William and Mary Quarterly* 62 (January 2005): 99–106.

Boardman, Michelle. "Picturing the Past: Studying Clothing through Portraits." Unpublished research paper. Old Sturbridge Village, Sturbridge, MA, 1990.

Boardman, Susan R., and Aimee E. Newell. "Nantucket Needlework: Samplers from Quaker Schools." *Fine Lines* 7 (Fall 2002): 7–9.

Bodnar, John. "Generational Memory in an American Town." *Journal of Interdisciplinary History* 26 (Spring 1996): 619–637.

Bolton, Ethel Stanwood, and Eva Johnston Coe. *American Samplers.* 1921; reprint, New York: Dover Publications, 1987.

Bonfield, Lynn A. "Diaries of New England Quilters before 1860." *Uncoverings* 9 (1988): 171–197.

———. "The Production of Cloth, Clothing and Quilts in 19th Century New England Homes." *Uncoverings* 2 (1981): 77–96.

Bonfield, Lynn A., and Mary C. Morrison. *Roxana's Children: The Biography of a Nineteenth-Century Vermont Family.* Amherst: University of Massachusetts Press, 1995.

Borish, Linda J. "'A Fair, Without *the* Fair, is no Fair At All': Women at the New England Agricultural Fair in the Mid-Nineteenth Century." *Journal of Sport History* 24 (1997): 155–176.

Bowman, Doris M. *American Quilts: The Smithsonian Treasury.* Washington, DC: Smithsonian Institution Press, 1991.

Boydston, Jeanne. "Gender as a Question of Historical Analysis." *Gender and History* 20 (November 2008): 558–583.

———. *Home and Work: Housework, Wages and the Ideology of Labor in the Early Republic.* New York: Oxford University Press, 1990.

Boylan, Anne M. *The Origins of Women's Activism: New York and Boston, 1797–1840.* Chapel Hill: University of North Carolina Press, 2002.

———. "Timid Girls, Venerable Widows and Dignified Matrons: Life Cycle Patterns among Organized Women in New York and Boston, 1797–1840." *American Quarterly* 38 (Winter 1986): 779–797.

Brackman, Barbara. *Clues in the Calico: A Guide to Identifying and Dating Antique Quilts.* McLean, VA: EPM Publications, 1989.

———. *Encyclopedia of Applique: An Illustrated, Numerical Index to Traditional and Modern Patterns.* McLean, VA: EPM Publications, 1993.

———. *Encyclopedia of Pieced Quilt Patterns.* Paducah, KY: American Quilter's Society, 1993.

———. "Fairs and Expositions: Their Influence on American Quilts." In *Bits and Pieces: Textile Traditions,* edited by Jeannette Lasansky, 90–99. Lewisburg, PA: Oral Traditions Project, 1991.

———. *Patterns of Progress: Quilts in the Machine Age.* Los Angeles: Autry Museum of Western Heritage, 1997.

———. "Signature Quilts: Nineteenth-Century Trends." *Uncoverings* 10 (1989): 25–37.

Bresenhan, Karoline Patterson, and Nancy O'Bryant Puentes. *Lone Stars: A Legacy of Texas Quilts, 1836–1936.* Austin: University of Texas Press, 1986.

Brown, Gillian. *Domestic Individualism: Imagining Self in Nineteenth-Century America.* Berkeley: University of California Press, 1990.

Brown, Kathleen M. *Good Wives, Nasty Wenches, and Anxious Patriarchs: Gender, Race and Power in Colonial*

Virginia. Chapel Hill: University of North Carolina Press, 1996.

Bruner, Jerome. "Life as Narrative." *Social Research* 71 (Fall 2004): 691–710.

Buckler, Patricia P., and C. Kay Leeper. "An Antebellum Woman's Scrapbook as Autobiographical Composition." *Journal of American Culture* 14 (1991): 1–8.

Bullard, Lacy Folmar, and Betty Jo Schiell. *Chintz Quilts: Unfading Glory.* Tallahassee, FL: Serendipity Publishers, 1983.

Burdick, Nancilu. *Legacy: The Story of Talula Gilbert Bottoms and Her Quilts.* Nashville: Rutledge Hill Press, 1988.

Burgess-Olson, Vicky. *Sister Saints.* Provo, UT: Brigham Young University Press, 1978.

Burman, Barbara, ed. *The Culture of Sewing: Gender, Consumption and Home Dressmaking.* Oxford, UK: Berg, 1999.

Burstein, Andrew. *America's Jubilee: How in 1826 a Generation Remembered Fifty Years of Independence.* New York: Alfred A. Knopf, 2001.

Burstyn, Joan N. "Catharine Beecher and the Education of American Women." *New England Quarterly* 47 (September 1974): 386–403.

Bushman, Richard L. *The Refinement of America: Persons, Houses, Cities.* New York: Vintage Books, 1992.

Butler, Robert N. "The Life Review: An Interpretation of Reminiscence in the Aged." *Psychiatry* 26 (February 1963): 65–76.

Carlisle, Elizabeth Pendergast. *Earthbound and Heavenbent: Elizabeth Porter Phelps and Life at Forty Acres, 1747–1817.* New York: Scribner, 2004.

Carrier, James. "Gifts, Commodities, and Social Relations: A Maussian View of Exchange." *Sociological Forum* 6 (1991): 119–136.

———. "Gifts in a World of Commodities: The Ideology of the Perfect Gift in American Society." *Social Analysis* 29 (1990): 19–37.

Carson, Cary. "Doing History with Material Culture." In *Material Culture and the Study of American Life,* edited by Ian M. G. Quimby, 41–64. New York: W. W. Norton, 1978.

Carvalho, David N. *Forty Centuries of Ink.* New York: Burt Franklin, 1971.

Carvalho, Joseph, III. "Rural Medical Practice in Early 19th Century New England." *Historical Journal of Western Massachusetts* 4 (Spring 1975): 1–15.

Cawley, Lucinda Reddington, Lorraine DeAngelis Ezbiansky, and Denise Rocheleau Nordberg. *Saved for the People of Pennsylvania: Quilts from the State Museum of Pennsylvania.* Harrisburg: Pennsylvania Historical and Museum Commission, 1997.

Cerny, Catherine A. "Quilt Ownership and Sentimental Attachments: The Structure of Memory." *Uncoverings* 18 (1997): 95–119.

Chace, Elizabeth Buffum. *Two Quaker Sisters.* New York: Liveright Publishing, 1987.

Chambers-Schiller, Lee Virginia. *Liberty, a Better Husband: Single Women in America, the Generations of 1780–1840.* New Haven, CT: Yale University Press, 1984.

Chautauqua County Historical Society, New York. "The Unfinished Story of the Twin Quilts." *County History Newsletter* (February 1992): 1–2.

Cheal, David. *The Gift Economy.* London: Routledge, 1988.

———. "Intergenerational Family Transfers." *Journal of Marriage and the Family* 45 (November 1983): 805–813.

———. "The Ritualization of Family Ties." *American Behavioral Scientist* 31 (July / August 1988): 632–643.

———. "'Showing Them You Love Them': Gift Giving and the Dialectic of Intimacy." In *The Gift: An Interdisciplinary Perspective,* edited by Aafke E. Komter, 95–106. Amsterdam: Amsterdam University Press, 1996.

———. "The Social Dimensions of Gift Behaviour." *Journal of Social and Personal Relationships* 3 (1986): 423–439.

Chodorow, Nancy. *The Reproduction of Mothering: Psychoanalysis and the Sociology of Gender.* Berkeley: University of California Press, 1978.

Christie's. *Important American Furniture, Folk Art, Silver and Prints Including Property from the Garbisch Collection from the Sky Club.* New York: Christie's, 2006.

Chudacoff, Howard P. *How Old Are You? Age Consciousness in American Culture.* Princeton: Princeton University Press, 1989.

Chudacoff, Howard P., and Tamara K. Hareven. "From the Empty Nest to Family Dissolution: Life Course

Transitions into Old Age." *Journal of Family History* 4 (Spring 1979): 69–83.

Clark, Christopher. *The Roots of Rural Capitalism: Western Massachusetts, 1780–1860.* Ithaca, NY: Cornell University Press, 1994.

Clark, Ricky. "Fragile Families: Quilts as Kinship Bonds." *Quilt Digest* 5 (1987): 5–19.

———. "Mid-Nineteenth Century Album and Friendship Quilts, 1860–1920." In *Pieced by Mother: Symposium Papers,* ed. Jeannette Lasansky, 77–85. Lewisburg, PA: Oral Traditions Project, 1988.

———. "Quilt Documentation: A Case Study." In *Making the American Home: Middle-Class Women and Domestic Material Culture, 1840–1940,* edited by Marilyn Ferris Motz and Pat Browne, 158–192. Bowling Green, OH: Bowling Green State University Popular Press, 1988.

———. *Quilted Gardens: Floral Quilts of the Nineteenth Century.* Nashville: Rutledge Hill Press, 1994.

———, ed. *Quilts in Community: Ohio's Traditions.* Nashville: Rutledge Hill Press, 1991.

Cleveland, Richard L., and Donna Bister. *Plain and Fancy: Vermont's People and Their Quilts as a Reflection of America.* San Francisco: Quilt Digest Press, 1991.

Clunie, Margaret Burke. "Joseph True and the Piecework System in Salem." *The Magazine Antiques* III (May 1977): 1006–1013.

Cole, Thomas R. *The Journey of Life: A Cultural History of Aging in America.* Cambridge: Cambridge University Press, 1992.

Conforti, Joseph. *Imagining New England: Explorations of Regional Identity from the Pilgrims to the Mid-20th Century.* Chapel Hill: University of North Carolina Press, 2001.

Cooper, Grace Rogers. *The Copp Family Textiles.* Washington, DC: Smithsonian Institution Press, 1971.

———. *The Invention of the Sewing Machine.* Washington, DC: Smithsonian Institution, 1968.

Cott, Nancy F. *The Bonds of Womanhood: "Women's Sphere" in New England, 1780–1835.* New Haven, CT: Yale University Press, 1977.

Cott, Nancy F., Gerda Lerner, Kathryn Kish Sklar, Ellen Carol DuBois, and Nancy A. Hewitt. "Considering the State of US Women's History." *Journal of Women's History* 15 (2003): 145–163.

Cowan, Ruth Schwartz. *More Work for Mother: The Ironies of Household Technology from the Open Hearth to the Microwave.* New York: Basic Books, 1983.

Cozart, Dorothy. "An Early Nineteenth Century Quiltmaker and Her Quilts." *Uncoverings* 7 (1986): 73–82.

Crews, Patricia Cox, and Ronald C. Naugle, eds. *Nebraska Quilts and Quiltmakers.* Lincoln: University of Nebraska Press, 1991.

Cross, Whitney R. *The Burned-Over District: The Social and Intellectual History of Enthusiastic Religion in Western New York, 1800–1850.* Ithaca, NY: Cornell University Press, 1950.

Crothers, Pat. "Gender Misapprehensions: The 'Separate Spheres' Ideology, Quilters, and Role Adaptation, 1850–1890." *Uncoverings* 14 (1993): 41–61.

Csikszentmihalyi, Mihaly, and Eugene Rochberg-Halton. *The Meaning of Things: Domestic Symbols and the Self.* New York: Cambridge University Press, 1981.

Culley, Margo. *A Day at a Time: The Diary Literature of American Women from 1764 to the Present.* New York: Feminist Press at CUNY, 1985.

Curry, David Park. *Stitches in Time: Samplers in the Museum's Collection.* Lawrence: University of Kansas, Museum of Art, 1975.

Cutter, William Richard. *Historic Homes and Places and Genealogical and Personal Memoirs Relating to the Families of Middlesex County, Massachusetts.* New York: Lewis Historical Pub., 1908.

Dacome, Lucia. "Noting the Mind: Commonplace Books and the Pursuit of the Self in Eighteenth-Century Britain." *Journal of the History of Ideas* 65 (October 2004): 603–625.

D'Ambrosio, Paul S., and Charlotte M. Emans. *Folk Art's Many Faces: Portraits in the New York State Historical Association.* Cooperstown: New York State Historical Association, 1987.

Davidoff, Leonore, and Catherine Hall. *Family Fortunes: Men and Women of the English Middle Class, 1780–1850.* London: Hutchinson, 1987.

Davidson, Mary M. *Plimoth Colony Samplers.* Marion, MA: Channings, 1975.

Davis, Carolyn O'Bagy. *Pioneer Quiltmaker: The Story of Dorinda Moody Slade, 1808–1895.* Tucson, AZ: Sanpete Publications, 1990.

———. *Quilted All Day: The Prairie Journals of Ida Chambers Melugin.* Tucson, AZ: Sanpete, 1993.

Davis, Gayle R. "Women in the Quilt Culture: An Analysis of Social Boundaries and Role Satisfaction." *Kansas History* 13 (Spring 1990): 5–12.

Davis, Nancy E. *The Baltimore Album Quilt Tradition: Maryland Historical Society.* Tokyo: Kokusai, 1999.

Davis, Natalie Zemon. *The Gift in Sixteenth-Century France.* Madison: University of Wisconsin Press, 2000.

Deetz, James. *In Small Things Forgotten: The Archaeology of Early American Life.* New York: Doubleday, 1977.

Degler, Carl N. *At Odds: Women and the Family in America from the Revolution to the Present.* New York: Oxford University Press, 1980.

Delaplaine, Edward S. *Francis Scott Key: Life and Times.* New York: Biography Press, 1937.

Demos, John. *Circles and Lines: The Shape of Life in Early America.* Cambridge, MA: Harvard University Press, 2004.

———. "Old Age in Early New England." In *Turning Points: Historical and Sociological Essays on the Family,* edited by John Demos and Sarane Spence Bocock, 248–287. Chicago: University of Chicago Press, 1978.

Demos, John, and Sarane Spence Bocock, eds. *Turning Points: Historical and Sociological Essays on the Family.* Chicago: University of Chicago Press, 1978.

Deutsch, Davida Tenenbaum. "Needlework Patterns and Their Use in America." *The Magazine Antiques* 139 (February 1991): 368–381.

Dewhurst, C. Kurt, Betty Macdowell, and Marsha Macdowell. *Religious Folk Art in America: Reflections of Faith.* New York: E. P. Dutton, 1983.

Dickinson, Cindy. "Creating a World of Books, Friends, and Flowers: Gift Books and Inscriptions, 1825–60." *Winterthur Portfolio* 31 (1996): 53–66.

Di Leonardo, Micaela. "The Female World of Cards and Holidays: Women, Families, and the Work of Kinship." *Signs* 12 (Spring 1987): 440–453.

Ditz, Toby L. *Property and Kinship: Inheritance and Early Connecticut, 1750–1820.* Princeton: Princeton University Press, 1986.

Dodge, Joseph Thompson. *Genealogy of the Dodge Family of Essex County, Mass., 1629–1894.* Madison, WI: Democrat Printing, 1898.

Douglas, Ann. *The Feminization of American Culture.* New York: Noonday Press, 1998.

———. "Heaven Our Home: Consolation Literature in the Northern United States, 1830–1880." In *Death in America,* edited by David E. Stannard, 49–68. Philadelphia: University of Pennsylvania Press, 1975.

Douglas, Diane M. "The Machine in the Parlor: A Dialectical Analysis of the Sewing Machine." *Journal of American Culture* 5 (Spring 1982): 20–29.

Douglas, Mary, and Baron C. Isherwood. *The World of Goods.* New York: Basic Books, 1979.

Dublin, Thomas, ed. *Farm to Factory: Women's Letters, 1830–1860.* New York: Columbia University Press, 1993.

———. *Transforming Women's Work: New England Lives in the Industrial Revolution.* Ithaca, NY: Cornell University Press, 1994.

———. *Women at Work: The Transformation of Work and Community in Lowell, Massachusetts, 1826–1860.* New York: Columbia University Press, 1993.

Duke, Dennis, and Deborah Harding, eds. *America's Glorious Quilts.* New York: Hugh Lauter Levin Associates, 1987.

Dwight, Benjamin W. *The History of the Descendants of John Dwight of Dedham, Mass.* New York: John F. Trow and Son, 1874.

Earle, Swepson, and Percy G. Skirven. *Maryland's Colonial Eastern Shore: Historical Sketches of Counties and of Some Notable Structures.* Baltimore: Munder-Thomsen Press, 1916.

Eaton, Linda. *Quilts in a Material World: Selections from the Winterthur Collection.* New York: Abrams, 2007.

Edmonds, Mary Jaene. *Samplers and Samplermakers: An American Schoolgirl Art, 1700–1850.* London: Rizzoli, 1991.

Elbert, E. Duane, and Rachel Kamm Elbert. *History from the Heart: Quilt Paths across Illinois.* Nashville: Rutledge Hill Press, 1993.

Embroidered Samplers in the Collection of the Cooper-Hewitt Museum. Washington, DC: Smithsonian Institution, 1984.

Epstein, Kathy. "Padded, Stuffed and Corded: White-on-White Quilts." *Piecework Magazine* 5 (November/December 1997): 33–37.

Farley, Harriet, or Rebecca C. Thompson. "The Patchwork Quilt." In *A Patchwork of Pieces: An Anthology of Early Quilt Stories, 1845–1940,* compiled by Cuesta Ray Benberry and Carol Pinney Crabb, 18–23. Paducah, KY: American Quilter's Society, 1993.

Farnam, Anne. "Essex County Furniture Carving: The Continuance of a Tradition." *Essex Institute Historical Collections* 116 (July 1980): 145–155.

Farnham, Joseph E. C. *Brief Historical Data and Memories of My Boyhood Days in Nantucket.* Providence, RI: Snow and Farnham, 1915.

Farrell, James J. *Inventing the American Way of Death, 1830–1920.* Philadelphia: Temple University Press, 1980.

Federico, Jean Taylor. "White Work Classification System." *Uncoverings* 1 (1980): 68–71.

Feinson, Marjorie Chary, "Where Are the Women in the History of Aging?" *Social Science History* 9 (Autumn 1985): 429–452.

Ferrero, Pat, Elaine Hedges, and Julie Silber. *Hearts and Hands: Women, Quilts and American Society.* Nashville: Rutledge Hill Press, 1987.

Field, Corinne T. "'Are Women . . . All Minors?': Woman's Rights and the Politics of Aging in the Antebellum United States." *Journal of Women's History* 12 (Winter 2001): 113–137.

Fields, Catherine Keene, and Lisa C. Kightlinger, eds. *To Ornament Their Minds: Sarah Pierce's Litchfield Female Academy, 1792–1833.* Litchfield, CT: Litchfield Historical Society, 1993.

Finkel, M., and Daughter. *Samplings* 1–35 (1992–2009).

Fischer, David Hackett. *Growing Old in America.* New York: Oxford University Press, 1977.

Fleming, E. McClung. "Artifact Study: A Proposed Model." *Winterthur Portfolio* 9 (1974): 153–173.

Fox, Sandi. *For Purpose and Pleasure: Quilting Together in Nineteenth-Century America.* Nashville: Rutledge Hill Press, 1995.

———. *Quilts: California Bound, California Made, 1840–1940.* Los Angeles: FIDM Museum and Library, 2002.

———. *Small Endearments: Nineteenth-Century Quilts for Children and Dolls.* Nashville: Rutledge Hill Press, 1980.

———. *Wrapped in Glory: Figurative Quilts and Bedcovers, 1700–1900.* Los Angeles: Thames and Hudson and Los Angeles County Museum of Art, 1990.

Frank, Robin Jaffee. *Love and Loss: American Portrait and Mourning Miniatures.* New Haven, CT: Yale University Art Gallery, 2000.

Fratto, Toni Flores. "'Remember Me': The Sources of American Sampler Verses." *New York Folklore* 2 (Winter 1976): 205–222.

Fuhrer, Mary Babson, ed. *Letters from the "Old Home Place": Anxieties and Aspirations in Rural New England, 1836–1843.* Boylston, MA: Old Pot Publications, 1997.

Furgason, Mary Jane, and Patricia Cox Crews. "Prizes from the Plains: Nebraska State Fair Award-Winning Quilts and Quiltmakers." *Uncoverings* 14 (1993): 188–220.

Gabel, Laurel K. "A Common Thread: Needlework Samplers and American Gravestones." *Markers* 19 (2002): 18–49.

Gardner, Martin. *Famous Poems from Bygone Days.* New York: Dover Publications, 1995.

Gilbert, Jennifer. *The New England Quilt Museum Quilts.* Concord, CA: C and T Publishing, 1999.

Gillespie, Joanna Bowen. "'The Clear Leadings of Providence': Pious Memoirs and the Problems of Self-Realization for Women in the Early Nineteenth Century." *Journal of the Early Republic* 5 (Summer 1985): 197–221.

Glassie, Henry. *Material Culture.* Bloomington: Indiana University Press, 1999.

Goggin, Maureen Daly. "One English Woman's Story in Silken Ink: Filling In the Missing Strands in Elizabeth Parker's Circa 1830 Sampler." *Sampler and Antique Needlework Quarterly* 8 (Winter 2002): 38–49.

Goody, Jack. "Inheritance, Property and Women: Some Comparative Considerations." In *Family and Inheritance: Rural Society in Western Europe, 1200–1800,* edited by Jack Goody, Joan Thirsk, and E. P. Thompson, 10–36. Cambridge: Cambridge University Press, 1976.

Goody, Nancy H. "Fiskdale: 1816–1850." Unpublished paper, Old Sturbridge Village Research Library, Sturbridge, MA, 1977.

Gordon, Beverly. *Bazaars and Fair Ladies: The History of the American Fundraising Fair.* Knoxville: University of Tennessee Press, 1998.

———. *The Saturated World: Aesthetic Meaning, Intimate Objects, Women's Lives, 1890–1940.* Knoxville: University of Tennessee Press, 2006.

———. *Shaker Textile Arts.* Hanover, NH: University Press of New England, 1980.

———. "Victorian Fancy Goods: Another Reappraisal of Shaker Material Culture." *Winterthur Portfolio* 25 (Summer/Autumn 1990): 111–129.

———. "Victorian Fancywork in the American Home: Fantasy and Accommodation." In *Making the American Home: Middle-Class Women and Domestic Material Culture, 1840–1940,* edited by Marilyn Ferris Motz and Pat Browne, 48–68. Bowling Green, OH: Bowling Green State University Popular Press, 1988.

Gouldner, Alvin W. "The Norm of Reciprocity: A Preliminary Statement." *American Sociological Review* 25 (April 1960): 161–178.

Graffam, Olive Blair. *"Youth Is the Time for Progress": The Importance of American Schoolgirl Art, 1780–1860.* Washington, DC: DAR Museum, 1998.

The Great River: Art and Society of the Connecticut Valley, 1635–1820. Hartford, CT: Wadsworth Atheneum, 1985.

Green, Harvey. *The Light of the Home: An Intimate View of the Lives of Women in Victorian America.* New York: Pantheon Books, 1983.

Grier, Katherine C. *Culture and Comfort: People, Parlors and Upholstery, 1850–1930.* Rochester, NY: Strong Museum, 1988.

Gross, Robert. *The Minutemen and Their World.* New York: Hill and Wang, 1976.

Gunn, Virginia. "From Myth to Maturity: The Evolution of Quilt Scholarship." *Uncoverings* 13 (1992): 192–205.

———. "Quilts at Nineteenth-Century State and County Fairs: An Ohio Study." *Uncoverings* 9 (1988): 105–128.

———. "Template Quilt Construction and Its Offshoots: From *Godey's Lady's Book* to Mountain Mist." In *Pieced by Mother: Symposium Papers,* edited by Jeannette Lasansky, 69–75. Lewisburg, PA: Oral Traditions Project, 1988.

Haber, Carole. *Beyond Sixty-Five: The Dilemma of Old Age in America's Past.* Cambridge: Cambridge University Press, 1983.

Haber, Carole, and Brian Gratton. "Aging in America: The Perspective of History." In *Handbook of the Humanities and Aging,* edited by Thomas R. Cole, David D. Van Tassel, and Robert Kastenbaum, 352–370. New York: Springer Publishing, 1992.

———. *Old Age and the Search for Security: An American Social History.* Bloomington: Indiana University Press, 1994.

Hahn, Steven, and Jonathan Prude, eds. *The Countryside in the Age of Capitalist Transformation: Essays in the Social History of Rural America.* Chapel Hill: University of North Carolina Press, 1985.

Hall, Ruth Gardiner. *Descendants of Governor William Bradford (Through the First Seven Generations).* Ann Arbor, MI: [s.n.], 1951.

Halttunen, Karen. *Confidence Men and Painted Women: A Study of Middle-Class Culture in America, 1830–1870.* New Haven, CT: Yale University Press, 1982.

Hamden, Jane Amstutz, and Pamela Frazee Woolbright, eds. *Oklahoma Heritage Quilts: A Sampling of Quilts Made in or Brought to Oklahoma before 1940.* Paducah, KY: American Quilter's Society, 1990.

The Hands That Made Them: Quilts of Adams County, Pennsylvania. Camp Hill, PA: Adams County Quilt Project Committee, 1993.

Hansen, Debra Gold. *Strained Sisterhood: Gender and Class in the Boston Female Anti-slavery Society.* Amherst: University of Massachusetts Press, 1993.

Hansen, Karen V. *A Very Social Time: Crafting Community in Antebellum New England.* Berkeley: University of California Press, 1994.

Harbeson, Georgiana Brown. *American Needlework.* New York: Bonanza Books, 1938.

Hareven, Tamara K. "The Last Stage: Historical Adulthood and Old Age." *Daedalus* 105 (Fall 1976): 13–27.

Hartigan-O'Connor, Ellen. "Abigail's Accounts: Economy and Affection in the Early Republic." *Journal of Women's History* 17 (Fall 2005): 37–58.

Hatch, Nathan O. *The Democratization of American Christianity.* New Haven, CT: Yale University Press, 1989.

Heaps, Jennifer Davis. "Remember Me: Six Samplers in the National Archives." *Prologue* 34 (Fall 2002): 185–195.

Hedges, Elaine. "The Nineteenth-Century Diarist and Her Quilts." *Feminist Studies* 8 (Summer 1982): 293–299.

Hemphill, C. Dallett. *Bowing to Necessities: A History of Manners in America, 1620–1860.* New York: Oxford University Press, 1999.

Hersh, Tandy. "1842 Primitive Hall Pieced Quilt Top: The Art of Transforming Printed Fabric Designs through Geometry." *Uncoverings* 7 (1986): 47–59.

Hewitt, Nancy A. *Women's Activism and Social Change: Rochester, New York, 1822–1872.* Ithaca, NY: Cornell University Press, 1984.

Hiester, Jan, and Kathleen Staples. *This Have I Done: Samplers and Embroideries from Charleston and the Lowcountry.* Charleston, SC: Curious Works Press and Charleston Museum, 2001.

Hijiya, James A. "American Gravestones and Attitudes toward Death: A Brief History." *Proceedings of the American Philosophical Society* 127 (October 1983): 339–363.

History of Erie County, Pennsylvania. Chicago: Warner, Beers, 1884.

Hoffert, Sylvia D. "Female Self-Making in Mid-Nineteenth-Century America." *Journal of Women's History* 20 (Fall 2008): 34–59.

Hoffman, Lynn T. *Patterns in Time: Quilts of Western New York.* Buffalo, NY: Buffalo and Erie County Historical Society, 1990.

Hollander, Stacy C. *American Radiance: The Ralph Esmerian Gift to the American Folk Art Museum.* New York: Harry N. Abrams, 2001.

———. "Talking Quilts." *Folk Art* 29 (Spring/Summer 2004): 32–41.

———. "White on White and a Little Gray." *Folk Art* 31 (Spring/Summer 2006): 32–41.

Hollander, Stacy C., and Brooke Davis Anderson. *American Anthem: Masterworks from the American Folk Art Museum.* New York: Harry N. Abrams, 2001.

Holmes, Kenneth L., ed. *Covered Wagon Women: Diaries and Letters from the Western Trails, 1840–1890.* Glendale, CA: Arthur H. Clark, 1983.

Holmes, William. *Religious Emblems and Allegories.* London: William Tegg, 1868.

Hood, Adrienne D. *The Weaver's Craft: Cloth, Commerce and Industry in Early Pennsylvania.* Philadelphia: University of Pennsylvania Press, 2003.

Hornung, Clarence P. *Treasury of American Design.* New York: Harry N. Abrams, 1972.

Horton, Laurel. *Mary Black's Family Quilts: Memory and Meaning in Everyday Life.* Columbia: University of South Carolina Press, 2005.

———. "Quiltmaking Traditions in South Carolina." In *Social Fabric: South Carolina's Traditional Quilts,* edited by Laurel Horton and Lynn Robertson Myers, 11–33. Columbia, SC: McKissick Museum, 1986.

Horton, Laurel, and Lynn Robertson Myers. *Social Fabric: South Carolina's Traditional Quilts.* Columbia, SC: McKissick Museum, 1986.

Hoskins, Janet. *Biographical Objects: How Things Tell the Stories of People's Lives.* New York: Routledge, 1998.

Howe, Henry. *Historical Collections of Ohio.* Columbus: Henry Howe and Son, 1891.

Huber, Stephen, and Carol Huber. *Miller's Samplers: How to Compare and Value.* London: Octopus Publishing Group, 2002.

Huish, Marcus. *Samplers and Tapestry Embroideries.* New York: Dover Publications, 1970.

Hume, Janice. *Obituaries in American Culture.* Jackson: University Press of Mississippi, 2000.

———. "Press, Published History, and Regional Lore: Shaping the Public Memory of a Revolutionary War Heroine." *Journalism History* 30 (Winter 2005): 200–209.

Hyde, Lewis. *The Gift: Imagination and the Erotic Life of Property.* New York: Random House, 1983.

Ivey, Kimberly Smith. *In the Neatest Manner: The Making of the Virginia Sampler Tradition.* Austin, TX: Curious Works Press and Colonial Williamsburg Foundation, 1997.

Izard, Holly V. "The Ward Family and Their 'Helps': Domestic Work, Workers, and Relationships on a New England Farm, 1787–1866." *Proceedings of the American Antiquarian Society* 103 (1993): 61–90.

James, Edward T., ed. *Notable American Women, 1607–1950: A Biographical Dictionary.* Cambridge: Belknap Press of Harvard University Press, 1971.

James, Louise B. "The Federal Eagle Quilt." *Quilting Quarterly* 24 (Spring 1996): 23–24.

Jeffrey, Julie Roy. *The Great Silent Army of Abolitionism: Ordinary Women in the Antislavery Movement.* Chapel Hill: University of North Carolina Press, 1998.

Jehle, Michael A., ed. *Picturing Nantucket: An Art History of the Island with Paintings from the Collection of the Nantucket Historical Association.* Nantucket, MA: Nantucket Historical Association, 2000.

Jensen, Joan M. *Loosening the Bonds: Mid-Atlantic Farm Women, 1750–1850.* New Haven, CT: Yale University Press, 1988.

Johnson, Barbara, and Natalie Rothstein. *A Lady of Fashion: Barbara Johnson's Album of Styles and Fabrics.* New York: Thames and Hudson, 1987.

Johnson, Paul E. *A Shopkeeper's Millennium: Society and Revivals in Rochester, New York, 1815–1837.* New York: Hill and Wang, 1978.

Jones, Michael Owen. "How Can We Apply Event Analysis to 'Material Behavior,' and Why Should We?" *Western Folklore* 56 (Summer/Fall 1997): 199–214.

Kammen, Michael. "Changing Perceptions of the Life Cycle in American Thought and Culture." *Proceedings of the Massachusetts Historical Society* 91 (1979): 35–66.

———. *Mystic Chords of Memory: The Transformation of Tradition in American Culture.* New York: Alfred A. Knopf, 1991.

———. *A Season of Youth: The American Revolution and the Historical Imagination.* Ithaca, NY: Cornell University Press, 1988.

Karlsen, Carol F. *The Devil in the Shape of a Woman: Witchcraft in Colonial New England.* New York: W. W. Norton, 1998.

Kasson, John F. *Rudeness and Civility: Manners in Nineteenth-Century Urban America.* New York: Hill and Wang, 1990.

Keister, Douglas. *Stories in Stone: A Field Guide to Cemetery Symbolism and Iconography.* Salt Lake City, UT: Gibbs Smith, 2004.

Keller, Patricia J. "Quaker Quilts from the Delaware River Valley, 1760–1890." *The Magazine Antiques* 156 (August 1999): 184–193.

———. "To Go to Housekeeping: Quilts Made for Marriage in Lancaster County." In *Bits and Pieces: Textile Traditions,* edited by Jeannette Lasansky, 56–63. Lewisburg, PA: Oral Traditions Project, 1991.

Kelley, Mary. *Learning to Stand and Speak: Women, Education, and Public Life in America's Republic.* Chapel Hill: University of North Carolina Press, 2006.

———. "Reading Women/Women Reading: The Making of Learned Women in Antebellum America." *Journal of American History* 83 (September 1996): 401–424.

———. "A Woman Alone: Catharine Maria Sedgwick's Spinsterhood in Nineteenth-Century America." *New England Quarterly* 51 (June 1978): 209–225.

Kelly, Catherine E. "The Consummation of Rural Prosperity and Happiness: New England Agricultural Fairs and the Construction of Class and Gender, 1810–1860." *American Quarterly* 49 (September 1997): 574–603.

———. *In the New England Fashion: Reshaping Women's Lives in the Nineteenth Century.* Ithaca, NY: Cornell University Press, 1999.

———. "'Well Bred Country People': Sociability, Social Networks, and the Creation of a Provincial Middle Class, 1820–1860." *Journal of the Early Republic* 19 (Fall 1999): 451–479.

Kentucky Quilt Project. *Kentucky Quilts, 1800–1900.* Louisville, KY: Time Capsules, 1982.

Kerber, Linda K. "Separate Spheres, Female Worlds, Woman's Place: The Rhetoric of Women's History." *Journal of American History* 75 (1988): 9–39.

———. *Women of the Republic: Intellect and Ideology in Revolutionary America.* Chapel Hill: University of North Carolina Press, 1987.

Kete, Mary Louise. *Sentimental Collaborations: Mourning and Middle-Class Identity in Nineteenth-Century America.* Durham, NC: Duke University Press, 2000.

Kidwell, Claudia B., and Margaret C. Christman. *Suiting Everyone: The Democratization of Clothing in America.* Washington, DC: Smithsonian Institution Press, 1974.

Kiracofe, Roderick. *The American Quilt: A History of Cloth and Comfort, 1750–1950.* New York: Clarkson Potter Publishers, 2004.

Kleinberg, S. J. "The History of Old Age." *Convergence in Aging* 1 (1982): 24–37.

Klimaszewski, Cathy Rose. *Made to Remember: American Commemorative Quilts.* Ithaca, NY: Cornell University Press, 1991.

Komter, Aafke E., ed. *The Gift: An Interdisciplinary Perspective.* Amsterdam: Amsterdam University Press, 1996.

———. *Social Solidarity and the Gift.* Cambridge: Cambridge University Press, 2005.

Komter, Aafke, and Wilma Vollebergh. "Gift Giving and the Emotional Significance of Family and Friends." *Journal of Marriage and the Family* 59 (August 1997): 747–757.

Kopytoff, Igor. "The Cultural Biography of Things: Commoditization as Process." In *The Social Life of Things: Commodities in Cultural Perspective,* edited by Arjun Appadurai, 64–91. New York: Cambridge University Press, 1986.

Kort, Ellen. *Wisconsin Quilts.* Charlottesville, VA: Howell Press, 2001.

Kraak, Deborah E., and Barbara C. Adams. "Reflections on Little Girls and Their Sewing for Dolls." *Piecework Magazine* 11 (January/February 2003): 59–64.

Krueger, Glee F. *A Gallery of American Samplers: The Theodore H. Kapnek Collection.* New York: Bonanza Books, 1984.

———. "Mary Wright Alsop, 1740–1829, and Her Needlework." *Connecticut Historical Society Bulletin* 52 (Summer/Fall 1987): 125–224.

———. *New England Samplers to 1840.* Sturbridge, MA: Old Sturbridge Village, 1978.

LaBranche, John F., and Rita F. Conant. *In Female Worth and Elegance: Sampler and Needlework Students and Teachers in Portsmouth, New Hampshire, 1741–1840.* Portsmouth, NH: Portsmouth Marine Society, 1996.

Lane, Janie Warren Hollingsworth. *Key and Allied Families.* Macon, GA: Press of the J. W. Burke Co., 1931.

Lane, Rose Wilder. *Woman's Day Book of American Needlework.* New York: Simon and Schuster, 1963.

Lapsansky, Emma Jones, and Anne A. Verplanck, eds. *Quaker Aesthetics: Reflections on a Quaker Ethic in American Design and Consumption.* Philadelphia: University of Pennsylvania Press, 2003.

Lasansky, Jeannette, ed. *Bits and Pieces: Textile Traditions.* Lewisburg, PA: Oral Traditions Project, 1991.

———. *A Good Start: The Aussteier or Dowry.* Lewisburg, PA: Oral Traditions Project, 1990.

———, ed. *In the Heart of Pennsylvania: Symposium Papers.* Lewisburg, PA: Oral Traditions Project, 1986.

———, ed. *On the Cutting Edge: Textile Collectors, Collections, and Traditions.* Lewisburg, PA: Oral Traditions Project, 1994.

———, ed. *Pieced by Mother: Symposium Papers.* Lewisburg, PA: Oral Traditions Project, 1988.

———. "Quilts in the Dowry." In Lasansky, *Bits and Pieces,* 48–55.

Lebsock, Suzanne. *The Free Women of Petersburg: Status and Culture in a Southern Town, 1784–1860.* New York: W. W. Norton, 1985.

Lenz, Heather. "Learning to Quilt with Grandma Mary Sibley: Gift Labor, Traditional Quiltmaking, and Contemporary Art." *Uncoverings* 19 (1998): 109–136.

Lepore, Jill. *A Is for American: Letters and Other Characters in the Newly United States.* New York: Alfred A. Knopf, 2002.

Lerner, Gerda. "The Lady and the Mill Girl: Changes in the Status of Women in the Age of Jackson." *Midcontinent American Studies Journal* 10 (1969): 5–15.

Lessons Stitched in Silk: Samplers from the Canterbury Region of New Hampshire. Hanover, NH: Hood Museum of Art, 1990.

Lipsett, Linda Otto. *Elizabeth Roseberry Mitchell's Graveyard Quilt: An America Pioneer Saga.* Dayton, OH: Halstead and Meadows Publishing, 1995.

———. *Remember Me: Women and Their Friendship Quilts.* San Francisco: Quilt Digest Press, 1985.

Llewellyn, Nigel. "Elizabeth Parker's 'Sampler': Memory, Suicide and the Presence of the Artist." In *Material Memories,* edited by Marius Kwint, Christopher Breward, and Jeremy Aynsley, 59–68. Oxford, UK: Berg, 1999.

Locklair, Paula W. *Quilts, Coverlets and Counterpanes: Bedcoverings from the MESDA and Old Salem Collections.* Winston-Salem, NC: Old Salem, 1997.

Logan, Andy, Brendan Gill, and Gordon Cotler. "The Talk of the Town: Never Die." *New Yorker,* May 12, 1951, 24–25.

Loscalzo, Anita B. "The History of the Sewing Machine and Its Use in Quilting in the United States." *Uncoverings* 26 (2005): 175–208.

Lovell, Margaretta L. *Art in a Season of Revolution: Painters, Artisans, and Patrons in Early America.* Philadelphia: University of Pennsylvania Press, 2005.

Ludwig, Allan I. *Graven Images: New England Stonecarving and Its Symbols, 1650–1815.* Middletown, CT: Wesleyan University Press, 1966.

Macdonald, Anne L. *No Idle Hands: The Social History of American Knitting.* New York: Ballantine Books, 1988.

MacDowell, Marsha, and Ruth D. Fitzgerald, eds. *Michigan Quilts: 150 Years of a Textile Tradition.* East Lansing: Michigan State University Museum, 1987.

Macheski, Cecilia. "Penelope's Daughters: Images of Needlework in Eighteenth-Century Literature." In *Fetter'd or Free? British Women Novelists, 1670–1815,* edited by Mary Anne Schofield and Cecilia Macheski, 85–100. Athens: Ohio University Press, 1986.

Madden, Edward H., and James E. Hamilton. *Freedom and Grace: The Life of Asa Mahan.* Metuchen, NJ: Scarecrow Press, 1982.

Maier, Pauline. *American Scripture: Making the Declaration of Independence.* New York: Alfred A. Knopf, 1997.

Marston, Gwen, and Joe Cunningham. *Mary Schafer and Her Quilts.* East Lansing: Michigan State University Museum, 1990.

Martin, Ann Smart. "Makers, Buyers, and Users: Consumerism as a Material Culture Framework." *Winterthur Portfolio* 28 (1993): 141–157.

Mastromarino, Mark A. "Cattle Aplenty and Other Things in Proportion: The Agricultural Society and Fair in Franklin County, Massachusetts, 1810–1860." *UCLA Historical Journal* 5 (1984): 50–75.

———. "Elkanah Watson and Early Agricultural Fairs, 1790–1860." *Historical Journal of Massachusetts* 17 (Summer 1989): 105–118.

Masur, Louis P. "'Age of the First Person Singular': The Vocabulary of the Self in New England, 1780–1850." *Journal of American Studies* 25 (1991): 189–211.

Mathieson, Judy. "Some Published Sources of Design Inspiration for the Quilt Pattern Mariner's Compass—17th to 20th Century." *Uncoverings* 2 (1981): 11–18.

Matthews, Jean V. "'Woman's Place' and the Search for Identity in Ante-Bellum America." *Canadian Review of American Studies* 10 (Winter 1979): 289–304.

Mauss, Marcel. *The Gift: The Form and Reason for Exchange in Archaic Societies.* New York: W. W. Norton, 1990.

McInnis, Maurie D. *The Politics of Taste in Antebellum Charleston.* Chapel Hill: University of North Carolina Press, 2005.

McNair, James Birtley. *McNair, McNear, and McNeir Genealogies.* Chicago: privately printed, 1923.

Meginness, John Franklin. *Biographical Annals of Lancaster County, Pennsylvania.* Chicago: J. H. Beers, 1903.

Meyer, Richard E., ed. *Cemeteries and Gravemarkers: Voices of American Culture.* Ann Arbor: UMI Research Press, 1989.

Meyer, Suellen. "Early Influences of the Sewing Machine and Visible Machine Stitching on Nineteenth-Century Quilts." *Uncoverings* 10 (1989): 38–53.

Miller, Marla R. "'My Part Alone': The World of Rebecca Dickinson, 1787–1802." *New England Quarterly* 71 (September 1998): 341–377.

———. *The Needle's Eye: Women and Work in the Age of Revolution.* Amherst: University of Massachusetts Press, 2006.

Miller, Susan. *Assuming the Positions: Cultural Pedagogy and the Politics of Commonplace Writing.* Pittsburgh: University of Pittsburgh Press, 1998.

Minnesota Quilts: Creating Connections with Our Past. Stillwater, MN: Voyageur Press, 2005.

Mohanty, Gail Fowler. "Esther Slater and Her Falling Blocks Quilt." In *Down by the Old Mill Stream: Quilts in Rhode Island,* edited by Linda Welters and Margaret T. Ordonez, 226–231. Kent, OH: Kent State University Press, 2000.

Monkhouse, Christopher. "The Spinning Wheel as Artifact, Symbol, and Source of Design." *Nineteenth Century* 8 (1982): 155–172.

Mosaic Quilts: Paper Template Piecing in the South Carolina Lowcountry. Greenville, SC: Curious Works Press, 2002.

Motz, Marilyn Ferris. *True Sisterhood: Michigan Women and Their Kin, 1820–1920.* Albany: State University of New York Press, 1983.

———. "Visual Autobiography: Photograph Albums of Turn-of-the-Century Midwestern Women." *American Quarterly* 41 (March 1989): 63–92.

Motz, Marilyn Ferris, and Pat Browne, eds. *Making the American Home: Middle-Class Women and Domestic Material Culture, 1840–1940.* Bowling Green, OH: Bowling Green State University Popular Press, 1988.

Myers, Thomas M. *The Norris Family of Maryland.* New York: W. M. Clemens, 1916.

Neal, Roy. "A Chronological History of Ink." *American Ink Maker* 38 (September 1960): 38–41.

Nelson, Cyril I., and Carter Houck. *Treasury of American Quilts.* New York: Greenwich House, 1984.

Newell, Aimee E. "Agricultural Fairs and Quilts." In *Massachusetts Quilts: Our Common Wealth,* edited by Lynne Z. Bassett, 181–193. Hanover, NH: University Press of New England, 2009.

———. "Island Pride: The Nantucket Agricultural Society Quilt." *Piecework Magazine* 14 (September/October 2006): 28–31.

———. "More than Warmth: Gift Quilts by Aging Women in Antebellum America." *Uncoverings* 29 (2008): 43–74.

———. "'No Harvest of Oil': Nantucket's Agricultural Fairs, 1856–1890." In *New England Celebrates: Spectacle, Commemoration, and Festivity,* edited by Peter Benes, 149–165. Boston: Boston University, 2002.

———. "Paper-Template Piecing in Early-Nineteenth-Century America." *Piecework Magazine* 13 (September/October 2005): 40–43.

———. "Sarah Clarke Ellis Ide Quilt." In *Massachusetts Quilts: Our Common Wealth,* edited by Lynne Z. Bassett, 93–95. Hanover, NH: University Press of New England, 2009.

———. "'Tattered to Pieces': Amy Fiske's Sampler and the Changing Roles of Women in Antebellum New England." In *Women and the Material Culture of Needlework and Textiles, 1750–1950,* edited by Maureen Daly Goggin and Beth Fowkes Tobin, 51–68. Aldershot, UK: Ashgate Publishing, 2009.

———. "'Tattered to Pieces': Samplers by Aging Women in Antebellum New England." *Sampler and Antique Needlework Quarterly* 13 (Fall 2007): 28–35.

Nicoll, Jessica F. *Quilted for Friends: Delaware Valley Signature Quilts, 1840–1855.* Winterthur, DE: Winterthur Museum, 1986.

———. "Signature Quilts and the Quaker Community, 1840–1860." *Uncoverings* 7 (1986): 27–37.

Norling, Lisa. *Captain Ahab Had a Wife: New England Women and the Whalefishery, 1720–1870.* Chapel Hill: University of North Carolina Press, 2000.

Norton, Mary Beth. *In the Devil's Snare: The Salem Witchcraft Crisis of 1692.* New York: Alfred A. Knopf, 2002.

———. *Liberty's Daughters: The Revolutionary Experience of American Women, 1750–1800.* Boston: Little, Brown, 1980.

Nutter, Charles S., and Wilbur F. Tillett. *The Hymns and Hymn Writers of the Church.* New York: Eaton and Mains, 1911.

Nylander, Jane C. "Provision for Daughters: The Accounts of Samuel Lane." In *House and Home,* edited by Peter Benes, 11–27. Boston: Boston University, 1990.

Oliver, Celia Y. *Enduring Grace: Quilts from the Shelburne Museum Collection.* Lafayette, CA: C and T Publishing, 1997.

Onuf, Peter, ed. *All Over the Map: Rethinking American Regions,* Baltimore: Johns Hopkins University Press, 1996.

Opal, J. M. "Exciting Emulation: Academies and the Transformation of the Rural North, 1780s–1820s." *Journal of American History* 91 (September 2004): 445–470.

Orcutt, Samuel. *The History of the Old Town of Derby, Connecticut, 1642–1880.* Springfield, MA: Springfield Printing, 1880.

Ordonez, Margaret T. "Ink Damage on Nineteenth Century Cotton Signature Quilts." *Uncoverings* 13 (1992): 148–168.

———. "Technology Reflected: Printed Textiles in Rhode Island Quilts." In *Down by the Old Mill Stream: Quilts in Rhode Island,* edited by Linda Welters and Margaret T. Ordonez, 122–160. Kent, OH: Kent State University Press, 2000.

Orlofsky, Patsy, and Myron Orlofsky. *Quilts in America.* New York: Abbeville Press, 1992.

Osaki, Amy Boyce. "A 'Truly Feminine Employment': Sewing and the Early Nineteenth-Century Woman." *Winterthur Portfolio* 23 (Winter 1988): 225–241.

Osteen, Mark, ed. *The Question of the Gift: Essays across Disciplines.* London: Routledge, 2002.

Otnes, Cele, and Richard F. Beltramini, eds. *Gift Giving: A Research Anthology.* Bowling Green, OH: Bowling Green State University Popular Press, 1996.

Palmer, Heather Ruth. "Where Is Nineteenth-Century Southern Decorative Needlework?" *Southern Quarterly* 27 (1988): 57–71.

Parker, Rozsika. *The Subversive Stitch: Embroidery and the Making of the Feminine.* New York: Routledge, 1989.

Parmal, Pamela. *Samplers from A to Z.* Boston: MFA Publications, 2000.

Parry, Jonathan. "*The Gift,* the Indian Gift and the 'Indian Gift.'" *Man* 21 (September 1986): 453–473.

Payne, Michael R., and Suzanne Rudnick Payne. "A 'woman could paint a likeness?'" *The Magazine Antiques* 175 (January 2009): 178–185.

Peck, Amelia. *American Quilts and Coverlets in the Metropolitan Museum of Art.* New York: Metropolitan Museum of Art, 2007.

Pecquet du Bellet, Louise. *Some Prominent Virginia Families.* Baltimore: Genealogical Pub., 1976.

Pierce, Frederick Clifton. *Batchelder, Batcheller Genealogy.* Chicago: W. B. Conkey, 1898.

———. *Fiske and Fisk Family.* Chicago: F. C. Pierce, 1896.

———. *Whitney: The Descendants of John Whitney.* Chicago: F. C. Pierce, 1895.

Pike, Martha. "In Memory Of: Artifacts Relating to Mourning in Nineteenth Century America." In *Rituals and Ceremonies in Popular Culture,* edited by Ray B. Browne, 296–315. Bowling Green, OH: Bowling Green University Popular Press, 1980.

Pike, Martha V., and Janice Gray Armstrong. *A Time to Mourn: Expressions of Grief in Nineteenth Century America.* Stony Brook, NY: Museums at Stony Brook, 1980.

Premo, Terri L. "'A Blessing to Our Declining Years': Feminine Response to Filial Duty in the New Republic." *International Journal of Aging and Human Development* 20 (1984–1985): 69–74.

———. "'Like a Being Who Does Not Belong': The Old Age of Deborah Norris Logan." *Pennsylvania Magazine of History and Biography* 107 (January 1983): 85–112.

———. *Winter Friends: Women Growing Old in the New Republic, 1785–1835.* Urbana: University of Illinois Press, 1990.

Priddy, Sumpter T. *American Fancy: Exuberance in the Arts, 1790–1840.* Milwaukee, WI: Chipstone Foundation, 2004.

Prown, Jules David. "Style as Evidence." *Winterthur Portfolio* (1980): 197–210.

Prude, Jonathan. *The Coming of the Industrial Order: Town and Factory Life in Rural Massachusetts, 1810–1860.* Cambridge: Cambridge University Press, 1983.

———. "Town-Factory Conflicts in Antebellum Rural Massachusetts." In *The Countryside in the Age of Capitalist Transformation: Essays in the Social History of Rural America,* edited by Steven Hahn and Jonathan Prude, 71–102. Chapel Hill: University of North Carolina Press, 1985.

Purcell, Sarah J. *Sealed with Blood: War, Sacrifice and Memory in Revolutionary America.* Philadelphia: University of Pennsylvania Press, 2002.

Quilts and Quiltmakers: Covering Connecticut. Atglen, PA: Schiffer Publishing, 2002.

Ramsey, Bets, and Merikay Waldvogel. *The Quilts of Tennessee: Images of Domestic Life prior to 1930.* Nashville: Rutledge Hill Press, 1986.

———. *Southern Quilts: Surviving Relics of the Civil War.* Nashville: Rutledge Hill Press, 1998.

Range, Jane, and Maris A. Vinovskis. "Images of the Elderly in Popular Magazines: A Content Analysis of *Littell's Living Age,* 1845–1882." *Social Science History* 5 (Spring 1981): 123–170.

Reddall, Winifred. "Pieced Lettering on Seven Quilts Dating from 1833 to 1891." *Uncoverings* 1 (1980): 56–63.

Rettew, Gayle A., William H. Siener, and Janice Turner Wass. *"Behold the Labour of My Tender Age": Children and Their Samplers, 1780–1850.* Rochester, NY: Rochester Museum and Science Center, 1984.

Richter, Paula Bradstreet. "Lucy Cleveland, Folk Artist." *The Magazine Antiques* 158 (August 2000): 204–213.

———. "Lucy Cleveland's 'Figures of Rags': Textile Arts and Social Commentary in Early-Nineteenth-Century New England." In *Textiles in Early New England: Design, Production, and Consumption,* edited by Peter Benes, 48–63. Boston: Boston University, 1999.

———. *Painted with Thread: The Art of American Embroidery.* Salem, MA: Peabody Essex Museum, 2002.

Ring, Betty. *American Needlework Treasures: Samplers and Silk Embroideries from the Collection of Betty Ring.* New York: E. P. Dutton, 1987.

———. *Girlhood Embroidery: American Samplers and Pictorial Needlework, 1650–1850.* New York: Alfred A. Knopf, 1993.

———. *Let Virtue Be a Guide to Thee: Needlework in the Education of Rhode Island Women, 1730–1830.* Providence: Rhode Island Historical Society, 1983.

———. "New England Heraldic Needlework of the Neoclassical Period." *The Magazine Antiques* 144 (October 1993): 484–493.

———. "Samplers and Pictorial Needlework at the Chester County Historical Society." *The Magazine Antiques* 126 (December 1984): 1422–1433.

———. "Schoolgirl Embroideries: A Credit to the Teachers." *Worcester Art Museum Journal* 5 (1981/1982): 18–31.

Roach, Susan. "The Kinship Quilt: An Ethnographic Semiotic Analysis of a Quilting Bee." In *Women's Folklore, Women's Culture,* edited by Rosan A. Jordan and Susan J. Kalcik, 54–64. Philadelphia: University of Pennsylvania Press, 1985.

Robinson, Charles Seymour. *Annotations upon Popular Hymns.* New York: Hunt and Eaton, 1893.

Roebuck, Janet. "Grandma as Revolutionary: Elderly Women and Some Modern Patterns of Social Change." *International Journal of Aging and Human Development* 17 (1983): 249–266.

———. "When Does 'Old Age' Begin? The Evolution of the English Definition." *Journal of Social History* 12 (Spring 1979): 416–428.

Rogers, Sherbrooke. *Sarah Josepha Hale: A New England Pioneer, 1788–1879.* Grantham, NH: Tompson and Rutter, 1985.

Rosenthal, Carolyn J. "Kinkeeping in the Familial Division of Labor." *Journal of Marriage and the Family* 47 (November 1985): 965–974.

Rubin, Stella. *Miller's How to Compare and Value American Quilts.* London: Octopus Publishing Group, 2001.

Rugh, Susan Sessions. "Patty B. Sessions." In *Sister Saints,* edited by Vicky Burgess-Olson, 305–322. Provo, UT: Brigham Young University Press, 1978.

Rust, Marion. *Prodigal Daughters: Susanna Rowson's Early American Women.* Chapel Hill: University of North Carolina Press, 2008.

Ryan, Mary P. *The Cradle of the Middle-Class: The Family in Oneida County, New York, 1780–1865.* Cambridge: Cambridge University Press, 1978.

———. "The Power of Women's Networks: A Case Study of Female Moral Reform in Antebellum America." *Feminist Studies* 5 (Spring 1979): 66–85.

———. *Women in Public: Between Banners and Ballots, 1825–1880.* Baltimore: Johns Hopkins University Press, 1990.

Safford, Carleton L., and Robert Bishop. *America's Quilts and Coverlets.* New York: Weathervane Books, 1974.

Sale, Edith Tunis. *Old Time Belles and Cavaliers.* Philadelphia: J. B. Lippincott, 1912.

Salmon, Marylynn. *Women and the Law of Property in Early America.* Chapel Hill: University of North Carolina Press, 1986.

Saxton, Martha. *Being Good: Women's Moral Values in Early America.* New York: Hill and Wang, 2003.

Schiffer, Margaret B. *Historical Needlework of Pennsylvania.* New York: Charles Scribner's Sons, 1968.

Schinto, Jeanne. "Old Women Ground Young." *Maine Antiques Digest* (May 2009): 29C.

Schmeal, Jacqueline Andre. *Patchwork: Iowa Quilts and Quilters.* Iowa City: University of Iowa Press, 2003.

Schorsch, Anita. *Mourning Becomes America: Mourning Art in the New Nation.* Clinton, NJ: Main Street Press, 1976.

Schulz, Constance B. "Daughters of Liberty: The History of Women in the Revolutionary War Pension Records." *Prologue* 16 (Fall 1984): 139–153.

Schwartz, Barry. "Social Change and Collective Memory: The Democratization of George Washington." *American Sociological Review* 56 (April 1991): 221–236.

———. "The Social Context of Commemoration: A Study in Collective Memory." *Social Forces* 61 (December 1982): 374–402.

———. "The Social Psychology of the Gift." *American Journal of Sociology* 73 (July 1967): 1–11.

Scott, Ann Firor. "The Ever Widening Circle: The Diffusion of Feminist Values from the Troy Female Seminary, 1822–1872." *History of Education Quarterly* 19 (Spring 1979): 3–25.

Scott, Joan W. "Gender: A Useful Category of Historical Analysis." *American Historical Review* 91 (December 1986): 1053–1075.

Scott, Paula A. *Growing Old in the Early Republic: Spiritual, Social, and Economic Issues, 1790–1830*. New York: Garland Publishing, 1997.

———. "'Tis Not the Spring of Life with Me': Aged Women in Their Diaries and Letters, 1790–1830." *Connecticut History* 36 (1995): 12–30.

Seale, William. *The Tasteful Interlude: American Interiors through the Camera's Eye, 1860–1917*. New York: Praeger, 1975.

Sellers, Charles. *The Market Revolution: Jacksonian America, 1815–1846*. New York: Oxford University Press, 1991.

Shammas, Carole. "Re-assessing the Married Women's Property Acts." *Journal of Women's History* 6 (Spring 1994): 9–30.

Sherman, Mimi. "A Fabric of One Family: A Saga of Discovery." *Clarion* (Spring 1989): 55–62.

Showalter, Elaine. "Piecing and Writing." In *The Poetics of Gender*, edited by Nancy K. Miller, 222–247. New York: Columbia University Press, 1986.

Shurtleff, Benjamin, and N. B. Shurtleff. *The Descendants of William Shurtleff of Plymouth and Marshfield, Massachusetts*. Revere, MA: [n.p], 1912.

Silver, Allan. "Friendship in Commercial Society: Eighteenth-Century Social Theory and Modern Sociology." *American Journal of Sociology* 95 (May 1990): 1474–1504.

Simons, D. Brenton, and Peter Benes, eds. *The Art of Family: Genealogical Artifacts in New England*. Boston: New England Historic Genealogical Society, 2002.

Skinner, Inc. *American Furniture and Decorative Arts*. Boston: Skinner, 2009.

Sklar, Kathryn Kish. *Catharine Beecher: A Study in American Domesticity*. New York: Norton, 1976.

———. "The Founding of Mount Holyoke College." In *Women of America: A History,* edited by Carol Ruth Berkin and Mary Beth Norton, 177–201. Boston: Houghton Mifflin, 1979.

———. "The Schooling of Girls and Changing Community Values in Massachusetts Towns, 1750–1820." *History of Education Quarterly* 33 (Winter 1993): 511–542.

Sloat, Caroline F., ed. *Meet Your Neighbors: New England Portraits, Painters, and Society, 1790–1850*. Sturbridge, MA: Old Sturbridge Village, 1992.

Smith, Daniel Scott. "Child Naming Practices, Kinship Ties, and Change in Family Attitudes in Hingham, Massachusetts, 1641–1880." *Journal of Social History* 18 (1985): 541–566.

Smith, Hilda L. "Cultural Constructions of Age and Aging—'Age': A Problematic Concept for Women." *Journal of Women's History* 12 (Winter 2001): 77–86.

Smith-Rosenberg, Carroll. *Disorderly Conduct: Visions of Gender in Victorian America*. New York: Oxford University Press, 1985.

Smith-Rosenberg, Carroll, and Charles Rosenberg. "The Female Animal: Medical and Biological Views of Woman and Her Role in Nineteenth-Century America." *Journal of American History* 60 (September 1973): 332–356.

Snyder, Grace. *No Time on My Hands*. Lincoln: University of Nebraska Press, 1986.

Sobel, Mechal. *Teach Me Dreams: The Search for Self in the Revolutionary Era*. Princeton: Princeton University Press, 2000.

Spicker, Stuart F., Kathleen M. Woodward, and David D. Van Tassel, eds. *Aging and the Elderly: Humanistic Perspectives in Gerontology*. Atlantic Highlands, NJ: Humanities Press, 1979.

Spitzer, Alan B. "The Historical Problem of Generations." *American Historical Review* 78 (December 1973): 1353–1385.

Stabile, Susan M. *Memory's Daughters: The Material Culture of Remembrance in Eighteenth-Century America*. Ithaca, NY: Cornell University Press, 2004.

Stannard, David E., ed. *Death in America.* Philadelphia: University of Pennsylvania Press, 1975.

Staples, Kathleen. "Samplers from Charleston, South Carolina." *The Magazine Antiques* 169 (March 2006): 80–89.

———. "Tangible Displays of Refinements: Southern Needlework at MESDA." *The Magazine Antiques* 171 (January 2007): 198–203.

Stavenuiter, Monique, and Karin Bijsterveld. "Introduction: Long Lives, Silent Witnesses—Elderly Women in the Past." *Journal of Family History* 25 (April 2000): 196–201.

Stearns, Peter N. "Old Women: Some Historical Observations." *Journal of Family History* 5 (Spring 1980): 44–57.

Stearns, Peter N., and Jan Lewis, eds. *An Emotional History of the United States.* New York: New York University Press, 1998.

St. George, Robert B. *Conversing by Signs: Poetics of Implication in Colonial New England Culture.* Chapel Hill: University of North Carolina Press, 1998.

Stiles, Henry Reed. *The Stiles Family in America.* Jersey City, NJ: Doan and Pilson, 1895.

The Story of Samplers. Philadelphia: Philadelphia Museum of Art, 1971.

Strasser, Susan. *Never Done: A History of American Housework.* New York: Henry Holt, 2000.

Strathern, Marilyn. *The Gender of the Gift.* Berkeley: University of California Press, 1992.

Studebaker, Sue. *Ohio Is My Dwelling Place: Schoolgirl Embroideries, 1800–1850.* Athens: Ohio University Press, 2002.

———. *Ohio Samplers: Schoolgirl Embroideries, 1803–1850.* Lebanon, OH: Warren County Historical Society Museum, 1988.

Swan, Susan Burrows. "Appreciating American Samplers, Part II." *Early American Life* 15 (April 1984): 42–45, 72, 93.

———. *Plain and Fancy: American Women and Their Needlework, 1650–1850.* Austin, TX: Curious Works Press, 1995.

———. *A Winterthur Guide to American Needlework.* New York: Crown Publishers, 1976.

Sykes, Karen. *Arguing with Anthropology: An Introduction to Critical Theories of the Gift.* New York: Routledge, 2005.

Taylor, Sarah Elizabeth. "Remembering Elderly Women in Early America: A Survey of How Aged Women Were Memorialized in Late Eighteenth- and Early Nineteenth-Century Tombstone Inscriptions, Death Notices, Funeral Sermons, and Memoirs." Master's thesis, Virginia Polytechnic Institute and State University, 2002.

Tennessee Stitches: Catalog to Accompany an Exhibit of Nineteenth Century Williamson County Samplers. Franklin, TN: Carter House, 1993.

Teute, Fredrika J. "In 'the gloom of evening': Margaret Bayard Smith's View in Black and White of Early Washington Society." *Proceedings of the American Antiquarian Society* 106 (1996): 37–58.

———. "Roman Matron on the Banks of Tiber Creek: Margaret Bayard Smith and the Politicization of Spheres in the Nation's Capital." In *A Republic for the Ages: The United States Capitol and the Political Culture of the Early Republic,* edited by Donald R. Kennon, 89–121. Charlottesville: University Press of Virginia, 1999.

Thane, Pat. "Social Histories of Old Age and Aging." *Journal of Social History* 37, no. 1 (2003): 93–111.

Thomas, Nicholas. *Entangled Objects: Exchange, Material Culture and Colonialism in the Pacific.* Cambridge, MA: Harvard University Press, 1991.

Torsney, Cheryl B., and Judy Elsley, eds. *Quilt Culture: Tracing the Pattern.* Columbia: University of Missouri Press, 1994.

Travers, Len. *Celebrating the Fourth: Independence Day and the Rites of Nationalism in the Early Republic.* Amherst: University of Massachusetts Press, 1997.

Tricarico, Barbara. *Quilts of Virginia, 1607–1899: The Birth of America through the Eye of a Needle.* Atglen, PA: Schiffer Publishing, 2006.

Troyansky, David. "The History of Old Age in the Western World." *Ageing and Society* 16 (1996): 233–243.

Turkle, Sherry, ed. *Evocative Objects: Things We Think With.* Cambridge, MA: MIT Press, 2007.

Ulrich, Laurel Thatcher. *The Age of Homespun: Objects and Stories in the Creation of an American Myth.* New York: Alfred A. Knopf, 2001.

———. "An American Album, 1857." *American Historical Review* 115 (February 2010): 1–25.

———. "Creating Lineages." In *The Art of Family: Genealogical Artifacts in New England,* edited by D. Brenton Simons and Peter Benes, 5–11. Boston: New England Historic Genealogical Society, 2002.

———. "Furniture as Social History: Gender, Property, and Memory in the Decorative Arts." In *American Furniture,* edited by Luke Beckerdite, 39–68. Milwaukee, WI: Chipstone Foundation, 1995.

———. *Good Wives: Image and Reality in the Lives of Women in Northern New England, 1650–1750.* New York: Alfred A. Knopf, 1987.

———. "Hannah Barnard's Cupboard: Female Property and Identity in 18th-Century New England." In *Through a Glass Darkly: Reflections on Personal Identity in Early America,* edited by Ronald Hoffman, Mechal Sobel, and Fredrika J. Teute, 238–273. Durham: University of North Carolina Press, 1997.

———. *A Midwife's Tale: The Life of Martha Ballard, Based on Her Diary, 1785–1812.* New York: Alfred A. Knopf, 1990.

———. "Of Pens and Needles: Sources in Early American Women's History." *Journal of American History* 77 (June 1990): 200–207.

———. "Wheels, Looms, and the Gender Division of Labor in Eighteenth-Century New England." *William and Mary Quarterly* 55 (January 1998): 3–38.

Valentine, Fawn. *West Virginia Quilts and Quiltmakers: Echoes from the Hills.* Athens: Ohio University Press, 2000.

Van Broekhoven, Deborah. *The Devotion of These Women: Rhode Island in the Antislavery Network.* Amherst: University of Massachusetts Press, 2002.

Van Burkleo, Sandra F. *Belonging to the World: Women's Rights and American Constitutional Culture.* New York: Oxford University Press, 2001.

Van De Krol, Yolanda. "Candlewicking." *Piecework Magazine* 5 (November/December 1997): 23–27.

Vanderpoel, Emily Noyes. *Chronicles of a Pioneer School from 1792–1833.* Cambridge, MA: University Press, 1903.

Van Horn, Jennifer. "Samplers, Gentility, and the Middling Sort." *Winterthur Portfolio* 40 (Winter 2006): 219–247.

Van Tassel, David, and Peter N. Stearns, eds. *Old Age in a Bureaucratic Society: The Elderly, the Experts, and the State in American History.* New York: Greenwood Press, 1986.

Van Valin, Marsha, ed. *Common Thread, Common Ground: A Collection of Essays on Early Samplers and Historic Needlework.* Sullivan, WI: Scarlet Letter, 2001.

———. "Epistolary Samplers: When Needles Were Pens." In Van Valin, *Common Thread, Common Ground,* 50–55.

Veasey, Patricia V. *Virtue Leads and Grace Reveals: Embroideries and Education in Antebellum South Carolina.* Greenville, SC: Curious Works Press, 2003.

Vedder, J. V. V. *Historic Catskill.* Catskill, NY: [s.n.], 1922.

Vincent, Margaret. *The Ladies' Work Table: Domestic Needlework in 19th-Century America.* Allentown, PA: Allentown Art Museum, 1988.

———. *"May Useful Arts Employ My Youth": The Hope R. Hacker Sampler Collection in the Allentown Art Museum.* Allentown, PA: Allentown Art Museum, 1987.

Vinovskis, Maris A. "Angels' Heads and Weeping Willows: Death in Early America." *Proceedings of the American Antiquarian Society* 86 (1976): 273–302.

Vinovskis, Maris A., and Richard M. Bernard. "Beyond Catharine Beecher: Female Education in the Antebellum Period." *Signs* 3 (1978): 856–869.

Waciega, Lisa Wilson. "A "Man of Business": The Widow of Means in Southeastern Pennsylvania, 1750–1850." *William and Mary Quarterly* 44 (January 1987): 40–64.

Waldstreicher, David. *In the Midst of Perpetual Fetes: The Making of American Nationalism, 1776–1820.* Chapel Hill: University of North Carolina Press, 1997.

Waldvogel, Merikay. *Childhood Treasures: Doll Quilts by and for Children.* Intercourse, PA: Good Books, 2008.

Ward, Barbara McLean. "Women's Property and Family Continuity in Eighteenth-Century Connecticut." In *Early American Probate Inventories,* edited by Peter Benes, 74–85. Boston: Boston University, 1987.

Ward, Barbara McLean, and Gerald W. R. Ward. "Sterling Memories: Family and Silver in Early New England." In *The Art of Family: Genealogical Artifacts in New England,* edited by D. Brenton Simons and Peter Benes, 177–190. Boston: New England Historic Genealogical Society, 2002.

Ward, Blanche Linden. "Strange but Genteel Pleasure Grounds: Tourist and Leisure Uses of Nineteenth-

Century Rural Cemeteries." In *Cemeteries and Grave-markers: Voices of American Culture,* edited by Richard E. Meyer, 293–328. Ann Arbor, MI: UMI Research Press, 1989.

Warfield, Joshua Dorsey. *The Founders of Anne Arundel and Howard Counties, Maryland: A Genealogical and Biographical Review from Wills, Deeds and Church Records.* Baltimore: Kohn and Pollock, 1905.

Warren, Elizabeth V. *Quilts: Masterworks from the American Folk Art Museum.* New York: Rizzoli, 2010.

Warren, Elizabeth V., and Sharon L. Eisenstadt. *Glorious American Quilts: The Quilt Collection of the Museum of American Folk Art.* New York: Penguin Studio, 1996.

Wayland, John W. *The Washingtons and Their Homes.* Staunton, VA: McClure Printing, 1944.

Weiner, Annette B. *Inalienable Possessions: The Paradox of Keeping-While-Giving.* Berkeley: University of California Press, 1992.

———. "Inalienable Wealth." *American Ethnologist* 12 (May 1985): 210–227.

Weinraub, Anita Zaleski, ed. *Georgia Quilts: Piecing Together a History.* Athens: University of Georgia Press, 2006.

Weissman, Judith Reiter, and Wendy Lavitt. *Labors of Love: America's Textiles and Needlework, 1650–1930.* New York: Wings Books, 1987.

Welter, Barbara. *Dimity Convictions: The American Woman in the Nineteenth Century.* Athens: Ohio University Press, 1976.

Welters, Linda. "Homespun Folk Art." In *Down by the Old Mill Stream: Quilts in Rhode Island,* edited by Linda Welters and Margaret T. Ordonez, 236–238. Kent, OH: Kent State University Press, 2000.

Welters, Linda, and Margaret T. Ordonez, eds. *Down by the Old Mill Stream: Quilts in Rhode Island.* Kent, OH: Kent State University Press, 2000.

Weybright, Victor. *Spangled Banner: The Story of Francis Scott Key.* New York: Farrar and Rinehart, 1935.

What's American about American Quilts? A Research Forum on Regional Characteristics. Washington, DC: National Museum of American History, 1995.

Wheeler, Candace. *The Development of Embroidery in America.* New York: Harper and Brothers, 1921.

White, Richard. *Remembering Ahanagran: A History of Stories.* New York: Hill and Wang, 1998.

Willard, Frances E., and Mary A. Livermore, eds. *American Women: Fifteen Hundred Biographies.* New York: Mast, Crowell and Kirkpatrick, 1897.

Wilson, Lisa. *Life after Death: Widows in Pennsylvania, 1750–1850.* Philadelphia: Temple University Press, 1992.

Woods, Marianne Berger, ed. *Threads of Tradition: Northwestern Pennsylvania Quilts.* Meadville, PA: Crawford County Historical Society, 1997.

Wulfert, Kimberly. "The Journey of a Whitework Wedding Quilt." *Piecework Magazine* 14 (May/June 2006): 32–35.

Young, Alfred F. *The Shoemaker and the Tea Party: Memory and the American Revolution.* Boston: Beacon Press, 1999.

Zagarri, Rosemarie. "Morals, Manners, and the Republican Mother." *American Quarterly* 44 (June 1992): 192–215.

Zimmerman, Philip D. "Workmanship as Evidence: A Model for Object Study." *Winterthur Portfolio* (1981): 283–307.

Zonderman, David A. *Aspirations and Anxieties: New England Workers and the Mechanized Factory System, 1815–1850.* New York: Oxford University Press, 1992.

INDEX

⅋ ⅋

(page numbers in italics refer to illustrations)